JOHN POPE-HENNESSY

The Portrait in the Renaissance

The A. W. Mellon Lectures in the Fine Arts · 1963

The National Gallery of Art, Washington, D. C.

Bollingen Series XXXV · 12

Princeton University Press

To Nicky Mariano

Contents

Preface

THIS VOLUME *is the outcome of a lifelong interest in the portrait. The first book I ever wrote—it has remained unpublished—dealt with the iconography of Sir Walter Scott. Years later, during the last war, I returned to portraiture, this time to Hilliard and the Elizabethan miniature. After the war I found myself involved successively with the painted portrait in Florence in the middle of the fifteenth century and with the Renaissance portrait bust. When, therefore, I received the honor of an invitation to deliver the Andrew W. Mellon Lectures in the Fine Arts at the National Gallery of Art in Washington, I selected as my subject "The Artist and the Individual: Some Aspects of the Renaissance Portrait." The field covered by the lectures was very wide, and I have resisted the temptation to reduce it in this book: the text consequently deals with aspects of the northern portrait as well as with Italian portraiture.*

At the outset it must be established what is meant by the Renaissance and what is meant by portraits. The Renaissance began in Italy and spread slowly to the north. It exerted a calculable influence on northern art for the first time in the late fifteenth century, and the work of the great Flemish and French painters of the early and mid-fifteenth century, of Jan van Eyck and Rogier van der Weyden and Fouquet, impinges on it but is not an organic part of its development. Dürer is the first northern painter whose pictures are considered in this book. As for the portrait, any definition whereby portraiture was limited to independent portraits, single paintings of individuals, would be illogical. Renaissance art is packed with portraits, and some of the most cogitated of them are to be found in frescoes and in large religious paintings. The only cases we should disregard are those in which the features of a model were employed to give reality to an ideal type. Portraiture is the depiction of the individual in his own character.

Once my subject had been chosen, it remained to decide how the material should be grouped. One method would have been comparatively simple, to subdivide it by portrait

types—the full-length portrait, the group portrait, and so on. But though simple, it would also have been academic and unilluminating. Instead, therefore, I decided to discuss Renaissance portraiture in terms of the ideas by which it was inspired. The six chapters of this book correspond with the six lectures, save that the material has been somewhat amplified. The first deals with the portrait under the aspect it presented to painters in the fifteenth century, as the recording of an artistically viable likeness, and discusses their efforts to interpret the message of the human face. The second describes the impact of humanist thinking on the portrait; and the third is devoted to the painting of the mind and the contribution that was made to it by High Renaissance artists. The fourth is dedicated to a phase in the history of portraiture in which the sitter, not the artist, was predominant, the court portrait; the fifth surveys certain attempts to extend the scope of portraiture by literary or programmatic means; and the last discusses the depiction of individuals as donors or participants.

While preparing the volume for the press I have been acutely conscious of its omissions. Readers who search the index for references to the portrait busts of Francesco Laurana or to the paintings of Anthonis Mor will find neither mentioned in the book. Some elision is inevitable if a synoptic account is to be given of the part played by portraits in the Rennaissance world. The bibliography of Renaissance portraiture is very large, and references to it are given in the annotation to this book; but I must acknowledge a special debt to the only study in which these problems have previously been discussed, a masterly essay by Jakob Burckhardt published in Beiträge zur Kunstgeschichte Italiens *in 1898.*

London
October 1964 JOHN POPE-HENNESSY

List of Illustrations

Special acknowledgment is made to Her Majesty the Queen for gracious permission to reproduce photographs of works in her collection. Similar acknowledgment is also made to the following individuals and institutions: Ashmolean Museum, Oxford; Boston Museum of Fine Arts; The Frick Collection, New York; Ny Carlsberg Glyptotek, Copenhagen; the President and Fellows of Harvard College; Kunsthaus, Zurich, Gottfried Keller Collection; Kunsthistorisches Museum, Vienna; Isabella Stewart Gardner Museum, Boston; the Louvre, Paris; the Metropolitan Museum of Art, New York; the Earl of Radnor; and Wildenstein & Company, New York.

The Portrait in the Renaissance

I

The Cult of Personality

Portrait painting is empirical. The artistic problem it presents is one that we can all envisage no matter how distant the time context where it occurs, and a great part of its fascination is due to the fact that it results from the interaction of two forces, artist and sitter, and not from the action of one. But portraiture, like other forms of art, is an expression of conviction, and in the Renaissance it reflects the reawakening interest in human motives and the human character, the resurgent recognition of those factors which make human beings individual, that lay at the center of Renaissance life. It is sometimes said that the Renaissance vision of man's self-sufficient nature marks the beginning of the modern world. Undoubtedly it marks the beginning of the modern portrait.

In one sense the portrait in the Renaissance is no more than a watershed between the medieval portrait and the portrait as we know it now. Representationally it is the story of how eyes cease to be linear symbols and become instead the light-reflecting, light-perceiving organs we ourselves possess; how lips cease to be a segment in the undifferentiated texture of the face, and become instead a sensitized area through whose relaxation or contraction a whole range of responses is expressed; how the nose ceases to be a fence between the two sides of the face, and becomes instead the delicate instrument through which we breathe and smell; and how ears cease to be repulsive Gothic polypi emerging from the head, and become instead a kind of in-built receiving set whose divine functions compensate for its rather unattractive form. The transition is reflected not only in the rendering of individual organs, but in their depiction in relation to each other as part of a coherent structural whole. Through a long series of experiments the profile, which was originally a silhouette cut out with a pair of scissors, becomes a solid image caught momentarily in side face, and the cheek, which was originally an unfamiliar terrain plotted sectionally on the surface of the panel, acquires an intelligible shape in which the jaw and cheekbone are defined. The conquest of physical appearances is in turn bound up with a change in the function of the artist. In

3

the earlier of the portraits illustrated here [1] he appears as an observer; his puzzled face peers out at us through the ground fog of a theocratic world. In the later [2] he is an interpreter whose habit is to probe into the mind and for whom inspection connotes analysis.

The Renaissance in its initial phase is rather an untidy concept in that the influence of the antique on literature and thought anticipates the process of renewal in the visual arts. The practice of public commemoration was for this reason generally accepted before the portrait was clothed in a Renaissance dress. Giotto, in the chapel of the Palazzo del Podestà in Florence, painted portraits of Dante and Dante's master Brunetto Latini and his own self-portrait,[1] and in Ambrogio Lorenzetti's fresco of *Good Government* in Siena it is tacitly accepted that the community is composed of individuals and can be depicted only in terms of crudely differentiated portrait heads.[2] In Tuscany a further impulse was supplied, in the last quarter of the fourteenth century, by the factor of cultural chauvinism which led Leonardo Bruni to declare that every Italian child owed allegiance to two fatherlands, his place of origin and that "città umanissima per la vita umana," Florence.[3] If Florence were indeed the heir of the city-states of Greece, let there be recorded the features of those who made her so. This was the climate in which, in the fourteen twenties, a current event was set down in realistic terms in paint. The occasion was the consecration in 1422 of the church of the Carmine,

1. TADDEO DI BARTOLO: Self-portrait as St. Thaddeus, detail from the *Assumption of the Virgin* (Montepulciano)

2. LORENZO LOTTO: *Portrait of a Youth,* detail (Venice)

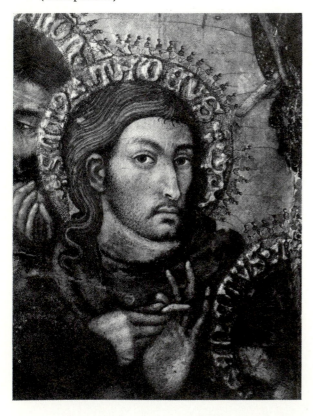

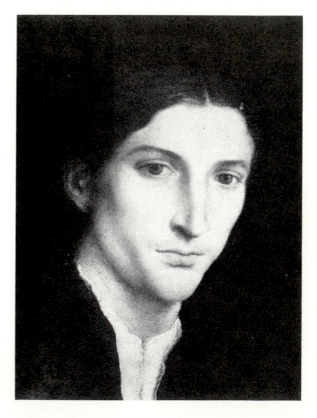

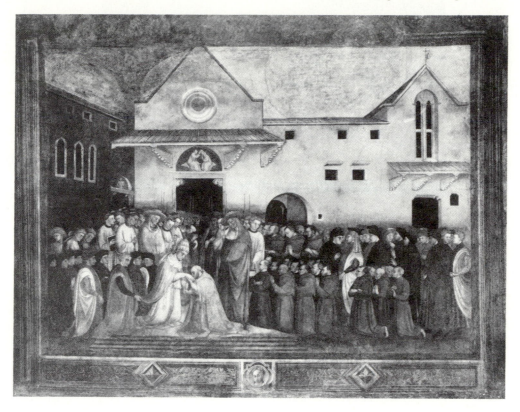

3. BICCI DI LORENZO: *Pope Martin V consecrating the Church of Sant' Egidio* (Florence)

and it was depicted in a fresco by Masaccio. The fresco is lost, but we can imagine what it looked like from partial copies and from a later fresco of the same type that survives [3]. Masaccio's fresco showed the Piazza del Carmine thronged with citizens, among whom were the founder of the Medici dynasty, Giovanni di Bicci de' Medici; Lorenzo Ridolfi, the Florentine ambassador in Venice; Bartolomeo Valori; Niccolò da Uzzano; Brunelleschi the architect; and the sculptor Donatello.[4] The fresco was not a portrayal from the life. It was a reconstruction of the scene, painted, it seems, a year or two after the event took place, and there is no proof that all the persons depicted in it were present at the ceremony. Indeed, if we look attentively at Vasari's list of the men whose portraits were included, we shall find among them Antonio Brancacci, who had died in 1391. To judge from the drawing Michelangelo made more than seventy years later of two of the figures from the fresco,[5] the portraits, whether or not the sitters were alive, were sharply individualized.

If tradition is to be believed, the *Consecration* fresco was preceded by a fresco inside

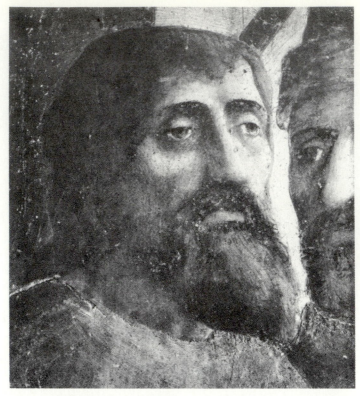

4. MASACCIO: Presumed portrait of Donatello, detail from *St. Peter curing the Sick with his Shadow* (Florence)

5. MASACCIO and FILIPPINO LIPPI *The Raising of the Son of Theophilus* (Florence)

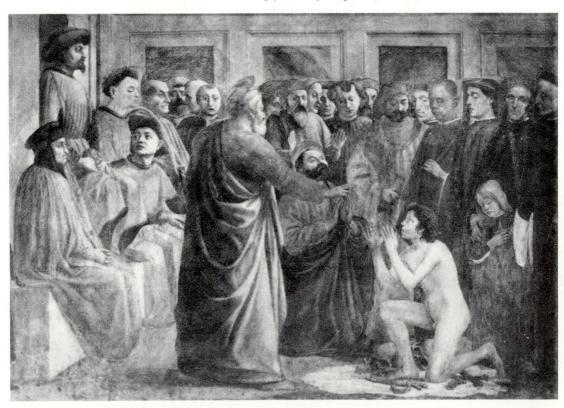

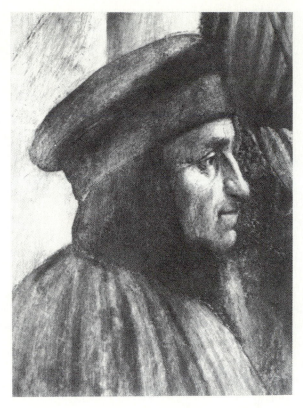

6. MASACCIO: Coluccio Salutati, detail from the *Raising of the Son of Theophilus* (Florence)

the church in which a Florentine magistrate, Bartolo di Angiolino Angiolini, was painted by Masaccio as St. Paul, and after it was finished Masaccio started work in the Brancacci Chapel, where the lower frescoes, beside the altar and on the left wall, are once more filled with portrait heads.[6] In the scene of *St. Peter curing the Sick with his Shadow* there is a presumed portrait of Donatello [4], and perhaps a self-portrait of Masaccio too, and the *Raising of the Son of Theophilus* [5] is also replete with portraits. But as soon as we examine them more closely, we find once more that certain of these heads are posthumous. A figure seated on the left, for instance, has been conclusively identified as the State Chancellor, Coluccio Salutati [6], whose death had taken place twenty years before.[7] This union of living figures and reanimated figures from the past as participants in one and the same narrative is not peculiar to Masaccio. Fifty years later Botticelli, in the well-known *Adoration of the Magi* in the Uffizi, unites the portraits of Lorenzo and Giuliano de' Medici, who were living, with those of

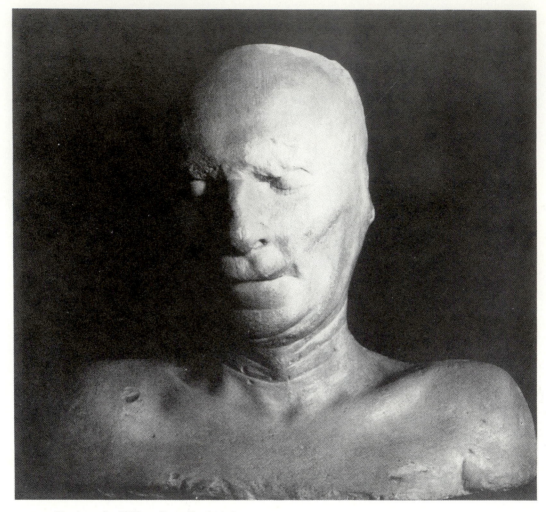

7. Death mask of Filippo Brunelleschi (Florence)

Cosimo il Vecchio and Piero de' Medici, who were dead. The reason for the practice is that initially the role of the Renaissance portrait was commemorative; it was consciously directed to a future when the living would no longer be alive.

Fundamental to this procedure was the making of proper records of the human face. When Coluccio Salutati died in 1406, a mask or drawing was taken of his features, and this must have supplied the basis of the portrait in Masaccio's fresco.[8] Similarly a mask was molded of Brunelleschi's features when he died in 1446 [7], from which the sculptor Buggiano worked up an artificially vivacious marble portrait for the Cathe-

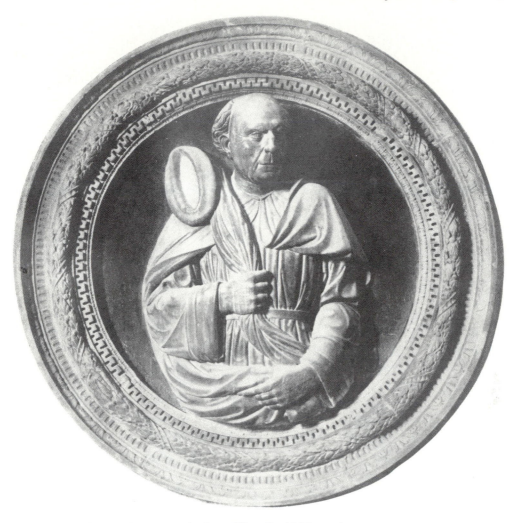

8. BUGGIANO: Commemorative bust of Brunelleschi (Florence)

dral [8].[9] In the Middle Ages masks of this kind were made in connection with sepul-
chral monuments, but in Florence in the fifteenth century they take on a slightly differ-
ent character. They represent a last despairing effort to salvage the data of physical
appearance on the threshold of the tomb. This was the same motive that caused
Vespasiano da Bisticci to describe in minute detail the appearance of the men whose
lives he wrote.

In Florence in the first half of the fifteenth century the notion of personal com-
memoration by visual means was confined to quite a small circle of men. One of the

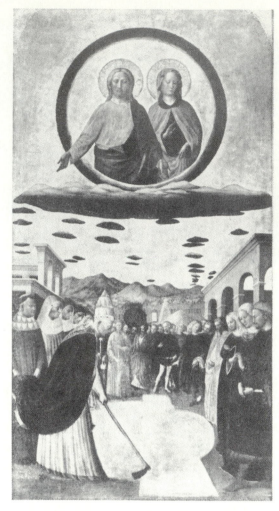

9. MASOLINO: *The Foundation of Santa Maria Maggiore* (Naples)

figures who appeared in Masaccio's *Consecration* fresco commissioned a cycle of frescoes of famous men from Lorenzo di Bicci for the old Palazzo Medici.[10] Another, Niccolò da Uzzano, filled the choir of the church of Santa Lucia with a cycle of frescoes with his own and other portraits.[11] A third, Bartolomeo Valori, who died in 1427, was the subject of a number of independent paintings. They showed, says his biographer, in a passage which explains the didactic bias of these early portraits, such austerity and seriousness that when you looked at them you were left with the impression of a man praiseworthy from every point of view.[12]

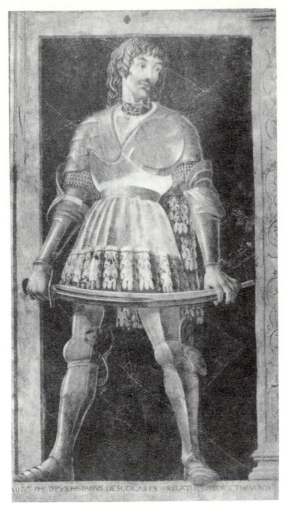

10. ANDREA DEL CASTAGNO: *Pippo Spano* (Florence)

The principle enunciated in the Carmine spread like a weed. It was transplanted to Rome by Masolino in a panel of the *Foundation of Santa Maria Maggiore* [9], in which Pope Martin V plays the part of his predecessor Pope Liberius, and the Emperor Sigismund enacts the role of the Patrician John, the founder of the church. The picture, as Michelangelo intimated in a conversation with Vasari, is a pious charade.[13] In a fresco by Fra Angelico in the Vatican, St. Lawrence receives the treasures of the Church from the hands of Pope Nicholas V, and Angelico's lost frescoes in the Chapel of the Sacrament included portraits of the Emperor Frederick III and the King of

Naples and Biondo da Forlì.[14] Late in life Angelico passed on the torch to his pupil Benozzo Gozzoli, whose frescoed chapel in the Palazzo Medici is again compact of portraits.[15] There are portraits in Gozzoli's frescoes in the Campo Santo at Pisa and portraits at San Gimignano.[16] About 1460 Fra Filippo Lippi's fresco of the *Burial of St. Stephen* in Prato Cathedral is filled with more than twenty portraits, of Carlo de' Medici, the provost of the church [11], and past and present members of the governing body of the Opera Pia del Ceppo.[17] Domenico Veneziano's lost fresco of the *Marriage of the Virgin* in Santa Maria Nuova contained portraits—of Bernardetto de' Medici and Bernardo Guadagni, and members of the Portinari family[18]—and Baldovinetti's lost frescoes in Santa Trinità did so too; in them there were portraits of the Gianfigliazzi and of Diotisalvi Neroni and Luca Pitti, which Vasari was able to identify from portraits in other frescoes or from busts in the possession of their families.[19] One of Baldovinetti's portraits, a self-portrait head which was cut out of the wall when the frescoes were effaced in the eighteenth century, exists at Bergamo.[20] The six figures of famous men in the loggia painted by Castagno in the Villa Pandolfini [10] register as portraits, and the heads of all save one seem to have been based on earlier likenesses.[21] At Arezzo Piero della Francesca included in the *Victory over Heraclius* portraits of Luigi Bacci and his three brothers and other learned Aretines.[22] In 1473 living and dead members of the Vespucci family gather before the Virgin in Ghirlandaio's fresco in the Ognissanti,[23] and about 1485 portraiture runs riot once again in the frescoes which Filippino Lippi added to the right wall of the Brancacci Chapel.[24]

In Rome, under Pope Sixtus IV, this tide became a flood. The appointment of the papal biographer Platina as prefect of the Vatican Library was commemorated by Melozzo da Forlì in a fresco which shows him kneeling before the Pope [12]. At the back are Giuliano della Rovere, the Pope's nephew, and three other members of the court.[25] A few years later work started on the decoration of the Sistine Chapel, where the walls were filled with frescoes of scenes from the lives of Moses and of Christ, painted in great haste by a scratch team of Florentine and Umbrian artists.[26] The intention was part expository—the scenes in the Biblical and Christian cycles correspond— and part journalistic—certain episodes were chosen because they were applicable to contemporary events. So the *Punishment of Korah* referred to the condemnation of the Dominican Andrea von Krain, and the *Crossing of the Red Sea* alluded to the papal victory in 1482 at Campo Morto. The two scenes are respectively by Botticelli and Cosimo Rosselli, and inevitably they contain a portrait of Krain by Botticelli [13] and heads of the victors of Campo Morto, Roberto Malatesta and Virginio Orsini, by Rosselli. But many of the portraits are incidental to the action of the scenes. In Botticelli's three frescoes we can identify the Pope's nephews Giuliano della Rovere and Clemente Grosso della Rovere, Girolamo Riario, the head of the Roman Academy

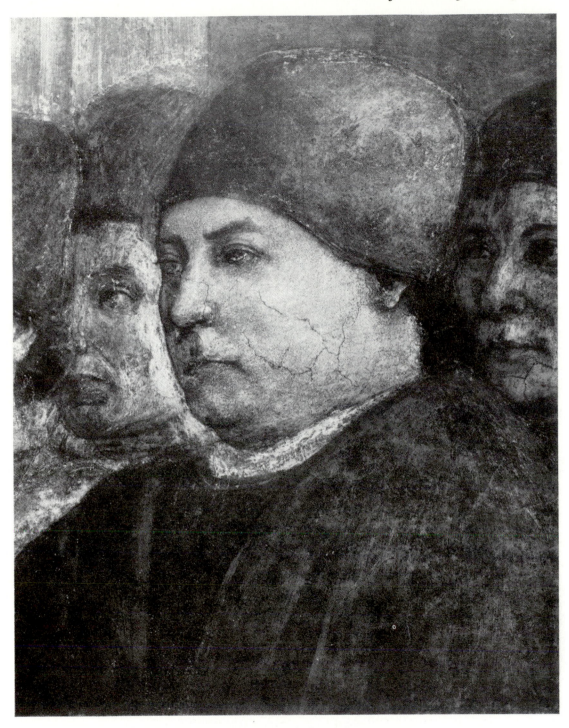

11. FRA FILIPPO LIPPI: Carlo de' Medici, detail from the *Funeral of St. Stephen* (Prato)

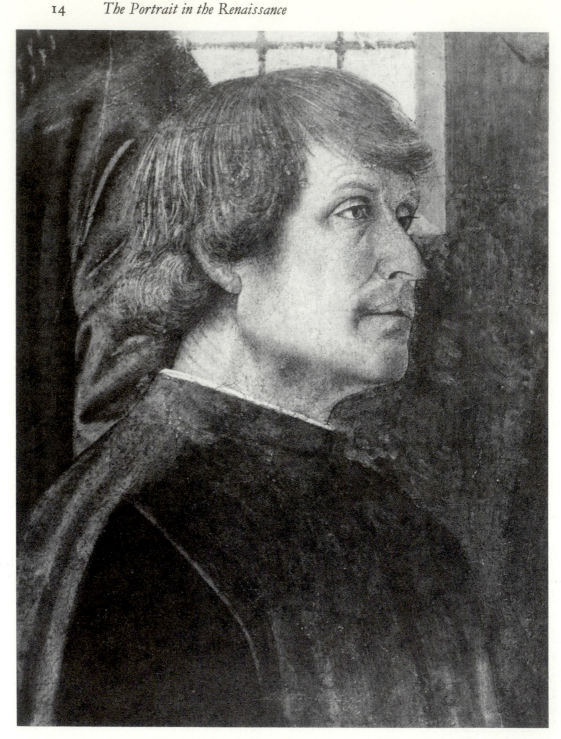

12. MELOZZO DA FORLÌ: Platina, detail from *Platina before Pope Sixtus IV* (Vatican)

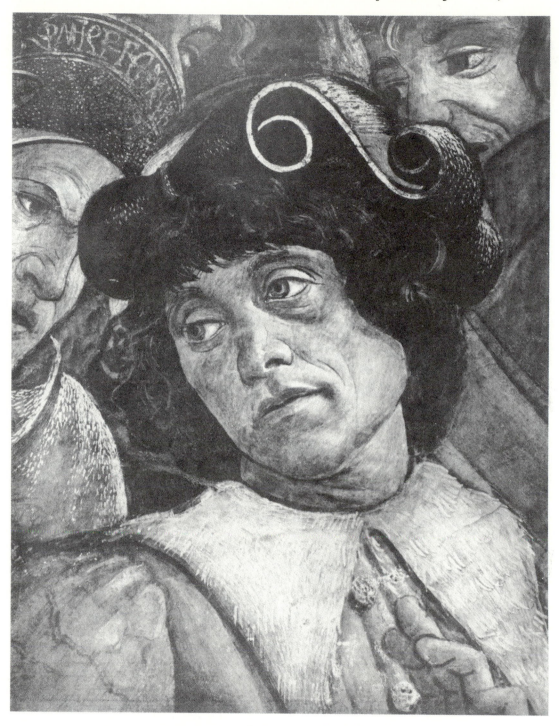

13. BOTTICELLI: Andrea von Krain, detail from the *Punishment of Korah* (Vatican)

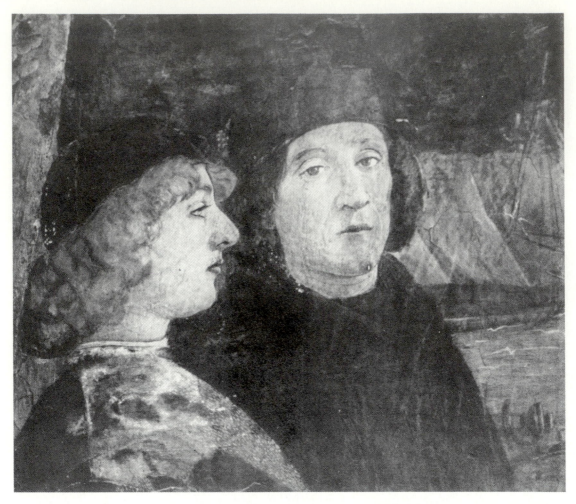

14. BOTTICELLI: Pomponius Laetus, detail from the *Punishment of Korah* (Vatican)

Pomponius Laetus [14], and the boy Alessandro Farnese, who at the end of his long life was to be the subject of one of Titian's greatest portraits. The action in Perugino's *Baptism of Christ* is almost halted by the advance of two groups of intruders, one of them led by the brother-in-law of the Pope, Giovanni Basso della Rovere with his sons [15], while the scene of *Christ presenting the Keys to St. Peter* is watched, at a respectful distance, by the defeated Neapolitans. Among the spectators of Ghirlandaio's *Calling of Saints Peter and Andrew* are Giovanni Tornabuoni and the members of a Florentine embassy which had arrived in Rome. So the frescoes were in-

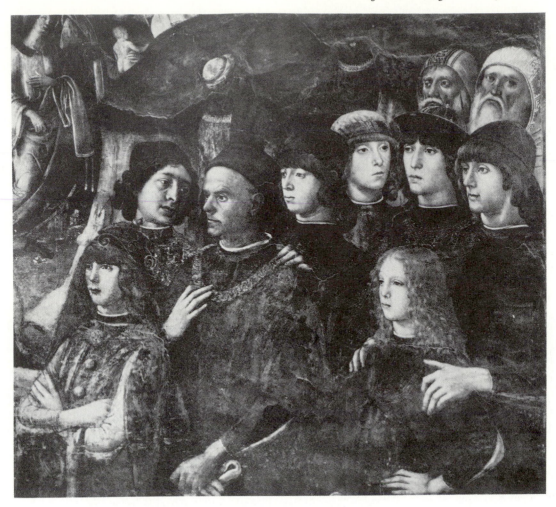

15. PERUGINO: Giovanni Basso della Rovere and members of his family, detail
from the *Baptism of Christ* (Vatican)

tended to be read on two quite different levels, as applied theology and as a *Who's
Who* of 1482.

Back in Florence, Ghirlandaio executed two great fresco cycles that were likewise
constructed round the portrait. The first is in Santa Trinità, where the scene of *Pope
Honorius III confirming the Franciscan Rule* takes place in a narrow corridor of space with
a secular scene in front of it showing Politian leading the children of Lorenzo the
Magnificent up a flight of steps [16] toward a group which comprises the donor of the
chapel, Francesco Sassetti, with one of his sons, Lorenzo de' Medici, and a kinsman

Antonio Pucci.[27] In the second cycle in Santa Maria Novella one fresco, *Zacharias in the Temple,* contains twenty-two portraits of members of the Tornabuoni and Tornaquinci families [17], which can be identified only because an eighty-nine-year-old man who had known all of the persons represented dictated their names in 1561 to an inquisitive descendant of the Tornaquinci.[28] Small wonder that Savonarola should express his disapproval of a secular component in religious scenes, when the choirs of so many churches were in effect a civic portrait gallery.

In Rome this commemorative technique was pursued in the Borgia Apartments of the Vatican, where scenes from the life of St. Catherine of Alexandria are surrounded by contemporary figures, most of them unidentified,[29] and the artist of the Borgia Apartments, Pinturicchio, carried it on to the scenes from the life of Pope Pius II in the Piccolomini Library of Siena Cathedral. In the very year in which these frescoes were completed, 1508, the decoration of the Vatican was resumed by Pope Julius II. As Giuliano della Rovere, the Pope had been painted by Melozzo in the Library and by Botticelli in the Sistine Chapel, and though the new frescoes were superior to the

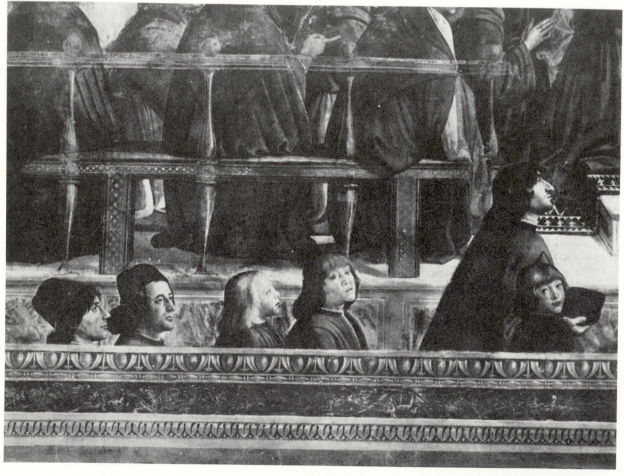

16. DOMENICO GHIRLANDAIO: Politian with the children of Lorenzo il Magnifico, detail from *Pope Honorius III confirming the Franciscan Rule* (Florence)

old—they were not run up against time, they emanated from a single mind, and they illustrated a philosophical theme—they shared with the frescoes in the Chapel the factor of the ubiquitous portrait. At one end of the Stanza della Segnatura was a fresco of *Gregory IX delivering the Decretals* [18], where the Pope played the part of Gregory IX and was attended by the future Leo X and the future Paul III.[30] At the opposite end was the Parnassus thronged with figures of dead and living poets, and on the long walls were the Disputa and the School of Athens, where real and imaginary portraits occurred side by side.

In North Italy the collective portrait made its appearance rather later than in Florence, and, like all late infections, it struck with special violence. Introduced in Venice in the first half of the fifteenth century by Pisanello, it was established by 1474, when paintings of scenes from the history of the city were commissioned from Gentile Bellini for the Palazzo Ducale. The paintings are lost, but descriptions of them leave no doubt as to their character; one showed Pope Alexander III offering the Doge a consecrated sword, and another represented the Pope blessing the Venetian

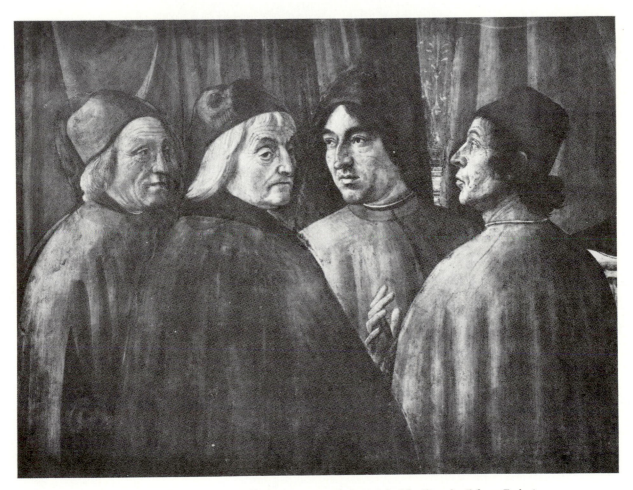

17. DOMENICO GHIRLANDAIO: Members of the Tornabuoni and Tornaquinci families, detail from *Zacharias in the Temple* (Florence)

18. RAPHAEL: *Pope Gregory IX delivering the Decretals* (Vatican)

fleet, in both cases in the presence of a crowd of Venetian notabilities.[31] Their style can be reconstructed from three paintings by Gentile Bellini that survive, where a vast topographical stage is filled with a quantity of laborious portrait heads. This type of painting reaches its zenith with Carpaccio. He was a subtler, more tactful artist than Gentile Bellini, and for a moment we might be misled into supposing that the members of the School of St. Ursula standing at the back of the scene of the *Reception of the Ambassadors* [19] are really the casual sightseers they claim to be. When Dürer came to Venice in 1505 to paint the *Feast of the Rose Garlands* for San Bartolomeo in Rialto, he was compelled to follow the Venetian practice and fill the altarpiece with portraits of the Pope, the Emperor Maximilian I, and members of the German colony.

In Rome in the generation after Raphael's and in Florence after the reinstatement of the Medici, the collective portrait became less popular. One reason for that may have been the influence of Michelangelo, who resolutely turned his back on portraiture. But new impetus was given to the documentary portrait by the famous collection

19. VITTORE CARPACCIO: Members of the School of St. Ursula, detail from the *Reception of the Ambassadors* (Venice)

20. JACOPO TINTORETTO: *Four Senators before the Virgin and Child* (Venice)

of historical portraits formed at Como by Paolo Giovio.[32] Raphael himself had been alive to the value of the portrait as a record—when he destroyed some pre-existing frescoes to make way for the *Mass of Bolsena*, he enjoined that copies should be made of all the portrait heads[33]—and on a monumental scale this growing sense of historicity is reflected in Vasari's frescoes of episodes from the lives of the Medici in the Palazzo Vecchio in Florence,[34] and in the scenes from the life of Paul III in the Cancelleria and at Caprarola.[35] In Venice, on the contrary, the vogue of the official collective portrait grew and grew. It spread outward from the Palazzo Ducale to the Schools, and it extended from records of historical events to those innumerable canvases of Procurators and Treasurers and Chamberlains kneeling in a body before St. Mark or the Virgin and Child [20]. Status and portraiture became inextricably intertwined, and there was almost nothing patrons would not do to intrude themselves in paintings; they would stone the woman taken in adultery, they would clean up after martyrdoms, they

would serve at table at Emmaus or in the Pharisee's house. The elders in the story of Susannah were some of the few figures whom respectable Venetians were unwilling to impersonate. The only contingency they did not envisage was what actually occurred, that their faces would survive but their names go astray. For the artist this thirst for immortality was something of an incubus, and many a picture tells of Tintoretto's boredom when he found himself confronted by yet another pertinacious bearded face.

Not unnaturally, the portraits included in these paintings vary in quality. Their emphasis is generally descriptive, and not all of them penetrate beneath the surface of the personality. Dürer's, of course, do so—the portrait heads in the *Feast of the Rose Garlands* represent the summing up of a lifelong study of the independent portrait— but Carpaccio's interest is in the human face as a visual phenomenon, and Gentile Bellini confines himself to the prosaic task of taking what were once called speaking likenesses. In Florence Ghirlandaio operates on a higher level and on a more ambitious scale. His marmoreal heads none the less read as interpolations, and the figures, though they stand side by side, are segregated from each other much as they were when the preparatory cartoons were made. In this respect they differ from the portrait heads of Botticelli, who emerges from this quattrocento context as a giant among portraitists. He can animate the human face, he can apprehend its contours and its planes, he can invest it with a sentient response to the scene where it occurs. The same life-giving imagination is apparent in the portraits of Castagno, but even they cannot aspire to Masaccio's sublime disregard for the descriptive and the inessential and to his effortless command of form.

In all these works the main heads are usually depicted in three-quarter face. Some secondary heads are shown in profile, but for the principal figures it is the three-quarter face that is most generally employed. Since the independent panel portrait (in all categories save one) depends from the collective painting, there the three-quarter face naturally recurs. The phrase "depends from the collective painting" can mean two different things. It can mean either that the portrait is directly adapted from a fresco, or that it results from the employment of a style that originates in painting in larger forms. Probably in the fifteenth century portraits copied from frescoes were commoner than the extant examples suggest. Vasari was aware of the identity of seven of the figures in Masaccio's *Consecration of the Carmine* because copies of them, reputedly made by Masaccio, were preserved in a sixteenth-century collection.[36] The copies may have shown seven heads with names written beneath. One panel of this kind actually survives [21]; it contains five portraits behind an inscribed parapet. The heads differ slightly in size (Vasari tells us that the figures in the *Consecration* fresco were arranged in rows and diminished in size as they receded), and each is illuminated

independently, in such a way as to suggest that it was planned for a fresco lit from the right. In the first edition of Vasari's *Lives* the panel is given to Masaccio, and in the second to Uccello, but even when allowance has been made for its much deteriorated state, it can hardly be looked on as an autograph work by either artist.[37] In the best preserved of the five heads, the so-called Donatello [22], the connection is with Masaccio rather than Uccello. The idiom is realistic—a particularly telling detail is the ear pressed down by the cap—the three-quarter face view is handled with masterly assurance, and the prevailing sense of purpose is established through the structure of the head.

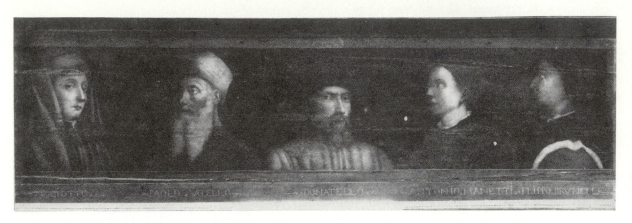

21. PAOLO UCCELLO (?): *The Founders of Florentine Art* (Paris)

A diptych at Zurich [23] must have originated in somewhat the same way.[38] It shows the heads of two men, presumably members of the Medici family, since the Medici device is painted on the back, lit uniformly from the right. On the evidence of costume the original portraits seem to have been made soon after the middle of the century. Possibly they occurred in the lost frescoes of Baldovinetti or Domenico Veneziano. In the sixteenth century a double portrait of Giovanni di Bicci de' Medici and Bartolomeo Valori was in the Medici collection.[39]

In one instance only do both the fresco and the panel painting that corresponds with it survive. The subject is Giovanna degli Albizzi, who married Lorenzo Tornabuoni in 1486 and died in childbirth two years afterwards. Her father-in-law, Giovanni Tornabuoni, was responsible for commissioning the fresco cycle by Ghirlandaio in Santa Maria Novella, and there Giovanna degli Albizzi's portrait has a prominent place [24]. It occurs in the fresco of the *Visitation*, which appears to have been painted

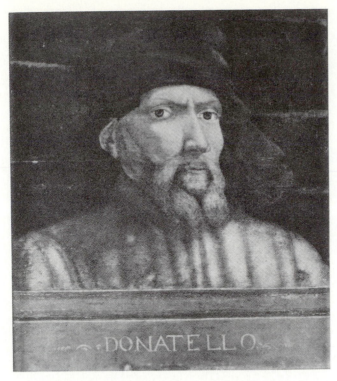

22. PAOLO UCCELLO (?): Donatello, detail of the *Founders of Florentine Art* (Paris)

23. FLORENTINE: *Two Members of the Medici Family* (Zurich)

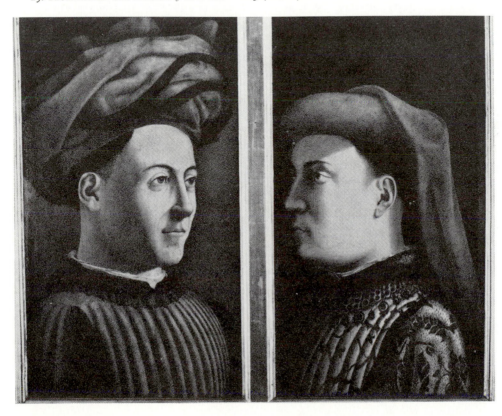

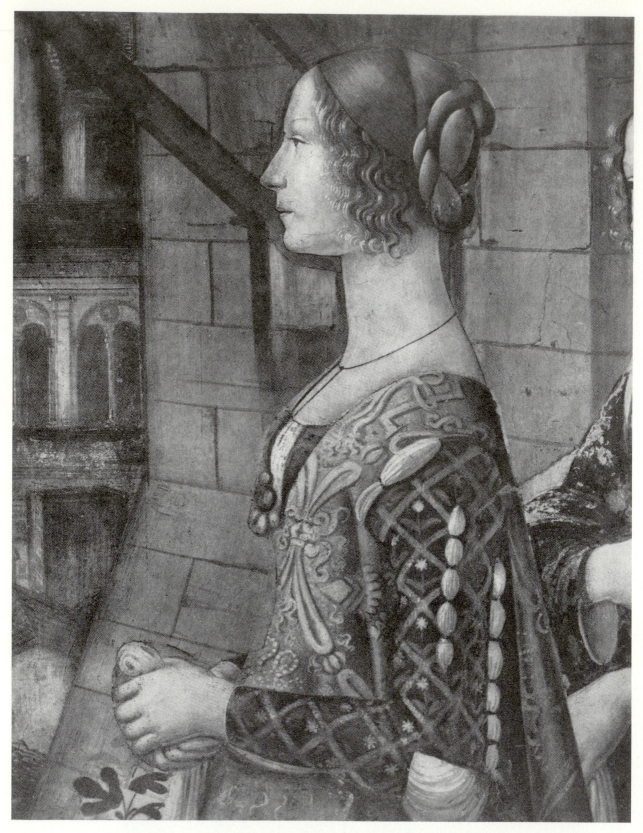

24. DOMENICO GHIRLANDAIO: Giovanna degli Albizzi, detail from the *Visitation* (Florence)

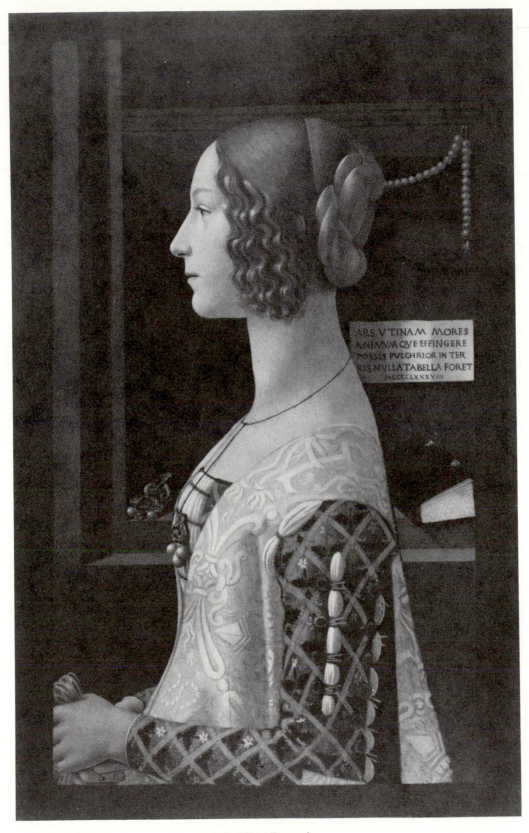

ARS VTINAM MORES
ANIMVM QVE EFFINGERE
POSSES PVLCHRIOR IN TER
RIS NVLLA TABELLA FORET
MCCCCLXXXVIII

25. DOMENICO GHIRLANDAIO: *Giovanna degli Albizzi* (Lugano)

early in 1490 or late in the preceding year, and in any event after her death.[40] That the panel [25] was adapted from the fresco and not vice versa is established by two details, that the left hand is severed through the knuckles and that the handkerchief held in it has been abbreviated. In the panel the setting of the fresco is dispensed with, and a rectangle of cupboard is inserted at the back. Behind is a jewel, the symbol of the worldly life, opposed to a rosary and prayer book, and above the prayer book is an epitaph from Martial: "O art, if thou wert able to depict the conduct and the soul, no lovelier painting would exist on earth." The date 1488 inscribed on the panel is that of Giovanna degli Albizzi's death.

The class of portrait in which the style palpably depends from works in larger forms is met with much more frequently. One reason for this is that fifteenth-century Florentine painters were not professional portraitists; they subsisted by applying to the portrait lessons they had learned elsewhere. With Castagno the connection is particularly evident. His relationship to Donatello must have been extremely close, and like Donatello he had temperamental bias toward the individualizing processes of portraiture. From a portrait standpoint the most impressive of the *Famous Men* from the Villa Pandolfini is the one who lived closest to Castagno's time, Pippo Spano [10], whose head has the power and vivacity we might expect in a life portrait. But it is less powerful and less vivacious than the only life portrait by Castagno that we know, the magnificent painting in the National Gallery of Art in Washington [26].[41] In construction this portrait closely recalls Castagno's frescoes. At the bottom the figure is cut through the waist, like the seated figures in the *Last Supper*, and at the top the head, like the heads of the figures from the Villa Pandolfini, almost touches the containing frame. For Castagno the human face was seldom unemotional or relaxed. Whether it be the repentant figure of St. Julian in the Annunziata, with his furtive sideways glance, or the ecstatic head of St. Jerome in the same church, the type is inseparable from its dramatic character. The portrait in Washington has this same freedom and dynamism and expressiveness. As a great critic of Italian art has written of it, "What is at one moment the projection of pure vision, is at the next a delineation of those moral and intellectual features we are wont collectively to call character."[42]

The impulse behind Botticelli's portraits was not dramatic; it was philosophical, and it stemmed from a tenuous web of Neoplatonic thinking whereby reality came to be accepted as a symbol and the depiction of reality took on symbolic overtones. In the *Birth of Venus* the figurative language warns us that the standards of the real world are not to be applied, and in Botticelli's *Youth with a Medal of Cosimo de' Medici* [27][43] that is no less evident. In the nineteenth century, however, the *Birth of Venus* was interpreted as a rather perverse narrative, and the portrait was thought to show a medalist exhibiting his skill. The linear features, the languid, reflective eyes, the

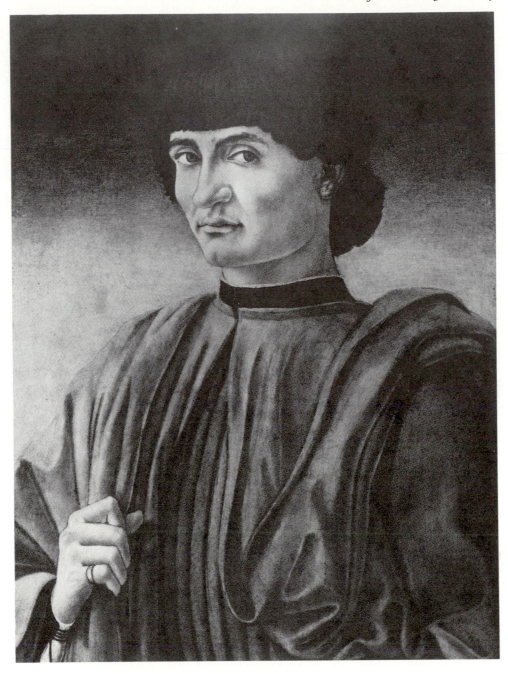

26. ANDREA DEL CASTAGNO: *Portrait of a Man* (Washington)

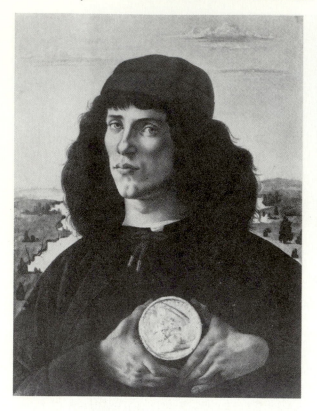

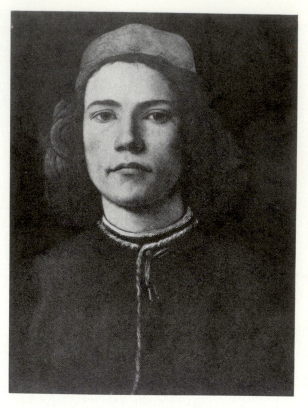

27. BOTTICELLI: *Portrait of a Youth with a Medal of Cosimo de' Medici* (Florence)

28. BOTTICELLI: *Portrait of a Youth* (London)

lyrical pose, assures us that this level of interpretation must be wrong. Botticelli's concern is with the kernel of the personality, and seldom in the fifteenth century was the poetic essence of the individual pinned down more faultlessly than it is here. This preoccupation with the image of the inner man led Botticelli to pose the portrait head with greater freedom than most painters of his time. In the *Adoration of the Magi* he employs a wide variety of postures, from the full face to the three-quarter face (or the eye and a half, as it was known in the sixteenth century) and from the three-quarter face to the lost profile (or hardly any eye at all).[44] At one head the painter looked with special curiosity, and when we isolate it, it seems that the head [29] is in turn inspecting us. Then as now the artist was dependent on a mirror to record his features, and could depict himself only in full or in three-quarter face. In his self-portrait in the *Adoration* Botticelli makes a virtue of that limitation by adopting a spontaneous pose which suggests that his attention is distracted momentarily from the scene. This cult of

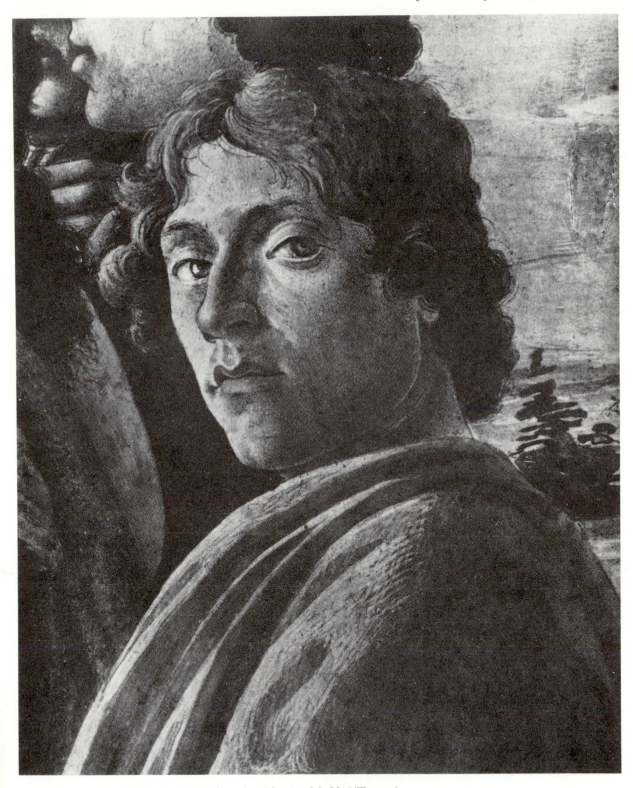

29. BOTTICELLI: Self-portrait, detail from the *Adoration of the Magi* (Florence)

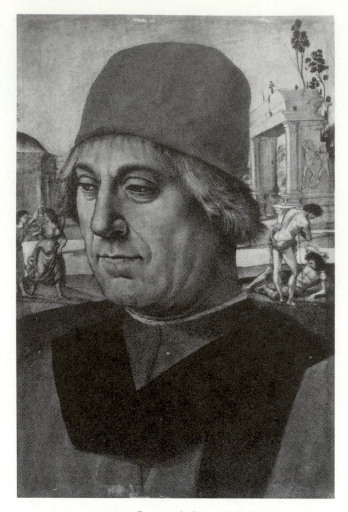

30. LUCA SIGNORELLI: *Portrait of a Jurist* (Berlin)

spontaneity he carried through into the independent portrait in a painting in the National Gallery in London of a youth looking outward in full face [28].[45] In the self-portrait we cannot remain unaware of an increase in depth as the painter seeks the identity behind the mask, and the London portrait also leaves us with the sense that he has pulled aside a veil shrouding the personality.

Of the other painters employed in the Sistine Chapel two are, from the standpoint of the independent portrait, specially significant. One of them is Signorelli, whose frescoes at Orvieto are filled with portrait heads, and who transfers their style to the noble *Portrait of a Jurist* in Berlin [30]. The portrait was painted about 1480,[46] and like

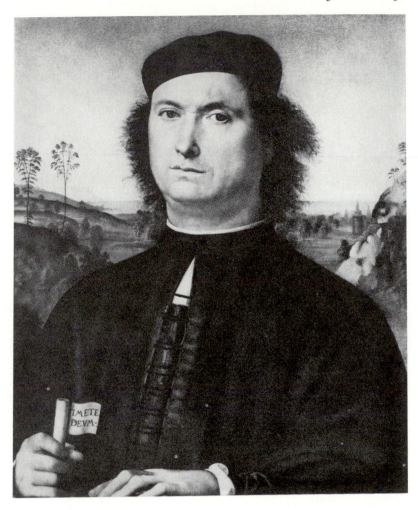

31. PERUGINO: *Francesco delle Opere* (Florence)

the more prominent portraits in the frescoes, is in three-quarter face. The planes have something of the massiveness and the solidity of Roman portrait busts, and this appeal to the antique is carried through into the background, where we see four classicizing figures posed before a temple and a triumphal arch. The second painter is Perugino, whose portrait heads are apprehended with exceptional strength; in the portrait of Francesco delle Opere of 1494 [31][47] he succeeds in translating them to panel and refining them by luministic means. The aspirations behind this painting are common also to another panel painted in Florence about 1495, Piero di Cosimo's vital, rounded portrait of the architect Giuliano da Sangallo [37].[48]

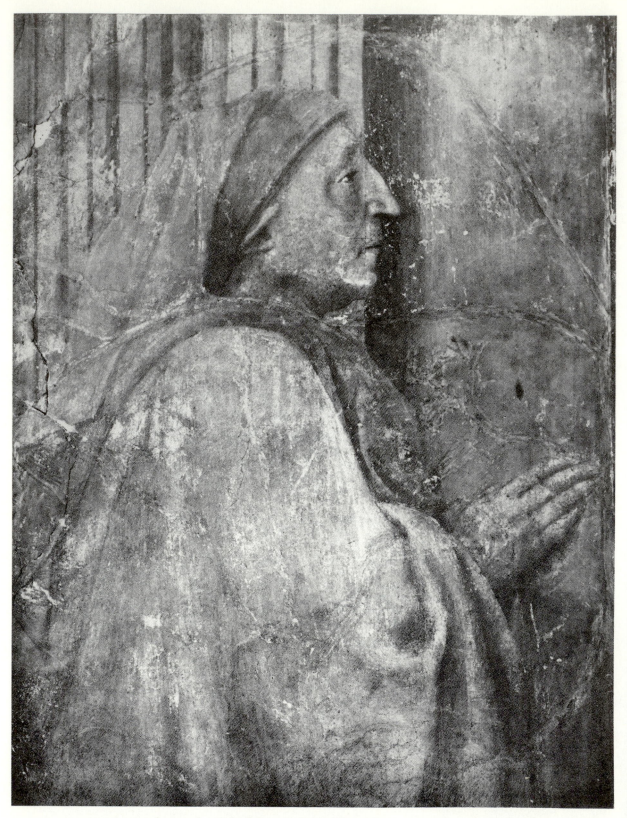

32. MASACCIO: Lorenzo Lenzi, detail from the *Trinity* (Florence)

None the less, there is one type of portrait which does not depend from works in larger forms, and that is the profile portrait.[49] It is a commonplace that a recognizable transcription of the features can be achieved more easily in profile than in any other way. We can all of us remember those nineteenth-century silhouettes in which amateurs, armed with black paper and a pair of scissors, succeeded in producing fairly well-individualized likenesses. For exactly the same reason a convincing memory image could be reconstructed in profile more readily than in three-quarter face. The *Notebooks* of Leonardo indeed include a recipe for "making a man's portrait in profile after having seen him only once." If the shape of the nose, mouth, chin, and forehead is committed to the memory, Leonardo tells us, a credible portrait will result. Portraiture in profile, moreover, had a weight of tradition behind it: in Gothic Italy the use of profile for the portrait of the donor of an altarpiece was an almost invariable rule.

The profile is as readily susceptible of realistic emphasis as any other type of portrait. It was treated in a semirealistic fashion by Giotto in the kneeling figure of Cardinal Stefaneschi in the polyptych in the Vatican, and in 1425, in the hands of the neorealist Masaccio, it gave rise to one of the great portraits of the fifteenth century [32]. This portrait occurs in the fresco of the *Trinity* in Santa Maria Novella in Florence [282], which marks the grave of Lorenzo Lenzi, the head of the Florentine judiciary.[50] Painted in the year preceding Lenzi's death, the head, like the heads of many earlier donors, was studied from the life, but it has no resemblance to previous donor portraits. It is the outcome of a realistic vision to which the coefficient of a classical art form has been applied. Before designing it, Masaccio must have studied the only Roman models that were relevant to his problem, coins, and it was these that taught him to perceive the head as a continuous sculptured surface, in which each feature sprang from the interior structure of the form. Perhaps the unbroken line that runs diagonally across the head beneath the hood was suggested by a laureated portrait. To the portrait of Lenzi's wife on the right side of the fresco classical models were inapplicable, and though the intention is no less realistic, the definition of the character is weaker and the head is less convincing as a life portrait.

Had the will been there, there was no reason why other profile portraits as vigorous and uncompromising as that of Lenzi should not have been produced. A drawing by Uccello [35], for example, proves that he was capable of recording the human head in profile with the same vitality and truthfulness, yet there is no surviving painting in which the profile is treated in this enterprising way.[51] Throughout the middle of the century the artist's goal was not a realistic image but a schematic abstract of reality. To point the difference, Uccello's drawing may be contrasted with the painted portrait of a youth at Chambéry [36], with which he has been credited,[52] or the head of Lenzi with two portraits of young men in Boston [34][53] and Washington[54] which are mis-

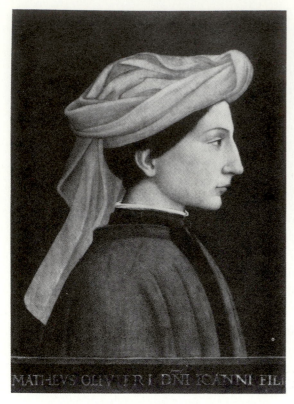

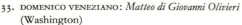

33. DOMENICO VENEZIANO: *Matteo di Giovanni Olivieri* (Washington)

34. FLORENTINE: *Portrait of a Youth* (Boston)

takenly given to Masaccio. The emphasis in these portraits is decorative; at Chambéry the face is subordinated to the pink and white folds of the headdress and the robe, and in Washington it is delimited by cursive lines, while at Boston the features are formalized and there is a fatal lack of volume in the cheek and mouth and chin. In Domenico Veneziano's much superior portraits of Matteo and Michele Olivieri in the National Gallery of Art in Washington [33] and the Rockefeller collection in New York[55] the brightly colored dresses are once more put to vivid decorative use. In all these portraits the profile is set against a neutral ground, and where the panel is inscribed, the legend is usually placed on a flat strip running across it and not on a foreshortened ledge which would commit the figure to an existence in real space.[56] One of the most attractive of the female portraits turned out in the middle of the century is a damaged painting of a lady ascribed to the Master of the Castello Nativity in the Lehman Collection in New York,[57] and here the claims of the image as representation are once more decisively rejected in favor of its claims as two-dimensional design.

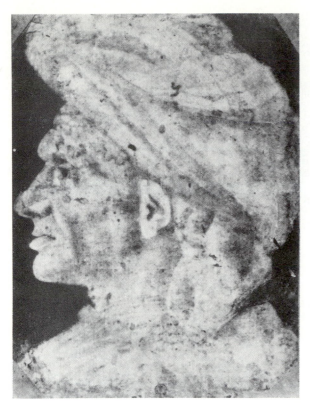

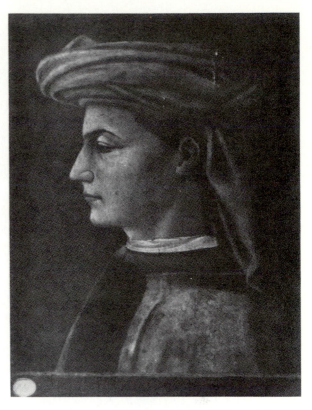

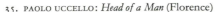

35. PAOLO UCCELLO: *Head of a Man* (Florence) 36. PAOLO UCCELLO (?): *Portrait of a Youth* (Chambéry)

Paintings of this type were certainly produced by the author of the Olivieri portraits, Domenico Veneziano—in the Medici inventory of 1492 there occurs a reference to one such panel with "una testa di una dama di mano di maestro Domenico di Vinegia"[58] —and in them the balance between decoration and representation may have been more carefully preserved. This bias toward decoration is usually explained as a matter of aesthetic choice, but the evidence is that these portraits were first and foremost social documents and only secondarily works of art. A few of them are mentioned in inventories—a pair of profile portraits of a father and son by Gentile da Fabriano is, for example, described in a Venetian collection[59]—and it is likely that they sprang up in obedience to the precept that, as a complement to the family tree, a visual record should be kept of the members of the family.

In a few cases it can be proved that these portraits were posthumous. Piero di Cosimo's painting of Giuliano da Sangallo [37], for instance, forms the left wing of a diptych; the right half contains a portrait of Sangallo's father, Francesco Giam-

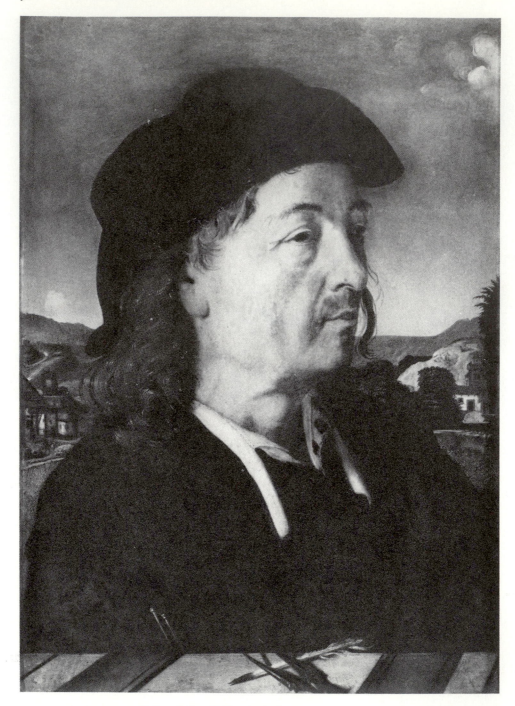

37. PIERO DI COSIMO: *Giuliano da Sangallo* (Amsterdam)

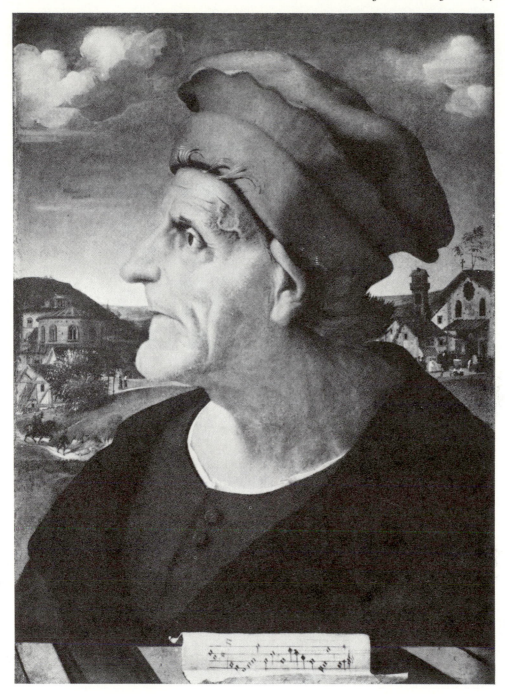

38. PIERO DI COSIMO: *Francesco Giamberti* (Amsterdam)

39. LUCA SIGNORELLI: *Vitellozzo Vitelli* (Florence)

berti [38].[60] Sangallo is shown in three-quarter face, but his father, who had died in 1480, is portrayed in profile. In this case, then, the three-quarter face pose is employed for the portrait from life, while the reconstructed portrait is in profile. Similarly, Signorelli, about 1505, painted for the Palazzo Vitelli at Città di Castello three reconstructed profile portraits of members of the family, Niccolò Vitelli, the tyrant of Città di Castello, who had died in 1486, and his sons Camillo and Vitellozzo [39], who died respectively in 1496 and 1502.[61] The portraits of Giamberti and of the Vitelli have it in common that they masquerade as portraits from the life: in this respect Piero di Cosimo's panel is a good deal more deceptive than the sentiment-laden heads of the Vitelli. What proportion of the profiles painted in the middle of the fifteenth century are reconstructed portraits we cannot tell. The painting ascribed to Uccello at Chambéry has an inscription ("El fin fa tutto") which may be commemorative, and the Olivieri panels by Domenico Veneziano also have the character of posthumous rather than life portraits. In addition, there are quite a number of portraits of women (in the

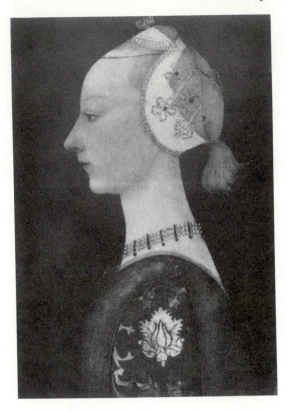

40. MASTER OF THE CASTELLO NATIVITY (?): *Portrait of a Lady* (Boston)

Metropolitan Museum in New York, the Gardner Museum at Boston [40], and elsewhere), whose crudeness and conventionality would be inexplicable if we supposed that they resulted from the conjunction of live sitters and live artists.[62]

With many female profile portraits, however, there remains an element of doubt. The profile was not only the most advantageous, it was also the most flattering view, and for this reason, until quite late in the fifteenth century it was the form in which portraits of women were invariably cast. As such it was the subject of experiment by a succession of great artists. What is by all accounts the earliest of these paintings, by Fra Filippo Lippi in the Metropolitan Museum in New York, is exceptional in that it is a double portrait [41].[63] The lady, dressed *alla parigina*, is shown facing to the left with her hands folded beneath her waist. She wears a richly ornamented headdress with scarlet lappets, and has an indecipherable motto embroidered on her sleeve. Presumably the motto is connected with a family impresa, since the second figure, a youth whose face is seen through a window on the left, holds on the window sill the

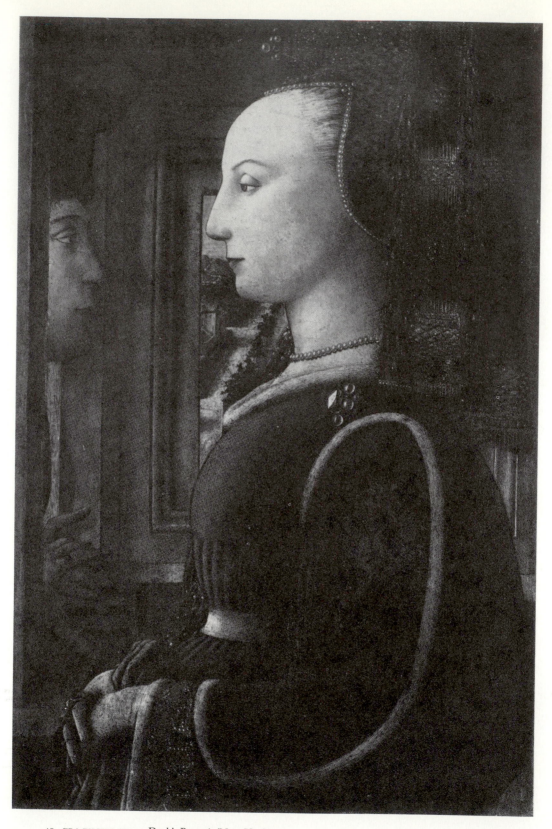

41. FRA FILIPPO LIPPI: *Double Portrait* (New York)

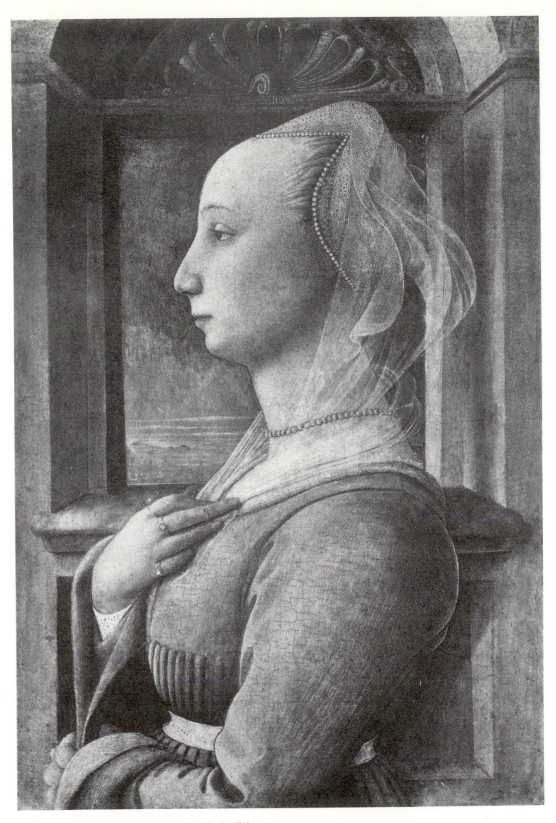

42. FRA FILIPPO LIPPI: *Portrait of a Lady* (Berlin)

stemma of the Scolari family. The main figure is set in a cube of space with a second window opening on a landscape at the back. In structure therefore the painting conforms to the deep semirealistic architectural settings that occur in Lippi's religious paintings about 1440 rather than to the shallower settings to which he had recourse in later works.

In the only other portrait by Lippi that we know, a painting in Berlin of about 1455 [42],[64] a lady dressed in green with a vermilion and white headdress is once more turned to the left. But on this occasion the window at the back is nothing but a means of visual emphasis; its receding lines converge on and give value to the head. By the time this portrait was produced Lippi habitually made use of line to decorate, not to describe, his forms, and the treatment of the features is likewise decorative. At the points of transition between forehead and cranium, nose and upper lip, and chin and neck, the form is sacrificed to a continuous flowing line. That this was a general limitation in Lippi's equipment as a portraitist is proved by the head of Geminiano

43. FRA FILIPPO LIPPI: Geminiano Inghirami, detail from the *Death of St. Jerome* (Prato)

44. ALESSO BALDOVINETTI: *Portrait of a Lady* (London)

Inghirami at Prato [43],[65] where these crucial areas are treated in the same evasive way.

More confident and more sharply observed is Baldovinetti's portrait of a lady in the National Gallery in London [44].[66] When he establishes the forms of his religious paintings, Baldovinetti rejects all adventitious aid. The heads of his Virgins are outlined against the sky and are bathed in soft, clear, even light. His portrait is treated essentially in the same way; the figure is shown against a neutral ground and its contours are defined by the pale light which catches on the flaxen hair, the necklace, and the muslin edging of the dress. Probably it was painted not long after the light-suffused three-quarter face medallions of Arrigo Arrigucci and his family round the fresco of

45. ANTONIO POLLAIUOLO: *Portrait of a Lady* (Berlin)

46. ANTONIO POLLAIUOLO: *Portrait of a Lady* (Milan)

the Nativity in the Annunziata. Though the impresa sewn on to the sleeve reveals that the intention once more is documentary, the treatment of the features is more sharply focused and more astringent than in most quattrocento portraits.

The fact that the bodies in these portraits are represented in pure profile, like the heads, gives them an almost dematerialized character. This was corrected by Antonio Pollaiuolo. The earlier and less well preserved of Pollaiuolo's two surviving female portraits is in Berlin [45].[67] At about the time he painted it, in the late fourteen sixties, he was working on the altarpiece for the Chapel of the Cardinal of Portugal which is now in the Uffizi, where the figures are shown against the sky and the spatial content of the scene is established by the inlaid pavement on which they stand. In the portrait in Berlin both these devices are introduced; the head is silhouetted against the sky, and set at the back is a balustrade inlaid with green porphyry discs. Seated and leaning slightly back, the body is turned so that a small area on the farther side is visible. A realist by inclination, Pollaiuolo approached the world of natural appearances with more curiosity than Lippi or Baldovinetti, and with a more fully developed representational technique. In the Berlin portrait this is apparent in the treatment of the dress; the dull green and crimson pile of the white velvet bodice and the crimson and gold sleeves have a strongly tactile quality. The implications of this change are still more marked in a later portrait in Milan [46], where the area of the body is reduced—that part of the body which is shown is once more slightly turned—and the modeling of the head is fortified.[68] Unlike his predecessors, Pollaiuolo makes local use of an oil medium; in this portrait its advantages are seen in the impasto on the edging of the dress and in the carefully differentiated texture of the hair. Moreover he was a sculptor—hence the relief-like treatment of the cheek—and his bias was toward veracity—hence the mouth, in which the lips are no longer tightly set but seem to be capable of movement if not of speech, hence the delicate rendering of the eyelash, which gives an added luster of the eye, hence the uneven surface of the hair, which in the fifteenth century must have elicited a strong tactile response. The importance of these paintings for the future cannot be overstressed. In them a first attempt is made to capture the mutability and charm which fascinated Titian in the *Bella* [157] and Raphael in the *Donna Velata* [124].

Botticelli's representational technique was less advanced than Pollaiuolo's, but in the beautiful portrait of a lady in the Palazzo Pitti [47], which he painted in the late fourteen seventies, another fundamental change is introduced.[69] Superficially the design seems to be no more than a variation on those of Lippi's portraits in New York and Berlin. But where Lippi's sitters are centralized, in Botticelli's portrait the figure is placed to the left of center, and this asymmetry is compensated by the architrave of a doorway on the right: it provides a dark background against which to isolate the

47. BOTTICELLI: *Portrait of a Lady* (Florence)

features and a light ground against which to set the long line of the back. Moreover, the artist's viewing point is no longer in the center of the body but on the level of the head. He looks down on the near shoulder and on the forward arm. This change also affects the projection of the architecture, and gives rise to an image which is remarkable for spontaneity of structure and for the sophisticated treatment of the face. The clouds that pass over the painting are very different from the monotonously sun-filled surfaces of Pollaiuolo. The illusion is less complete, but there were other means by which a sense of actuality could be induced. One of them, which Botticelli adopts here,

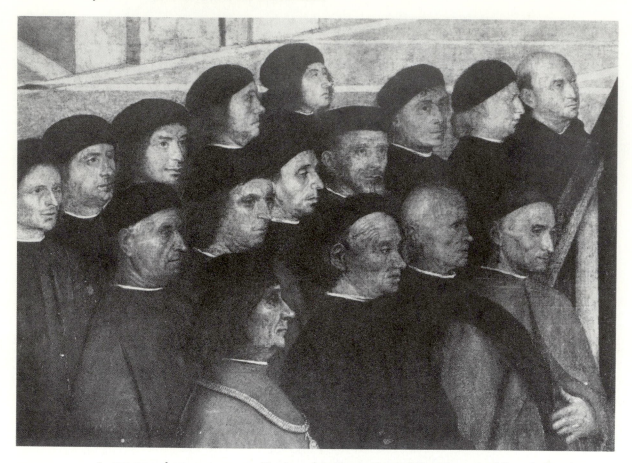

48. GENTILE and GIOVANNI BELLINI: Members of the Scuola Grande di San Marco, detail from the *Preaching of St. Mark* (Milan)

is to reduce the palette to simple harmonies of brown and gray offset by a sky which modulates from pale blue at the top to a white glow at the base.

The profile portrait plays a less important role in Venice, but there the relationship that can be traced in Tuscany between the independent portrait and the monumental painting is once more reproduced. Unlike his contemporaries in Florence, Gentile Bellini was a professional portraitist. When Sultan Mohammed II in 1479 sent a request to Venice for the services of an experienced portrait painter, it was Gentile that Signoria chose. The limitation of his portraits is that they are destitute of the pictorial ideas which effect the mysterious act of transubstantiation from history to art. The most familiar of them, the *Sultan Mohammed II* in London, is so much damaged that no valid inference can be drawn from it,[70] but a less badly preserved portrait of Caterina

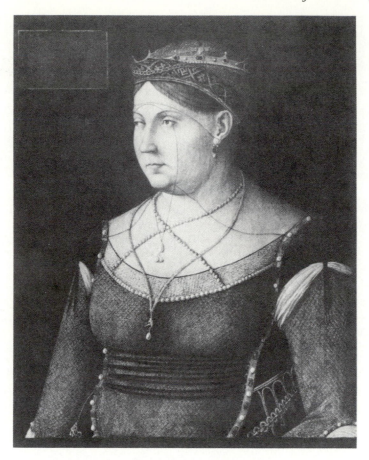

49. GENTILE BELLINI: *Caterina Cornaro* (Budapest)

Cornaro at Budapest [49][71] reveals, in its deadly evenness of emphasis, the mind of a cartographer. In the *Preaching of St. Mark*, which was left unfinished when Gentile died, most of the heads are of this quality, but a few are markedly superior to the rest—their volume is rendered more decisively and they take on a kind of animation from the play of light [48]—and these are due to Giovanni Bellini.[72] A poet of natural appearances, Giovanni brought to his portraits exactly the same interest in light and volume that inspired his other work.[73] Habitually he shows the sitter's head in three-quarter face turned to the left [50]. The lighting unifies the features, and more often than not the head is shown behind a parapet against a cloudy sky. This last device is common in Bellini's religious paintings, and was carried over from them to the portrait. Bellini, great artist as he was, did not engage closely with the human personality. His interest

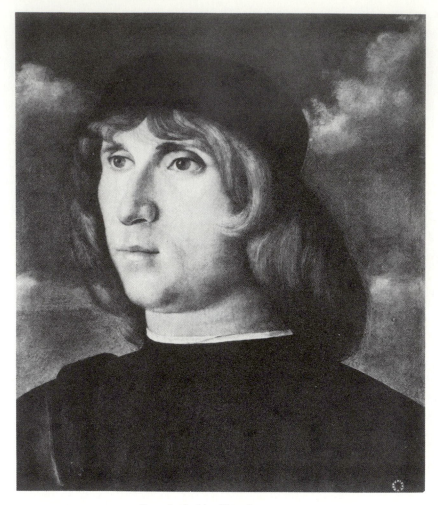

50. GIOVANNI BELLINI: *Portrait of a Man* (Rome)

was in the general, not in the particular, and never did he feel a lively curiosity at idiosyncrasies of character. But in one department of the portrait he had no peer: he was by far the greatest fifteenth-century official portraitist. The tendency toward ideality that impairs his private portraits here stood him in good stead, and enabled him to codify, with unwavering conviction, the official personality. The best as well as the best-known example is the portrait of Leonardo Loredano [51], who was elected Doge in 1501 and must have been painted by Bellini in 1503 or 1504.[74] Here the pictorial science that was deployed in the San Zaccaria altarpiece of 1505 is focused on

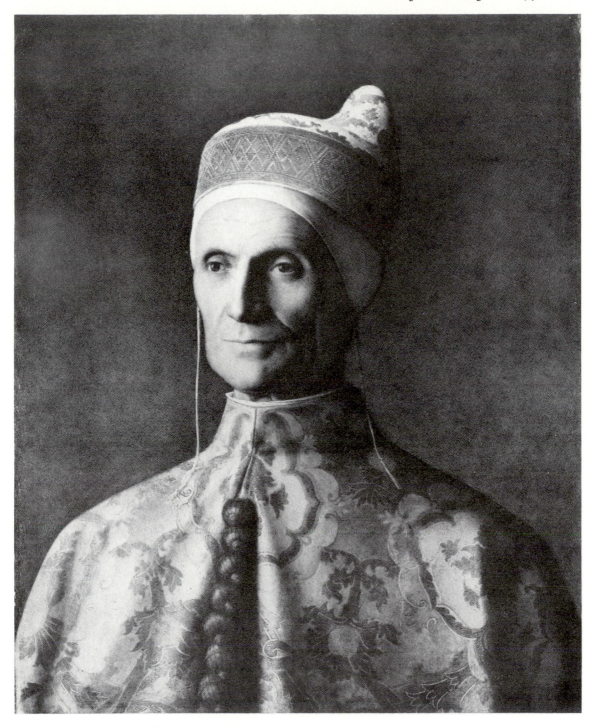

51. GIOVANNI BELLINI: *Doge Leonardo Loredano* (London)

the portrait. The figure forms a pyramid behind the red Verona-marble balustrade, and the head and cap and the brocaded robe are bathed in warm soft evening light. And even if it be acknowledged that the bland treatment of the features is evasive, that is permissible in the laudatory context of an official portrait.

Flemish painting is, by definition, excluded from the terms of reference of this book, but as we look at these Italian portraits we cannot efface the memory of that wonderful development in Flanders that runs from the Master of Flémalle and Jan van Eyck, through Petrus Christus and Rogier van der Weyden and Dirk Bouts, to Memling and Van der Goes. Nor should we attempt to do so. Some of the sitters in the portraits we have been discussing must have been conscious of it too. There were abundant contacts between north and south—patrons moved, and so did pictures, and just occasionally painters moved as well. Cardinal Albergati arrived in Florence in 1426, when Masaccio was at work in the Brancacci Chapel, and was drawn by Jan van Eyck at Bruges in 1431.[75] The Baroncelli sat to Flemish artists, and Giovanni Arnolfini was painted twice by Jan van Eyck. Works by Jan van Eyck existed at Urbino and works by Rogier van der Weyden were known at Florence and Ferrara, while in Florence a great altarpiece of Van der Goes with portraits of its Portinari donors stood in Santa Maria Nuova.[76] About 1461 an unnamed papal legate presented Cosimo il Vecchio with an altarpiece by Nicholas Froment, which also contained a donor portrait,[77] and only an accident at sea prevented Memling's *Last Judgment* at Danzig, with portraits of Angelo Tani and his wife, from reaching its Italian destination.[78] Lorenzo the Magnificent owned a portrait by Petrus Christus,[79] a self-portrait of Rogier van der Weyden was in Venice in the collection of Giovanni Ram,[80] and a famous portrait of Pope Eugenius IV and two cardinals by Jean Fouquet hung in Rome in the sacristy of Santa Maria sopra Minerva.[81] So there is no reason to postulate unfamiliarity in Italy with northern painting, and least of all with portraits.

The fact none the less remains that through almost the whole fifteenth century the styles of Flemish and Italian portraits did not mix. One reason for this was technical, that the oil medium employed in Flanders enabled artists to imitate appearances with all but complete fidelity, whereas the tempera medium used in Italy condemned them to compromises or approximations through which the disparity between the real world and the imaginary world within the painting could be reduced. But the difference went deeper than technique; it was rooted in disagreement as to the premises of portraiture. That point can be illustrated from two comparisons. When Canon Van der Paele in 1436 commissioned an altarpiece from Jan van Eyck, his portrait was included in it [52]. Five years later, in 1441, Francesco Maringhi in Florence commissioned an altarpiece from Fra Filippo Lippi, and his portrait was also introduced [53].[82] The head of Van der Paele is the *ne plus ultra* of realistic observation; in the

52. JAN VAN EYCK: Canon Van der Paele, detail from the
Virgin and Child with SS. George and Donatian (Bruges)

53. FRA FILIPPO LIPPI: Francesco Maringhi, detail from the
Coronation of the Virgin (Florence)

54. DOMENICO GHIRLANDAIO: *An Old Man* (Stockholm)

rendering of texture particularly it is unsurpassed. But in a rather different sense Lippi's portrait is also realistic; in detail it is conspicuously less well observed, but it is posed in a more enterprising fashion in relation to the picture plane. Where the head of Van der Paele is an incomparable piece of still-life painting, in Maringhi's motion and deportment are implied.

At first sight there may seem to be a striking similarity of outlook between the portrait of Cardinal Albergati by Jan van Eyck in Vienna [57] and Ghirlandaio's portrait of an old man suffering from rhinophyma in the Louvre [55]. But the creative intentions behind these paintings are in fact entirely different. In both cases the preliminary drawings are preserved. Van Eyck's drawing [56] corresponds with the portrait as it was carried out. Some of the detail has been effaced, but much of it is legible, and at the left are color notes, on the *sanguynachtich* nose, the whitish purple of the lips, the light-gray stubble of the beard—made necessary by the fact that the Cardinal's brief residence in Bruges precluded further sittings for the painting.[83] Ghirlandaio's drawing [54] reveals that his subject never sat at all. He was drawn lying on his bier, and the head from the preliminary drawing was then adapted for the painting with the minimum changes that would enable it to pass as a life portrait.[84] The suspicion of a smile was imposed on the tight lips, the eyes were very slightly opened, the hair was rearranged, and what we now think of as its most audacious feature, the growth on the right nostril, was modified.

55. DOMENICO GHIRLANDAIO: *An Old Man and his Grandson* (Paris)

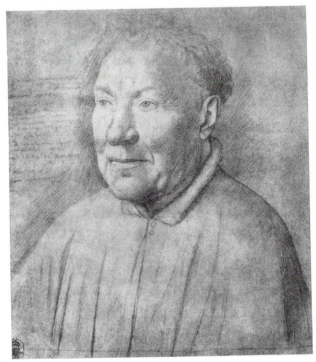

56. JAN VAN EYCK: *Cardinal Albergati* (Dresden)

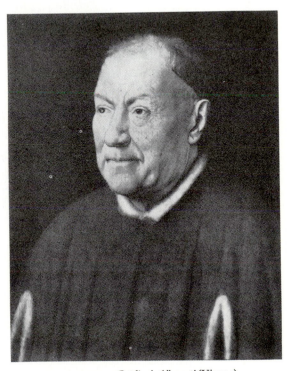

57. JAN VAN EYCK: *Cardinal Albergati* (Vienna)

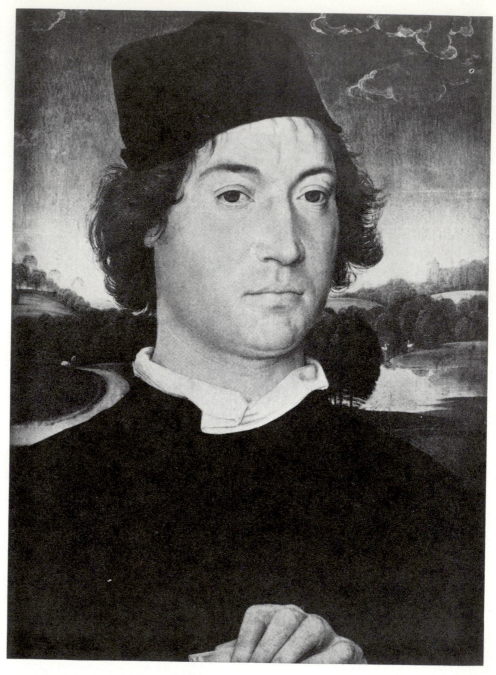

58. HANS MEMLING: *Portrait of a Man* (Florence)

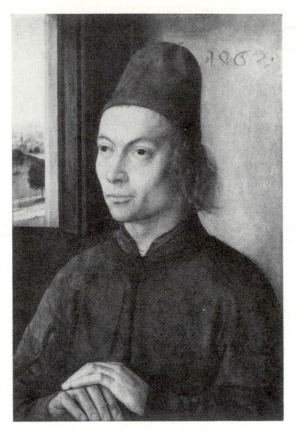

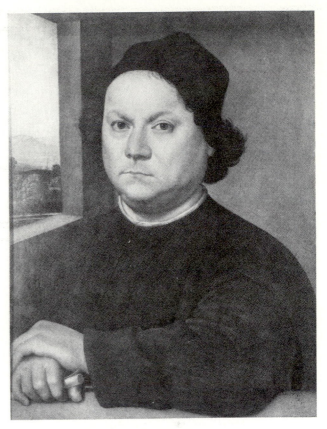

59. DIRK BOUTS: *Portrait of a Man* (London)

60. PERUGINO: *Self-Portrait* (Florence)

In discussing the interaction of Flemish and Italian portraits, one point must constantly be borne in mind—that the wastage in private portraits was extremely high. Whether the surviving portraits represent a tenth or a twentieth of the portraits that were actually painted in the fifteenth century we cannot guess. Certainly the incalculable ratio between what was produced and what has been preserved prohibits any statistical approach to the few paintings we know. Never are we justified in thinking that the first time a motif appears in paintings known to us is the first time that it occurs. Moreover, it is extremely difficult to look at Flemish portraits with the eyes of a fifteenth-century Italian artist. It has been suggested that the landscape in Lippi's portrait in New York [41] depends from Petrus Christus. That may be so, but there is no proof. It has been suggested that the incised slab at the bottom of the portrait of a youth at Chambéry [34] was inspired by Jan van Eyck. Very possibly it was, but the

debt cannot be demonstrated. The earliest point at which it can be confidently claimed that the monumental Italian portrait diverted the course of portrait painting in the Netherlands is in the fourteen eighties in late portraits by Memling [58], which reveal a knowledge of the work of Perugino.[85] Until late in the century the barrier of technique ruled out any reciprocal stylistic influence of Flemish on fifteenth-century Italian painting save in those centers where Flemish artists were employed, and if we seek for a connection, it is to be found initially on the plane not of style but of motifs. To take just one example, Jan van Eyck seems to have experimented with the half-length or head-and-shoulders portrait in a room, and this is employed again in 1446 in a painting by his pupil Petrus Christus.[86] By 1462, in a portrait by Dirk Bouts in London [59], the relation of the figure to the setting was thought out afresh, and the head was set against the point of juncture of two walls, which present contrasted planes, one in shadow and the other brightly lit. This type of portrait became known in Italy in the fourteen eighties, and is developed about 1503 in the great self-portrait of Perugino [60].[87] By more cerebral artists the lesson of the Flemish portrait was read in a more comprehensive way, and without Flemish models we can imagine neither the slow ruminative structure of the *Mona Lisa* [111] nor the instantaneous portrait as it was evolved in Raphael's *Tommaso Inghirami* [125].

The first significant breakthrough occurs with the arrival in Venice in 1475 of a Flemish-trained Sicilian painter. Exactly how it was that Antonello da Messina came in contact with Eyckian painting we do not know, but he unquestionably did, for it affected both his creative processes and his technique. The oil medium used by Jan van Eyck permitted pictorial second thoughts, enabling the picture to be modified as work on it progressed. From infra-red photographs it can be seen, for instance, that the Arnolfini marriage portrait underwent a whole series of changes in the interests of expressiveness.[88] The right hand of Arnolfini was originally set farther back, with the palm turned to the spectator and not toward his wife, and his left hand was originally clenched possessively round hers. The beautiful male portrait by Antonello in the National Gallery in London [61] was evolved essentially in the same way. The eyes originally looked outward to our left, but, as the result of a revision, the direction of the glance was changed.[89]

To Venetians Antonello's paintings looked extremely Flemish; Michiel, who made an inventory of pictures in north Italian collections in the early sixteenth century, says of one portrait that it is by Antonello or Memling or Jan van Eyck, as though the styles of the three painters were interchangeable.[90] Certainly we should be hard put to it to discover a parallel in Italy for Antonello's portrait of about 1470 at Cefalù [62], in which the mouth is parted in a wide, warm, open smile.[91] Antonello was indeed the first Italian painter for whom the independent portrait was an art form in its own right.

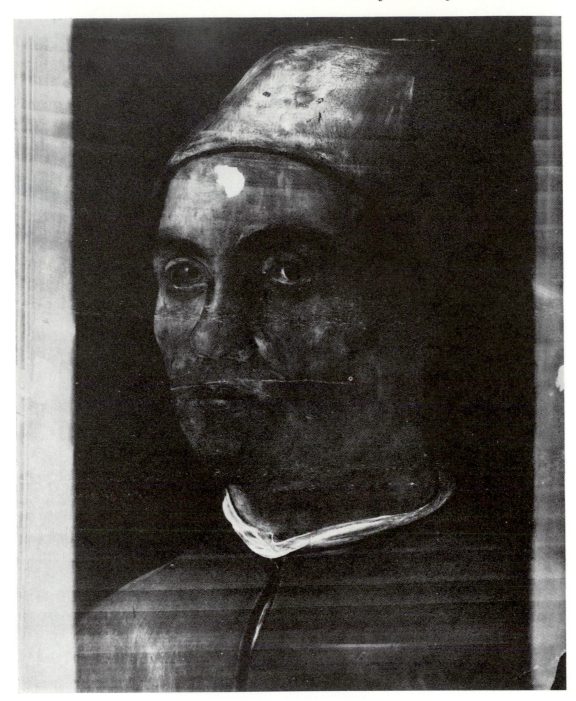

61. ANTONELLO DA MESSINA: Infra-red photograph of *Portrait of a Man* (London)

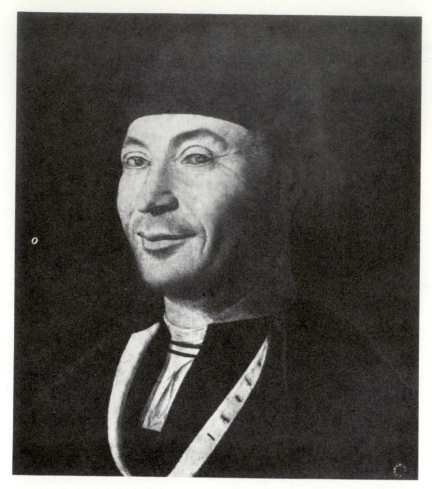

62. ANTONELLO DA MESSINA: *Portrait of a Man* (Cefalù)

His grasp of the architecture of the human head [63] was bolder than that of Christus or Dirk Bouts, his concern with detail was less uncritical, and his interest in the play of the muscles of the face was more pronounced. Alone among Italian quattrocento painters he acknowledged frankly that the key to personality lay in the lips and eyes. Not even Titian's portraits quite effaced the impression of vitality that was made by his, and as late as 1532 Michiel could write of two Antonello portraits owned by Antonio Pasqualino that "they have great power and vivacity, especially in the eyes."[92] In a treatise on sculpture prepared in Padua fifteen years after Antonello's death, Pomponius Gauricus declares that the eyes "by the will of nature are the mirrors of

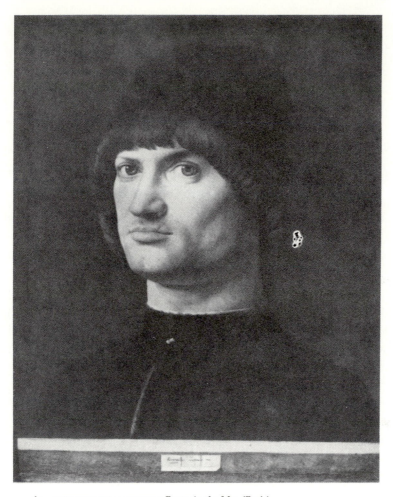

63. ANTONELLO DA MESSINA: *Portrait of a Man* (Paris)

our souls,"[93] and it was in that spirit that Antonello painted them. He was in Venice for just under two years, but in that short space of time he changed the history of the Renaissance portrait. He did so directly by his action on Giovanni Bellini, who in 1474 was still painting static, archaizing portraits of the class of the *Jörg Fugger*,[94] but a few years later, under Antonello's inspiration, evolved a more forward-looking and optically more truthful portrait style.[95] And he did so indirectly through the standards of expressiveness he set, which made possible the miraculous effulgence of the Venetian High Renaissance portrait.

II

Humanism and the Portrait

The word humanist can mean two rather different things. It can be used restrictively, as a synonym for grammarian or philologist, and it can be employed, less narrowly, as denoting what we would now call an intellectual. It is used here in the wider sense. Battista Guarino, writing in 1459, distinguishes the scholar from the specialist.[1] "Whilst in Nature," he says, "we find some animals which are content to feed upon flowers like bees; others on leaves, like goats; others on roots, like swine; the appetite of the scholar demands the best of each and every kind of mental food." The scholar's appetite was not confined to texts. He devoured every relic of the Roman way of life, and none with greater relish than coins and sculptured portraits. His concern was not simply with the academic study of classical thought processes, but with their application to the world of his own time, and his influence on the portrait first manifests itself in the revival of two classical art forms, the medal and the portrait bust.

The motivation for the earliest Italian medal was historical; it commemorated the recovery of Padua by Francesco I Carrara in 1390.[2] Padua was one of the very earliest centers of Italian humanism—Francesco Carrara's son, Ubertino, was the recipient in 1404 of a celebrated essay by Vergerio, *De Ingenuis Moribus*, which remained for over a century the standard statement of the liberal educational ideal—and the Carrara medal [64] evinces, as we might expect, a more than superficial knowledge of Roman imperial coins. In terms of portraiture it is an astonishingly forward-looking work. The handling of the features is indeed so confident that, if we knew nothing of the history of the medal, we might assume it marked the dawn of a new art. In fact it did nothing of the kind. The lesson was stated, but it remained unread, and when, half a century later, probably in 1439, Pisanello was engaged on a closely comparable commission, a medal of Gian Francesco Gonzaga, Marquess of Mantua [65],[3] no reference was made to the antique. The portrait looks like a figure cut out from an International Gothic fresco, and may even have originated in that way, for at Mantua Pisanello was painting scenes of life at the Gonzaga court. It might also be expected that the Carrara

64

64. Medal of Francesco I Carrara, lord of Padua

65. PISANELLO: *Gian Francesco Gonzaga, Marquess of Mantua* (Washington)

medal would have exercised some influence in Florence, where the dominance of the antique was so pronounced. But in Florence in the first half of the fifteenth century, no medals were produced. Perhaps the republican sentiment that was ingrained in Florentine society was responsible for that. It was appropriate that the individual should be recorded; it was inappropriate that he should be deified.

Responsibility for kindling interest in the medallic portrait none the less rests with a Florentine, the architect and theorist Alberti. Like Erasmus a century later in the north, Alberti was the victim of a lifelong fascination with his own intellectual identity. In Vasari's day a self-portrait by him, "fatto alla spera," painted in a mirror, was preserved in the most famous of his secular buildings, the Palazzo Rucellai,[4] and a manuscript of his essay *On Tranquillity of Mind* is enriched by a self-portrait drawing that shows him standing in full length in a field or garden filled with flowers.[5]

The two self-portraits of Alberti that survive are bronze reliefs.[6] The earlier [67] is in the National Gallery of Art in Washington and seems to have been made in the middle of the fourteen thirties, possibly in Florence, though that is not absolutely sure. If we pass from the contemporary profile paintings ascribed to Masaccio and Uccello to this self-portrait, the revolutionary nature of Alberti's thinking cannot be misconstrued. The inspiration is antique—the portrait type seems to have been suggested by a gem of the class of an amethyst head of Agrippa in Paris—and the figure is dressed

66. LEON BATTISTA ALBERTI: *Self-Portrait* (Paris)

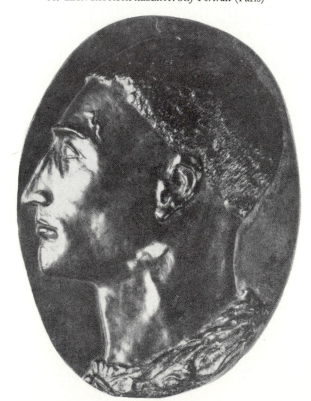

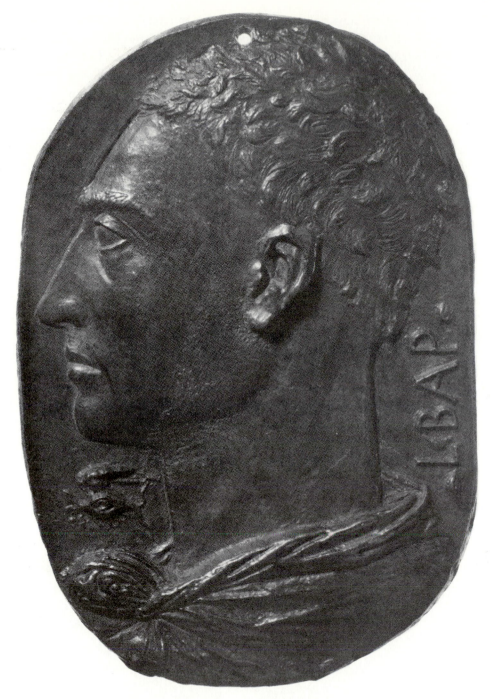

67. LEON BATTISTA ALBERTI: *Self-Portrait* (Washington)

all'antica, as though challenging comparison with the thinkers and heroes of antiquity. Perhaps the relief was intended as a manifesto; on the left-hand side is Alberti's emblem, the winged eye, and eyes are used again as stops in the name cast on the right. But the claim of the relief on our attention is not as a portrait type but as a portrait. The face is conceived as a paradigm of character, and is inspired by the same intuitions about human nature that light up the muddy waters of Alberti's social treatises.

Both as painter and sculptor, Alberti was an amateur. That had its advantages, as we can see from the empirical and brilliantly unorthodox treatment of the hair in this relief, but it had its disadvantages as well, the most conspicuous being the blemish through the cheek which resulted from a casting flaw. To this flaw we owe the fact that Alberti made a second bronze self-portrait [66]. The later relief, now in the Louvre,[7] is very slightly smaller than the relief in Washington. The exact time relationship between them cannot be established, but it is clear that they were modeled separately, and the second evidently represents a more advanced stage in Alberti's thinking on the portrait than the first. The carriage of the head is more convincing, the mouth is firmer, the neck is more rotund, and the base area is reduced. At the same time the glosses of the name and emblem have been left out, so that the message of the features is unimpaired.

The reason why some doubt is felt as to whether the reliefs were made in Florence is that they exercised no influence there. Indeed, the only center in which their influence can be conjecturally traced is Ferrara, and the artist in whose work it is apparent is Pisanello. For most of his career Pisanello was an International Gothic decorator, and not till 1438 did he become a medalist. Initially the relation of his medals to his paintings is much the same as that which is found in Burgundy between the work of the International Gothic medalist known as the Master of the Roman Emperors and con-

68. PISANELLO: *Leonello d'Este, Marquess of Ferrara* (Washington)

69. MATTEO DE' PASTI: *Leon Battista Alberti* (Washington)

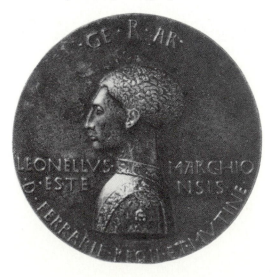

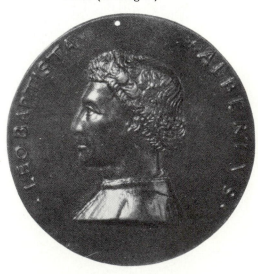

temporary Burgundian painting. But this phase lasted at most three years, and by the early fourteen forties, when he prepared his medals of Leonello d'Este, Marquess of Ferrara [68],[8] his portrait style had been transformed. Leonello d'Este was a friend and patron of Alberti—three of Alberti's treatises were dedicated and presented to him, and Alberti visited him at Ferrara after he succeeded to the marquisate in 1441— and in some mysterious fashion the aspirations behind Alberti's two self-portraits transferred themselves to the medals of Leonello d'Este.

Not that we can expect medallic portraits to prove as powerful as Alberti's two reliefs. The scale is smaller and the depth more limited, and the very fact that medals were produced in bulk militated against portraits that were strongly analytical. When we remember Alberti's reading of his own features, the reading of his features by Matteo de' Pasti, in a famous medal [69] which was produced at Rimini during the building of the Tempio Malatestiano, seems almost anodyne. But in the hands of Pisanello they gave rise to a whole series of vivid, firmly apprehended portraits.

The best-known medals of the middle of the century are those of rulers and military leaders. But with the ruler convention inhibited a truthful likeness, while with military leaders the frequently expressed conviction of Renaissance humanists that the life of action was superior to the life of thought introduced a concomitant of rhetoric. In the humane portrait, on the other hand, the features were explored in greater depth. The claim of the humanist upon posterity rested on knowledge integrated in the character, and the duty of the medalist was to define its traces on his face. That is achieved with superb assurance in Matteo de' Pasti's medal of the Veronese

70. MATTEO DE' PASTI: *Guarino* (Washington)

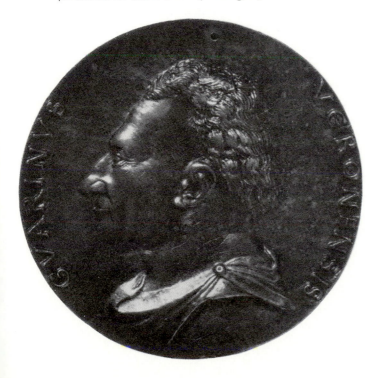

71. PISANELLO: *Vittorino da Feltre* (Washington)

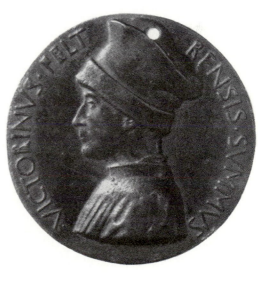

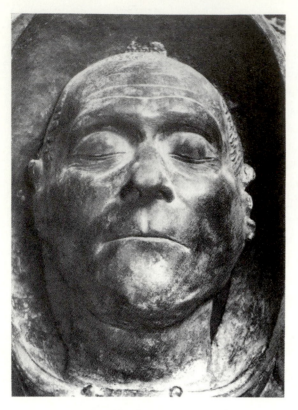

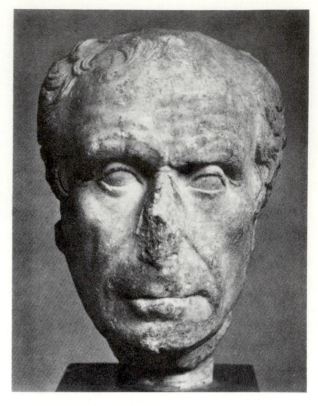

72. RICCIO: Mask of Girolamo della Torre, from the
Della Torre Monument (Verona)

73. GREEK: Male portrait bust (Copenhagen)

humanist Guarino [70].[9] Like Alberti in the two self-portraits, Guarino wears classical costume, and there is also an analogy with the self-portraits in the prominence that is accorded to the ponderous, penetrating head. We know very little about the part played by humanists in determining the idiom of their portraits, but in the north Erasmus took a lively interest in the matter, and probably Guarino did too.

Medallic portraits of those humanists who were primarily teachers were in great demand. One such case is that of Vittorino da Feltre, who for over twenty years directed a school at Mantua, La Giocosa, a Renaissance Eton at which Federigo da Montefeltro and other sons of noble houses were trained in the humanities. The educational methods he employed are to some extent accountable for the broad uniformity of cultural outlook among rulers in north and central Italy in the middle of the fifteenth century. According to Prendilacqua's life, Pisanello painted a portrait of him, and prepared a bronze sculpture in which the emblem of a pelican feeding its young was shown at his feet. This protracted study of his features was also summed

74. LORENZO GHIBERTI: Self-portrait, detail from the *First Bronze Door* (Florence)

75. LORENZO GHIBERTI: Self-portrait, detail from the *Gate of Paradise* (Florence)

up in a medal [71].[10] "O father Vittorino," writes Basinio after Vittorino's death, "glory of the Latin tongue, thou too shalt live through the genius of Pisano. This was thy appearance, this thy countenance, this thy gravity. For a moment I had the illusion that thou wert once more alive, great Vittorino, and boundless was the joy I felt." The medal apostrophized by Basinio was in turn adopted as the basis of a painting of Vittorino for Federigo da Montefeltro's Studiolo at Urbino. In this its early phase the medal was the tangible expression of a way of life.

The main source from which Renaissance humanists culled their knowledge of the part which portraits played in Roman life was Pliny.[11] By Pliny's time the incidence of private portraits was much reduced. "The painting of portraits," he complains, "which used to transmit through the ages the accurate likenesses of people, has entirely gone out." In private houses "the display of material profit is now preferred to a recognizable likeness of one's self," and a habit had sprung up of buying portraits of strangers and boasting of the price they cost. "Indolence," lamented Pliny, "has de-

stroyed the arts, and since our minds cannot be portrayed, our bodily features are also neglected. In the halls of our ancestors it was otherwise; portraits were the objects displayed to be looked at, not statues by foreign artists . . . and wax models of faces were set out each on a separate sideboard, to furnish likenesses to be carried in procession at family funerals." This matter of recording the features of members of the family was linked in Pliny's mind with two other indispensable activities, the maintenance of a family archive and the keeping of a family tree.

Pliny alludes to two different categories of object. The first is death masks, the so-called *imagines* by which the features were recorded within the family. A rather forbidding statue in the Palazzo Barberini shows a Roman holding his ancestors' masks. Almost the only case in the Renaissance in which death masks, unadorned and practically un-worked up, are put to use, is Riccio's Della Torre monument at Verona, where the program is rigorously classical, and at the top are inserted the *imagines* of Girolamo and Marcantonio della Torre [72].[12] In Rome casts from death masks were sometimes incorporated in clay or terra-cotta busts, and very unappetizing were the results. This practice too was resumed in the fifteenth century. These Florentine busts —there are quite a lot of them about—have some social significance, but are not artistically of much note. The second class of object to which Pliny refers is the marble portrait bust. Nowadays we take these Roman portrait busts for granted, but to spectators whose minds were filled with memories of Plutarch and Suetonius they appeared in a more vivid light. If the individual's reputation sprang from his character, and character, as classical physiognomical treatises insisted, was directly mirrored in the face, it was in this way that he should be commemorated.

The first artist whose mind demonstrably moved along these lines is the sculptor Ghiberti.[13] Before the earlier of his self-portraits [74], which was modeled about 1415 for the frame of the first bronze door of the Baptistry in Florence, we might doubt if he possessed any of the talents necessary for effective portrait sculpture. His head is crowned by a contemporary headdress, and the face beneath is featureless and bland. But by 1447, the date of the later of his two self-portraits [75], that on the Gate of Paradise, the problem of the portrait was thought out afresh in the light of the antique. The headdress was discarded, so that the intellectual forehead could be shown in all its height, the brow was creased in thought, the lips were loosened as though about to smile, and the eyes looked out upon the world with a combination of shrewdness and benignity. The type of bust which must have inspired Ghiberti to produce this extraordinary work is a male portrait of the first century B.C., of which the Hellenistic original is at Copenhagen [73] and a Roman copy is in the Uffizi.

In the Renaissance there was no formal science of psychology. That was no great deprivation for the portraitist, for the concern of portraiture is with visible aspects of

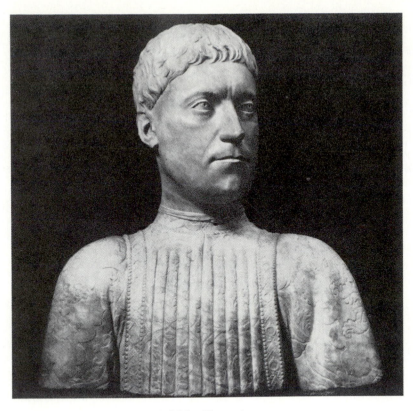

76. MINO DA FIESOLE: *Piero de' Medici* (Florence)

the personality, not with the subconscious impulses from which action springs. The lack was compensated by a lively concern with physiognomy (based on two treatises wrongly ascribed to Aristotle)[14] and a deep interest in human nature (which permeates the histories of Leonardo Bruni and attains an enviable sophistication in Machiavelli). Alberti, whose thinking was anything but unconventional, was convinced that individuals in the most literal sense were singular. "In the whole body of citizens," he declares in his treatise on sculpture, *De Statua*,[15] "no voice will be found that is precisely the same as this voice, and no noses that are identical." For this reason it was essential that the statue should portray an individual; it must provide an image not of man in general, but of a man, be he utterly unknown. The consequences of this doctrine are apparent in Ghiberti's two self-portraits; the first is an ideal head adjusted so as loosely to conform to the features of the artist, while the second is a punctilious study of particularity.

If the surviving documents are to be trusted (and the reserve expressed about the

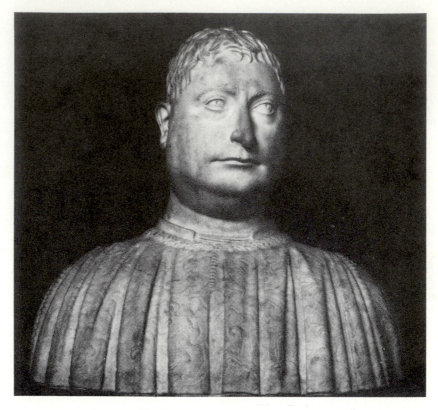

77. MINO DA FIESOLE: *Niccolò Strozzi* (West Berlin)

validity of laws deduced from painted portraits of course applies to sculptured portraits, too), this train of thought was not responsible for the revival of the portrait bust. The impulse was political and sprang from a demand for self-perpetuation made by some of the great military and administrative figures of the time. The earliest dated bust [76] shows Piero de' Medici, the son and successor of Cosimo il Vecchio, and it was made in Florence in 1453. A bust of his wife was also carved by the same sculptor, Mino da Fiesole, and a little later it was followed by a bust of Piero's brother, Giovanni de' Medici.[16] All three were set on the architraves of doorways in the Palazzo Medici. The cult of portrait busts was not limited to Florence, and Mino's services were also in demand in Rome, where in 1454 he made a bust of a Florentine exile, the banker Niccolò Strozzi [77],[17] and in Naples, where he depicted Astorgio Manfredi.[18] Mino da Fiesole was a painstaking and far from unaccomplished artist, but his technical resources were limited, and his busts, physiognomically speaking, are inexact in that their form is dictated by the preconceptions of the sculptor rather than by

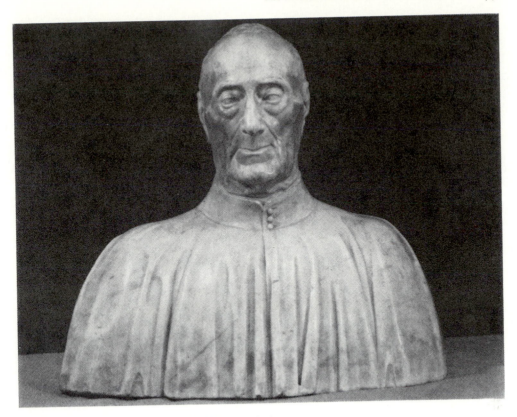

78. ANTONIO ROSSELLINO: *Giovanni Chellini* (London)

the head in front of him. If, in the fifteenth century, they were compared with authentic Roman busts, they could only be rated as inadequate, first because they were less life-like and second because, humanly speaking, they were less communicative. Never did it seem that they possessed the potentials of mobility or thought.

In an attempt to bridge this gap a little group of learned men determined, in the fourteen fifties, to refine the sculptured portrait. They were the doctor Giovanni Chellini, the statesman Neri Capponi, and the writer Matteo Palmieri, and the agent they employed was the sculptor Antonio Rossellino. Rossellino's bust of Chellini [78] is dated 1456,[19] his relief of Capponi in Santo Spirito [80] was made before Capponi's death in 1457,[20] and his bust of Palmieri [79] was carved in 1468.[21] There are two assumptions implicit in this account: that these men formed a group and that their critical intelligence was brought to bear upon artistic problems. The first can actually be proved, and the second can be shown to be at least far from improbable. Chellini was born in 1372, and in his twenties lectured on philosophy and logic in the University

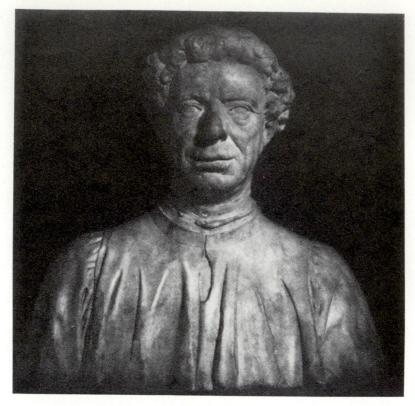

79. ANTONIO ROSSELLINO: *Matteo Palmieri* (Florence)

of Florence.[22] Not only was he learned, he was also well-to-do; he owned a collection of silver vessels which he lent out to his fellow citizens, and when Capponi was appointed ambassador in Milan, he took with him six of Chellini's silver dishes. Four years before Rossellino's bust was carved, Chellini lost his elder son, and in accordance with the practice of the time, hasty arrangements were made for the marriage of his second son in order that the family should have an heir. The negotiations were entrusted to Capponi. Matteo Palmieri is remembered nowadays as the author of a heretical Dantesque poem, the *Città di Vita*. In it he made the mistake of supposing that at the time of the War with the Rebel Angels some angels were neutral, and the Church came down on him, posthumously, like a ton of bricks. One of his shorter works, the *De Captivitate Pisarum*, is prefaced by a letter to Capponi. So the interconnection of these three men must have been extremely close.

Chellini's contacts with art were in the main professional. He was the doctor of Donatello, whom he saved from death in 1456, the year in which his bust was carved;

but for his skill we might have been deprived of Donatello's latest works, the *Magdalen* in the Baptistry in Florence and the two pulpits in San Lorenzo. Palmieri's interest in art is proved by a prose work on the good life, *Della Vita Civile*, which was written in 1449. He entertained what must have been a common view of the evolution of representational technique. "Before Giotto," he writes,[23] "painting was dead, and painters produced figures that are risible. Revived by him and maintained by his disciples, it has become the worthiest art that you could have. Sculpture and architecture, which with us lagged behind so long, and produced so many wondrous horrors, have been raised up in our time and brought back into the light and perfected by many cultivated masters." It is natural, he adds with just a suspicion of complacency, that lost arts should revive when there is demand for them; in ancient Greece and Rome one period was distinguished for its orators, another for its poets, and others again for philosophers, historians, or sculptors.

It is Palmieri, too, who provides a clue as to the purpose these busts were designed to serve. "To go back to the subject of old age," he writes,[24] "what dignity it gains from a life lived by the light of virtue. What learning the old possess, what rich precepts they command. How often do his family, his friends, his fellow citizens hasten to consult an eminent old man. No longer able to exercise his body, he exerts his mind, and his deeds and sayings are recorded for posterity. To his children and their descendants he leaves the glory of his virtue, whence through many generations his seed becomes honored in its turn." To his children and their descendants, moreover, he left his portrait. Pliny tells us that in Rome the busts of eminent men were shown outside their houses, and Palmieri's bust is gravely weathered because, following the antique practice, it was placed over the doorway of his house in Florence. Luckily the Chellini bust was treated more circumspectly, and was preserved as an heirloom in the interior of Chellini's house.

If we had to define exactly what it is that distinguishes these busts from Mino's portraits, we might say that Rossellino's attitude toward the human head is anatomical. It goes without saying that this change, from a crude approximation to a faithful record, could not be achieved by scrutiny alone. It necessitated a rethinking of the portrait, and a change in the way in which it was produced. What resulted was a new technique, the use of the life cast.[25]

The origins of the life cast are classical—life masks are mentioned by Pliny—and a technique for making life casts from the human face is described at the extreme end of the fourteenth century in the treatise of Cennino Cennini. It seems to have been used intermittently for effigies on tombs, but there is no evidence from surviving works to suggest it was adopted for portrait busts by any sculptor before Rossellino. With its aid the features could be reproduced with far greater precision than was pos-

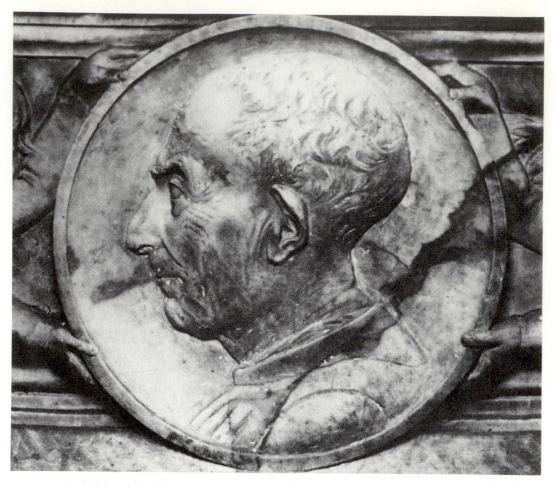

80. ANTONIO ROSSELLINO: Neri Capponi, detail from the *Capponi Monument* (Florence)

sible by other means. The portraits that resulted are actually much subtler than the majority of Roman busts, for Rossellino had a preternatural sensibility to texture, which is manifest in the Chellini bust in the veins across the temple and the folds of skin beneath the cheek, and he was fortified by the humanist's determination that the whole man, and not merely the carapace, should be perpetuated.

The difference between Antonio Rossellino and Mino da Fiesole as portrait sculptors is best seen in reliefs. The relief on the Capponi monument [80] set up a vogue for life portraits on tombs, and before the statesman Bernardo Giugni died in 1466, a profile portrait from the life was made of him by Mino for the lunette of his monument in the Badia [81].[26] In it a sense of vividness is achieved through the exaggeration of

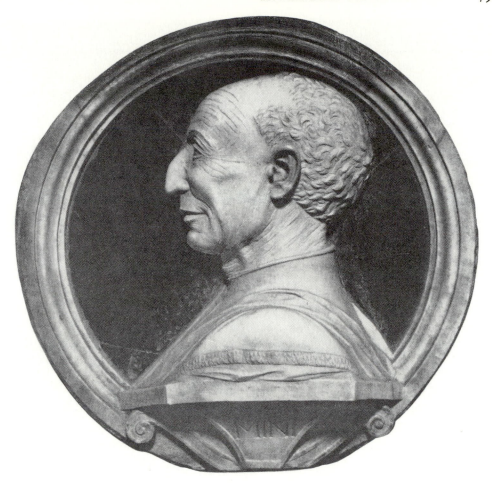

81. MINO DA FIESOLE: Bernardo Giugni, detail from the *Giugni Monument* (Florence)

physical peculiarities, but the apprehension of the forms is too coarse and inexact to suggest more than the casing of the character. Rossellino's Capponi portrait [80], on the other hand, owes its effect to the faithfulness with which the features are reproduced. There is no suspicion of distortion, and the image that results is at once more human and more credible.

It must not be inferred from this that a better superseded an inferior type of sculptured portrait. Later in the century it became possible to achieve results that were much superior to Mino da Fiesole's. One of the finest examples of these freely modeled busts is a portrait of 1495 in the Bargello [82], which may have been made from a clay model by Pollaiuolo and which was long thought to depict Machiavelli.[27] And in the

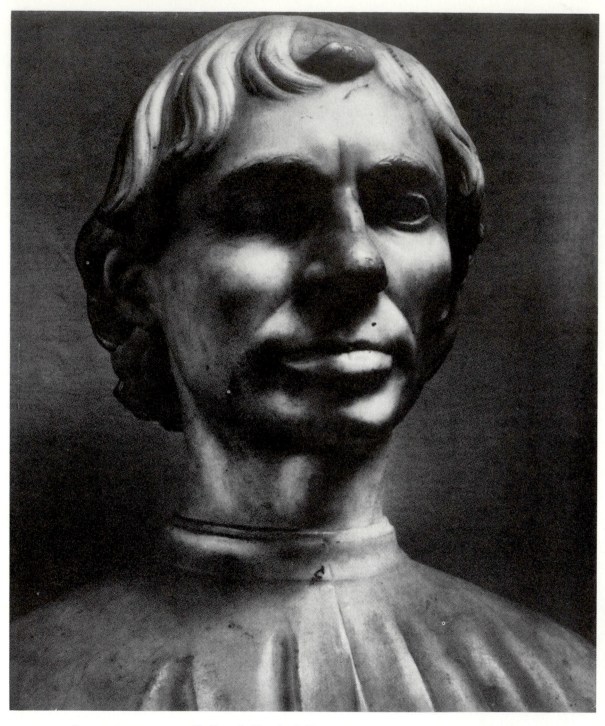

82. ANTONIO POLLAIUOLO (?): *Bust of a Man,* detail (Florence)

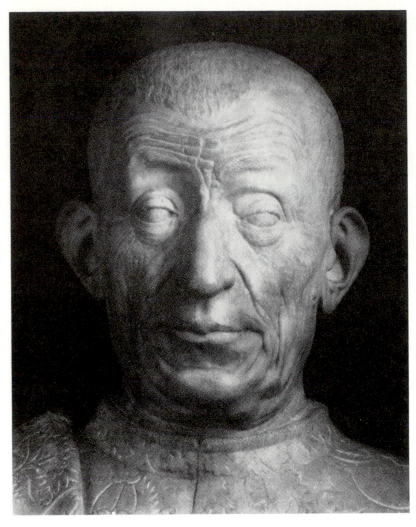

83. BENEDETTO DA MAIANO: *Pietro Mellini* (Florence)

hands of Benedetto da Maiano the life-mask portrait, though handled with still greater technical accomplishment than Rossellino's, lost something of its pristine character. Benedetto da Maiano's commissions, like Ghirlandaio's, stemmed from the great merchant princes who pursued their careers in the wake of Piero and Lorenzo de' Medici—Pietro Mellini, whose bust, now in the Bargello in Florence, was carved in 1474 [83],[28] and Filippo Strozzi, the creator of the Palazzo Strozzi in Florence. It was a stolid commercial society, and Benedetto da Maiano's busts carry with them a sense

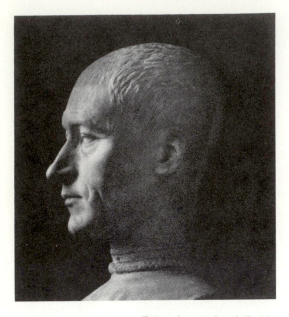

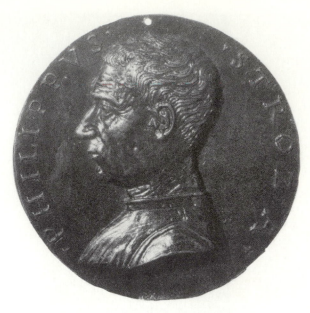

84. BENEDETTO DA MAIANO: *Filippo Strozzi*, detail (Paris) 85. NICCOLÒ FIORENTINO: *Filippo Strozzi* (Washington)

of self-sufficiency. For the life well lived he substitutes the race well run. Though his portraits are outwardly so realistic, he succumbed to the temptation that is endemic in all rich societies, to compromise between the image seen and the image as the sitter wishes it to be. When the foundation stone of the Palazzo Strozzi was laid in 1491, a medal was cast for the occasion by Niccolò Fiorentino, on the obverse of which is an almost photographic likeness of its founder, Filippo Strozzi [85].[29] Benedetto da Maiano's bust of Strozzi [84][30] seems also to have been produced about this time, and when it and the medal are juxtaposed, we may well feel that the head has been ennobled just a little further than is permissible.

Since most men in Italy in the second half of the fifteenth century were clean-shaven, Republican portraits constituted natural models for their busts. Only occasionally did some special feature—the tousled hair of Matteo Palmieri, for example, which we see again in an altarpiece by Botticini in the National Gallery in London[31]— defy reference to the antique. But with the female portrait the externals of dress and hair style militated against classicizing portraiture, and so did the Renaissance conception of femininity. What distinguishes the busts of women by Rossellino [86] and Desiderio da Settignano from Roman busts is not simply their form, but their insistence on qualities which were not recorded in classical art, the mutability of mood and play of feature that are so often described in poems and *novelle* in the fifteenth century.[32] No

86. ANTONIO ROSSELLINO: *Bust of a Lady* (West Berlin)

87. ANDREA DEL VERROCCHIO: *Bust of a Lady* (Paris)

88. ANDREA DEL VERROCCHIO: *Bust of a Lady* (Florence)

89. ROMAN: *Bust of a Lady* (Florence)

90. DONATELLO: *San Rossore,* detail (Pisa)

more than with the male bust is the face generic; part of the fascination of these por-
traits is due to the fact that as we look at them, we are conscious of engaging with an
individual personality, often of bewitching charm. But their relationship to the antique
inevitably is less intimate than with their male counterparts. The first artist to bridge
the gulf was Verrocchio, and the first evidence of his doing so is contained in a bust
formerly in the Dreyfus collection [87].[33] If we compare it with a Roman portrait bust
[89], the affinities are very marked; there is the same insistence on the physical presence
of the sitter, and the same determination to define the form beneath the dress. Just for
that reason it leaves us with a sense of slight discomfort, which arises from the sculp-
tor's effort to reconcile a static classicizing style with the prevailing predisposition
toward spontaneity. This led Verrocchio, in a rather later work [88],[34] to take a step
that was of great importance for the sixteenth century, to extend the body so that the
hands were shown and the bust became in fact the upper half of a figure in full length.

One of the great gaps in our knowledge of portraiture in the first half of the
fifteenth century is the absence of a portrait bust by Donatello.[35] Some impression of

91. DONATELLO: *Gattamelata,* detail (Padua)

what Donatello's portrait style must have been like can be gained from the reliquary bust of San Rossore of 1427 [90], where the head was evidently modeled in obedience to Alberti's injunctions from a living head but the sculptor's plastic sense led him to treat certain features—the protruding cheekbones, for example—with exaggerated emphasis. When in the late fourteen forties Donatello at last emerges as a professed portrait sculptor, the portrait is posthumous. It occurs at Padua on the statue of Gattamelata [91]. Its status as a portrait has been doubted,[36] but since it was prepared about four years after Gattamelata's death, it was almost certainly based on a mask, or drawing, or a painted portrait. The modeling is no less forceful than in the *San Rossore*, but, as befitted the academic Paduan milieu, the head approximates more closely to a Roman type.

While Donatello was at work upon the statue, Mantegna was painting his first frescoes in the Ovetari Chapel. Mantegna's debt to Donatello was very great, but his temperament was more detached, and he had a bias toward archaeology. Whereas for Donatello the antique was the basis of a living art, to be adapted or discarded as he

thought fit, for Mantegna its sanction was absolute; it must be transcribed and not transposed. This academic bias led him to take a step that had eluded Tuscan artists, to compensate for the lack of antique painted portraits by evolving a painting style based on the Roman bust. According to legend Medusa turned men to stone, and in his independent portraits Mantegna turned them to stone, too. His earliest surviving portrait [92] was painted about 1459, probably at Padua. It represents Cardinal Mezzarota, a warrior prelate who corresponded with Cyriacus of Ancona and owned a famous collection of antiques.[37] Mantegna's portrait is commemorative, not analytical, and is designed to isolate Mezzarota's historic personality.

In or soon after 1459 Mantegna moved from Padua to the stronghold of north Italian humanism, Mantua. At the same time there arrived in Mantua, in the suite of Pope Pius II, a figure who came to dominate artistic thinking at the Mantuan court, Leon Battista Alberti. But not till 1474, two years after Alberti died, did Mantegna apply himself to the aspect of the portrait to which he made his most decisive contribution, the portrait group. The place in which he did so was the Camera degli Sposi of the Palazzo Ducale.[38] From comparatively early in the century it had been usual for palaces in the courts of northern Italy to be decorated with frescoes of court life. The best-known cycle of the kind is in the Palazzo Schifanoia at Ferrara. But Mantegna's differ from the frescoes that precede them in that the whole scheme was inspired by the antique. In the spandrels beneath the ceiling are Roman emperors and above the Gothic arches are scenes from classical mythology, and the same classicizing spirit permeates the frescoes on the walls. On the entrance wall are three frescoes at eye level, of which that on the right [93] is filled with portraits. In the foreground are the male members of the Gonzaga family, Lodovico Gonzaga [95], whose features agree with those of a bronze bust in Berlin for which Alberti may have been responsible, his eldest son Federigo, in profile on the right, and his second son, Cardinal Francesco Gonzaga in the center, almost in full face. At the back are six subsidiary figures, four of them in profile. The disposition of these figures may have been suggested by an Aurelian relief. Mantegna's fresco represents the Marquess greeting his son the Cardinal,[39] but it reads like a quattrocento *Last Year at Marienbad*, where each actor is unconscious that anybody else is there.

We have no proof that an interval of time separates this fresco from the second fresco above the chimney piece [94], but it seems that between the two Mantegna paused, at least briefly, to take thought. First of all, there is a difference in technique: the entrance wall is painted in the rapid medium of true fresco, while the second scene is painted *a secco*.[40] *Secco* technique permitted slow retouching, and the heads [96], though damaged, are realized with the same deliberation and exactness as Mantegna's independent portraits. Second, the figures are posed as though standing on a platform

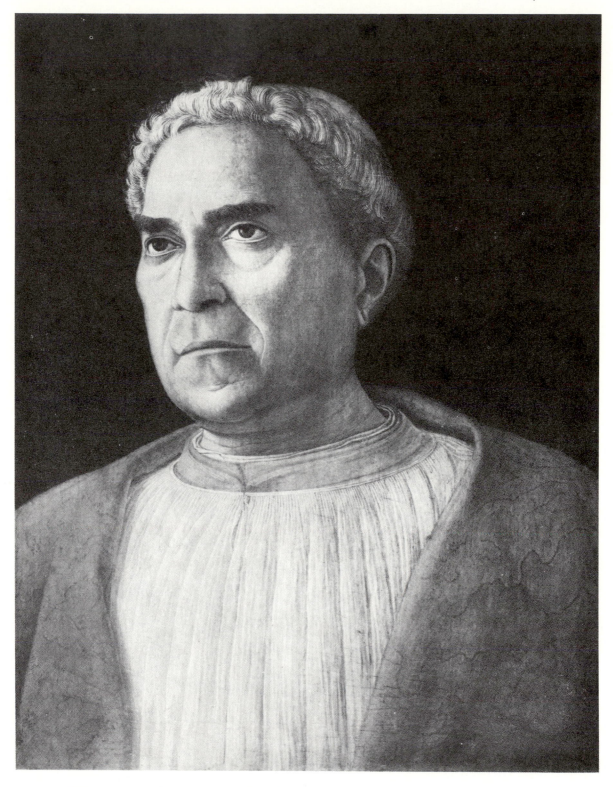

92. ANDREA MANTEGNA *Cardinal Mezzarota* (West Berlin)

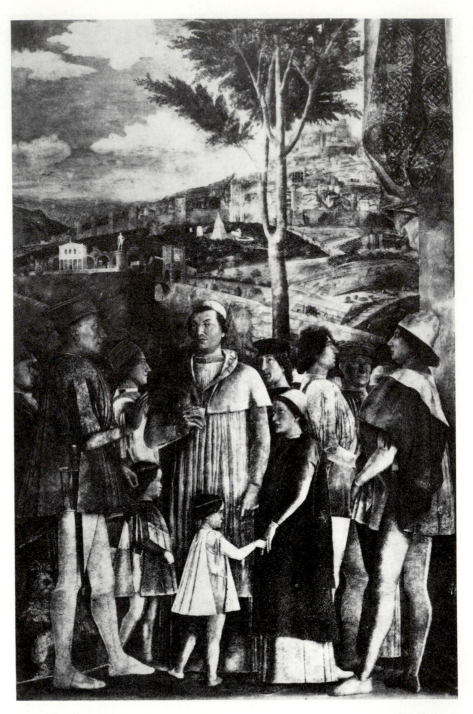

93. ANDREA MANTEGNA: *Lodovico Gonzaga, Marquess of Mantua, greeting his Son, Cardinal Francesco Gonzaga* (Mantua)

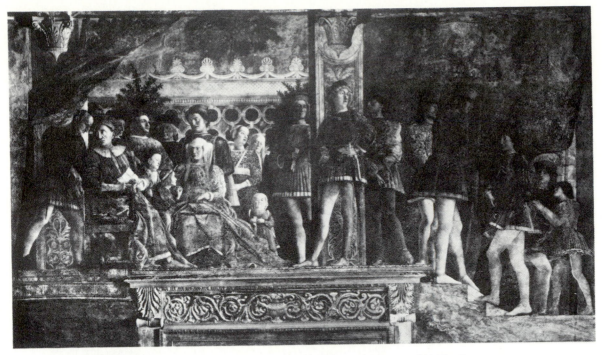

94. ANDREA MANTEGNA: *Lodovico Gonzaga, Marquess of Mantua, with Members of his Family and Court* (Mantua)

of real space—Mantegna had learned the uses of a low viewing point at Padua from the reliefs of Donatello—and the composition has the clarity and narrative compulsion that the first fresco lacks. It shows the Marquess and his wife, Barbara of Brandenburg, seated ceremonially with members of their family and court, awaiting an emissary whose arrival is heralded by figures on the right.[41] What is astonishing about this fresco is the ease with which it is articulated. Once more the means derive from the antique; there was a whole host of classical reliefs, from the Gemma Augustea up, from which the principles that are applied in it could have been deduced. Its historical importance is difficult to overrate, for here Mantegna, by a supreme act of artistic will, creates a new art form, and establishes the principles of the conversation piece. In at least one northern painting the influence of this fresco is very marked.

Portraits of the great Italian humanists were much sought after by northern students in Italian universities. In 1459, for instance, a young German writes from Padua to his father at Augsburg that he is sending him lead casts from medals of Filelfo, Guarino, and other scholars. But it was half a century before portrait medals were widely cast in Germany. Dürer, in 1508, after his second Italian journey, experi-

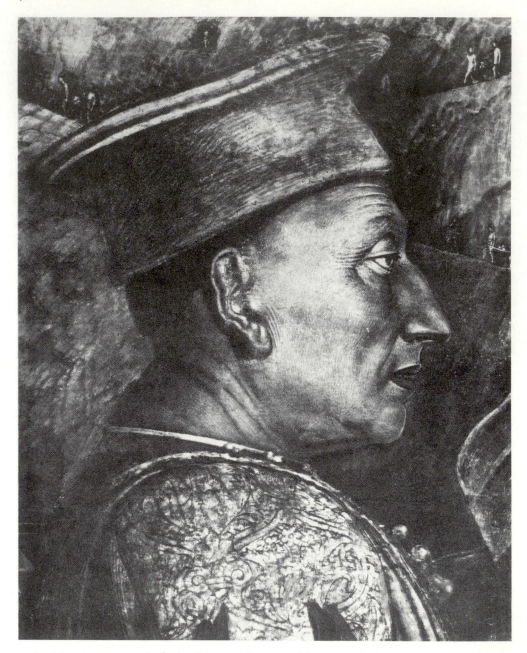

95. ANDREA MANTEGNA: Lodovico Gonzaga, Marquess of Mantua, detail of Fig. 93 (Mantua)

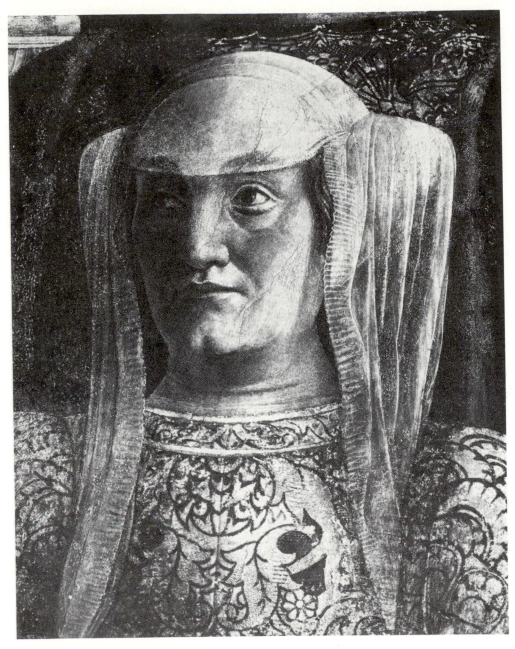

96. ANDREA MANTEGNA: Barbara of Brandenburg, detail of Fig. 94 (Mantua)

mented briefly with the medal, and in 1513 Cranach was required to carve a honestone portrait of Frederick the Wise which could be cast in bronze. In Germany the medal was from the first closely bound up with the painted portrait, and the head is for that reason sometimes shown in full or in three-quarter face. In Hans Schwarz's medal of Kunz von der Rosen [97], the counselor of the Emperor Maximilian I, of about 1518, the beard juts forward aggressively. Had the classical heritage of the medal been understood in Germany, it would have discouraged experiments like this. When pure profile is employed, as it is in Schwarz's medal of Konrad Peutinger of 1517 [98], it is treated with unsparing attention to detail. Representationally the German medal has many merits—the features are often rendered with uncanny precision, no matter how coarse or commonplace—but scarcely ever is it borne forward on that afflatus of nobility that raises the Italian medal to such heights.[42]

None the less, in 1519 a northern humanist medal was produced—not in Nuremberg but at Antwerp by the painter Quentin Matsys [99]. It was invented by Erasmus. On the obverse are two inscriptions; one is a declaration that the portrait is taken from the life, and the other is a warning, in Greek, that the true portrait of Erasmus is delineated in his works.[43] Erasmus had visited Italy—between 1506 and 1509 he was in Rome and Padua and Venice—and the collection of medals he assembled is now preserved at Basel. He distributed copies of Matsys' medal very widely, and nine years after it was made, he expressed approval of it in a letter, adding the sentence: "Dürer has drawn me, but nothing like."[44] It is not surprising that Erasmus preferred the crisp contours of the medal to the crumpled features with which he was invested in the drawing that Dürer made of him in 1520, when he visited the Netherlands.[45]

Like Alberti before him, Erasmus had an abiding interest in his own appearance—as a young man he made some marginal caricatures of his own features in a volume that is still preserved[46]—and basing himself on Cicero's *De Amicitia*, he evolved a cult of friendship which expressed itself in the exchange of portraits.[47] For five years he lived in England, in part in the house of Thomas More, the northern humanist whose fame was most nearly comparable to his own. When, after two years in Basel, he returned to the Low Countries, to the house of his friend Petrus Aegidius at Antwerp, More's *Utopia*, thanks to Aegidius' intervention, was already being printed at Louvain. In the summer of 1516 he went back for a short time to London, and from this visit a painting sprang. It was a diptych showing Aegidius and Erasmus, and was designed as a joint gift for More.[48] In a letter written in the spring of 1517 Erasmus tells More of the project for the portrait. Work on it, he writes, has been suspended for some days because his doctor had given him some pills to purify his bile, and the painter, Quentin Matsys, complained that he no longer looked the same. Six weeks later More is impatiently awaiting the arrival of the painting "which will bring me your likeness and

97. HANS SCHWARZ: *Kunz von der Rosen*
 (Washington)

98. HANS SCHWARZ: *Konrad Peutinger* (Washington)

99. QUENTIN MATSYS: *Erasmus* (London)

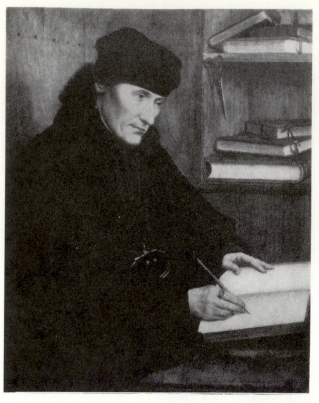

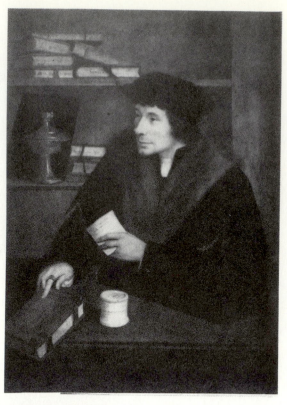

100. QUENTIN MATSYS: *Erasmus* (Rome)　　　　101. QUENTIN MATSYS: *Petrus Aegidius* (Longford Castle)

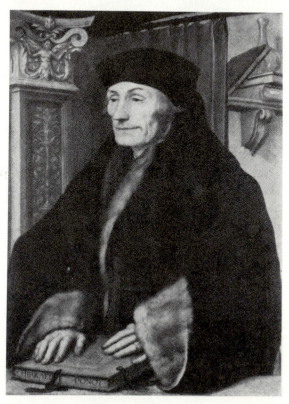

102. HANS HOLBEIN THE YOUNGER: *Erasmus*
(Longford Castle)

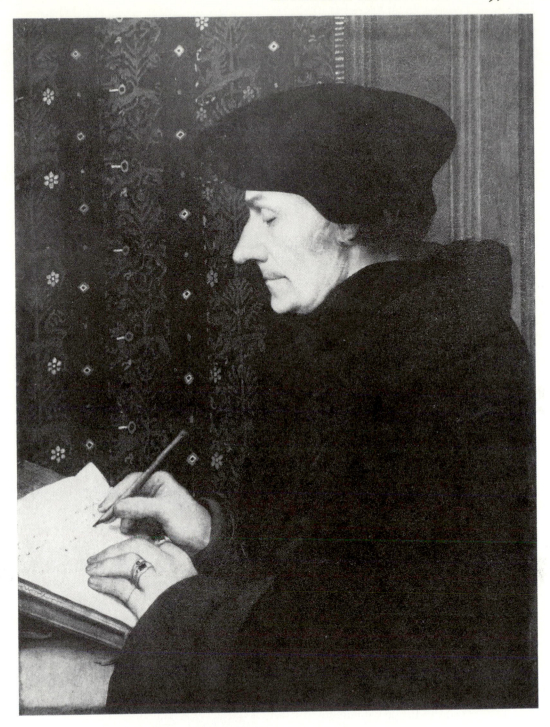

103. HANS HOLBEIN THE YOUNGER: *Erasmus* (Paris)

that of Peter," and at the end of the first week in September it was dispatched. "I am sending you the portrait," writes Erasmus, "in order that we may be always with you, even when death shall have annihilated us."

When he received it, More wrote to Erasmus: "I cannot tell you how proud I am to think that by this signal proof you have declared that there is no one by whom you are more loved than me." Thanks to the portrait the memory of Erasmus is kindled in his heart every hour of every day. To Aegidius he sent a poem, comparing the friendship that bound the donors to the bond between Castor and Pollux, and praising the painter Matsys, who could perpetuate the features of men such as antiquity knew only in small numbers and the present day in smaller numbers still. "If the terrible Mars does not triumph over Minerva," the poem ends, "what price will posterity not set upon this painting."

The painting—for though it has been broken up, we must refer to it in the singular —shows Aegidius [101] and Erasmus [100] seated at the two ends of a table, Erasmus at work upon his *Paraphrase of the Epistle to the Romans* and Aegidius with his right hand resting on Erasmus' *Antibarbarorum Liber* and with More's letter in his left. The unity of setting is established by two shelves loaded with books which run across the back, and more decisively by the psychological relationship between the sitters. They are enclosed in their own world, oblivious to the presence of all save More, the third member of the group.

Holbein's first portrait of Erasmus [102][49] was also intended as a gift, this time for Warham, Archbishop of Canterbury. The painting shows Erasmus in his study, standing at a desk, with a curtain behind him and a shelf of books. In this its terms of reference correspond with Matsys' painting. But the head and hands are rendered with much greater intensity, and an intrusive classical pilaster is the only significant concession to the painter's taste. In the same year, 1523, Holbein painted Erasmus twice more,[50] this time in profile in the act of composition [103], with eyes directed to a sheet of paper on which we can read, as though over the sitter's shoulder, the opening words of his *Commentary on the Gospel of St. Mark.* The decorative column is omitted and a patterned curtain throws into relief the formidably concentrated head. These devices have no precedent in Holbein's work, and once more they are likely to be due to the creative imagination of Erasmus.

In the summer of 1526 Erasmus informed Aegidius that a painter from Basel was leaving forthwith for Antwerp and London, and before Christmas Holbein was installed at Chelsea in the household of Sir Thomas More. He must have come to London at the instigation of Erasmus or with his encouragement, and in the short time he spent there—he was back in Basel in 1528—his main task was to record the features of the English members of Erasmus' circle, Warham and More himself. The

FAMILIA THOMÆ MORI ANGL: CANCELL:

Thomas Morus A'.50. Alicia Thomæ Mori uxor A'.57. Iohannes Morus Thomæ filius A'.19. Anna Grisacria Iohannes Mori Spensa A'.15 Margareta Ropera Thomæ Mori filia A'.22.
Elisabeta Danæa Thomæ Mori filia A'.21. Cæcilia Heroina Thomæ Mori filia A'.20. Margareta Giga Clementis uxor Mori filiabus Condiscipula et cognata A'.22 Henricus Patensonus Thomæ Mori morio A'.40.

104. HANS HOLBEIN THE YOUNGER: *The Family of Sir Thomas More* (Basel)

image we all have of More and of his family at Chelsea depends in the main from a famous letter which Erasmus wrote to the German humanist Ulrich Hutten in 1519.[51] Oddly enough, it opens with a simile from painting: "As to your demand for a complete portrait, as it were, of More, would that I could execute it with a perfection to match the intensity of your desire. But I wonder whether he will tolerate being depicted by an indifferent artist; for I think it no less a task to portray More than it would be to portray Alexander the Great or Achilles, and they were no more deserving of immortality than he." So we can assume that when Holbein was at length confronted by Sir Thomas More in person, he was not dependent on ocular impressions, but was fortified by a description of More's temperament and character, by knowledge of his motives and career and background sifted through Erasmus' psychologically subtle

105. HANS HOLBEIN THE YOUNGER: *Sir Thomas More,* detail (New York)

106. HANS HOLBEIN THE YOUNGER: *Sir Thomas More*
(Windsor Castle)

mind. And if we seek visual confirmation of the depth of understanding with which Holbein approached his sitter, it is there in the works that he produced.[52]

One of them was a portrait group. It measured over eight feet high and thirteen feet in width, it was painted in water color on linen or canvas, and it was burned at Kremsier in 1572.[53] The subject was the family of Sir Thomas More, and in it were twelve portraits. What we know of its composition depends from two main sources, a drawing by Holbein at Basel [104][54] and a version on canvas by a copyist.[55] The drawing is annotated by Holbein—"Diese soll sitze" (she is to sit), we read beside the figure of Dame Alice More—and the names and ages of the members of More's family were written on it by Nicholas Kratzer, the astronomer royal, a close friend of both More and Holbein, presumably when it was decided to present the drawing to Erasmus. Holbein took it with him when he left England in 1528, and Erasmus in a letter to More expressed his enthusiasm for the gift: "I cannot put into words the deep pleasure I felt when the painter Holbein gave me the picture of your whole family,

which is so completely successful that I should scarcely be able to see you better if I were with you."

The *More Family* is much more than the record of a domestic relationship. Erasmus, in a celebrated passage, compares More's household to the Academy of Plato, and Holbein's painting was an encomium of that aspect of More's life. There are quite a number of discrepancies between the drawing for the painting and the copy that was made after it.[56] Some of the changes annotated on the drawing appear on the copy, but the drawing is apparently more faithful to the space structure of the completed painting. Holbein had been in Lombardy, and the pose of one figure, Cicely Heron, has been repeatedly referred to Leonardo. More important is the dependence of the composition from Mantegna's fresco in the Camera degli Sposi at Mantua, which Holbein must have known at first hand or by report, and from which he derived the notion of a scheme where the lucid space takes on an intellectual dimension, and the articulation of the figures suggests the homogeneity of outlook by which they were linked. But Holbein was a far greater portrait painter than Mantegna, and the preliminary drawings for figures in the painting [106] and the painted portrait that was based on one of them [105] trespass on the subject of the next chapter, the painter as psychologist.

III

The Motions of the Mind

The change that overtakes the profile portrait in the last decade of the fifteenth century reflects a change of a more general kind, the invention of the autonomous portrait. It was created by Leonardo, and it sprang from the belief that the portrait should portray what is described in Leonardo's *Notebooks* as "the motions of the mind." The new type of portrait was coined by him in Milan in the fourteen eighties, when he was liberated from the system·of judgment by result that was endemic in Medicean Florence and was free to speculate at leisure as a subsidized dependent of the Sforza court. The revolution in his attitude toward portrait painting can be measured in two pictures, the portrait of Ginevra de' Benci [108], which was painted in Florence about 1475, and the most ambitious of the portraits that he made in Milan, the *Cecilia Gallerani* [107]. The *Ginevra de' Benci* is a quattrocento portrait raised to a new power. The definition of the contours is more delicate and the sense of the face as a relief surface is more pronounced, but there is nothing to suggest that the head was posed or lit by any other method than that current in the Verrocchio shop. The *Cecilia Gallerani*, on the other hand, is illuminated from above and slightly from the right, and is divided into pools of diffused light and shadow which throw the serpentine pose into relief. The figure is not set in open space, like the *Ginevra de' Benci*, or on a neutral ground, like so many quattrocento portraits; it is shown in restricted space, and X-rays seem to prove that in the background there was originally a window or a door.[1]

The meaning of this change becomes apparent if we turn to the three passages in Leonardo's *Notebooks* which refer explicitly to portraiture. "When the light falls from in front on faces placed between dark walls," says Leonardo in the first,[2] "the faces acquire great relief, especially when the light is above the face." That thought is elaborated in the second passage. "A very high degree of grace in the light and shadows," writes Leonardo,[3] "is added to the faces of those who sit in the doorways of rooms that are dark, where the eyes of the observer see the shadowed part of the face obscured by the shadows of the room, and see the lighted part of the face with the

107. LEONARDO DA VINCI: *Cecilia Gallerani* (Crakow)

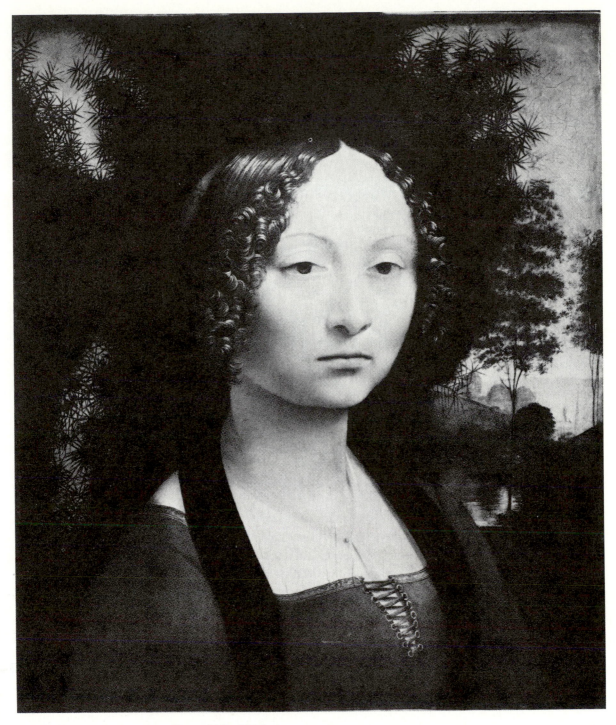

108. LEONARDO DA VINCI: *Ginevra de' Benci* (Vaduz)

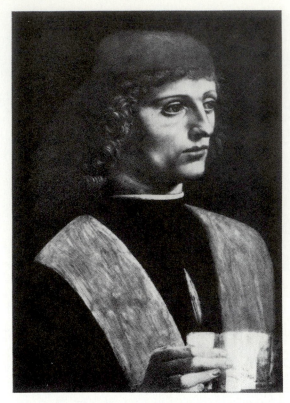

109. LEONARDO DA VINCI: *Portrait of a Musician* (Milan)

greater brilliance which the air gives it. Through this increase in the shadows and the lights, the face is given great relief." The third passage qualifies the other two, in so far as it makes clear that however deep the shadow, the lighted area of the face was never to be brightly lit. "In the streets at twilight," it reads,[4] "note the faces of men and women when the weather is bad, how much attractiveness and softness is seen in them. Therefore, painter, have a courtyard made suitable with walls stained black. . . . If you do not cover your courtyard with an awning, make your portrait at twilight, or when there are clouds and mist. That is the perfect atmosphere." Lest the term courtyard should prove vague, Leonardo gives the dimensions of the area he has in mind— forty feet long, twenty feet wide, twenty feet high. There is nothing theoretical about these passages; they are a recipe for painting portraits, and taken together they describe the way in which the *Cecilia Gallerani* was produced.

In Milan Leonardo must have been quite a prolific portrait painter, but over and above the *Cecilia Gallerani* only three portraits painted by him at this time survive.

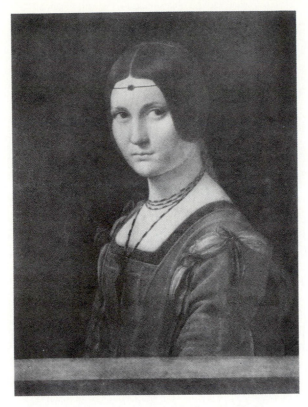

110. LEONARDO DA VINCI: *La Belle Ferronière* (Paris)

One of them is that strange painting in the Louvre known as the *Belle Ferronière* [110]. The panel appears to have been cut from the same trunk as the panel of the *Cecilia Gallerani*,[5] but Leonardo must have suspended work when only the head and shoulders were complete. Perhaps it was originally intended that the asymmetrical placing of the body should be compensated by some architectural feature on the left, and that the painting should include the hands—the hands were shown in the *Ginevra de' Benci*, which has been cut down, and they are shown again in a drawing of Isabella d'Este and in the *Mona Lisa* and the *Cecilia Gallerani*, and it can hardly have been Leonardo's intention that the corresponding section of the *Belle Ferronière* should be blocked by the meaningless parapet that we see now. Another painting of this time is the portrait of a musician in the Ambrosiana in Milan [109], where the impact of the head is stronger because the surrounding area is reduced. What these three figures isolated in an ambiguous void contribute to the portrait is a new sense of the mystery and the uniqueness of the human personality.

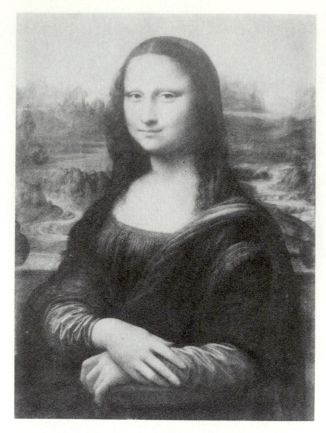

111. LEONARDO DA VINCI: *Mona Lisa* (Paris)

In about 1503 Leonardo, armed with this method, began work on what bids fair to be considered the best-known painting in the world [111]. By the time he returned to Florence, the style of the *Madonna of the Rocks* had given way to the noble cartoon of the *Virgin and Child with St. Anne*, and the same change of heart is evident in the transition from the *Cecilia Gallerani* to the *Mona Lisa*. In the cartoon the figures are more classical than in the *Madonna of the Rocks* and the system of movement is less abrupt, and in the *Mona Lisa* the pose is consolidated in somewhat the same way. The body recedes more gently, and is broadened out so that at the base it fills almost the whole width of the panel, and the head is turned nearly in full face. But the *Virgin and Child with St. Anne*, though less unnatural than the *Madonna of the Rocks*, is none the less a highly artificial structure, and the *Mona Lisa* is a highly artificial structure too. The figure is set in the exact center of the panel, between the parallel planes of the

112. LEONARDO DA VINCI: *Mona Lisa*, detail (Paris)

113. ANDREA DEL SARTO: Study for *Portrait of an Architect* (Florence)

114. ANDREA DEL SARTO: *Portrait of an Architect* (London)

chair arm and the parapet. Like the *Cecilia Gallerani*, it seems to have been planned initially in relation to a containing wall, which was then replaced by a mountain landscape, visually unrelated to the figure and inevitably lit from a different light source. The possibilities of mountain landscape as a background to a figure composition had been explored by Leonardo in the early *Madonna* in Munich, but at Munich the landscape is framed conventionally by two windows, while in the *Mona Lisa* this containing frame has been removed. According to Vasari, work on the *Mona Lisa* continued for four years, and the landscape may have been inserted, in the absence of the sitter, after 1506 when Leonardo returned to Milan.

Throughout his writings Leonardo's mind moves to the general from the particular; facts are recorded, and from them laws of general application are deduced. With the *Mona Lisa* this same process occurred. As he worked year after year upon the panel, the portrait of an individual was transformed into an essay about portraiture. The poet Bellincioni describes Cecilia Gallerani as "seeming to listen but not to

speak," and of the Mona Lisa [112] that is also true. In neither case was Leonardo concerned directly with psychology, but in both the working of the brain was reflected in the immanence of movement in the face. In that sense and that sense only there is a profound congruity between the human image of the Mona Lisa and the landscape at the back, for both result from protracted ocular analysis and both are scientific and passionless.

In a famous description of the picture Vasari mentions the sitter's rosy nostrils and pink lips, and one or two scholars have read his words more literally than they deserve. There are two reasons for discounting them: first, Vasari never saw the painting, and second, laboratory examination shows that from the first it was distinguished by its relatively pallid face.[6] That is not surprising, for the method of portrayal described by Leonardo in the *Notebooks* inevitably tended to a monochromatic treatment of the flesh and a reduction in local coloring.

The lesson of the twilight portrait could be read in many different ways. In Florence its advocate was Andrea del Sarto, and the key work is the *Portrait of an Architect* in the National Gallery in London [114], painted some twelve years after Leonardo had left Florence.[7] From the posing of the figure, which is wedged between a chair arm and the rear wall of the studio holding a block of masonry, we might guess that Leonardo's example was at work, and confirmation that that is really so is provided by one of the preliminary drawings [113],[8] which reveals the same thought processes as the *Cecilia Gallerani*. But in Andrea's portrait the rendering of the features is, by Leonardo's standard, weak, though pools of shadow in the eyes and mouth lend it an adventitious identity. The procedure by which Sarto's portraits were produced was less cerebral, and the resulting paintings were less cogitated.

In Florence at the end of the first quarter of the sixteenth century formal considerations, though important, were not paramount. In 1518 Pontormo's ecstatic altarpiece for San Michele Visdomini was finished, and in 1522 work started on the Passion frescoes in the Certosa at Galluzzo. Where religious art was impelled by the emotions, it was inescapable that portraiture should be controlled by the emotions too. What was relevant here was Leonardo's system of directed light, which was originally designed to isolate the figure and to unite its forms, but could also be employed as a means of interpretative emphasis. Pontormo in particular was concerned with the spirit, not the form. It has been claimed by Croce that the portrait painter paints only his own sentiments, and not the model in front of him. Of Pontormo something of the kind is indubitably true. Solitary and introspective, he imposed upon his sitters the apprehension and the sense of insecurity, the tension and the pressures, the isolation and self-pity by which his life was dogged, and as a result his startled portrait of Francesco dell'Ajolle the musician [115] reads as a cry of anguish at the human pre-

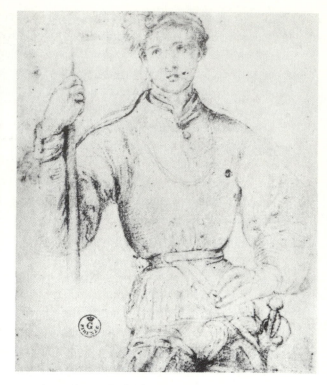

115. PONTORMO: *Francesco dell'Ajolle* (Florence) 116. PONTORMO: *Study of a Youth* (Florence)

dicament.[9] His technique for establishing the structure of his portraits was more casual even than Andrea's. A youth holding a halberd[10] would stand challengingly in his workshop with his right thigh slightly advanced [116]. But by the time the painting [117] was carried out, the confidence that was natural to the sitter, and was so clearly stated in the drawing, had been drained away, and his features became ravaged by self-questioning.

For one artist Leonardo's experiments in portraiture were of supreme significance. What he knew of portrait painting when he arrived in Florence had been gleaned in Umbria from Perugino; one of the earliest portraits by him that survive, a self-portrait drawing of about 1500 [118],[11] maintains Perugino's disarmingly unself-conscious attitude toward the portrait. But where Perugino tends to assimilate the forms of the face seen to pre-existing pictorial formulas, the features are here rendered more incisively; the outline of the cheek is captured with a rapid movement of the chalk, and the same assurance is felt in the drawing of the lids that frame the questioning eyes and in the firm line of the mouth. Two or three years later these qualities

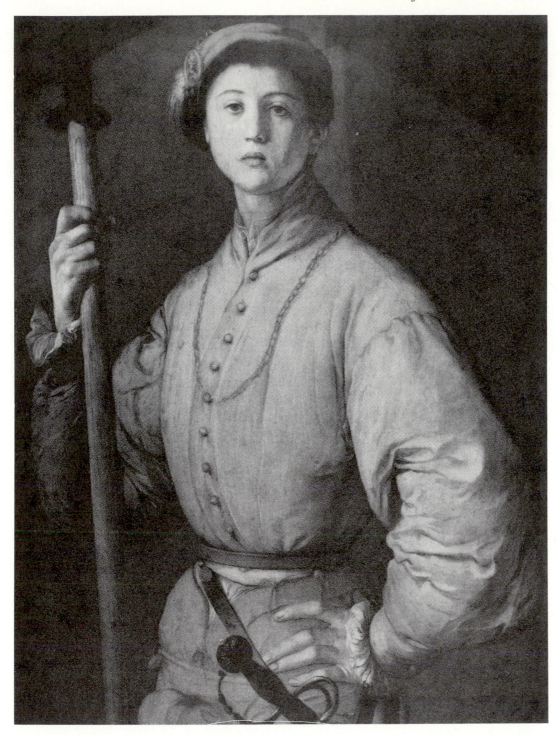

117. PONTORMO: *Youth with a Halberd* (New York)

118. RAPHAEL: *Self-Portrait* (Oxford)

119. RAPHAEL: *Presumed Portrait of Francesco Maria della Rovere* (Florence)

were translated to a painting, the presumed portrait of Francesco Maria della Rovere in Florence [119]. In the drawing the body is barely indicated, but in the painting it is shown below the chest, and very insecure it is, a lay figure acting as a kind of plinth for the beautifully realized head. For Raphael the revelation of the *Mona Lisa* was of a portrait where the head and body were welded into one organic form. We can be certain that he studied it, since in the painting of Maddalena Doni of about 1506 [121] he imitates the setting of the body on its panel, the placing of the hands and the direction of the glance. But in the *Maddalena Doni* the compressed pose accords uneasily with the placid landscape at the sides—that may have been less evident when it was shown, not as an independent painting, but as one wing of a static diptych with an architectural frame—and there is an unresolved conflict between ideality and realism in the face. Paradoxically, in the companion portrait [120], where the scheme does not depend from Leonardo, more of Leonardo's spirit is preserved. But Raphael was more humanly inquisitive than Leonardo. The object of his attention is not the human phenomenon

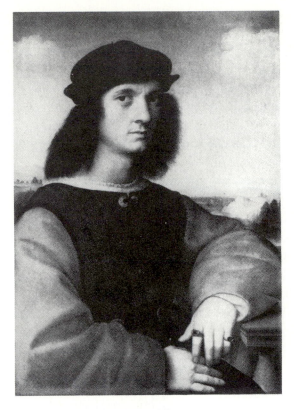

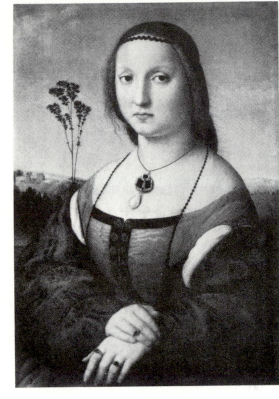

120. RAPHAEL: *Angelo Doni* (Florence

121. RAPHAEL: *Maddalena Doni* (Florence)

but the individual man, and his portrait is conceived as a psychologically truthful image based on conscious analysis of character.

Raphael is one of the great unknown quantities in the history of painting. He left no notebooks and few letters, and the portrait of Angelo Doni is our sole basis for the claim that at the age of twenty he already had original convictions about portraiture. Circumstances fostered them, for after 1508 he was engaged on the frescoes in the Stanze of the Vatican which, by their terms of reference, were filled with portraits. The conjunction in the frescoes of great figures from the present and the past sprang from an ennobled vision of the present which finds its literary expression in Castiglione's *Cortegiano*. The outcome can be seen in the *Portrait of a Cardinal* in Madrid [122],[12] which imposes itself on us as an embodied intellect. The miracle, for miracle it is, occurs first on the level of perception—have all those properties that make the individual really individual ever been seized more faultlessly than they are here? in the eyelids even the movement of the lashes is observed—and then on that of statement,

for the received image is transmitted with incredible refinement and clear-headedness. In the humane circle in which Raphael moved in Rome it was believed that human beauty was a reflection of divine beauty, and that the human intellect was a microcosm of the universal mind.[13] There was a predisposition towards naturalness. "Writing," says Castiglione in the *Cortegiano*, "is nothing but a form of speech which remains when man has spoken."[14] Continuing recourse to the formal theorems of Leonardo consequently was unthinkable, and the scope of art, once more in Castiglione's definition, was "the artificial imitation of the truth." The currents of prevailing thought, moreover, induced a carefully cultivated hyper-self-criticism that made the work actually planned seem no more than a substitute for an ideal that was still out of reach.

All this is implied in Raphael's portrait of Castiglione in the Louvre [123]. Bembo, in a letter of 1516,[15] refers to a portrait of Castiglione, which "would seem to be by the hand of one of Raphael's apprentices so far as likeness is concerned," compared with a portrait of the humanist Tebaldeo which was just complete. Perhaps the reference is to this painting, but that is not absolutely sure because in 1519 the secretary to the Duke of Ferrara noticed that the door of Raphael's house was open, and went in.[16] Raphael, he was informed, could not come down to see him, and when he volunteered to go upstairs, he was deterred from doing so by the news that Raphael was painting Castiglione's portrait. Compositionally the painting in the Louvre [17] is affected by the fact that the bottom of the canvas has been cut. The base of the left hand was originally disengaged, so that the stance was less ambiguous and the head, though it was still central, fell rather higher in the picture space than it does now. In the *Portrait of a Cardinal* the sitter is clad in red and is shown in front of a dark ground. In the *Castiglione* that procedure is reversed; the dress is somber and the figure stands in front of a softly illuminated wall. Experiments along these lines had been conducted a few years earlier by Titian, but not even in Titian's portraits is silhouette put to a use as masterly as this. Where Titian seems to illuminate the features from a powerful pocket torch, Raphael in the *Castiglione* uses a lighting system that is softer and more affectionate. There is no concealment in the features, and the filaments of sympathy that illuminate the sitter are exposed for all to see.

The implied contrast between the tranquil features and the complexity of the sleeve and dress that is present in the *Castiglione* is developed in the mysterious portrait known as the *Donna Velata* [124],[18] where the head, classical in structure and realized with breath-taking simplicity, is placed like a jewel in a setting of unrestrained and almost willful elaboration. Hither and thither run the folds of the white gold-embroidered sleeve, as though they were looked on by the painter as an area where he could give free rein to his pictorial fantasy. A diaphanous veil forms a niche behind the head. By tradition the painting is regarded as a portrait of Raphael's mistress, the Fornarina,

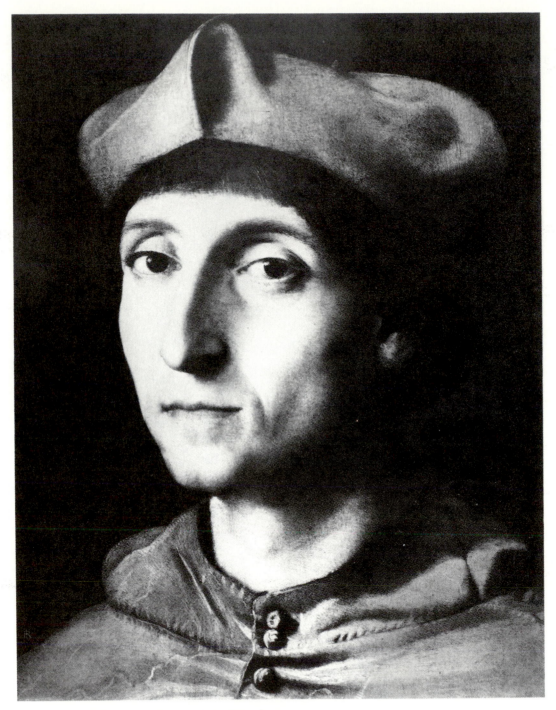

122. RAPHAEL: *Portrait of a Cardinal,* detail (Madrid)

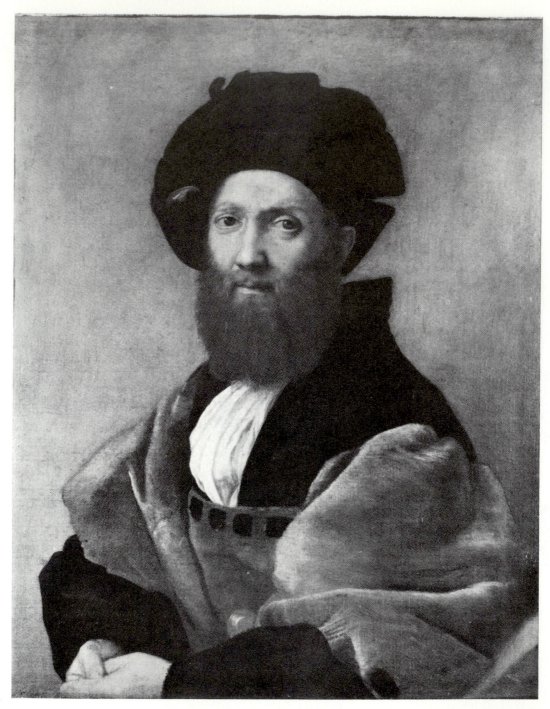

123. RAPHAEL: *Baldassare Castiglione* (Paris)

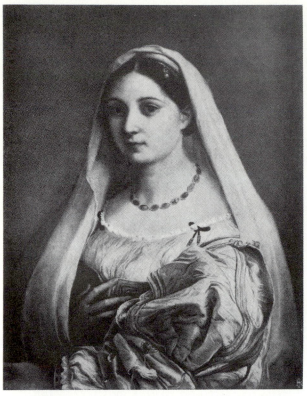

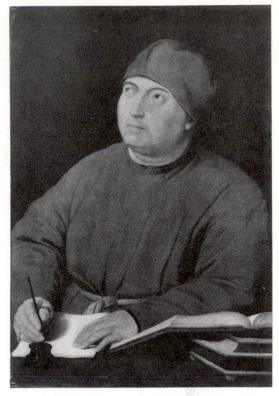

124. RAPHAEL: *Portrait of a Lady,* known as *La Donna Velata* (Florence)

125. RAPHAEL: *Tommaso Inghirami* (Boston)

but if it be so, never was an expression of physical affection so purged of passion and so intellectualized.

Many of the portraits in the Stanze show the sitter in a state of emotional or physical involvement in some scene, and by 1512 these gave rise to a new type of active portrait. Raphael's *Tommaso Inghirami* in Boston [125][19] is the first independent Renaissance portrait that is not psychologically self-contained; the sitter has been interrupted at his desk, and his attention is attracted by some unseen interlocutor. There are Flemish paintings in which the foreground is treated naturalistically, and proof that they were known in Rome is provided by Sebastiano del Piombo's portrait of Ferry Carondelet [126], which was painted between 1510 and 1512, when Carondelet was serving as imperial ambassador to the Curia.[20] Carondelet is seated at a table covered with a carpet, dictating to his secretary; a third head appears behind, and at the back is a colonnade. The contrast between the back and front is so pronounced that we might well suppose the figure seated at the table was adapted directly from a Flemish portrait,

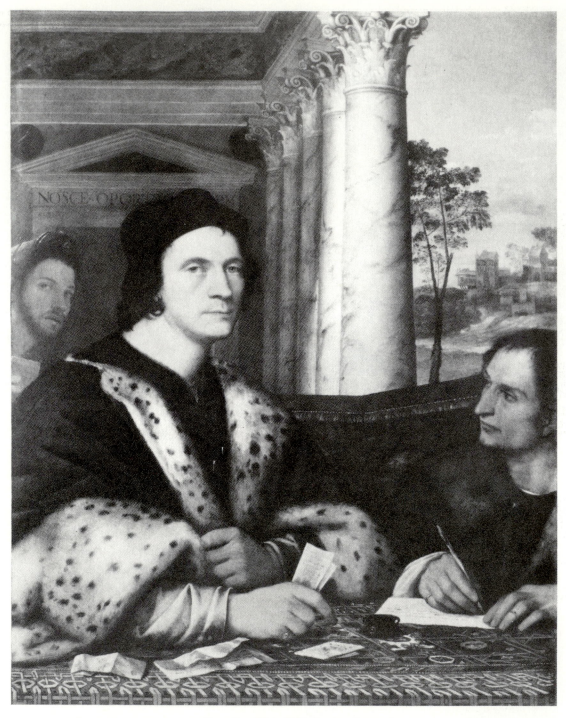

126. SEBASTIANO DEL PIOMBO: *Ferry Carondelet with his Secretary* (Lugano)

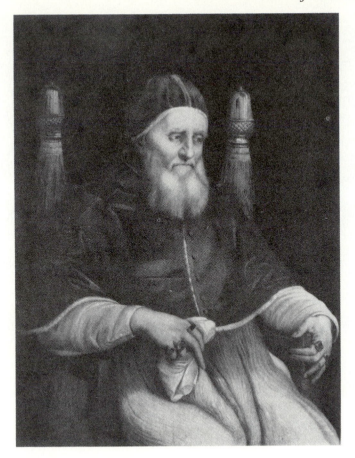

127. RAPHAEL: *Pope Julius II* (Florence)

and as in Flemish paintings, the table is nothing more than a descriptive, representation-al device. In Raphael's portrait, on the other hand, it is used in quite a different fashion; it establishes a context for the sitter's volatile, animated personality. Some years later Raphael made a second version, turning the head a little differently and increasing the angle of recession of the inkstand and the left edge of the book. The cause of this revision must have been that in the interval he had given further thought to the prob-lem of immediacy in two great papal portraits.

The earlier, of Pope Julius II, was painted about 1512 for the Della Rovere church of Santa Maria del Popolo. The best of several surviving versions is in the Uffizi [127], but in its present state there is no way in which we can be absolutely sure if it is a work-shop copy or, as is less likely, an obfuscated autograph.[21] The figure of the Pope is set diagonally to the picture plane, and is cut off in a seemingly arbitrary fashion just

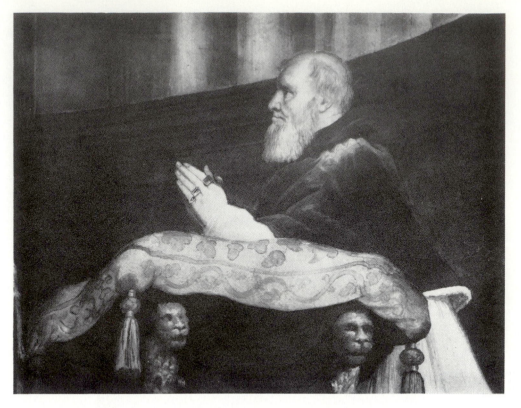

128. RAPHAEL: Pope Julius II, detail from the *Mass at Bolsena* (Vatican)

above the knees. The spatial content of the painting is established by the chair, but the ground is neutral so that attention is not distracted or dispersed. In the Stanze the portraits of the Pope show him involved in some external incident, gazing ferociously at Heliodorus or intently at the Mass [128]. Here he is alone with his own thoughts. Nowadays the ruminative portrait, the painting of the man consumed by thought, is something of a commonplace—it was taken up by Titian (who copied Raphael's portrait for Urbino) and was handed on by him to Rembrandt—but when Raphael conceived it, it was without precedent.

Raphael's years in Rome were clouded by the hostility of Michelangelo and by the emulation of Sebastiano del Piombo. Perhaps the stature of this great work is best established by contrasting it with another papal portrait [129], in which fourteen years later a challenge was thrown down to the shade of Raphael by the disciple of Michelangelo. When he designed it, Raphael's portrait must have been in the forefront of Sebastiano's mind. But for the gentle transition from shaded to lit areas in the

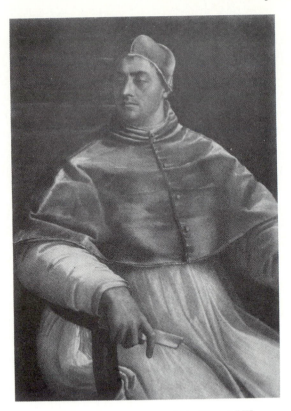

129. SEBASTIANO DEL PIOMBO: *Pope Clement VII*
(Naples)

Julius portrait, there is substituted the abrupt setting of dark on lighted areas, which Michelangelo developed in the Doni tondo and continued on the Sistine ceiling, and the head, in imitation of Michelangelo's statue of Giuliano de' Medici, is turned imperiously to one side. What results is undeniably a vivid portrait, but one controlled by the imagination, not the eye.

Some five years after the painting of the Julius portrait Raphael started work upon his only papal portrait group. It shows Pope Leo X with his nephews Cardinals Giulio de' Medici and Luigi de' Rossi [130]. De' Rossi, a son of the Pope's sister, became a cardinal in the summer of 1517 and died two years afterward, so the portrait must have been produced within that quite short space of time. When De' Rossi died, the Pope declared that even the deaths of his brother and his nephew had not caused him greater suffering. The significance of Raphael's portrait is dynastic, for Giulio de' Medici, the future Pope Clement VII, who is shown on the left, was Leo X's successor presumptive in the papacy. The portrait is extremely large, and no expedient is spared to make the

figure of the Pope seem even bigger than it is. The converging molding and cornice in the background and the steep angle of the chair and table all contribute to that effect. The painting is full of fascinating and voluptuous detail—the chair knob reflecting the source of light, which is described by Vasari and was copied by Ingres in his portrait of Bertin, the soft white quilting of the robe, and the action-painting of the tassels at the back—but the most memorable feature is the Pope's masterful, self-indulgent head; its structure is built up with a confidence founded on many years of close familiarity, and its texture reveals an amazingly meticulous attention to natural appearances.

The problems posed by multiple portraits in the early sixteenth century were by no means simple ones. Some twelve or eighteeen months before Raphael began work, Sebastiano del Piombo painted the quadruple portrait of Cardinal Bandinelli Saulli and three companions in the National Gallery of Art in Washington [131].[22] Here everything is inexplicit and ambiguous; it is like one of those scenes in opera in which two different duets are going on at the same time. The main cause of our bewilderment is that Sebastiano conceived the portrait group as an assembly of four heads. One reason for supposing this is that he left an unfinished painting of the kind; it represents Pope Clement VII and Pietro Carnesecchi.[23] In it the heads are worked up to a state of near completion, and the bodies are blocked out and were to be filled in afterwards. Many later artists worked in this way, and very seldom has the method yielded more than passable results.

Raphael, on the other hand, when he moved from the Stanza della Segnatura to the Stanza d'Eliodoro, applied himself to the problem of the integrated group. The place in which he did so was the right side of the *Mass at Bolsena*, where the Pope kneels before the altar, with the members of his court beneath. For the first time the figures are effectively caught up in a common action, and an impalpable web of thought links the cardinals to the Pope. The inferences drawn by Raphael from the fresco are embodied on panel in this majestic statement of the dialectic of the portrait group.

The force of the lessons to be learned from Leonardo was felt also by the first great northern Renaissance portrait painter, Albrecht Dürer. In a famous passage in the introduction to the *Unterweysung der Messung*, Dürer describes how German painters grew up "like wild ungrafted trees." To German portrait painters this analogy would be particularly apt, for the German portrait in the fifteenth century was conceived in rugged terms of character. In the portrait Dürer's task was to systematize and to consolidate, and thanks to his unaided efforts, within a generation the intuitive painting of his predecessors was transformed into the rational likeness of Johannes Kleeberger [132], where the portrait type depends from the traditional German St. John's head shown on a charger, but the portrayal of the features is Ingres-like in its clarity.[24] The

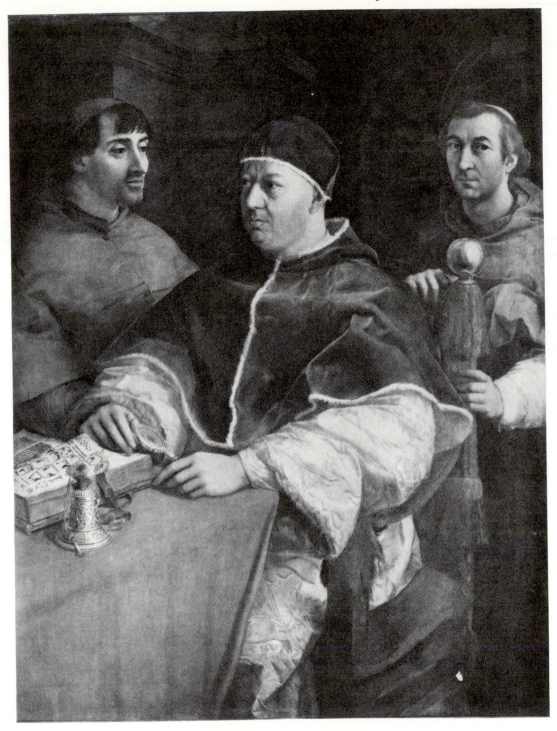

130. RAPHAEL: *Pope Leo X with Cardinals Giulio de' Medici and Luigi de' Rossi* (Florence)

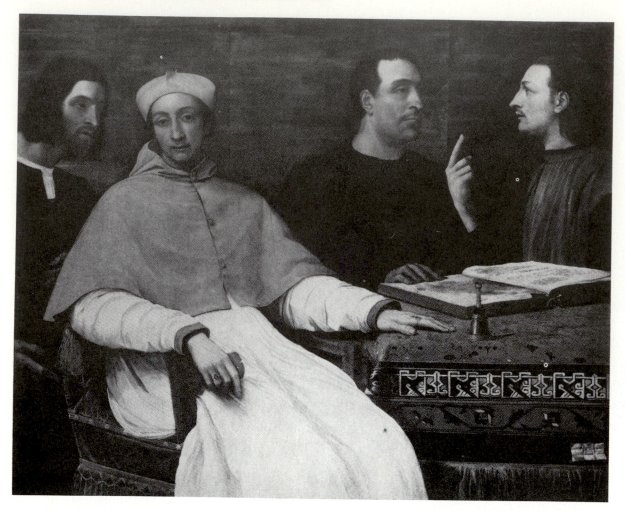

131. SEBASTIANO DEL PIOMBO: *Cardinal Bandinelli Saulli with three unidentified Companions* (Washington)

painting of Kleeberger was produced in 1526, and marks the last phase in Dürer's search for a classical portrait formula. As he advances toward his goal, the overtly expressive content of his portraits becomes less pronounced. The furtive gaze that links the *Oswolt Krell* [133] to the German portraits that precede it, the self-deprecatory pursing of the lips in the London portrait of Dürer's father, give way to heads which are not less effective for being more reticent and more restrained.

From the time he was thirteen Dürer made records of his own appearance. There are sequences of earlier self-portraits, of course—those of Alberti, for example—but there is no prior case of any painter applying himself over many years to the problem

132. ALBRECHT DÜRER: *Johannes Kleeberger* (Vienna)

133. ALBRECHT DÜRER: *Oswolt Krell*, detail (Munich)

of self-portraiture. "I have copied this from myself in a mirror," says the inscription on the earliest self-portrait drawing of 1484 [134], and we can tell that it is so from the disparate dimensions of the eyes and from the unconvincing gesture of the right hand. Probably the mirror Dürer used was a circular convex mirror of the type that is depicted in so many northern paintings. Nine years later, when he made another drawing of his own features [135], a convex mirror was undoubtedly employed. Perhaps the simplest way of proving that is to compare the drawing with Parmigianino's *Self-Portrait in a Convex Mirror* at Vienna [136], where the mouth diminishes in the same disconcerting fashion on the right, and the eyes, just as they do in Dürer's sketch, appear to rest on two quite different planes. In another drawing made at about this time Dürer looks into the mirror more closely, with his left hand pressed against his head so that it shall not distort. Probably these sheets were part of a much larger series of studies of the head and mirror in different relationships.

In casual sketches it was possible to accept the image reflected in the mirror and

134. ALBRECHT DÜRER: *Self-Portrait* (Vienna) 135. ALBRECHT DÜRER: *Self-Portrait* (New York)

136. PARMIGIANINO: *Self-Portrait in a Convex Mirror* (Vienna)

137. ALBRECHT DÜRER: *Self-Portrait* (Paris)

to record it. But as soon as the head was embodied in a half-length figure, the fact of its reversal proved at best a hazard and at worst a liability. Should the reversed head and a normal body be joined together, or was the body too to be reversed? Initially Dürer—and in this he seems to have had tradition on his side—adopted the first course. In his earliest self-portrait drawing, the sheet of 1484, the near hand is raised in a gesture which must have been designed to prove that the arm was the right arm and not the left. And in his first painted self-portrait, of 1493 [137], a spray of eryngium is likewise held in the near or supposedly right hand. In this case the expedient was excusable, for the painting was made as a betrothal portrait and almost certainly had as its counterpart a normal portrait of Dürer's wife. None the less it leaves us with a slight sense of discomfort, in that it pretends to be something it is not.

But Dürer by temperament and by profession was a scrupulously truthful artist, and when we next encounter his features in an independent painted portrait, the reversal is complete—the forward arm, that is to say, reads as the left arm and the right hand is clasped over it. This would hardly have been possible had the convex mirror

of the drawings and the earlier painting not been abandoned and a flat mirror been employed instead. Now it is a curious fact that whereas the mirrors shown in northern paintings in the fifteenth century are almost invariably convex, the mirrors shown in Venetian paintings are generally flat. The *Lady at her Toilet* in Giovanni Bellini's painting of 1515 in Vienna uses a flat hand mirror behind her on the wall, and Titian in the Munich *Vanitas* of about 1512 shows a large mirror of the same type. It was doubtless a mirror of this kind that permitted Dürer to luxuriate in the long act of pharisaical self-admiration that is recorded in the portrait in the Prado in Madrid [138]. [25]

When Dürer was in Venice for the second time, in 1506, he observed that the pictures which had previously pleased him no longer did so. He had taken note, that is, of the new phenomenon of High Renaissance style. And in his last self-portrait the principle of concentration which was Leonardo's major contribution to the portrait is rigidly applied. This famous painting [139] bears the apocryphal date 1500, and may have been painted about 1505.[26] Typologically it has been connected with Flemish paintings of the Salvator Mundi and German paintings of the Veronica Veil, and the contention has been advanced that Dürer "deliberately styled himself into the likeness of the Saviour ... [and] idealized his own features so as to make them conform to those traditionally attributed to Christ."[27] The arguments for that contention, when one examines them objectively, are very thin. Indeed, the analogies cited with the iconography of the Salvator Mundi really rest upon two points, the long hair which falls upon the shoulders on either side and the fact that the head is represented in full face. So far as concerns the style of hairdressing, this was the way Dürer wore his hair. In a fresco painted by Campagnola in Padua, probably in 1506, Dürer peers out at us from under the same curtain of greasy locks.[28] So far as concerns the full-face image, there is evidence, not of a quite conclusive kind, which suggests that Venice possessed a tradition of full-face portraiture. Probably the earliest surviving portrait of this type is a Bellinesque painting by Catena in the National Gallery in London, which seems to date from the first half-decade of the sixteenth century.[29] Simultaneously Lorenzo Lotto was also experimenting with the full-face portrait, first in the malformed portrait of a youth of soon after 1500 at Bergamo [140], and then in the much more secure head of a boy of about 1505 or 1506 in the Uffizi.[30] In Venice during his second visit Dürer must have encountered portraits of this kind. The view that the portrait really was painted in Venice is corroborated by the fact that it was known to Lotto—for how otherwise can we explain the advance from the painting by Lotto in Florence to the beautiful portrait of about 1510 at Hampton Court [141], where the distribution of light and shade seems to have been copied from Dürer's painting?

It has also been claimed that Dürer, in order to make his face more Christ-like,

138. ALBRECHT DÜRER: *Self-Portrait* (Madrid) 139. ALBRECHT DÜRER: *Self-Portrait* (Munich)

"softened the characteristic contours of his nose and cheek-bones and enlarged the size and altered the shape of his small and somewhat slanting eyes."[31] That hypothesis results from a misreading of the portrait. Whereas the head in the self-portrait in the Prado is erect, the head in the later painting [142] is bent slightly forward, gazing intently at the mirror. The high cheekbones are naturally less prominent, the nostrils are concealed and only the top surface of the nose is shown, while the upper eyelids are retracted, with a resultant change in the visible surface of the eye. It is not the features that have been changed, but the angle from which they are portrayed. The prevailing impression the portrait leaves in the original is of the relentless pertinacity with which the eyes drill into the mirror that is held so close to them. The painting has a crucial place in the transition from the portrait as description to the portrait as encephalograph.

Leonardo's message was passed on to another great northern portrait painter, Holbein. From the time he was nineteen Holbein showed an interest in Italian decorative motifs, which is manifest in the bastard architectural backgrounds of the portraits

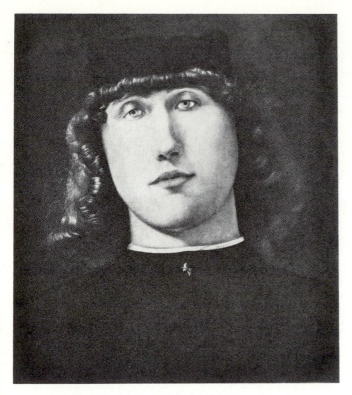

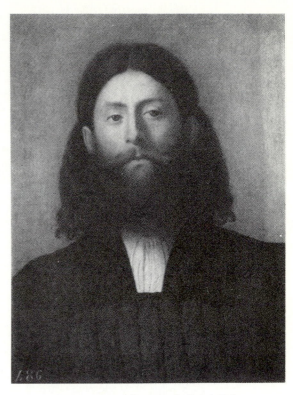

140. LORENZO LOTTO: *Portrait of a Youth* (Bergamo)

141. LORENZO LOTTO: *Portrait of a Bearded Man* (Hampton Court Palace)

of Jakob Meyer and his wife in Basel. But then and for some years afterward the principles of structure laid down by Leonardo were beyond his grasp. The clearest proof is offered by the Basel *Last Supper*, where the composition is based on Leonardo's fresco, but with the omission of those factors that account for its supreme originality. Not till 1526, in a secular painting, the *Lais Corinthaica* at Basel, was the organic pyramid of Leonardo's Christ assimilated into Holbein's work. The *Lais Corinthaica* was followed by the English journey, and only in 1528, when Holbein once more returned to Basel, were lessons learned from Leonardo applied to portraiture. Holbein's exemplar was not the *Last Supper*, but the pyramidal multifigure composition of the *Virgin and Child with St. Anne*, and the work to which it was applied was the portrait of the artist's wife and children in Basel [143].[32] Perhaps it looks more Leonardesque as we see it now than Holbein meant it to. It is on paper stuck on to a neutral panel, and in one copy the figures are set on an architectural ground. But even if it were originally intended to have an architectural setting, and even if it were the left half of a diptych of which Holbein's self-portrait would have formed the other wing, the fact remains

that the structure is more highly integrated than in any Holbein portrait that precedes it, and that a new psychological dimension is revealed. It is a puzzling dimension, or, more correctly, one that was found puzzling in the nineteenth century, when it was explained in the light of the little that is known about Holbein's relations with his family. Holbein's biographer Wornum, in a passage that might come from a minor novel by George Eliot, puts it like this: "Whence this frown of abstraction and look of deadened sympathies, which neither she nor Holbein have been able to suppress? Has she created a hell for herself out of her own wilfulness and impatience, or does her unhappiness arise from ill-usage and neglect on Holbein's part?"[33] Unmistakably the head speaks the language of compassion, and the emotion is ambivalent only because ambivalence is of the essence of the High Renaissance portrait.

When Dürer visited Venice for the second time, the changes that he found there could be summed up in a single name, Giorgione. Even today it is a little difficult to define exactly what the advent of Giorgione means for the history of taste. Like Proust, he taught educated people that the world could be looked at in a more pleasurable, more subjective way. His recipe for doing so was to infuse painting with the lyricism and romance that were already current in the prose and poetry of his time. The great divide is marked by the appearance in 1499 of Colonna's *Hypnerotomachia Poliphili*, which is so often discussed as though it were a manual for iconographers, but is really a milestone of the Renaissance romantic movement. In 1502 there was printed in Venice a clandestine edition of the *Arcadia*, in which Sannazaro describes the wanderings of a lovesick poet in a bucolic world, and fourteen years later it was followed by the triumphant issue of the *Orlando Furioso*. No longer did sophisticated patrons wish to be portrayed in three-quarter face against the sky with their shoulders severed by a parapet. Let the figure rather be set mysteriously against a neutral ground, let the body be lengthened to the elbows, let the parapet be lit from the same light source as the head. What matter if the hand grasping the parapet read in a rather unconvincing fashion, what matter if there was a lack of definition in the face, provided that the sitter was portrayed as a participant in the poetic literature circulating at the time. The appeal of Giorgione's subject paintings arises in large part from their inexplicitness, and in a painting in Berlin of about 1505 [144][34] this art of the half statement is extended to the portrait. Still more unashamedly literary is the portrait of a youth at Budapest [145][35] with his hand pressed to his heart. Are these the pangs of inspiration or the throes of love? Is this hope or devotion or despair? After Giorgione's untimely death the Giorgionesque portrait was as widely accepted as the pastoral; it produced, to take one instance only, a strange double portrait [146] in the Palazzo Venezia in Rome, where an imitator of Giorgione shows the sitter in full face with shadowed eyes and with his cheek supported on his palm.[36] It is always difficult to define the point at

142. ALBRECHT DÜRER: *Self-Portrait*, detail of Fig. 139 (Munich)

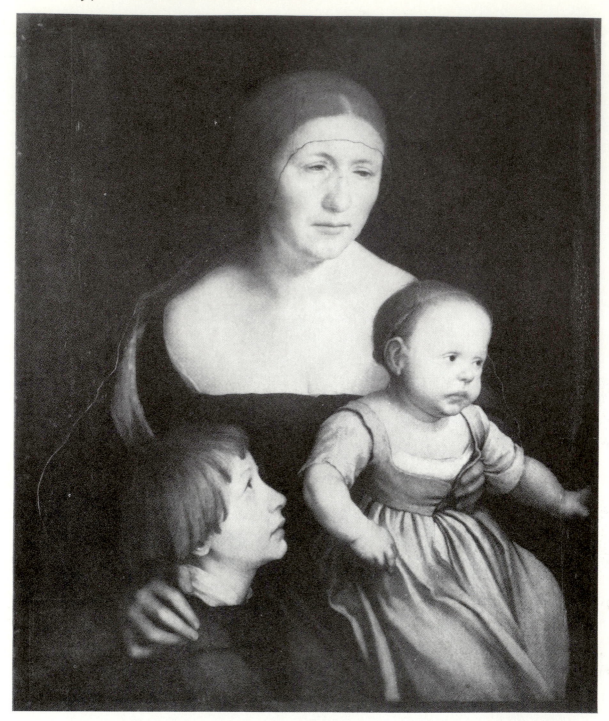

143. HANS HOLBEIN THE YOUNGER: *The Artist's Wife and Children* (Basel)

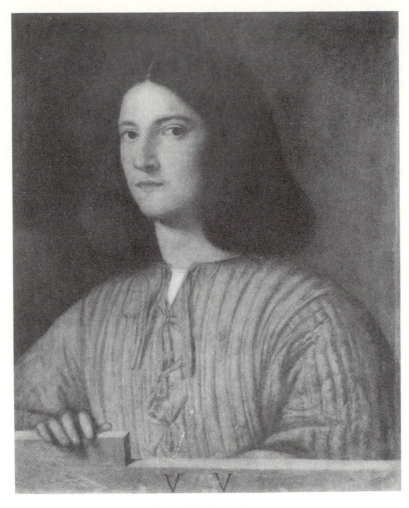

144. GIORGIONE: *Portrait of a Youth* (West Berlin)

which a mode of literary or pictorial thinking becomes conventional, but one cannot help suspecting that the emotions in this painting are synthetic, and that its drama is self-induced.

In Venice in the early sixteenth century two views of the function of the portrait were permissible. Should it portray the sitter, as Giorgione does in the portrait of a youth at Budapest, in a state of emotional involvement which shows up one aspect of the personality as a beam of light shows up the face, or should it represent the whole man, stripped of local contingencies and outside time, for the inspection of mankind? No sooner was Giorgione dead than this second view of portraiture found its expositor

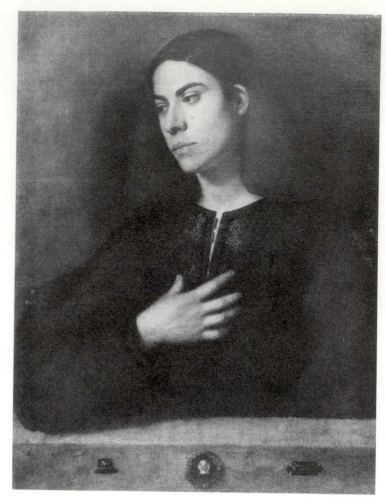

145. GIORGIONE: *Portrait of a Youth* (Budapest)

in Titian, and though a number of Titian's early portraits have at one time or another been given to Giorgione, his portraits essentially are a reaction against Giorgione's work. Titian did not, like Giorgione, see the human personality through a haze of literary romance. For him the portrait was a panegyric, but a panegyric rooted in veracity.

Expounding the program of the statues on the Loggetta opposite St. Mark's the sculptor Sansovino declares that the god Mercury represented Eloquence, "since everything thought and worked out needs to be expressed with eloquence."[37] The cult of eloquence is fundamental to the work of Titian. To it is due the upward surge of the

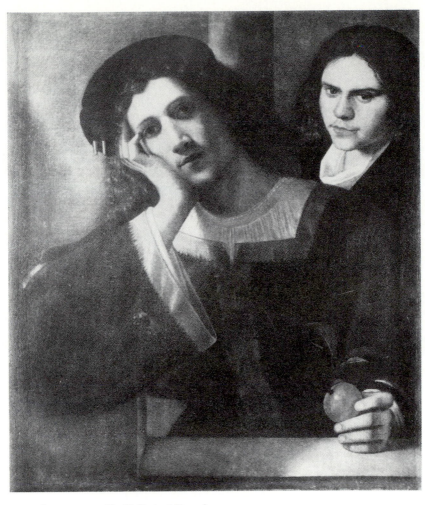

146. VENETIAN: *Double Portrait* (Rome)

Frari *Assumption* and the vast diagonal movement of the Pesaro altarpiece, and it inevitably influenced his attitude toward the portrait, in that his portraits conform to the same principles of rhythmic structure as the religious paintings. Perhaps it is worth while to take just one example of the way in which they interlock. Titian's *St. Mark Enthroned* [147] was commissioned for Santo Spirito in Isola as an *ex voto* after the plague of 1510, the same plague in which Giorgione died. In it the figures are fused together partly through consonance of posture and partly through the agency of directed light. Especially notable is the bold cartoon of the St. Mark, who leans back in space with his right hand thrust forward and his left shoulder thrust back, and the

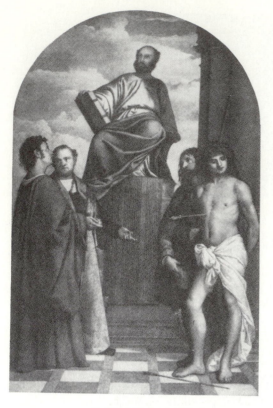

147. TITIAN: *St. Mark Enthroned* (Venice)

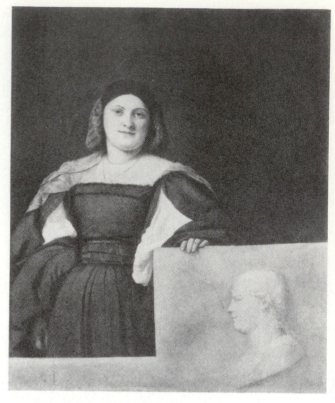

148. TITIAN: *Portrait of a Lady* (London)

torsion of the St. Sebastian, whose right shoulder is retracted and whose head is shown almost in full face. In a less aggressive form these poses are repeated in two contemporary portraits, the so-called *Schiavona* in London [148], where the torsion of the figure behind the parapet loosely corresponds with that of the St. Sebastian, and the so-called *Ariosto*, also in the National Gallery [149], which recedes in space from the forward elbow to the head in much the same manner as does the St. Mark. In this latter painting the rhetorical lighting of the altarpiece is deliberately adapted to the portrait.

Directed lighting involves the corollary of shadows, and in portraits the use of shadow is an evasion; it is not depiction, but a refusal to depict. Those portraits in which Titian's interest was most thoroughly engaged tend, on the other hand, to be lit evenly, in such a way as to leave all the face completely legible. That is the difference, for example, between the male portrait in the National Gallery and the less dramatic but more cogitated painting of the same date in the collection of Lord Halifax [150],[38]

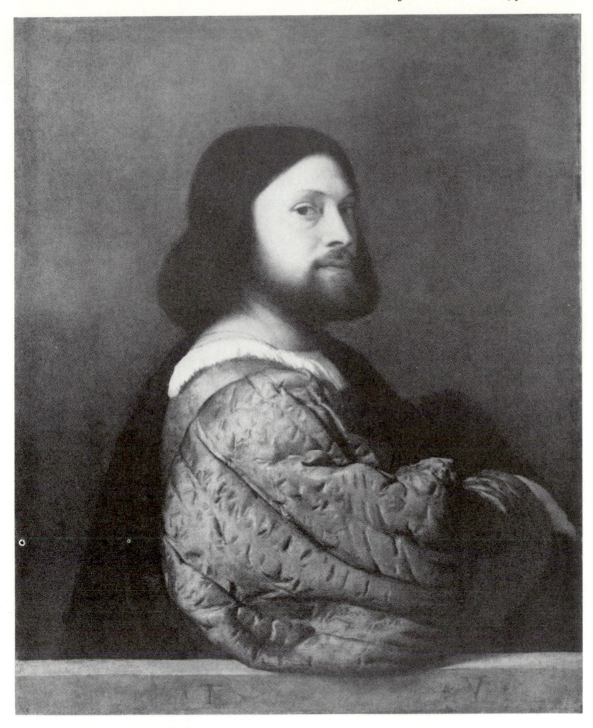

149. TITIAN: *Portrait of a Man* (London)

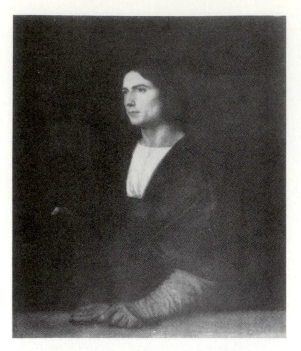

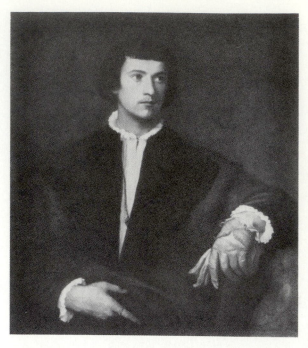

150. TITIAN: *Portrait of a Man* (Earl of Halifax) 151. TITIAN: *Portrait of a Youth with a Glove* (Paris)

where we are conscious in the head of that supreme effort of concentration, that almost supernatural empathy of which Titian was capable. The same contrast obtains between the *Youth with a Glove* [151],[39] where the features are redeemed from commonplaceness only by the contrast between a brightly illuminated area and a veiled area opposite, and the portrait known as the *Young Englishman* [152],[40] where the head seems to have inspired an act of prolonged inspection and the features take on a quivering lifelikeness that is rare even in Titian's portraits.

Shadow could also be employed to accentuate features that were coarse and strong, and it is so used in Titian's earliest surviving painting of Pietro Aretino [153]. The portrait dates from 1545, and was a gift from Aretino to Cosimo de' Medici,[41] whose father, Giovanni delle Bande Nere, had died of wounds in Aretino's arms. Aretino himself viewed it with qualified approval. If he had been able to pay more, he wrote to Cosimo I, Titian would have taken greater trouble about the dress. But however much he paid, he could not have secured a more truly comprehensive portrait. Behind it lay eighteen years of intimacy with the painter, and at least one earlier lost painting.[42] Aretino was more than just a satirist; he was a poet and dramatist and religious commentator of exceptional capacity, who had enough of the journalist in his make-up to

152. TITIAN: *Portrait of a Man,* detail (Florence)

153. TITIAN: *Pietro Aretino* (Florence)

154. TITIAN: *Pietro Aretino* (New York)

ensure him posthumously a bad press. His overincisive style reflected an overastringent mind, and in the complacent society in which Titian moved in Venice he was a wholesome catalyst. There is scarcely any other portrait by Titian where the shoulders are level, as they are in this, and the purpose must have been to convey Aretino's bulk and stance, and through them his pugnacious personality. The head is lit locally, roughly from the center, and the light picks out the quick eyes and the caustic mouth. Perhaps the portrait was too truthful, for when, a few years later, Titian again painted Aretino [154], he changed the pose, apparently with the intention of bringing out the strain of idealism intermittently present in his personality, but invisible, or at least no more than latent, in the earlier portrait.[43] This time the body is turned three-quarters to the left, in a nobler but less vivid pose, and though the simian arm is still brought across the body, the head is illuminated from the left, in such a way as to suggest that Aretino was worthy of the epithet that he bestowed upon himself, "Divine."

Titian's practice, for so it must have been, of allowing the sitter's personality to determine the structure of the portrait gives his work greater variety than that of any other Renaissance portrait painter. Three hundred years before Degas he made it an

article of faith to "make portraits of people in typical attitudes, and to give the same degree of expression to the body as to the face."[44] Occasionally one of Titian's portraits in some particular recalls another, but never, in his great meditated portraits, does a composition recur. Each was a unique experience, and could only be so because the circumstances which evoked it were peculiar to that sitter and were not susceptible of repetition. Most portrait painters, when the spark of their creative imagination has not been kindled, tend to fall back on formulas. Van Dyck does that repeatedly, and so, in the Venice of Titian's day, does Tintoretto. If, for example, we compare Tintoretto's splendid portrait of Sansovino of 1566 in Florence [155] with his masterly male portrait of about 1570 in Vienna [156], we find that in both cases the conception of the portrait is restricted to what in the eighteenth century was contemptuously called face-painting, and that the way in which the heads are lit and modeled is broadly uniform. Titian is scarcely ever guilty of conventional thinking, and one is in two minds whether most to admire the strength of purpose which prevented his reusing old motifs or the unimpaired flow of invention which relieved him of that necessity.

Nowhere is that more evident than in the female portraits. As late as the fifteen twenties Palma Vecchio in Venice was manufacturing pictures which must have been accepted by the patrons who commissioned them as portraits, but where the individual

155. TINTORETTO: *Jacopo Sansovino* (Florence) 156. TINTORETTO: *Portrait of an Elderly Man* (Vienna)

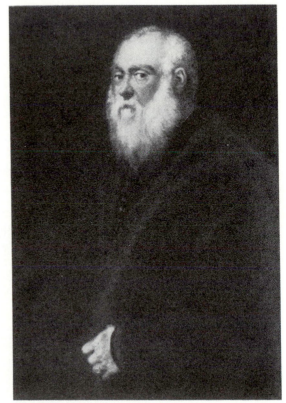

sinks within the type. Titian, on the other hand, from the very first applies to the female portrait the same ideal of fidelity as in his male paintings. Yet the notion of character behind them is inevitably rather different, for one of the chinks in Titian's armor of detachment was his susceptibility to charm. So voluptuous were the resulting paintings that though they were recognized as portraits, they were purchased by patrons to whom the sitter's identity was of no account. "Tell Titian," says the Duke of Urbino to his agent in 1536, "we want him to finish the portrait of a woman with a blue dress." That is the first reference to the painting known as *La Bella* [157].[45] It is also the first properly documented case in which a portrait was sold by the painter to a purchaser, not as a record, but as a work of art.

Visually Titian was the most seducible of artists, and we can still sense the enchantment with which his eye caressed the ear and lips and the soft surface of the cheek. But even here appearance is inseparable from personality, and always we are conscious of a controlling mind behind the mask. This sharpness of perception is in a very special sense personal to Titian. In the late fifteen forties the young Tintoretto, in the *Lady in Mourning* at Dresden [158], tries his hand at the same type of portrait, but as soon as we compare his painting with the *Bella*, we find that the quality of observation is disparate; the form of the ear, the delineation of the mouth, the shape of the eyes, the modeling of the nostrils are conventional, and the living essence of the individual

157. TITIAN: *La Bella* (Florence)

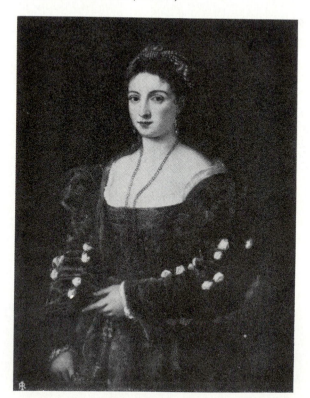

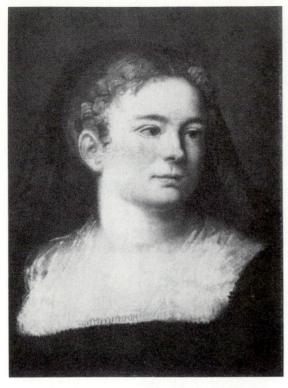

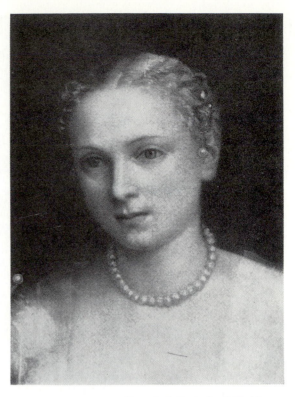

158. TINTORETTO: *Lady in Mourning,* detail (Dresden) 159. PAOLO VERONESE: *Portrait of a Lady,* detail (Paris)

evaporates. Only Veronese, a more consistent portraitist than Tintoretto, captures that mysterious sense of a palpitating living presence [159] that we receive from Titian's female portraits.

To judge from the paintings he produced, Titian was gifted with a godlike view of the potentials of character and mind against which the individual before him was sized up. On only one occasion is his private reaction to a sitter set down in print. The victim was Jacopo Strada, a dealer in antiques, who was born at Mantua, allied himself with the Fuggers at Augsburg, joined the court of the Emperor Maximilian II, and in 1567 visited Venice in search of antiques for Albert, Duke of Bavaria. Titian, who had known him for some years, viewed him with unfeigned dislike. A pretentious humbug, he called him, one of the most solemn ignoramuses that you could find. His success, Titian declared, was due to a capacity for flattery, and to the "tante carotte" he had held out to the Germans, who were too dense to realize his incompetence and his duplicity. In the painting [160] Strada is shown bending obsequi-

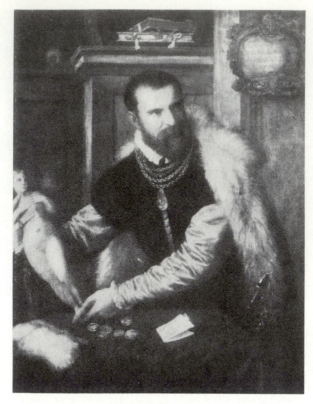

160. TITIAN: *Jacopo Strada* (Vienna)

ously across a table, holding a marble statuette which he is displaying deferentially to some patron on the right.[46] The significance of this motif would have been even more apparent than it is today when the picture was still free of the pompous cartouche in the upper right-hand corner which was added at Strada's own request. The fur and sleeve are some of the most splendid passages in any Titian portrait—they are, after all, contemporary with the *Martyrdom of St. Lawrence* in the Escorial—but the features [161] contrast with the splendor of dress; they are petty, and are stamped with guile and a particularly unattractive sort of eagerness. And there is no reason to suppose that the effect was anything but calculated.

This judicial view of portraiture was not the outcome of old age; it was already present a quarter of a century before when Titian linked up with the tradition of the papal portrait. His first contact could hardly have been more direct; it was to make a copy for the Duke of Urbino of Raphael's portrait of Julius II. When Titian was at Bologna in 1543, he painted the portrait of Pope Paul III that is now in Naples [162]

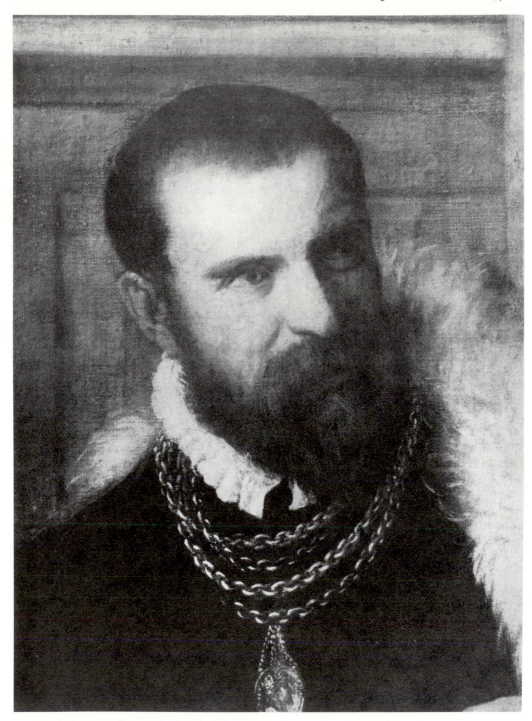

161. TITIAN: *Jacopo Strada,* detail (Vienna

and Raphael's portrait [127] formed his starting point. The chair is aligned more closely on the picture plane, and the Pope leans forward from it with his body slightly turned. Whereas in Raphael's painting the edges of the cape are shown in shadow, in Titian's they are illuminated so that the cape reads as a pyramid culminating in the head. Titian was more conscious than Raphael of the individuality of the human hand, and it is to the wasted hand emerging from the alb that we owe the illusion of a withered body enclosed in a voluminous shell of robe. The head in Raphael's portrait is lit centrally, so that the cheek on the right side is silhouetted against the dark ground. The head in Titian's portrait is lit further from the left; the line of the cheeks merges in the background, and the beam floods like a searchlight on to the temple and into the right eye.

Three years later Titian went to Rome. He was accommodated in the Belvedere, was shown round the sites of the city by Vasari, and then settled down to paint the Pope with his two nephews, Ottavio and Cardinal Alessandro Farnese [163]. It has never been established exactly why work on this painting was broken off. Perhaps it was the antipathy of Michelangelo, who was the Pope's artistic mentor and who was painting in the Cappella Paolina at the time. Michelangelo was taken by Vasari to visit Titian, and seeing a mythological painting on which Titian was engaged, "praised it greatly as was polite." But afterward he criticized Titian's methods, "saying that he liked his style, but that it was a pity good design was not taught at Venice from the first." Perhaps it was the decrepit appearance of the Pope. Never before had any Pope been presented as a senile figure manipulated by his obsequious family. Or perhaps it was the use of an unprecedented portrait type in which Raphael's Leo X and two cardinals [130] evolves in the direction of the conversation piece. The fact that the picture was suspended when only one head was more than half complete has deprived us of one of Titian's greatest paintings, but it supplies invaluable evidence as to the way in which his portraits were produced. The least finished of the three heads is that of the Pope [164], which survives only in the form of underpainting. The areas of light and darkness are established, but the expression has not been defined. Some indication of what the painter had still to do can be gained by comparing it with the head of Gabriele Vendramin [165] in the great group portrait [304] which Titian painted immediately after his return to Venice, in 1547. Had he continued work, the texture of the beard would have been less indeterminate, and the mouth, nose, and eyes would have been clearly stated and not simply implied. The head of Ottavio Farnese is more fully worked up, but even here much work was still required before it took on the same surface richness as the head of Marco Vendramin. Titian seems seldom to have used preliminary portrait drawings, and the image was habitually built up on canvas as a simulacrum of the living figure before the painter's eyes. The move-

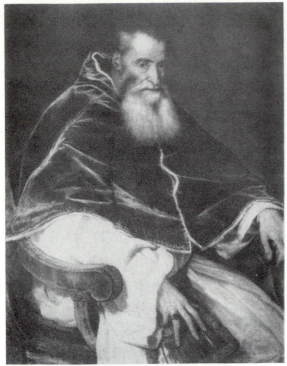

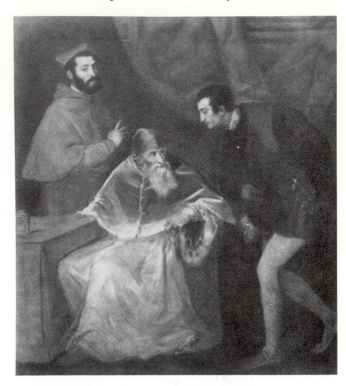

162. TITIAN: *Pope Paul III* (Naples)

163. TITIAN: *Pope Paul III and his Nephews* (Naples)

ment of the lips, the light reflected from the eye, the play of the cheek muscles during speech, all these could be reproduced in the quivering surface of the paint.

When we speak of Counter-Reformation art, we think of Michelangelo's *Last Judgment* and of the frescoes in the Pauline Chapel. But Titian, as a portrait painter, was also a Counter-Reformation artist. The belief in reason that lies just beneath the surface in all Raphael's portraits gives way to an intuitive attitude to portraiture, which is reflected in the empiricism of the image and in the hesitancy of the technique. Appropriately, it was Titian who erected, as a rejoinder to the Reformation portraiture of Cranach, the splendid structure of the Counter-Reformation ruler portrait.

One painter was specially alive to this aspect of Titian's work. "A young man from Candia, a pupil of Titian, who . . . has a rare gift for painting," he arrived in Rome in 1570,[47] and through the good offices of the miniaturist Giulio Clovio, secured a room in the Palazzo Farnese. In Rome his familiarity with Titian's and with Tintoretto's Venetian paintings could be filled out by daily study of Titian's Farnese portraits, and

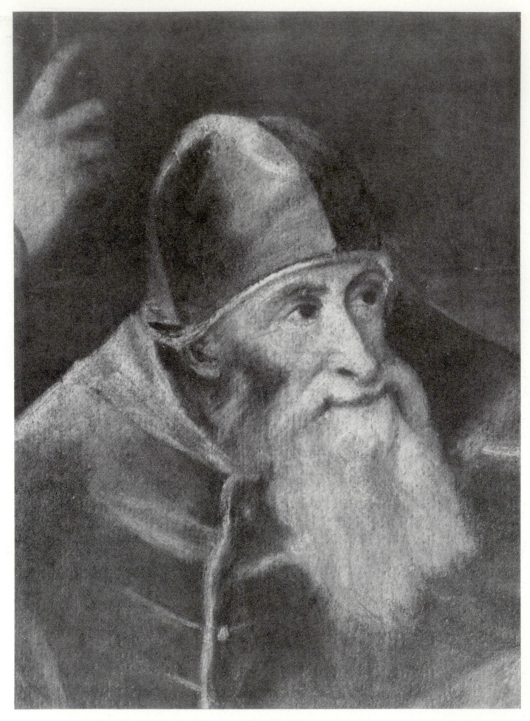

164. TITIAN: Pope Paul III, detail of *Pope Paul III and his Nephews* (Naples)

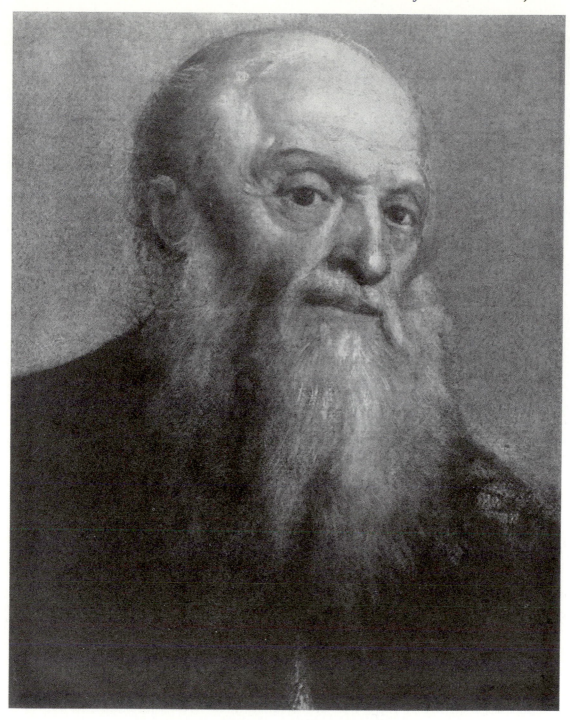

165. TITIAN: Gabriele Vendramin, detail from the *Vendramin Family* (London)

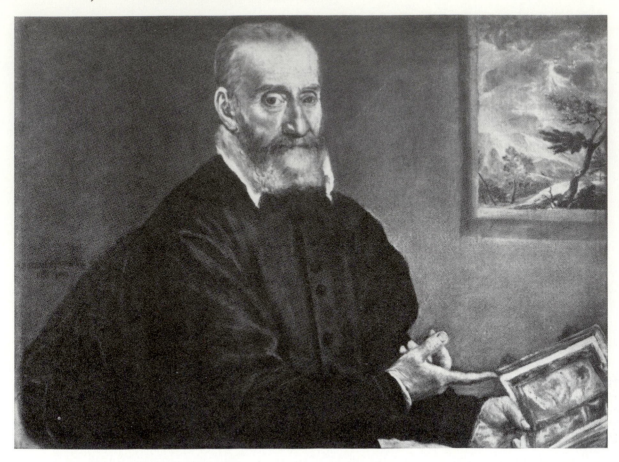

166. EL GRECO: *Giulio Clovio* (Naples)

when he was commissioned by Cardinal Farnese's nephew, Fulvio Orsini, to paint his patron Giulio Clovio,[48] these lessons were distilled in the portrait he produced [166]. Its format was unlike that employed by Titian; it was oblong, like some of Tintoretto's portraits, and to the right there was a landscape seen through a window in the wall behind. The sitter was represented in half length, pointing with his right hand to the illuminated *Hours of the Madonna*, which he had completed a quarter of a century before and which was preserved in the Palazzo Farnese. Visiting El Greco's room to propose that they should walk together, Clovio on one famous occasion found that the curtains were closed because "daylight troubles his inner vision,"[49] and from the portrait of Clovio we might well guess that the study of reality played a smaller part in Greco's style than in that of any of the great portrait painters who

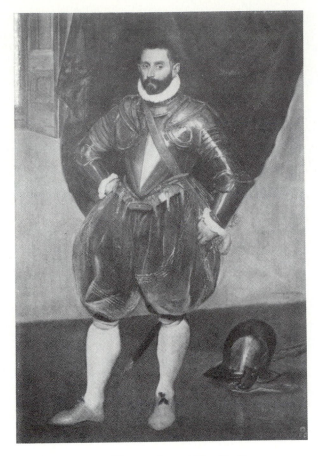

167. EL GRECO: *Vincenzo Anastagi* (New York)

preceded him. From a rational standpoint the posture of the figure is artificial, the space it occupies is indeterminate, and the landscape is so little lifelike that it has even been mistaken for a painting on the wall. These features are still more pronounced in Greco's later portraits. In the painting of Vincenzo Anastagi in the Frick Collection in New York [167], which was produced toward the end of Greco's Roman period,[50] lip service is paid to the structure of Titian's full-length portraits, but what is built up is an acceptable pictorial setting for the figure, and not a space illusion in the conventional sense. The longer he explored the portrait, the more strenuously did Greco concentrate on the portrayal of the mind and personality, to the detriment of the physique. One of his early Spanish portraits, the *Knight taking an Oath* of about 1580 in the Prado in Madrid, is already so far dematerialized that the sitter is sometimes

168. EL GRECO: *Fray Hortensio Félix Paravicino* (Boston)

mistakenly supposed to be one-armed,[51] while in the latest and greatest portrait, the painting of the Dominican Fray Hortensio Félix Paravicino in Boston of about 1609 [168],[52] the recession of the body is indicated only in the most summary fashion and the chair is reduced to a visual formula. Yet paradoxically Greco's "inner vision" of the sitters before him yields to none in its authority and truthfulness, and we may imagine that Titian, to whom the conquest of the world of physical appearance was so largely due, would have approved the revolution whereby physical appearance was devalued and the sitter's spiritual character was alone expressed.

IV

The Court Portrait

On entering the Tempio Malatestiano at Rimini, one of the first things we notice is the presence, on the balustrades of the side chapels, of portrait reliefs of the lord of Rimini, Sigismondo Malatesta. In all of them his head is shown in profile facing to the left, surrounded by a wreath. A portrait of Sigismondo [169] occurs again in the fresco which Piero della Francesca painted in 1451 in the Chapel of the Relics, where he is shown kneeling before St. Sigismund, and here his head is once more represented in the same way. The painted head is observed in greater detail than the head in the reliefs, but both are founded on a common stereotype, a medal made by Matteo de' Pasti in 1446.[1] In the Milan of Lodovico il Moro the same pattern recurs. The stereotype of the Duke was again established by a medal, which was reproduced in sculpture in the Certosa at Pavia, and appears in painting about 1495 in the votive altarpiece known as the *Pala Sforzesca* [170].

To the ruler's bewilderment it sometimes happened that artists did not conform. At Ferrara Leonello d'Este was painted by both Pisanello and Jacopo Bellini, and a dialogue by Angelo Decembrio records his comments on their work. "You remember," he says, "that recently a Pisan and a Venetian, the best painters of our time, disagreed in various ways in their depiction of my features. The one made them appear more spare, while the other represented them as paler and less graceful. In spite of my requests, I could not get them to reconcile their portraits."[2] Jacopo Bellini's portrait has disappeared, so we can no longer tell just how it infringed the permitted norm, but a portrait at Bergamo that is generally identified as Pisanello's [171][3] corresponds closely with Pisanello's medals of the Marquess, and so do the heads of Leonello in a fresco at Verona and in a panel by Giovanni da Oriolo in the National Gallery in London.

In the course of the discussion in Decembrio's dialogue, Leonello d'Este describes the pleasure he experienced in studying the portrait heads on Roman coins,[4] and these imperial images were undoubtedly responsible for the prevalence of the profile ruler

169. PIERO DELLA FRANCESCA: Sigismondo Malatesta, lord of Rimini, detail from *Sigismondo Malatesta before St. Sigismund* (Rimini)

170. MASTER OF THE PALA SFORZESCA: Lodovico il Moro, Duke of Milan, detail from the *Pala Sforzesca* (Milan)

171. PISANELLO: *Leonello d'Este, Marquess of Ferrara* (Bergamo)

portrait. About 1400 it appears briefly in France, but in the form that it assumes in the middle of the fifteenth century it is an Italian phenomenon. Its significance transpires most clearly from the portraits of the Emperor Sigismund. Before the Emperor left for Italy in 1431 he was painted by a Bohemian artist.[5] The portrait [172] shows him in three-quarter face, with lips parted in a benevolent grimace, and if Bohemian portraits of the time were less uncommon than they are, we should dismiss it as a Gothic passport photograph. But on his return from Rome the Emperor stopped for a few days at Ferrara, and was drawn by Pisanello.[6] There is no proof that Pisanello's drawing [173] was made in connection with a medal, but in it the influence of classical numismatic portraits is extremely marked. In obedience to the lessons they had taught him, the artist sets himself to reconcile the Emperor's physical appearance with his ideal personality.

In one case we can trace exactly how that was achieved. The subject must have been by far the most intractable of Pisanello's sitters, Filippo Maria Visconti, Duke of

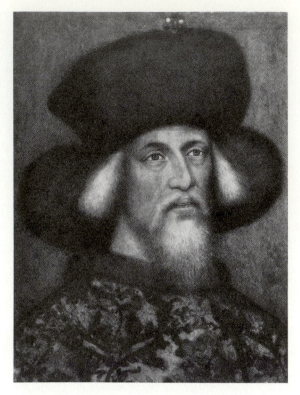

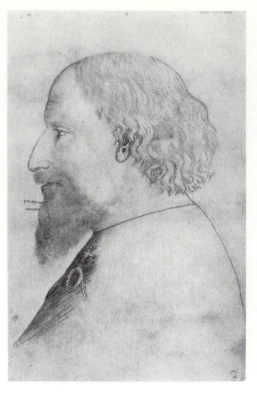

172. BOHEMIAN: *The Emperor Sigismund* (Vienna) 173. PISANELLO: *The Emperor Sigismund* (Paris)

Milan. The Duke habitually refused to sit to artists. "He would be painted by no one," says Pier Candido Decembrio,[7] and the instinct that guided him was wise. His heavy frame moved unsteadily on small splayed feet, he took no exercise, belched after meals, and was superstitious and frightened of the dark. In the first drawing of him by Pisanello that we know [174], the thick neck is set forward on the shoulders in a way that betrays something of his movements and his stance. Perhaps it betrayed more of them than was desirable, for in a second drawing [175], by a number of small touches, the effect is modified. The huge head is no longer thrust forward, and this lends the image a new authority. This second drawing was transformed into a medal [176], where the image is still further ennobled and refined.

At first sight it might seem that these ubiquitous numismatic portraits left painters no room to maneuver in. But in at least two centers their pictorial possibilities were thoroughly explored. One was Urbino, where the influence of Flemish painting was particularly strong, and the other Milan, where the profile portrait was scrutinized

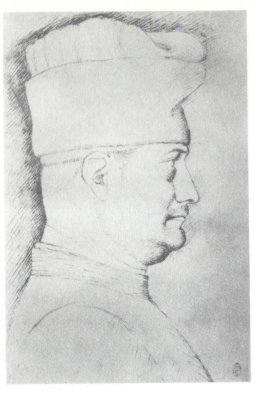

174. PISANELLO: *Filippo Maria Visconti, Duke of Milan* (Paris)

175. PISANELLO: *Filippo Maria Visconti, Duke of Milan* (Paris)

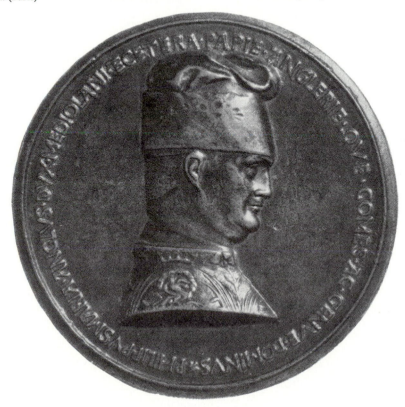

176. PISANELLO: *Filippo Maria Visconti, Duke of Milan* (Washington)

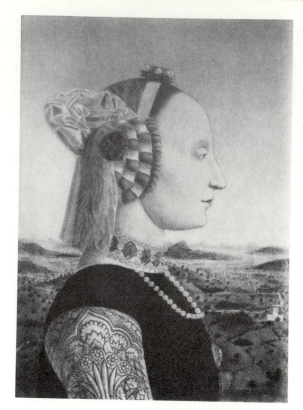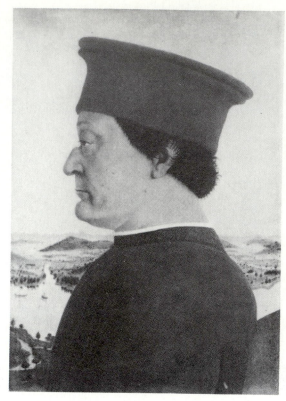

177. PIERO DELLA FRANCESCA: *Federigo da Montefeltro, Duke of Urbino, and his Wife, Battista Sforza* (Florence)

by the inquiring mind of Leonardo. At Urbino before 1466 there was produced one of the great monuments of ruler portraiture, Piero della Francesca's diptych of Federigo da Montefeltro and Battista Sforza [177].[8] Like the figures in the frescoes at Arezzo, the profiles of the Duke and Duchess are rendered with an unerring sense for the cubic volume of the head. They are illuminated from a common light source slightly to the right, and this cool, tranquil light, as it catches on the line of the Duke's collar and on Battista Sforza's necklace, serves to convince us that real figures, not abstractions, are portrayed. The intention is underlined by a poem written by the Carmelite Ferabos, in which the diptych addresses the Duke. "Piero," declares the painting, "has given me nerves and flesh and bones, but thou, Prince, hast supplied me with a soul from thy divinity." The heads are outlined against the sky, and are linked by a continuous strip of landscape representing the Duchy of Urbino, rendered with so acute a sense of tone that we might imagine the Duke and Duchess before an actual landscape, not a symbolic scene.

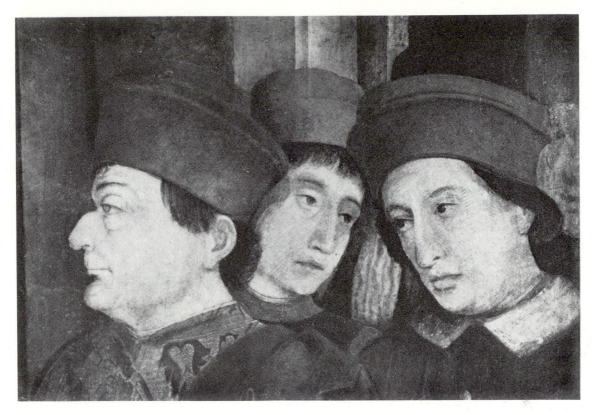

178. JUSTUS OF GHENT: Federigo da Montefeltro, Duke of Urbino, detail from the *Institution of the Eucharist* (Urbino)

At Urbino the numismatic portrait produced one of its strangest documents in Justus of Ghent's altarpiece of the *Institution of the Eucharist* [178], where the Duke's head alone is shown in profile, an Italian interpolation in what is otherwise a Flemish painting.[9] But the profile and the idiom of Flemish artists were less irreconcilable than this odd work might lead one to suppose, and they are combined, with something not far short of inspiration, by Pedro Berruguete in a painting of 1476 of the Duke and his son Guidobaldo [179] which presided over figures from antiquity, legislators, humanists, and Popes in the Studiolo of the Palazzo Ducale.[10] The portrait has a double character; it shows the Duke in armor in his role as Captain General of the Church, but seated at a reading desk with a volume open in front of him. Behind, with his left arm on his father's knee, wearing a yellow silk robe studded with pearls, is the four-year-old Guidobaldo da Montefeltro, portrayed as heir not only to the dukedom—he carries a scepter inscribed with the word *potere*, power—but to the humanistic values which shed luster on his father's court. The Duke's head is shown in profile,

and his body is therefore shown in profile too, aligned, like the reading desk, on the picture plane. But behind this planar scheme there opens out a room with a concealed window on the left whence the heads of the two figures are suffused with supernatural luminosity. This form of internal lighting was invented by Jan van Eyck—it occurs, for example, in panels at Melbourne and Frankfort—and the painting from which Berruguete copied it must have been the same that inspired another work painted at Urbino at this time, the sublime *Sinigallia Madonna* of Piero della Francesca, which is also lit internally from the same side.

The task of developing the profile on lines that were pictorially acceptable was also taken up by Leonardo. Leonardo's interest in the profile ruler portrait can be reconstructed from a drawing of Isabella d'Este in the Louvre and from the painting of a Sforza princess in Milan [181], of which his authorship is now generally denied.[11] Admittedly the design of the painting is much less complex than that of the *Cecilia Gallerani*—since the body is shown in profile that could not be otherwise—but the sense of the figure as a living organism is preserved, and the definition of the features has the same delicacy as the profile portrait drawings that Leonardo was preparing at this time. From Leonardo's standpoint the difficulty lay not with the head but with the flat profile of the body, and to judge from its hard, overresilient execution, the completion of the lower part must have been confided to a studio hand. If Leonardo had completed it himself, if he had worked up the detail of the jewelry with the concentration he applied to the bow of the riband round this head, what a memorable painting it would have been.

With the *Cecilia Gallerani* and the *Mona Lisa* in our minds, we might expect that Leonardo would have experimented with a type of profile portrait in which an element of *contrapposto* was introduced beneath. In the portrait of Isabella d'Este on which he worked at Mantua in 1500 it seems he did just that, for the versions of the composition that survive—a damaged and overdrawn cartoon that has been pricked for transfer is in the Louvre,[12] and a more pedestrian but in some respects a more revealing copy is at Oxford [180]—show an almost frontal body and a head in profile to the right.

Let it not be forgotten that the function of these portraits was, in a loose sense, informative. After the death of Leonello d'Este in 1450, the principal portrait painter in Ferrara was Cosimo Tura. Isabella of Aragon first made the acquaintance of her husband, Ercole d'Este, through a painting by Tura which was sent to Naples. When her first child, Alfonso, was a year old, Tura made three portraits of him. And when Lucrezia d'Este was betrothed to Annibale Bentivoglio of Bologna, and Isabella d'Este was contracted to Gian Francesco Gonzaga, and Beatrice d'Este was affianced to Lodovico il Moro, a portrait by Tura was in each case the means by which the prospective husband was apprised of the appearance of his bride. Only one of these

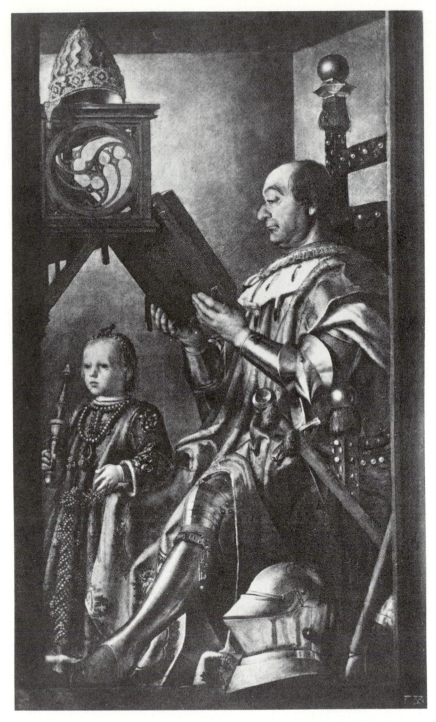

179. PEDRO BERRUGUETE: *Federigo da Montefeltro and his Son Guidobaldo* (Urbino)

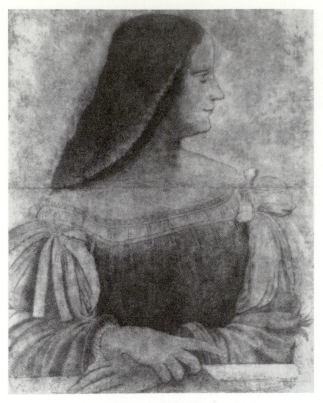

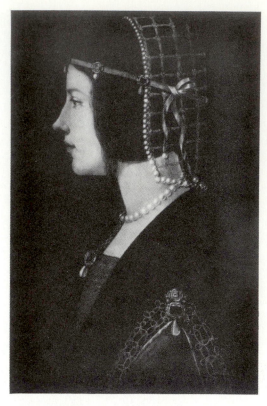

180. AFTER LEONARDO DA VINCI: *Isabella d'Este* (Oxford)

181. LEONARDO DA VINCI: *Portrait of a Sforza Princess* (Milan)

portraits by Tura survives, a little painting of an unknown Este prince in the Metropolitan Museum.

They were not accommodating, these members of Italian ruling families, and Isabella d'Este seems to have been among the most intransigent.[13] When in 1493 a friend asked for her portrait, she sat for it to Mantegna, who had already painted at least one diptych of her and of her husband, Gian Francesco Gonzaga. But when the painting was completed, she refused to send it on "because the painter has done his work so badly that it does not resemble us in any way." A new portrait was therefore commissioned from a painter from the Marches who had been recommended to her by the Duchess of Urbino, Raphael's father, Giovanni Santi. From Milan Isabella of Aragon also begged for Isabella d'Este's portrait. The chosen artist was a Ferrarese, Maineri, who approached his task with commendable diffidence. When the portrait was finished, it was sent to Milan with a covering letter from Isabella d'Este disavowing it; it was unlike her, she said, because it was too fat. Lodovico il Moro tactlessly re-

plied that she might have put on weight and that the portrait seemed to him extremely
like. She was painted again by the Bolognese Costa, for once to her satisfaction, and
still another picture of her was commissioned by her sister-in-law Lucrezia Borgia.
The chosen artist, Francia, had a harder passage, perhaps because he was a less efficient
portraitist. Lucrezia Borgia visited his studio and declared that the portrait was too
saturnine and too fined down, and Francia prudently agreed to change it, repeatedly
if necessary, as she advised. This was a less pleasurable portrait, and Isabella d'Este,
when she saw it, threatened to return it so that it could be reworked. How real were
the difficulties of these artists can be judged from the opulent but rather sullen portrait
that Giulio Romano made of Isabella d'Este about 1524 [182], where the painter
evades the hazard of the features and concentrates obsessively on the elaborate cut-
velvet dress.[14] Isabella d'Este also had a penchant for bringing pictures up to date.
Before his death in 1496 her father Ercole d'Este was painted by Ercole de' Roberti,
and in 1512 she requested that the portrait be lent her "to make another out of it with
the hat and robe he used to wear at the time he died." One of her last portraits was an
idealized painting by Titian [183]; it was based upon a portrait made of her in youth,
and was so successful that "we doubt whether at that age we were as beautiful as the
painting makes us seem."[15] It is important to remember that the determinant in many
ruler portraits was the sitter's self-conceit.

182. GIULIO ROMANO: *Isabella d'Este* (Hampton Court Palace)

183. TITIAN: *Isabella d'Este* (Vienna)

184. HANS VON KULMBACH: *Bianca Maria Sforza, Wife
of the Emperor Maximilian* (Private collection)

In 1493 Bianca Maria Sforza, the daughter of Lodovico il Moro, was married to
the Emperor Maximilian I, and to Germany she carried a taste for profile portraiture.
A drawing made of her there by Hans von Kulmbach [184][16] conforms exactly to the
profile portrait type current in Milan, save that the Empress is clothed in German,
not Italian, dress. More important, she took with her to Germany Leonardo's pupil,
Ambrogio de Predis, who had been official painter at the Sforza court. Predis made a
drawing of the Emperor Maximilian in which the head was shown in profile to the
left, and at Vienna there is a portrait by him dated 1502 in which the Emperor is posed
in the same way.[17] A drawing by Predis was made available to Dürer when he was
working on the *Feast of the Rose Garlands* in Venice in 1506, and in the altarpiece the
Emperor is again depicted in profile to the left [185]. The official portrait painter to
the Emperor Maximilian was Strigel—an inscription on the back of one of Strigel's
imperial portraits makes use of the rather inappropriate analogy of Alexander and
Apelles—and Strigel's portrait of the Emperor of 1507 shows him in three-quarter

185. ALBRECHT DÜRER: The Emperor Maximilian I, detail from the *Feast of the Rose Garlands* (Prague)

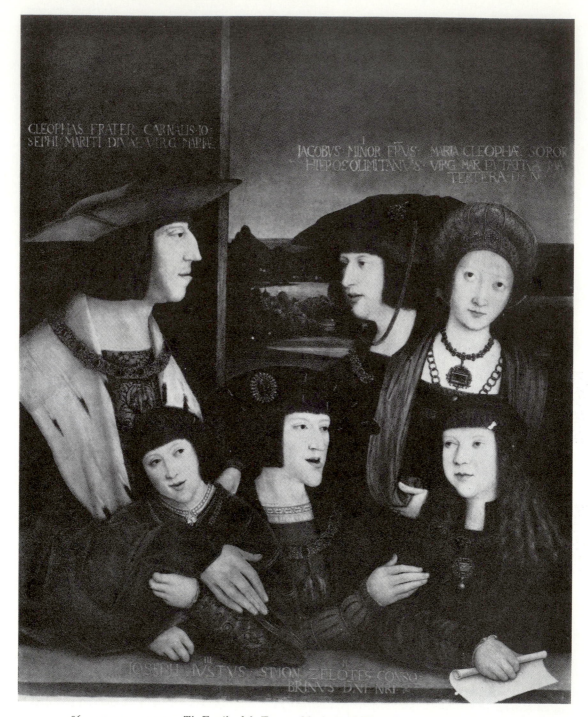

186. BERNHARD STRIGEL: *The Family of the Emperor Maximilian I* (Vienna)

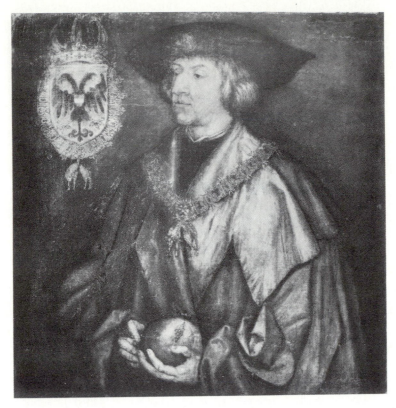

187. ALBRECHT DÜRER: *The Emperor Maximilian I* (Nuremberg)

face. But thereafter Strigel in turn adopted the pure profile for his imperial portraits. The implications of the change are underlined by a curious painting of 1515 [186] where the Emperor is shown in profile, while his wife and children are depicted in full or in three-quarter face.

None the less, at Augsburg in 1518 Dürer made a life drawing of the Emperor in three-quarter face, and from it he worked up two paintings. Visiting the Netherlands in 1521, he took one of them with him, probably the portrait that is now at Nuremberg [187],[18] intending to present it to the Emperor's daughter, Margaret of Austria, the regent of the Netherlands. But the regent took, in Dürer's words, "ein solchen Misfall," such a dislike to it, that he was compelled to take it back. Quite a number of different explanations have been offered of that embarrassing occurrence. Perhaps the portrait did not commend itself because it was painted on canvas. Perhaps the regent's taste was so perverted by Italian fashions that she could no longer respond to what Hans Sachs calls "echte Deutsche Kunst." Perhaps she disapproved of its expressive

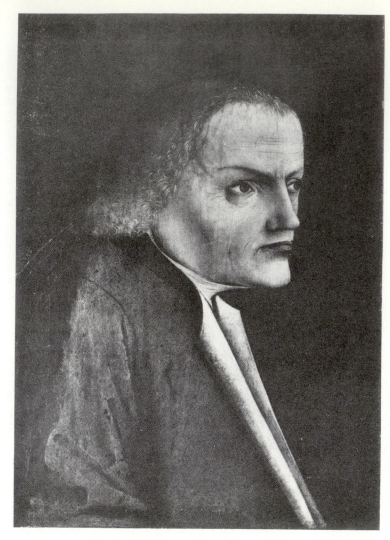

188. TYROLESE: *The Archduke Sigismund of the Tyrol* (Munich)

189. SOUTH GERMAN: *The Emperors Maximilian I and Charles V* (Vienna)

idiom, and of the implication that the Emperor was borne down by the same cares as ordinary men. Within a quarter of a century, however, all these prejudices were effaced by the joint efforts of Titian and the Emperor Charles V.[19]

There was a predisposition in German official portraits toward the stereotype, but there was no corresponding tendency toward ideality. A painting of Sigismund of the Tyrol of about 1460 [188] is a classic case of the official portrait with no holds barred. To our eyes the stereotype that was created of the Emperor Charles V after his election seems in many ways unfortunate—especially when juxtaposed, as it is in an Augsburg carving of 1529 [189], with the stereotype of his predecessor. Not until 1530, when he visited the court of Federigo Gonzaga at Mantua, did the Emperor's official image change. At Mantua he must have seen the portrait of Federigo painted by Titian, and he agreed to sit to Titian for a painting which has not survived. He sat to him again at Bologna in January 1533. The portrait that resulted, *Charles V with a Hound* [191], was a new departure not only in imperial portraiture but in the work of Titian too.

190. JAKOB SEISENEGGER: *The Emperor Charles V with a Hound* (Vienna)

191. TITIAN: *The Emperor Charles V with a Hound* (Madrid)

192. TITIAN: *Francesco Maria della Rovere,
Duke of Urbino* (Florence)

It is painted in full length in emulation of a full length of the Emperor by Seisenegger
[190] which had been completed in the preceding year, and though it remains a
German portrait, it has a nobility which was beyond Seisenegger's reach. In Germany
these full-length ruler portraits were traditional. As early as 1514 the form was
adopted by Cranach for the first of his official Saxon portraits, the great heraldic
painting of Heinrich der Fromme at Dresden, and when, twenty-three years later,
Cranach painted Heinrich der Fromme again, he was shown once more in full length.
Titian's knowledge of these full-length portraits cannot have been confined to Seisen-
egger's painting of the Emperor.[20] The proof of that is that in 1536 he prepared a
drawing of Francesco Maria della Rovere, Duke of Urbino [192], that makes use of
this German portrait type. In the event the scheme was not accepted; presumably the
Duke demurred. But from it there resulted the great three-quarter length portrait of
the Duke in the Uffizi [193]. This is a landmark in the history of the court portrait.
The Duke is shown as Captain of the Church, with the appurtenances of that role,

193. TITIAN: *Francesco Maria della Rovere, Duke of Urbino* (Florence)

and the head is ennobled not by compromise with an ideal but by the transfiguring imagination of the artist. In this sense it establishes the idiom of the later Hapsburg portraits.

Titian was summoned by the Emperor to Augsburg in 1547; he arrived there in January 1548, and stayed until October of the following year. There he painted two great imperial portraits. The first, at Munich, shows the Emperor seated [194]. The pose is not idealized—in it the Emperor's rather ungainly carriage is implied—and the head is treated with the same intensity and truthfulness as in the Urbino painting. The Emperor's claim on our respect rests here on tenacity of character and on superior subtlety and intellect. The second portrait [195] was commemorative. It was inspired by the battle of Mühlberg, in which the Emperor defeated the Lutheran princes and forced them back across the Elbe, and which contemporaries compared to Caesar's crossing of the Rubicon. A letter inscribed by Aretino to Titian-Apelles at Augsburg refers to a projected painting of the Emperor on the same horse and in the same

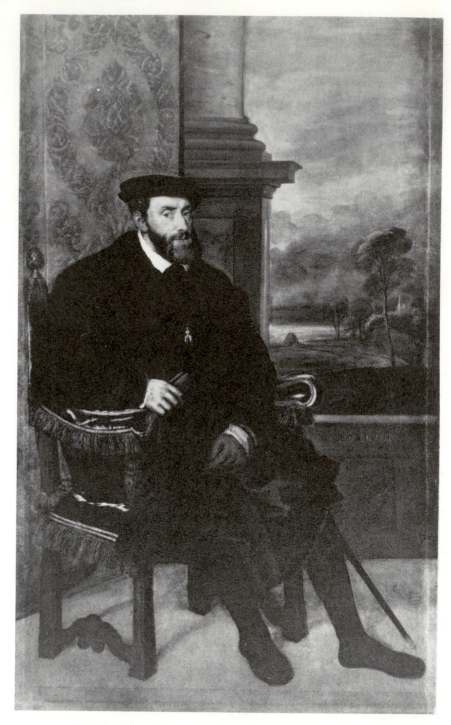

194. TITIAN: *The Emperor Charles V* (Munich)

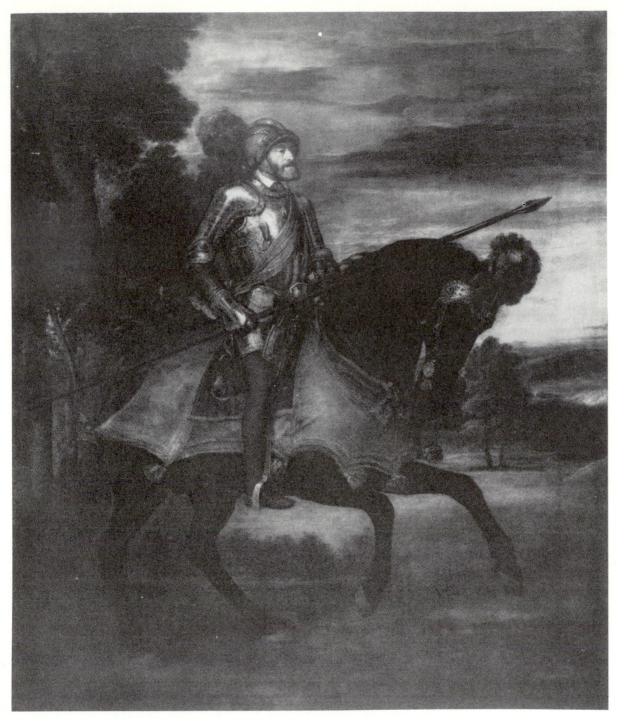

195. TITIAN: *The Emperor Charles V at the Battle of Mühlberg* (Madrid)

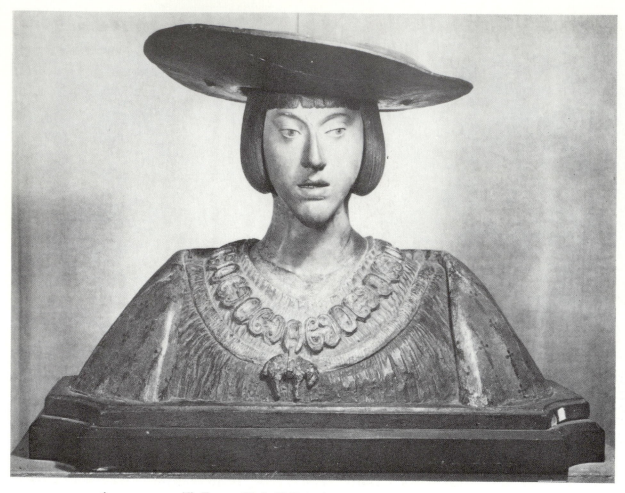

196. CONRAD MEIT: *The Emperor Charles V* (Bruges)

armor he had used at Mühlberg, and urges that it should include the figures of Religion with a cross and chalice and Fame bruiting the Emperor's achievements to the world. This advice would have tethered the painting in its own century, and Titian wisely disregarded it, producing instead, within the framework of commemorative German woodcuts,[21] the splendid active painting which was to prove a fruitful source of inspiration in the next century.

In raising the iconography of Charles V from that of a local German potentate to the leader of the forces of militant Catholicism Titian had an accomplice in the Milanese sculptor Leone Leoni. Leoni was a less percipient artist—there was a vein of sycophancy

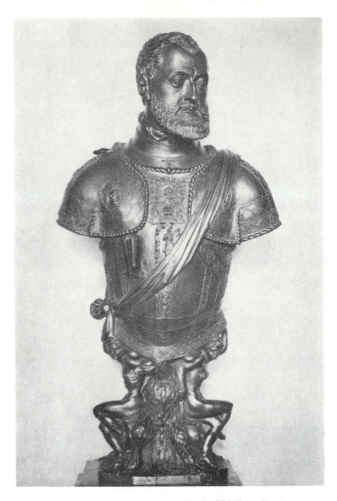

197. LEONE LEONI: *The Emperor Charles V* (Vienna)

in his personality that extended to his style—but he pursued this mission with singular success. As a young man Charles V was modeled by the sculptor Conrad Meit, and to judge from the bust Meit produced [196], never did a head have fewer sculptural possibilities. Leoni was a devotee of the antique, and he must have known Roman busts of the type of the *Commodus* in the Capitoline Museum, where the head is treated under a symbolic aspect and the base is allegorical. When he portrayed the Emperor [197], he depicted him essentially in the same way, in a kind of hieratic reliquary bust composed of an ideal head and of a related allegory beneath.[22]

The principal German painter in 1548 was Cranach, and in Augsburg Cranach

painted Titian. Cranach was the portrait painter of Reform; his commissions came from the reforming princes, and for more than a quarter of a century his workshop did a steady trade in little portraits of Luther and his wife and of Melanchthon. Once upon a time, forty years before, Cranach in Vienna had scaled the peaks of portraiture, but the painter who took Titian's portrait was no longer the Cranach of these early works. He was the trusted confidant of Johann Friedrich der Grossmütige of Saxony, and by the fifteen forties he was engaged in reducing the obese face of Johann Friedrich to the schematic terms of an advertisement [198].[23] Even in unofficial portraits his interpretative range is limited to that looking-down-the-nose, holier-than-thou state of mind that is associated with reform. They were not easy subjects, these Saxon princes—even Titian when he painted the portrait of Johann Friedrich in Vienna [199], presumably from a drawing or painting by Cranach, found some difficulty in negotiating his corpulent body and bull neck. Though some of them were covert hedonists—it was for them that Cranach's salacious little mythologies were produced— it seems that under the influence of reform the concept of the human personality became more cut and dried and the horizons of the portrait tended to contract. On the other side, the Counter-Reformation portrait took on the new poetry and depth that is apparent in the infinitely subtle portrait of Philip II of Spain [200]; which Titian made at Augsburg during his second visit in 1551.

198. LUCAS CRANACH THE ELDER: *Johann Friedrich der Grossmütige* (Private collection)

199. TITIAN: *Johann Friedrich der Grossmütige* (Vienna)

200. TITIAN: *King Philip II of Spain* (Madrid)

201. PONTORMO: *Cosimo de' Medici il Vecchio* (Florence)

In Florence the court portrait was more circumscribed. The reason was political. In the sixteenth century the Medici showed an almost morbid interest in self-perpetuation, which resulted from a sense of dynastic insecurity. They had been expelled from Florence at the time of Charles VIII; they returned in 1512, and under the papacy of Leo X took their place on the world stage. From this time, 1518, there dates Pontormo's posthumous portrait of Cosimo il Vecchio [201], where the head is adapted from a quattrocento medal but treated so expressively as to become a valid imaginative evocation of the past.[24] When another Medici, Clement VII, was elected Pope in 1523, their future seemed secure, but once more fate intervened with the sack of Rome and with a popular rising in Florence itself. After this second expulsion the tyrannical Alessandro de' Medici was appointed Duke, and it was a portrait of Alessandro [202], based on a medal by Domenico di Polo, with the city in the background, that laid the cornerstone of Vasari's reputation.[25] It conveys the simple message: "Here I am, and here I stay." But Alessandro de' Medici did not stay; he was murdered

202. GIORGIO VASARI: *Alessandro de' Medici, Duke of Florence* (Florence)

in 1537, and was succeeded by the eighteen-year-old Cosimo I, who through sheer persistency of character laid the foundations of two centuries of stable Medicean government. The visible expression of Cosimo I's dynastic philosophy is the Udienza, or audience platform, at the end of the Sala del Gran Consiglio in the Palazzo Vecchio, where the great figures of the family, Pope Leo X, Alessandro de' Medici, Cosimo himself and his father, Giovanni delle Bande Nere, are represented in marble statues carved by the cold chisel of Bandinelli. The fact that interest centered on a commemorative sculptural project in which contemporary figures were shown under the guise of the antique argues a bias in favor of a class of portrait that was durable, timeless, and detached. Cellini's bust of Cosimo I, which seems to our eyes much superior to the generality of Medicean portraits, was disavowed because it was animated and unorthodox.

After the marriage of Cosimo I in 1539 to Eleanora of Toledo, daughter of the Spanish viceroy of Naples, patronage in painting was diverted to Bronzino, and it is

203. AGNOLO BRONZINO: *Cosimo I de' Medici, Grand Duke of Tuscany* (Florence)

through Bronzino's eyes that we now visualize the Medicean court. In 1540 or 1541 he started work in the Chapel of Eleanora of Toledo, and his frescoes there impressed the Duke. "The Duke," Vasari tells us,[26] "seeing from these and other paintings the artist's excellence, and especially that he could draw from nature with the most diligence imaginable, had himself painted in white armor with his hand on a helmet." Eleanora of Toledo was painted at the same time. There followed another portrait of the Duchess with her son Don Giovanni, and more and still more portraits of the ducal family. The frescoes in the Chapel of Eleanora of Toledo are couched in a linear style derived from Michelangelo, and Bronzino's portrait of Cosimo I [203], which dates from 1545, is conceived in the same way. It is really an inversion of the upper part of Michelangelo's *Giuliano de' Medici*. Vasari refers repeatedly to the realism

204. AGNOLO BRONZINO: *Eleanora of Toledo, wife of Cosimo I de' Medici* (Florence)

of Bronzino's portraits, and Bronzino was certainly an incredibly attentive painter of inanimate detail. In the portrait of Eleanora of Toledo [204], which was painted about 1546, the patterned velvet dress corresponds exactly with the dress in which the Duchess was clad after death.[27] What commended Bronzino to Cosimo I was that he approached the human features as still life. If the ducal physiognomy had to be reproduced in painting and not just in the impassive art of sculpture, this style was the least undignified.

In art no less than life the Duke was reluctant to take chances. Titian volunteered to paint him on his return from Rome, but he turned the offer down, and no further sittings were given even to Bronzino. When painted portraits of him were required, it was the portrait of 1545 with minor variations that was reproduced. Hence

205. AGNOLO BRONZINO: *Giovanni di Cosimo de' Medici* (Oxford)

Bronzino's excitement when, in 1551, he was required to paint the children of the Duke. The proximity of royal children is a notorious intoxicant, but even that hardly excuses the terms in which Bronzino writes. "Here I am in Pisa," he says,[28] "where I am continually with these most saintly sovereigns, and I rejoice in the blessed sweetness of so good and benign a prince, who certainly is without a peer. To put it briefly, his most illustrious and unique consort, and his angelic children are such as such a lord deserves to have, and he is such a husband and father as such a lady filled with goodness and such wise and beautiful and well-trained children merit. When I look at them, I think them so many angels, and when I listen to them, they seem to be

spirits from heaven. I am painting in the room in which they learn Latin and Greek, and I take the utmost pleasure in seeing these tender, well-born plants directed in such a manner that they will yield the happiest fruit." One of the paintings of the little angels executed at this time is the truly angelic portrait at Oxford of Giovanni di Cosimo de' Medici at the age of seven [205].

In the sixteenth century the courts of Europe enjoyed what was practically a common market in portraiture. Taste and style, like fashions in costume, spread with remarkable rapidity, and it is often difficult to establish how they were transmitted or where they began. An example is the vogue of the miniature portrait. Late in life Bronzino executed a series of small paintings of members of the Medici family for a room in the Palazzo Vecchio [206]. Strictly speaking there were two sets of portraits, one opening with Giovanni di Bicci de' Medici, who had founded the family fortunes at the beginning of the fifteenth century, and ending with Catherine de Médicis, the wife of Henry II of France, and the other opening with Lorenzo, the brother of Cosimo il Vecchio, and ending with his descendants, the children of Cosimo I. The

206. AGNOLO BRONZINO: *Four Members of the Medici Family* (Florence)

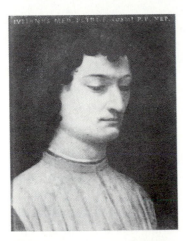

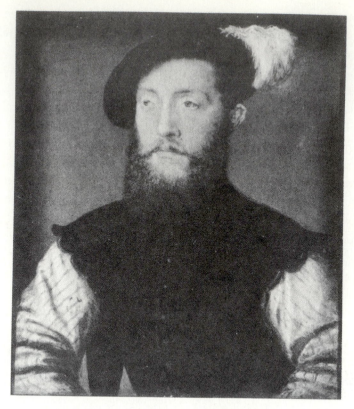

207. CORNEILLE DE LYON: *Charles de Cossé-Brissac* (New York)

portraits were taken from the best originals available; some are after Raphael and one is after Botticelli. One of the traits we associate with royalty is a liking for minuscule objects, and with these little paintings this perverse taste was gratified. Simultaneously a vogue for small oil portraits sprang up in France, where it was introduced by a Dutch painter attached to the suite of Henry II as Dauphin, Corneille de Lyon, who became naturalized in 1544.[29] Corneille de Lyon is not a very interesting artist, and a contemporary jingle by Eustache de Beaulieu praises him as what he was, a sort of court photographer. No one in France, says this little poem, is better at drawing a person from life, nor since the time of Noah has there been anyone better, not even the egregious Apelles. Brantôme in a famous passage describes Charles IX and his mother, Catherine de Médicis, inspecting portraits of the notabilities of the French court in Corneille's studio.[30] These pretty, flattering little portraits [207] were produced with great facility, and may have inspired Bronzino's small paintings.

The tone of Bronzino's portraits of Cosimo I is austere and rather forbidding, and

in that it differs from the official stereotype of Francis I of France.[31] When Francis I came to the throne in 1515, there was no tradition of French court portraiture. The fifteenth century had thrown up one great independent royal portrait, the painting of Charles VII by Jean Fouquet for the Sainte Chapelle at Bourges [208], where the idiom is monumental—more monumental certainly than that of contemporary Flemish paintings—but respect for the office and its occupant is combined with a cruelly objective dissection of the man. The iconography of Louis XI is mainly of a ceremonial character, and the features of Charles VIII, who astonished the Italians by his huge nose and his loose lips, seem to have been reproduced as infrequently as possible. The career of his successor, Louis XII, was centered on Milan, but there is no evidence that Lombardy exercised an influence on his portraits comparable to its influence on the portraits of the Emperor Maximilian I. When Francis I became king, therefore, the task of establishing a royal iconography had to be thought out afresh. It was handled in the main by a Flemish painter, Jean Clouet, Janet or Genet as he was known in his own lifetime, who was active at least as early as 1509 (when he is compared in a poem to Leonardo, Gentile Bellini, and Perugino), joined the court in 1516, succeeded Bourdichon as court painter in 1523, and died in 1540 or 1541.

The difference between the tone of the portraits of Francis I and that of other ruler portraits was due in part to the way in which they were produced. In France the

208. JEAN FOUQUET: *King Charles VII of France* (Paris)

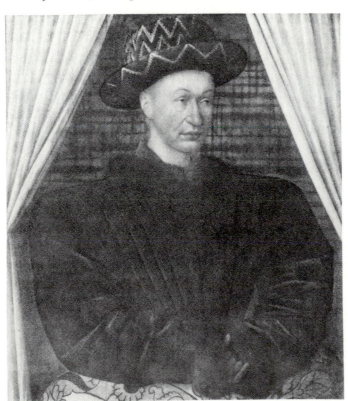

209. JEAN CLOUET: *King Francis I of France* (Paris)

official image was not, as it was in Florence, a painting that was diffused in countless copies, but a drawing of the head alone which might be employed in many different ways. The vogue of the court drawing was specifically French, and it gave rise to those great collections of drawings in colored chalk of the French kings and the members of their courts which are now at Chantilly and in the Bibliothèque Nationale. There are fifteen main collections of these drawings, and in them are eighteen drawings of Francis I, representing five portrait types; one is copied eleven times, another is copied on four occasions, and the remaining three appear once each. They show the King at different stages of his life, and they formed the basis of miniatures and enamels and paintings. The practice of making official drawings of this kind preceded Janet's arrival in France—some of the early drawings in the Hermitage are probably by Bourdichon—but fresh from the bourgeois background of the Netherlands, he gave them a special character. Whereas the artist we call Bourdichon presents an image of the King that is impassive and impersonal, Janet [209] shows him gazing at us slyly

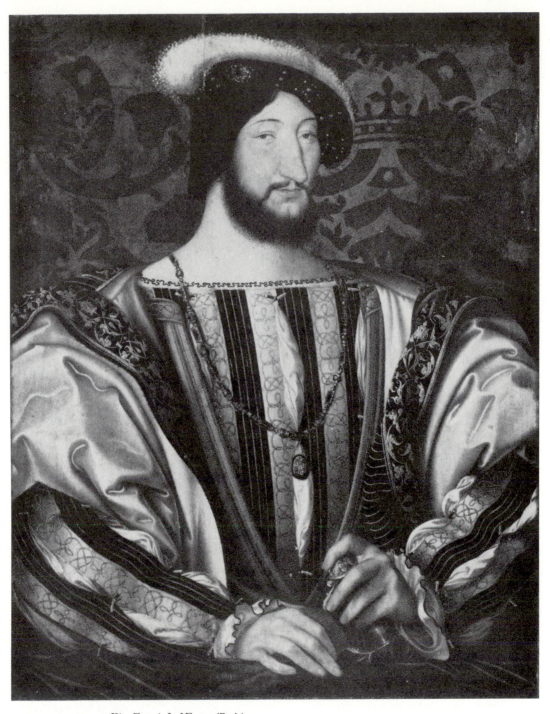

210. JEAN CLOUET: *King Francis I of France* (Paris)

211. AFTER JEAN CLOUET: *King Francis I of France* (Paris)

with a benign smile. When this image is elaborated in a painting, the effect is sometimes incongruous, as it is in the great Janet portrait in the Louvre [210], where the still intimate head is surrounded by all the panoply of royalty. Janet's last drawing of the King [211] survives only in copies; it was made at the extreme end of his life, about 1540, and is characterized with the greatest care. But a good deal of the definition is lost in the two little paintings in which it was introduced, a beautiful equestrian portrait of the King in Florence [212], where the horse, with yellow and pink trappings, is shown against a landscape, and a miniature in the Louvre where the landscape is replaced by a neutral ground. In both the King, mounted on his charger, looks us firmly in the eyes.

The English royal portraits of the time start from a different premise and were directed by a greater painter. Long before Francis I conceived the Italianizing style of Fontainebleau, Italian artists were at work in England. They were headed by Torrigiano, who was responsible for the tombs of Henry VII and of his mother at

Westminster and who made a bust of the King. But by the time the Fontainebleau experiment began, with the arrival of Rosso in 1528 and of Primaticcio three years later, the atmosphere in England was transformed. Wolsey fell in 1529, the Act of Supremacy was passed in 1531, and in 1536 there began the dissolution of the monasteries. This decisive alignment with the forces of reform had the same effect on painting in England as in Germany. The painter's subject matter shrank, for the practical reason that so many religious subjects were proscribed, and the boundaries of the portrait shrank as well. The artist involved was Holbein, who returned to London from Basel in 1532. Holbein was a dedicated religious artist, and in Basel, sympathetic as he was toward reform, he cannot have viewed the closing down of this part of his creative life without concern. But he was a painter of supreme intelligence, and he determined to canalize his creative propensities in portraiture.

On his return to England he was not at first associated with the court. He gravitated slowly toward it, and his channel of approach was Thomas Cromwell. He painted Cromwell probably in 1534, and seems to have been adopted as royal painter in 1536, the year in which Anne Boleyn was executed and the King married Jane Seymour. His connection with the court was limited therefore to a seven-year period between 1536 and his death in 1543. Unlike Janet in France, Holbein was bound by a conventional royal iconography, that of the frontal portrait. The frontal portrait is a common

212. JEAN CLOUET: *King Francis I of France* (Florence)

213. HANS HOLBEIN THE YOUNGER: *King Henry VIII* (Rome)

214. JOOS VAN CLEVE: *King Henry VIII* (Hampton Court Palace)

medieval phenomenon—in England the most notable example of its use is the large panel painting of Richard II in Westminster Abbey—and it was protracted into the sixteenth century through seals and illuminated charter headings. When Henry VIII came to the throne, he was depicted in charter headings as a medieval monarch in a conventional frontal pose, and fifteen years later he was still shown in charter headings essentially in the same way.[32] Holbein for this reason adheres to a full or almost full-face frontal portrait [213]. There was nothing amiable about this image; it was an icon, proud, hieratic, menacing. There is no way of deciding how far these overtones were due to Holbein and how far they expressed the wishes of the King. The extent of Holbein's contribution can be gauged, however, from two portraits of the King painted in 1536. The first [214], which shows him seated at a table, holding an inscription that refers to the publication of the Coverdale Bible in that year, is by a Flemish artist, Joos van Cleve, who also painted Francis I of France,[33] and while it is less good natured than Janet's portraits, it none the less is stamped with latent humanity. In the same year Holbein painted the King [215] with very different results.[34] The arms and hands are schematized, and are not rendered realistically, the eyes no longer engage

215. HANS HOLBEIN THE YOUNGER: *King Henry VIII* (Lugano)

216. HANS HOLBEIN THE YOUNGER: *King Henry VIII*, detail of cartoon.
(London)

with ours, the mouth is smaller, more sensual and more obstinate, and the bone structure has an almost architectural solidity and strength.

This portrait is bound up with Holbein's most important official painting, a fresco in the Privy-Council Chamber at Whitehall.[35] The fresco was destroyed by fire, and is known only through a small seventeenth-century copy and through the left half of the original cartoon [216]. It was painted in 1537. Queen Catherine of Aragon, the pretext of the King's rupture with the papacy, had died in January 1536, and her successor, Anne Boleyn, was executed in May of the same year. No dispute therefore was possible as to the validity of the King's marriage to Jane Seymour, which took place on the following day, and the fresco consequently showed the founders of the Tudor dynasty, Henry VII and Elizabeth of York, with, in the foreground, the reigning King and the new Queen. Perhaps the fresco was motivated by the Queen's pregnancy, for the future Edward VI was born in mid-October of that year. In the cartoon the King's head is shown in three-quarter face, as it is in the oil portrait, but in the copy it is in full face and corresponds with a larger painting which is now in Rome.[36] Probably the small portrait depends from. a drawing made in preparation for the fresco, while the Rome portrait follows the upper part of the figure as it was carried out. When Van Mander saw the fresco in 1604, he declared that he felt abashed or annihilated before the figure of the King,[37] and in the cartoon, damaged as it is, the figure is still of over-powering force.

The part that drawing played in Holbein's work is no less great than the part it played in Janet's, and initially his use of colored crayon may have owed something to France. The function of Holbein's drawings is none the less a little different. Where Janet's show the head alone, Holbein's indicate a pose as well; they establish the character of the whole figure and not simply of the head. With Janet the same head can be used for figures that are differently posed, whereas with Holbein the pose and head are indissociably linked. The reason for this distinction must be sought in the way in which the drawings were produced. Whereas Janet's are free drawings of the head, Holbein, in his later English portraits, seems to have drawn the figure on a pane of glass from which it was transferred to paper and worked up from the life. Among the Windsor drawings is a famous sketch of Jane Seymour [217] made in the second half of 1536.[38] It was used first for a small portrait at The Hague, where the form of the headdress is changed but the jewelry and dress are exactly reproduced. It was used a second time in a rather larger painting in Vienna [218], where the jewelry and dress are modified. And it was used for the third time in the full-length figure in the Whitehall fresco, where the jewelry and dress and headdress are changed once more. In all three paintings the same pose and the same head are shown. For Holbein the drawing was a considered statement on the personality, from which movement in the sense of play of feature

was excluded, and sentiment, if it threatened to be present, was rigorously excised.

The King must have felt unbounded confidence in Holbein's recording eye or the painter would not have played the part he did in the King's matrimonial policy after Jane Seymour's death.[39] The impulse behind the policy was part physical and part political—political in that the three alternatives were an alliance with the Emperor, the King of France, and the reformed princes of Germany, physical in that the King abhorred the prospect of an unattractive bride. Throughout the long negotiations that culminated in his marriage to Anne of Cleves in 1539, the political factors were weighed by Cromwell and the physical factors by Holbein. The first candidate was a niece of the Emperor Charles V, the sixteen-year-old widow of the Duke of Milan. The Emperor expressed qualified approval of this match, and the King thereupon requested that the Duchess should be sent to Calais so that he could look at her. This proposal was disallowed by her aunt, Mary of Hungary, the regent of the Netherlands, with whom she was living, and Philip Hoby and Holbein were thereupon dispatched to Brussels in March 1538, Hoby to report on the Duchess and Holbein to take her portrait. She sat or rather stood for him between one and four o'clock one afternoon, and he then returned to London. Not till the autumn did negotiations for this match break down. Meanwhile parallel negotiations went ahead with France, where the King's interest was excited by the daughters of the Duc de Guise, and especially by

217. HANS HOLBEIN THE YOUNGER: *Queen Jane Seymour* (Windsor Castle)

218. HANS HOLBEIN THE YOUNGER: *Queen Jane Seymour* (Vienna)

accounts of his youngest daughter "in a religious order but not yet professed." So in June Hoby and Holbein once more went abroad, this time to France. Then the King reverted to his old proposal, that he and Francis I should meet midway between Calais and Boulogne, and spend six or seven days inspecting all the eligible brides from France before the King made up his mind. This was again turned down. "They are not mares for sale," read the reply, "and there would be no propriety in it." In August, therefore, Hoby and Holbein set off on a further journey, to obtain portraits of Renée of Guise and the daughter of the Duke of Lorraine. But with the growing

rapprochement between Francis I and Charles V, an alliance with either party lost many of its practical advantages, and the eyes of Cromwell and the King consequently veered toward Germany. The cynosure of interest were two daughters of the Duke of Cleves, Anne and Amelia, and the negotiations were conducted with the Duke of Saxony, the bull-necked figure who was painted by Cranach and Titian. A request was made for a portrait of Anne of Cleves, but the Duke was unable to meet it because "his painter Lucas was sick." If Cranach had not been sick, a portrait by him of Anne of Cleves might have had a healthy deterrent effect. As it was, Holbein was sent in July to Düren to record her and Amelia's physiognomies. In January 1540 the marriage took place.

All that survives from these fifteen months of traveling are the full-length portrait of the Duchess of Milan in London [219], which was worked up from the painting or drawing Holbein made in Brussels in 1538,[40] and a painting in Paris of Anne of Cleves [220], which was probably begun at Düren in 1539.[41] Both portraits are in full face. It may have seemed that in full face evasion was impossible. The only flaw that is noted in accounts of the Duchess of Milan is that her skin was "less pure white" than Jane Seymour's. "Fair of colour she is not," read one report, "but a marvellous good brownish face she hath, with fair red lips and ruddy cheeks." Otherwise all accounts bear tribute to her wit and modesty, to the dimples which appeared in her chin when she smiled, and to the charm of her lisping speech. Hoby's instructions were to report on her "answers, her gestures and her countenance," and Holbein seems to have adopted these terms of reference too. At all events the likeness he produced, with its implications of movement, its direct gaze, and its full, sensitive lips, is the most comprehensive of his later portraits. Nowhere is the role of the portrait as a substitute life image more palpable. The threads of understanding that were woven between painter and sitter in those three hours in Brussels did not extend to Anne of Cleves. The idiom was more formal—probably the head alone was sketched at Düren and was later elaborated as a marriage portrait—and the featurelessness of the face and hands is barely redeemed by the decorative splendor of the crimson and gold dress.

In England Holbein had no fit successor, but in France the work of Janet was continued by his son François Clouet, who succeeded his father as court painter and for thirty years, until his death in 1572, prepared a record of the courts of Henry II and Charles IX.[42] So far as portraits of the sovereign were concerned, François Clouet followed the practice of his father; he made a drawing of the head—the best-known example dates from the year of Henry II's death, 1559—and it was then inserted in a larger painting [221]. But though the practice is that of Janet, the rather morose head is less ingratiating and may have been influenced by the hieratic image coined by Holbein

219. HANS HOLBEIN THE YOUNGER: *The Duchess of Milan* (London)

220. HANS HOLBEIN THE YOUNGER: *Queen Anne of Cleves* (Paris)

221. FRANÇOIS CLOUET: *King Henry II of France* (Florence)

at the English court. The use of a figure in full length is also what the English in the six-teenth century called "outlandish"; it brings royal portraiture in France into line with portrait types employed at the imperial court.

François Clouet was a painter of women rather than of men. In a verse in *Amoretti and Epithalamion*[43] Spenser writes:

> *The sweet eye-glances, that like arrows glide;*
> *The charming smiles, that rob sense from the heart;*
> *The lovely pleasance and the lofty pride;*
> *Cannot expressed be by any art.*

But François Clouet believed that they could be expressed, in chalk handled with ex-treme delicacy and sophistication, and that they could then be transferred, with some

222. FRANÇOIS CLOUET: *Anne de Pisseleu, Duchesse d'Étampes* (Chantilly)

loss admittedly, to the static medium of paint. In the most intimate of his drawings and paintings [222] that miracle is performed. His royal portraits are more unyielding and severe than these less official likenesses, but even in the painting of Elizabeth of Austria in the Louvre [223] the sense that the portrait painter's task is to capture a fleeting image, to record the eddies of the personality rather than its identity, charm rather than character, is not entirely lost.

François Clouet died in 1572, and in that year there occurs the first reference to the presence of Nicholas Hilliard the miniaturist at the court of Queen Elizabeth.[44] Holbein had painted miniatures, for the most part reductions from oil paintings, but it was Hilliard who first understood that the medium possessed unsuspected possibilities, in that the essence of the portrait drawing could be more faithfully preserved in a water-soluble medium on card than in oil paint. The force of this lesson was impressed on him between 1576 and 1578 in France. Hilliard married in July 1576 and left for France not long afterward, armed with a letter to the English ambassador in

223. FRANÇOIS CLOUET: *Elizabeth of Austria* (Paris)

Paris from the Queen. In 1577 he was working for the Duc d'Alençon, the brother of Henry III, and he became acquainted with Ronsard the poet and Blaise de Vigenères. A self-portrait that he produced about this time argues an inner sympathy with the aesthetic of the French court portrait. That transpires also from the *Arte of Limning*, the treatise on the portrait miniature which he composed after 1598 and before 1602.[45] "Who," asks Hilliard, "seeth an excellent precious stone, or discerneth an excellent piece of music with skill indeed, and is not moved above others with an amorous joy and contentment than the vulgar? . . . How then [can] the curious drawer watch, and as it were catch these lovely graces, witty smilings, and these stolen glances which suddenly like lightning pass and another countenance taketh place, except he behold and very well note? So hard a matter he hath in hand calling these graces one by one to their due places, noting how in smiling the eye changeth and narroweth, holding the sight just between the lids as a centre, how the mouth a little extendeth both ends of the line upwards, the cheeks raise themselves to the eyewards, the nostrils play and

are more open . . . and the forehead casteth itself into a plan as it were for peace and love to walk upon."

This passage explains the captivating intimacy of Hilliard's finest portraits. But no more in England than in France was such a theory fully applicable to the sovereign's portrait. The Queen herself had clear-cut views on portraiture. She disapproved of shadow—on one occasion she expressed the wish to sit for her portrait out of doors, "where no tree was near, nor any shadow at all"—and Hilliard disapproved of shadow too. "So to shadow as though it were not at all shadowed is best shadowed," he affirmed. No doubt at the Queen's behest the miniatures painted of her [224] are couched in the same euphuistic idiom as the literary apostrophes that were current at the court. These miniatures were private portraits, but the language they employed could be, and was, transferred to portraits on a larger scale, and these larger paintings, with their complex allegories and their rich web of literary reference, take us to the center of the subject of the next chapter, the emblematic portrait.

224. NICHOLAS HILLIARD: *Queen Elizabeth I* (London)

V

Image and Emblem

For the very greatest Renaissance portrait painters, Antonello da Messina and Raphael and Titian, the portrait was what it has been ever since, a statement by the artist on the sitter's personality. But there was also a second type of portrait, peculiar to the Renaissance, in which direct statement was reinforced by literary means. The difference is best established by comparing two north Italian paintings. In the first, Moroni's portrait of Giovanni Antonio Pantera [226],[1] the sitter is shown seated in a chair holding a volume of poems—the *Monarchia di Christo*, which was printed in Venice in 1545—in his left hand. The arm of the chair rests on the picture plane, and the poet looks out abruptly in full face. Nothing detracts from the immediacy of the image. Confronted by his startled and reproachful face, one wishes one had knocked before entering the room. The composition is reduced to bare essentials, and the color— the simple wooden chair, the black dress, the gray-brown background—is low in key. As a record of Pantera's appearance the painting could hardly be surpassed. But as so often when these devices are employed, the illusion of vitality is purchased at the price of shallowness.

Lorenzo Lotto's painting of Lucina Brembati of about 1523 at Bergamo [225][2] seems at first sight to represent no more than a lady in early middle age, with a sly, rather complacent smile, against a curtain lit by beams of moonlight from the back. Why moonlight? Because the moon, Luna, represents the first and last syllables of the Christian name, and with the central syllable *ci* written on its surface, the entire Christian name Lucina is shown. The symbol is not inserted in the picture but determines its whole modality. Lucina Brembati, moreover, was superstitious—she wears a jeweled horn against the evil eye—and over her left arm she has a sable or weasel fur. In Parmigianino's much more appealing portrait of a girl in Naples there appears a fur of the same kind with a gold sheath on the snout. These animals seem to have been ornaments—in Germany they had the rather unattractive name of *Flohpelz,* and were supposed to attract the fleas which might otherwise annoy their owners[3]—but

205

225. LORENZO LOTTO: *Lucina Brembati* (Bergamo)

226. GIOVANNI BATTISTA MORONI: *Giovanni Antonio Pantera* (Florence)

the weasel was also a symbol of propriety, and that is the significance it carries in
these portraits.

Inevitably, it was in the medal that the principles of the augmented portrait were
first laid down. Since the medal was double-sided, it was possible to introduce on the
reverse a commentary on the person depicted on the front. A famous medal of Alfonso
of Aragon, King of Naples [227], for example, has on the front a portrait of the King
with crown and helmet, and the inscription "triumphator et pacificus" (triumphant
and peace-loving), which alludes to his success in overthrowing the Angevin dynasty
in Naples and to the peaceful regime that he established there. On the back is the em-
blem of liberality, the eagle, which was supposed to share its kill with other birds
of prey.[4]

There were practically no limits to the messages that medals could convey. When
Galeazzo Maria Visconti became Duke of Milan in 1466, the architect and sculptor
Filarete busied himself with a self-portrait [228].[5] On the front his head is surrounded
by three bees sucking honey from a flowering shrub. The bee, says Filarete in his
treatise on architecture, is peaceful, stinging only when it is provoked, and speedy and
industrious. The point is made more bluntly on the other side, where Filarete sits with
a mallet in his hands, opening a bole in the trunk of a tree. The tree is laurel, and inside
it is a hive from which a stream of honey is released. From above, the sun beams down
upon the sculptor, and the inscription reminds us and Filarete's prospective patron
that as the sun causes everything to grow, so the patronage of princes has the same
beneficent result.

In the sixteenth century as well there are cases where the medal was so planned as

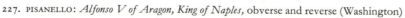

227. PISANELLO: *Alfonso V of Aragon, King of Naples,* obverse and reverse (Washington)

to epitomize an artist's views on life. In 1562, for instance, the Milanese sculptor Annibale Fontana made a beautiful medal of the painter and theorist Lomazzo [229].[6] On one side is a classicizing portrait head, and on the other (as Lomazzo himself explains in a poem describing the medal), he is introduced by Mercury to Fortune, that is to professional success. Lomazzo was only thirty-two at the time, and Fortune may have resented the claim staked out in the medal. At all events, eight years later he lost his sight, and became an art critic instead. By far the most moving of these medals was modeled in Rome in 1560 by another Milanese sculptor, Leone Leoni [230]. On the obverse it shows the head of Michelangelo, a constructed, overprecise image of a type in which Leoni specialized. The reverse, however, seems to have been planned by Michelangelo. He was already working in an access of emotional fervor on the Rondanini *Pietà*, and he chose an inscription from Psalm 51: "Then will I teach transgressors thy ways, and sinners shall be converted unto thee," and laid down the imagery of a blind beggar guided by a dog. The beggar is Michelangelo—the figure corresponds with a drawing which Zuccari made of Michelangelo in the Piazza Mattei in 1547—fortified by faith and begging for the gift of grace.[7]

The same principle was carried over to the double-sided painting. In the Urbino diptych of Piero della Francesca the numismatic portraits on the faces of the two panels are accompanied on the back by numismatic allegories inspired by the *Trionfi* of Petrarch. On one [231] is Federigo da Montefeltro in a triumphal car accompanied by the four Cardinal Virtues and crowned by Fame, and on the other [232] is Battista Sforza with the three Theological Virtues; a common strip of landscape and a common parapet link the two scenes. The inscriptions apostrophize the merits of the Duke

228. ANTONIO FILARETE: *Self-Portrait,* obverse and reverse (London)

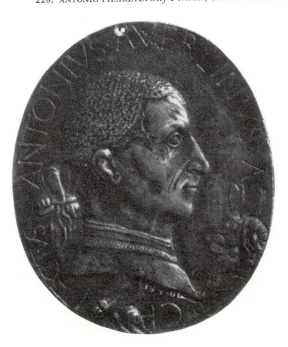

229. ANNIBALE FONTANA: *Giovanni Paolo Lomazzo,* obverse and reverse (London)

230. LEONE LEONI: *Michelangelo Buonarroti,* obverse and reverse (London)

and Duchess, and the last words, "per ora cuncta virorum" (on the lips of all men),
recall a sentence in the *Tusculan Disputations* of Cicero which relates to the continuance
of a posthumous reputation after death.[8]

Piero della Francesca's diptych was naturally known to Raphael, who came from
Urbino, and when in Florence he painted the portraits of Angelo and Maddalena
Doni, he planned them as double-sided paintings. Instead of the courtly allegories of
the Urbino panels, the reverses of the Doni diptych show two scenes from Ovid's
Metamorphoses, the flood that overwhelms the earth and the story of the two survivors,
Deucalion and Pyrrha, who pray for guidance to the goddess Themis and on her

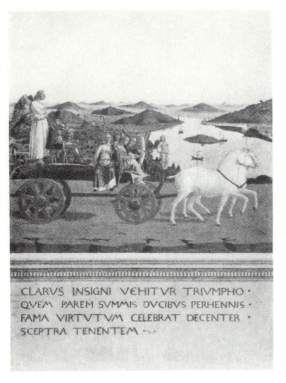

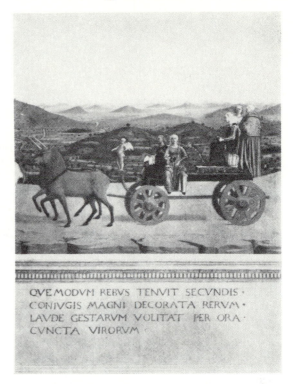

CLARVS INSIGNI VEHITVR TRIVMPHO ·
QVEM PAREM SVMMIS DVCIBVS PERHENNIS ·
FAMA VIRTVTVM CELEBRAT DECENTER ·
SCEPTRA TENENTEM ·~·

QVE MODVM REBVS TENVIT SECVNDIS ·
CONIVGIS MAGNI DECORATA RERVM ·
LAVDE GESTARVM VOLITAT PER ORA ·
CVNCTA VIRORVM ·

231. PIERO DELLA FRANCESCA: *Triumph of Federigo da Montefeltro* (Florence)

232. PIERO DELLA FRANCESCA: *Triumph of Battista Sforza* (Florence)

instructions throw over their shoulders stones that are transformed into men and women [233]. Though they were not painted by Raphael, the scenes are closely contemporary with the two portraits, and are based on illustrations in a Venetian edition of Ovid of 1497 which are repeated in four other editions printed between 1501 and 1508. The diptych seems to have commemorated Doni's marriage, and the paintings on the back may contain a playful reference to the founding of a family.

Many other permutations of the double-sided portrait were possible. One of them is described by Marcantonio Michiel in Venice in the house of Michele Contarini: "There is a small portrait of Messer Alvise Contarini who died some years ago, and in the same picture there is opposite the portrait of a nun of San Secondo. On the cover of these portraits is represented a car in a landscape, and the leather case in which the picture is contained is stamped with foliage in gold. It is a perfect work by Giacometto." The little panels are described again in an inventory of the Camerino delle Antigaglie of Gabriele Vendramin.[9] Giacometto was a miniaturist, and the two paintings [234, 235] are very small. One of them, the portrait of the nun, is three and a

233. FLORENTINE: *The Story of Deucalion and Pyrrha*
(Florence)

quarter inches high, and the other, the portrait of Alvise Contarini, measures about an inch more. So they cannot have formed a diptych in the conventional sense, and the fact that the landscape backgrounds, though homogeneous, are not continuous, proves that they were not intended to be looked at side by side. On the back of the larger panel, the male portrait, is a heraldic hind tethered to a metal boss with the word AIEI [236], and on the back of the small panel there are two almost illegible grisaille figures in a landscape [237]. Michiel tells us that the landscape was the cover of the painting, so we must assume that the portrait of the nun was on the inside of the lid and fitted over the male portrait.

Covers for portraits, sometimes in the form of lids and sometimes in the form of sliding or hinged panels, existed in some quantity. Vasari describes a portrait painted by Pontormo about 1529 of Francesco Guardi in military dress; it had a cover by Bronzino, showing Pygmalion praying that the statue of Galatea might become flesh and blood. In this case the cover exists[10]—it shows an altar with a sacrificial bull and

234. GIACOMETTO: *Alvise Contarini* (New York)

235. GIACOMETTO: *A Nun of San Secondo* (New York)

236. GIACOMETTO: Reverse of Fig. 234 (New York)

237. GIACOMETTO: Reverse of Fig. 235 (New York)

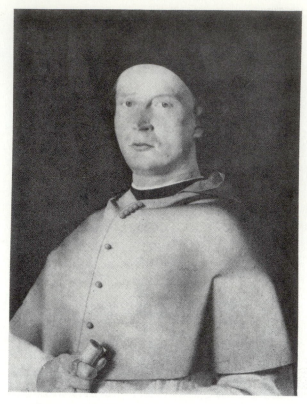

238. LORENZO LOTTO: *Bernardo de' Rossi, Bishop of Treviso*
(Naples)

Pygmalion kneeling with his implements beside him on the ground—but the portrait does not survive. Presumably the relationship was simply a matter of analogy; as Galatea's statue came to life, so too might Francesco Guardi's portrait. But in another case, where both the cover and portrait survive, the relationship proves to be more intimate. The portrait [238], by Lorenzo Lotto, is of Bernardo de' Rossi, Bishop of Treviso, and is at Naples, and the cover [239], also by Lotto, is a romantic painting in Washington.[11] Rossi was thirty-seven when it was painted, and seems to have been rather a contentious figure—internal dissension forced him to leave first Treviso and then Bologna—but, according to an eighteenth-century source, he dedicated himself to the study of antiquity, natural science, and the arts. His features were commemorated in a medal, which had on the back a figure of Virtue, with a flower in the right hand, standing in a chariot drawn by an eagle, the symbols of vigilance and understanding. No doubt Rossi was himself responsible for the allegory on the cover of Lotto's portrait. The foreground illustrates the opposition between the life of nature or

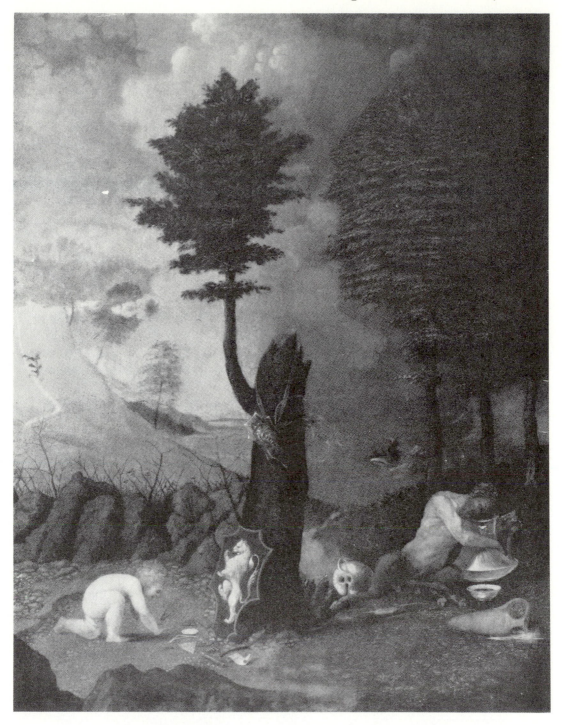

239. LORENZO LOTTO: *Allegory* (Washington)

license, represented by a satyr with a wine jar and a pitcher of spilled milk, and the life of discipline or reason, represented by an industrious child with dividers, a set square, a syrinx, and a flute. At the back is a winged child climbing a mountain illuminated by a beam of light. This is given a specific reference by the rampant lion on the shield which is found again on the ring worn by Rossi in the portrait and on the base of a terra-cotta bust which was modeled for Rossi's monument at Treviso by the sculptor Riccio. It would none the less be a mistake to conceive the relation of the cover to the portrait simply in expository terms. The connection is aesthetic as well as psychological, and the reference on the cover to the operation of natural forces in a primitive world adds a new poetic dimension to the rather pragmatical image within.

In all these cases the portrait is destitute of imagery. But it was also possible to merge it in an allegory and to combine the emblem and the portrait. The first course was adopted by Botticelli in the decoration of the Villa Tornabuoni. The room in which he worked must have been one of the most romantic of the fifteenth century. It included portraits of Giovanni Tornabuoni, who had bought the villa in 1469, as Gonfaloniere di Giustizia, and other members of his family, but the only pieces of the decoration we know are the frescoes which flanked the window.[12] On the right, against the background of a wood, the young Lorenzo Tornabuoni was presented by Grammar to Wisdom and the Liberal Arts [240]; on the left, a girl extended her handkerchief to catch the flowers dropped into it by Venus, who was accompanied

240. BOTTICELLI: *Lorenzo Tornabuoni presented to the Liberal Arts* (Paris)

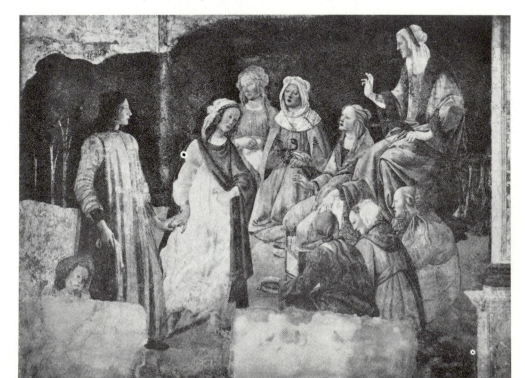

by the Graces [241]. The girl in the second fresco is unidentified, but is the same girl who appears behind Giovanna degli Albizzi in Ghirlandaio's *Visitation* in Santa Maria Novella. The contrast between Botticelli's entrancing allegories and the staid frescoes of Ghirlandaio is all the greater in that the portraits in Santa Maria Novella are cold and uninvolved, while Botticelli's figures have a committed character. Lorenzo Tornabuoni, whom Politian praised as his equal in the reading of Homer, is led diffidently forward as though conscious of his unworthiness before the humane disciplines, and the girl, with shining eyes and an eager movement of the hands, embraces Venus' gifts. The justification of these frescoes as portraits is that the allegories reveal aspects of the personality which could not otherwise have been expressed.

Some of the earliest experiments in combining the emblem and the portrait occur in the panel paintings of Pisanello. In the portrait of Ginevra d'Este in the Louvre [244], an Este emblem is embroidered on the sleeve, a sprig of juniper appears on the surcoat, and in the background is a curtain of frilled pinks and columbines.[13] Both pinks and columbines play a part in the symbolism of religious paintings, especially in the north, and the fact that they are inserted in Pisanello's panel without regard for their natural habits of growth suggests that here too they have an emblematic character. The thread of this tradition was picked up by Leonardo about 1475 in the portrait of Ginevra de' Benci [107], where the head is set against a dark bush of juniper and a sprig of juniper appears again in a wreath on the back of the panel.[14] Though the

241. BOTTICELLI: *An Unidentified Girl greeting the Three Graces* (Paris)

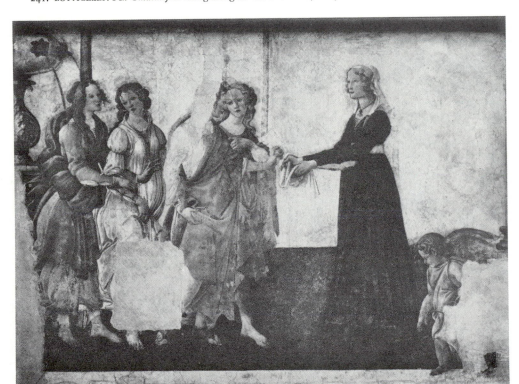

tradition was old, Leonardo's approach to it was personal, and the eponymous juniper invests the portrait with new overtones of poetry.

The use of juniper in Pisanello's *Ginevra d'Este* and in Leonardo's *Ginevra de' Benci* is an allusion to the sitter's name. More universal in its application was the laurel, which first fills the background of a Venetian painting in 1506, in the portrait by Giorgione known as the *Laura* [242].[15] In allusion to the myth of Daphne the laurel leaves seem to grow out of the figure, and are painted with the same delicacy as the large-leaved plants in the foreground of the *Judith*, though they convey no corresponding sense of out of doors. The painting has been thought to represent a member of a genus peculiar to Venice, the courtesan-poetess—a predecessor of the famous Veronica Franco, who was painted by Tintoretto—but probably the laurel relates (as it habitually does in Alciati and other emblem books) to virtue or inspiration, and the bared breast has an allegorical not a vocational significance. No more than a few years later, about 1515, a background of laurel occurs again, in Palma Vecchio's portrait of a poet [243], possibly Ariosto, whose *Orlando Furioso* was published in 1516.[16] Here it combines with the pensive head and languid pose to produce one of the first and most compelling images of the romantic poet awaiting inspiration from his muse.

In the sixteenth century laurels were not awarded solely for original creative activity; they could be earned by moral merit and quite a meager output of conventional literate verse. They were so gained by Ginevra Rangone, whose portrait by Correggio

242. GIORGIONE: *Laura* (Vienna)

243. PALMA VECCHIO: *Portrait of a Poet* (London)

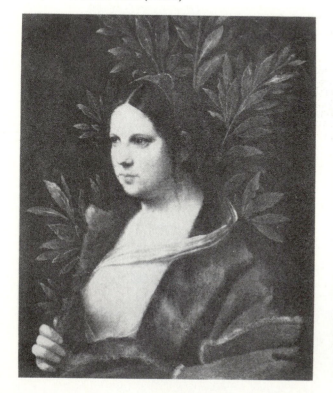

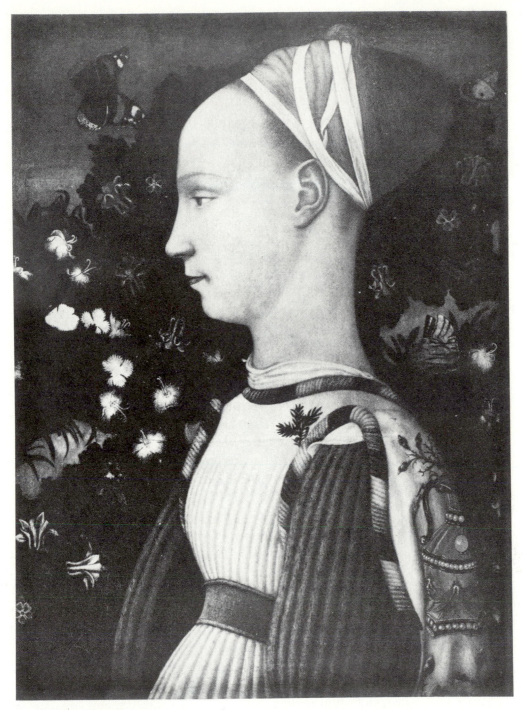

244. PISANELLO: *Ginevra d'Este* (Paris)

is in the Hermitage [245].[17] She was the wife of Giangaleazzo da Correggio, and was married before 1503, when her father-in-law describes her in a letter to Isabella d'Este: "I have the most delicate girl as a wife for my son that I could have desired, good through nature and good through the accident of her appearance; it seems a thousand years till I shall be able to show her to your ladyship." She was a passionate reader of Petrarch, addressed a Latin epigram to her mother which chance has chosen to preserve, and corresponded with Pietro Aretino; there is even a passing reference to her in the *Orlando Furioso*. Her husband died early in 1517, and Correggio's portrait was painted between that date and her remarriage two years later. She is shown seated in a landscape, holding a dish filled with nepenthe to quench her sorrow, and on her brown dress is the scapular of a Franciscan tertiary. Behind her is a hedge of laurel, in allusion to her intellectual attainments, and to the left is a tree trunk encircled with symbolic ivy in reference to her married state.

Probably this portrait was completed not long before Correggio started work on the frescoed room in the Camera di San Paolo at Parma, and in 1523 his learned but simple-seeming frescoes were adopted by Parmigianino as the basis of the more impulsive frescoes at Fontanellato. In the portrait the same change occurred, and when in 1524 the owner of Fontanellato, Gian Galeazzo Sanvitale, by whom the frescoes were commissioned, was painted by Parmigianino [246], the solemn pyramid of Correggio's portrait was abandoned in favor of a nervous, asymmetrical design, in which the light strikes, in an arbitrary fashion, on the head and hand and sword hilt, and on symbolic armor at the back. At the same time the emblematic content of the picture becomes more arcane, for what the sitter shows us with his gloved right hand is not an intelligible symbol, but a mysterious disc stamped with the digits seven and two.[18] One of Parmigianino's aims was to surprise—those precipitous changes of scale in his religious painting are sensational, not rational—and it may be that the intention here was to mystify and not elucidate.

The difficulty of explaining the symbolic content of a portrait such as that of Santivale is underlined by the few instances in which the imagery can really be explained. One of them is a portrait by Moroni at Bergamo [247], showing a man in full length in a crimson dress before a wall in which is inset a relief of Elijah bestowing his mantle on Elisha, with the Spanish motto "Mas el caguero que el primero" (better the second than the first). The relief would be unintelligible did we not know that the man portrayed was Gian Girolamo Grumelli, who in 1560 became the second husband of the Bergamasque poetess Isotta Brembati.[19] Isotta Brembati busied herself with inventing devices for her friends—her own impresa showed the garden of the Hesperides with a dragon guarding a tree of golden fruit, accompanied by the motto "Yo mejor las guardare"—and wrote poems in Spanish with her Bergamasque ad-

245. CORREGGIO: *Ginevra Rangone* (Leningrad)

246. PARMIGIANINO: *Gian Galeazzo Sanvitale, Count of Fontanellato* (Naples)

247. GIOVANNI BATTISTA MORONI: *Gian Girolamo Grumelli* (Bergamo)

mirers believed to be superior to the work of many poets who had Spanish as their native tongue.

In Venice the use of emblems to illustrate a psychological condition seems to have been due largely to German influence. The pattern is established by the greatest northern emblematic portrait, the picture of Cuspinian, the historian, poet, and rector of Vienna University, painted by Cranach on his arrival in Vienna in 1502 [248].[20] Cranach's approach both to religious iconography and to the portrait differed from Dürer's; his conception was of a nature-dominated universe, and where the subject matter permitted, the spirit of his early work is deeply Giorgionesque. Yet the background of the Cuspinian portrait is not an unself-conscious portrayal of a natural scene. Cuspinian is represented under the planet Saturn, accompanied in the distance by the traditional children of Saturn that we find again in the astrological frescoes in the Palazzo della Ragione at Padua, and both the owl and star have an astrological significance. In the companion portrait of his wife [249] these symbols of

248. LUCAS CRANACH THE ELDER: *Johannes Cuspinian* (Winterthur)

249. LUCAS CRANACH THE ELDER: *Anna Cuspinian* (Winterthur)

melancholy are replaced by a parrot and other symbols of the sanguine temperament.

The Venetian artists who invoked the language of the emblem most persistently were those in contact with the north. There was that ambiguous figure Jacopo de' Barbari, who appealed to northern, not Venetian taste—"only Anton Kolb," writes Dürer from Venice in 1506, "swears there is no better painter in the world than Jacopo. Here they laugh at him, and say that if he had been any good he would have

stayed here"—and there was a Cremonese pupil of Gentile Bellini, Bartolomeo Veneto. Bartolomeo's debt to Germany is unconcealed—in one painting he even includes in the background two figures copied from a Dürer print—and this led him to produce a whole series of emblematic portraits of ladies wreathed with symbolic flowers and brandishing symbolic hammers, of which the meaning is invariably arcane, and which have more interest as riddles than as works of art. One of the most curious is a painting at Frankfort [250] of a lady wearing a wreath of myrtle on her golden corkscrew curls and a white veil that leaves one breast exposed; she offers us a bunch of daisies, anemones, and ranunculus. Unwisely identified by Huysmans as a portrait of Giulia Farnese, the mistress of Pope Alexander VI, this "androgyne implacable et jolie," which seemed to him to embody all the lust and sacrilege of the Renaissance, appears to have been painted in Ferrara for Lucrezia Borgia between 1505 and 1507, but whether as an emblematic portrait or as an allegory we cannot tell.[21]

250. BARTOLOMEO VENETO: *Symbolic Portrait* (Frankfort on the Main)

251. AUSTRIAN: *Betrothal Portrait*
(Private collection)

252. LORENZO LOTTO: *Betrothal Portrait* (Madrid)

One Venetian artist, Lorenzo Lotto, contrived to reconcile this emblematic ten-
dency with serious portraiture.[22] Lotto's contacts with the German colony in Venice
were very close. In 1505 and 1506 he was in touch with Dürer—we know that from
the paintings that he executed at Recanati in 1508—and as late as 1540 he was painting
portraits of Luther and his wife, presumably after panels by Cranach. So it is no sur-
prise to find that in 1523, when he planned the double portrait of Messer Marsilio and
his bride [252], he made use of a German betrothal portrait type in which Cupid
links the engaged pair [251]. An interest in facial expression was endemic in German
portraiture up to the time of Dürer, and something of this is reflected in the meaningful

yet strangely ambivalent expressions of the sitters in this painting.[23] Lotto's portraits are stuffed with emblems. Sometimes a despairing hand rests on a heap of rose petals and lilies piled round a small skull, sometimes the sitter proffers a golden paw. Since they were painted in many different centers, in Venice and Bergamo and the Marches, we must explain them by the artist's temperament and not through local influences to which he was exposed.

Painters can depict the act of thinking but cannot define thought. Lotto's aim was to develop the romantic portrait of Giorgione into a literary portrait in which the sitter could be shown in some specific character or state of mind, and his use of emblems stems directly from the need to make the meaning of his portraits more definite and more precise. Sometimes he succeeds in establishing a mood that we can understand. In a painting in the Borghese Gallery [253], which has been looked upon as a self-portrait,[24] the skull and lily seem to be used in their customary connotations of mortality and hope, and the sense of the imagery is faithfully reflected in the grief-stained face. But in a portrait in Vienna [254] of a man holding a golden paw,[25] the message is inaudible. The sitter is addressing us, but from behind a pane of glass. One of the fascinations of Lotto's work is that it includes so many paintings of this kind. That bearded man whom Lotto painted in a portrait in Berlin,[26] with a pair of dividers in one hand and a roll of paper in the other, why does he look at us with such intensity? What is the drama behind the gesture of his right hand? And that youth in Venice, seated at a table turning the pages of an open book,[27] why does he turn his back on the lute and hunting horn hanging behind him? Why are rose petals scattered on the tablecloth? And what is the meaning of the box on the table at the back? Even when we can identify the sitter, it does not necessarily help. In 1527 Lotto painted Andrea Odoni [255], and thanks to an inventory made five years later by Michiel,[28] we know the context in which the portrait hung. Going into the courtyard of Odoni's house, one encountered two colossal sculptures after the antique, heads of Hercules and Cybele by Antonio Minelli; on the next floor one found a draped classical statue, a Roman bust, and a number of mutilated heads and statuettes; and on the top floor was a little study with a collection of porphyry and crystal cups and vases carved from semiprecious stones. Adjacent to it was Odoni's bedroom, with a bed painted by Savoldo and furniture painted by a pupil of Titian, and in it there was an allegorical painting by Palma Vecchio—of a girl and an old woman, much the same subject as Giorgione's *Col Tempo*—and Lotto's portrait. Michiel fails to tell us whether the mutilated statuettes in the *salone* were ranged along a single shelf as they are here, but it is hardly credible that the bust and the draped torso were propped against a table in this way. So the painting is a construction, and its subject is not, like that of Titian's portrait of the antiquary Jacopo Strada [160], pride of ownership. What Odoni

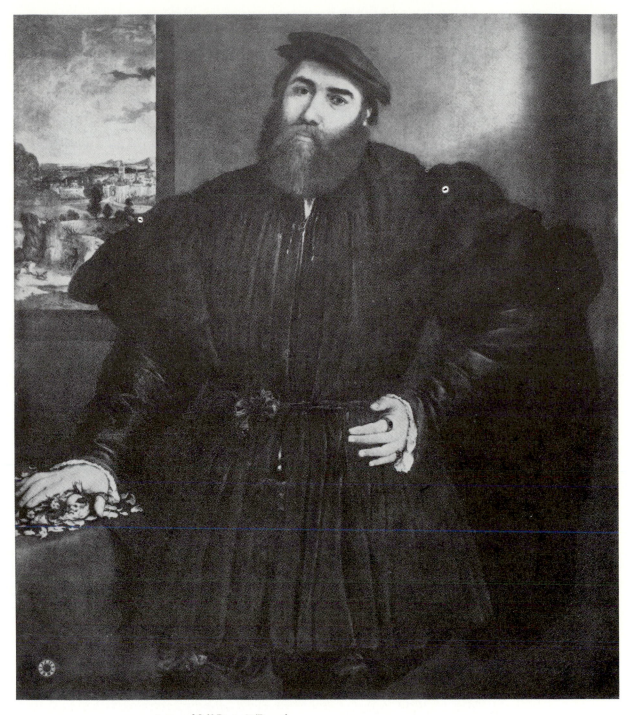

253. LORENZO LOTTO: *persumed Self-Portrait* (Rome)

254. LORENZO LOTTO: *Portrait of a Man* (Vienna)

255. LORENZO LOTTO: *Andrea Odoni* (Hampton Court Palace)

extends to us in his right hand is a statuette of Artemis Ephesia, Diana of Ephesus, which was commonly used as a symbol of Earth or Nature. It appears in this sense on the ceiling of the Stanza della Segnatura, and it is so described by Ripa. Perhaps in the portrait this meaning is retained, and the painting, as Burckhardt supposed,[29] illustrates the antithesis between nature and art. It may be that the thoughts behind Odoni's ruminative face center upon the destructiveness of time and the indignities to which the culture of the past has been exposed.

Of their nature emblems are intrusive, and even painters of Lotto's stature could not always integrate them satisfactorily in their designs. A painting by him in the Hermitage [256][30] shows a middle-aged couple on either side of a wide table. The man points with his right hand to a squirrel and holds a paper in his left, and the wife rests

256. LORENZO LOTTO: *Double Portrait* (Leningrad)

257. LORENZO LOTTO: Sketch for *Double Portrait* (Amsterdam)

258. ANDREA DEL SARTO: *Drawing of a Lady* (Florence)

259. ANDREA DEL SARTO: *Portrait of a Girl holding a Volume of Petrarch* (Florence)

her right hand on her husband's shoulder and holds a dog on her left arm. What lends this rather artificial painting its special interest is that we know the drawing from which it was evolved [257].[31] In it both figures are set diagonally to the picture plane, the man looking at the paper and the woman gazing outward wearily, with the arm holding the dog supported on the table edge. This scheme is by far the more natural of the two, and Lotto's motive in departing from it was more clearly to emphasize the pictorially inessential elements of the dog and squirrel and the *cartellino* with its puzzling inscription *Homo Nunquam*.

This problem was not peculiar to Lotto. In Florence it confronted Andrea del Sarto. If we knew him as a portraitist solely through the drawing of a lady in the Uffizi [258],[32] we might suppose him to have been a practitioner of the natural portrait, a sixteenth-century Degas. She sits in a solid wooden chair with one leg crossed over the other and a book resting on her knee, and looks up with parted lips as though in conversation with the artist who is drawing her. But the almost contemporary portrait of a girl in Florence [259] is treated very differently; her body is twisted above the waist, and she looks out coyly at the spectator, directing his attention to an open

260. AGNOLO BRONZINO: *Laura Battiferri* (Florence)

book. The poems inscribed in it are two of Petrarch's greatest sonnets. In one the poet begs mercy or death from his mistress, and in the other he describes her "sun-like radiance sublimely fair." It is very hard to associate the emotional tension of the first sonnet or the hyperbole of the second with the placid girl sitting in front of us, and we may suspect that her Christian name was Laura and that this accident was alone responsible for the pose.[33]

About 1555 the poetess Laura Battiferri was painted by Bronzino [260].[34] She was the wife of the sculptor Ammanati, and she and Bronzino exchanged many poems. But the open book which she displays to the spectator does not contain her poems or Bronzino's; it shows two poems by Petrarch—"Se voi poteste per turbati segni," where the poet entreats Laura not to hate the heart from which she is never absent, and "I'o pregato Amor," where he pleads excess of passion in palliation of his fault. Laura Battiferri must specially have admired these poems—they are not contiguous like the poems in the Sarto portrait, but are widely separated in editions of Petrarch's works—and once more they refer to the Christian name.

Bronzino's poems, as we might expect in Medicean Florence, are filled with tortuous mannerist conceits, and the same literary atmosphere permeates his paintings. In this his practice differs from Pontormo's. For Pontormo the human personality exists in a murky void. Attention is focused on the face, and the only detail that is admitted relates to the profession of the sitter—a volume of music in the case of Francesco dell'Ajolle [115] or an instrument for hard-stone carving in the portrait of a carver in the Louvre. Bronzino, on the other hand, portrays the individual in a setting—a physical setting, as those amazingly accurate views of the Palazzo Martelli and the Palazzo Capponi testify, and an intellectual setting, too. The intellectual setting could be built up by means of books—in the great portrait in Berlin [261] Ugolino Martelli has volumes of Bembo and Virgil and an open copy of the *Iliad*—or sculpture—the young man in a portrait in Florence has an inkstand with the bathing Susanna, and the lucky youth in a portrait in the Louvre fondles a figure of Fame—or it could take the form of a nest of images built round the figure—as it does about 1556 in the portrait of a widow in the Uffizi [262],[35] where a reduction from Michelangelo's *Rachel* on the Julius tomb stands on the table, and small figures from the Medici Chapel appear on the table edge. The significance of the *Rachel* is not in doubt. From the time that it was carved it was regarded as a statue of the Contemplative Life, and it is so described by Vasari: "Rachel, representing the Contemplative Life, with her hands clasped, her knee bent, and her expression one of ecstasy." There is no such certainty about the meaning attached in the middle of the sixteenth century to the allegories in the Medici Chapel. Contemporary warrant is supplied by Vasari and Condivi for interpreting the four allegories as the Times of Day, and in 1549 Benedetto Varchi declared that

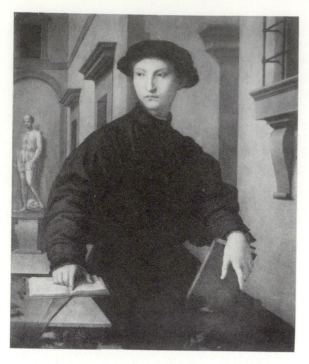

261. AGNOLO BRONZINO: *Ugolino Martelli* (West Berlin)

262. AGNOLO BRONZINO: *Portrait of a Widowed Lady* (Florence)

Michelangelo intended to signify through the allegories "that not just a hemisphere, but rather the whole world was a proper tomb for each of the two dukes." Though they were sometimes treated formalistically—two of them are incorporated in that spirit in Benvenuto Cellini's saltcellar—in their proper context they could only be regarded as funerary figures. The surface of Bronzino's paintings is imperturbable, and without this imagery the portrait would convey less clearly its message of bereavement and of the stoic resignation with which it has been sublimated.

On one blessed occasion a Florentine mannerist artist described the way in which he wished his painting to be read. The artist is Vasari, and the portrait is the celebrated likeness of Alessandro de' Medici [202]. The armor in which the Duke was clad, explained Vasari in a letter to Ottaviano de' Medici,[36] symbolized his readiness to defend his fatherland, and its luster characterized him as the mirror of his people. Behind him were ruined buildings intended to evoke the siege of Florence in 1530, and in the distance was a vision of the peaceful city over which he was to rule. The Duke's seat was circular because his reign and that of his successors would have no end, and the decoration of the stool contained an allusion to the arms of Florence, in the form of

263. GIOVANNI BELLINI: *Fra Teodoro da Urbino as St. Dominic* (London)

264. GIROLAMO SAVOLDO: *Portrait of a Lady as St. Margaret* (Rome)

lion's feet, and a mask representing volubility tethered by firm government. The blood which the Medici had shed on behalf of their city was evoked by a red cloak on the Duke's thigh, while a stem of laurel on the left represented the reviving Medicean dynasty, and a helmet beneath it denoted the eternal peace which the Duke's wisdom would confer upon the citizens.

Portraits accompanied by emblems abut on portraits in an ideal character, combined portrait and devotional paintings in which the sitters were invested with the emblems of figures from mythology or of their patron saints. Among religious orders the Dominicans attached special importance to the maintenance of accurate iconographical records; evidence of that can be found both in San Marco in Florence and at Treviso, where in the fourteenth century Tommaso da Modena painted a sort of Dominican portrait gallery. A consequence of this heritage is Giovanni Bellini's painting of Fra Teodoro da Urbino [263].[37] Fra Teodoro was a member of the community of SS. Giovanni e Paolo in Venice in 1514, and his name appears in large letters on the canvas. But in his right hand is the emblem of St. Dominic, a lily, and the name of

St. Dominic is inscribed on the copy of the rule held in the left hand. Toward the end of his life Titian seems also to have painted a portrait of his Dominican confessor as St. Dominic.[38]

It has been suggested that Raphael's *Donna Velata* was a painting of this kind—at all events, in a copy of it, owned in the seventeenth century by the Earl of Arundel and engraved by Hollar, the sitter held the palm and wheel of St. Catherine of Alexandria.[39] In a painting by Savoldo an unknown lady is similarly represented as St. Margaret with a dragon by her side [264].[40] The problem with these paintings is that the attributes were sometimes added later to a pre-existing portrait. This seems to have occurred with one of the most distinguished fifteenth-century examples, a painting by Botticelli at Altenburg in which a lady, possibly Caterina Sforza Riario, is shown with St. Catherine's palm and wheel.[41]

The most epoch-making of these portraits is secular. We first hear of it when Vasari, in Venice, visited the Patriarch of Aquileia and saw in his collection "a painting purporting to be a David with the head of Goliath," which was a self-portrait of Giorgione.[42] Vasari was sufficiently convinced of the validity of the tradition to include a reproduction of thè head in the second edition of his *Lives* as an authentic self-portrait, and the engraving by Hollar [266], through which the composition has come down to us, is perfectly consistent with that interpretation. If Hollar's engraving is to be believed, the portrait was stamped with great intensity, and that is confirmed by a fragment at Brunswick [265] which is all of the painting that survives.[43] In

265. GIORGIONE: *Self-Portrait* (Brunswick)

266. WENCESLAUS HOLLAR: Engraving after Giorgione's *Self-Portrait as David*

Florence the significance of the young David was part moral and part political; it is established by the inscription on Donatello's marble *David*: "To those who fight bravely for the fatherland the gods will lend aid even against the most terrible foes." But in Venice David the victor was less popular. Probably we shall never know why Giorgione depicted himself in this fashion, or to what conflict the portrait relates. But it is a curious fact that a century later another great painter, Caravaggio, whose debt to Giorgione was widely recognized, portrayed himself in precisely the same way, and that his example was followed by Bernini, who carved the face of the *David* in the Borghese gallery from his own features reflected in a mirror held up for him by Cardinal Maffeo Barberini.

The uses of self-dramatizing portraiture were limited, and it was left to Titian to develop from the allegory of the *David* a type of portrait whose appeal was deeper and more widespread. The supreme example of it is the *Flora* [267].[44] It is argued by Burckhardt,[45] possibly correctly, that the girl depicted is shown in her bridal dress. Pictorially the flowers perform the function of a metaphor in poetry. Without them this would be a splendid painting. "The neck," as Hazlitt says of another portrait of a girl by Titian, "is like a broad crystal mirror, and the hair which she holds so carelessly in her hand, is like meshes of beaten gold." But with the flowers it becomes a paean in praise of efflorescence, and it was so interpreted by Rembrandt, who saw it in 1640 in the house of a Portuguese collector at Amsterdam, and adopted the motif in the portrait of *Saskia with the Red Flower* at Dresden. In Venice itself it was continued by Palma, in an allegory of burgeoning youth which is less meaningful than Titian's because its focus is less secure.

Just occasionally the romantic imagination of one man imposed itself vividly upon his iconography. This occurred with the Genoese admiral Andrea Doria. Doria was born in 1466, and died in 1560 at the age of ninety-four. As a boy he left Genoa for Rome, where under the Cibo Pope, Innocent VIII, Genoese citizens were certain of preferment, and in the lifetime of Cesare Borgia he was already a figure of some prominence. The first great portrait that we have of him [268] was made shortly before the sack of Rome—on the strength of a letter from Francesco Gonzaga to Federigo Gonzaga in Mantua it can be dated to May 1526[46]—when for nine years he had been, directly or indirectly, in the service of Francis I of France. It was painted by Sebastiano del Piombo, and in it Doria, a rather saturnine figure, stands behind a sculptured parapet. The carvings show the prow of a trireme in the center, an akrotolion and anchor on the left, and an oar and rudder on the right, and were drawn from two pieces of a Roman marine frieze which still exist in the Stanza dei Filosofi of the Capitoline Museum.[47] With his right forefinger Doria points at the carving, as though establishing a claim to be ranked with the captains of antiquity.

267. TITIAN: *Flora* (Florence)

268. SEBASTIANO DEL PIOMBO: *Andrea Doria* (Rome)

269. PERINO DEL VAGA: *Loggia degli Eroi* (Genoa)

In 1528, after the sack of Rome, the French *condotta* expired, and Doria passed to the service of Charles V, returning in triumph to Genoa as first citizen. There he busied himself with the decoration of the newly built Palazzo Doria. Artists in Rome suffered much hardship in the years after the sack, and one of them, the painter Perino del Vaga, was recommended to Doria by an intermediary, traveled to Genoa, and began work in the palace. The principal frescoes he painted there are in the so-called Loggia of the Heroes, and represent earlier members of the Doria family, shown seated round the walls, wearing timeless classical armor, with an inscription that commemorates their services to Genoa [269].[48]

270. AGNOLO BRONZINO: *Andrea Doria* (Milan)

A public monument to Doria himself was projected at this time, but it was not completed—fortunately so, for it was entrusted to Bandinelli—and eventually it was set up at Carrara in an unfinished state.[49] What interest it has is iconographical; it shows Doria, almost in the nude, as Neptune with a dolphin at his side. This iconography was taken over in a painting by another Florentine artist, Bronzino [270]. The painting is not exactly datable, but may have been inspired by one of Doria's most celebrated exploits, the occupation of Tunis in 1535. At all events Vasari implies that it was painted before the death of Alessandro de' Medici, with whom Doria's relations were particularly close.[50]

Bronzino's image is much nobler than Bandinelli's—the system of modeling is Michelangelesque—and it agrees in all essentials with a medal of Doria struck in 1541. The medal was a token of gratitude from the sculptor Leone Leoni. After some years of employment at the papal mint, Leoni was accused in 1540 of plotting the murder of the papal jeweler, and was sentenced to the galleys for two years. When less than

half his sentence had been served he was rescued by Doria, and he forthwith prepared a medal showing Doria on one side (with the trident of Neptune at his back and a little dolphin beneath, the same emblems as in Bandinelli's statue), and on the other a portrait of himself surrounded by the chains which he had worn during his punishment. At the same time Leoni made an allegorical plaquette [271].[51] On the left is Andrea Doria in a car drawn by sea-horses, one of which shies at a sea-serpent, and on the right is Neptune waving him on. The meaning of the allegory is clarified by an inscription: ANDR. PATRIS AVSPICIIS [ET] PROPRIO LABORE (by his own efforts and with the aid of his father, Neptune). If any of these representations stood alone, we might suppose that the ideas in them originated with the artist. But when four artists as diverse as Sebastiano and Bandinelli and Bronzino and Leoni all concur in a uniform interpretation of Doria's personality, it is manifestly to the sitter that the uniformity is due.

Doria's portraits are public images, but the same thought processes could also be pursued in private portraits. Some of the most notable are of that mysterious figure Jean de Dinteville, lord of Polisy. The earliest of them is the great painting by Holbein known as the *Ambassadors* [274].[52] Its title is misleading because the picture arose not from a dual embassy but from a six-week visit paid by Georges de Selve, Bishop of Lavour, to his friend Dinteville, the French ambassador in London, in the spring of 1533. Dinteville himself arrived in London in the first week of February and returned to France, his mission accomplished, in November, and a year later De Selve became French ambassador in Venice. De Selve's appointment cannot have been anticipated when he was in England, and there is no case therefore for supposing

271. LEONE LEONI: *The Triumph of Andrea Doria*
(Washington)

272. HANS HOLBEIN THE YOUNGER: Jean de Dinteville, detail of the *Ambassadors* (London)

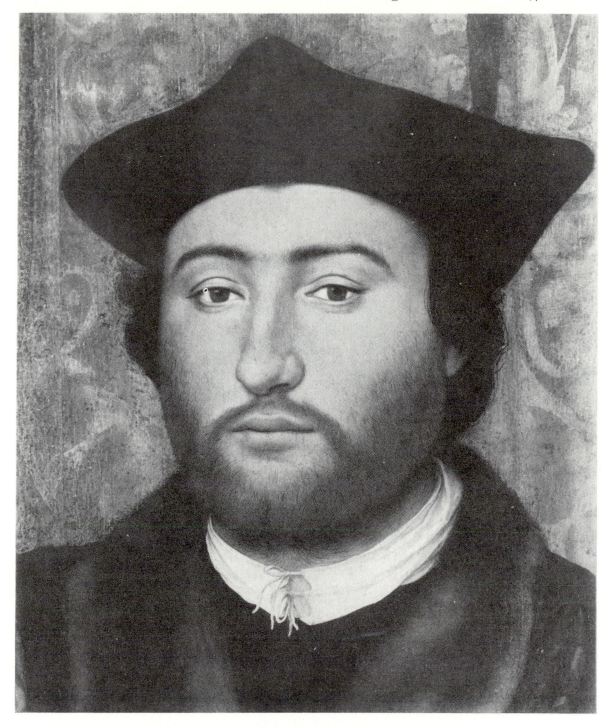

273. HANS HOLBEIN THE YOUNGER: Georges de Selve, detail of the *Ambassadors* (London)

274. HANS HOLBEIN THE YOUNGER: *The Ambassadors* (London)

that the picture (like the diptych which Erasmus presented to Sir Thomas More) was an attempt to compensate physical divorce by pictorial propinquity. Visually it consists of two psychologically discrete portraits [272, 273] which are united in a single emblematic scheme.

Though Dinteville's mission lasted a mere nine months, it was fraught with drama. A few weeks before he landed, the King was secretly married to Anne Boleyn, and the Pope, Clement VII, was threatening excommunication. In May his marriage with Catherine of Aragon was pronounced void by Cranmer, and Anne Boleyn was crowned Queen. Dinteville's brother, the Bishop of Auxerre, was French ambassador at the Vatican, and negotiations were in progress for the betrothal of the Duke of

275. FÉLIX CHRÉTIEN (?): *Moses and Aaron before Pharaoh* (New York)

Orléans, the second son of Francis I of France, to the Pope's niece. On the English side it was understood that the price which the Papacy paid for this alliance would be a more accommodating attitude toward the English royal marriage. But events developed otherwise, and a bilateral agreement was reached between France and the Papacy whereby the Pope secretly recognized the French claim to Milan and French religious policy developed in a militantly anti-Lutheran sense. Dinteville's last official task in London was to report the English king's resentment at what had taken place.

In the equation of the *Ambassadors* one term is unexplained, precisely why it was that Georges de Selve visited London. His visit was secret and official, official in that it was personally authorized by the King of France, secret in that news of it was to

be kept from Montmorency, the leader of the French clerical extremists. Dinteville and De Selve had it in common that both belonged to the party of moderate reformers. Entrusted with the upbringing of the Duke of Angoulême, Dinteville seems to have recommended the appointment as his tutor of Lefèvre, the author of the first complete translation of the Bible into French and an associate of the crypto-Lutheran Roussel. Similarly De Selve, acting as ambassador to Charles V in 1529, delivered at the Diet of Speyer views of a notably latitudinarian tendency. It is likely, therefore, that their conjunction in the painting is due to their involvement in the great religious crisis of their time and not to their common profession of diplomacy. That is corroborated by the emblematic content of the painting. Between the two figures is the symbol of discord, a lute with a broken string, beneath it is a German hymnbook, containing the first eight lines of Luther's translation of the *Veni Creator Spiritus*, and opposite it are the opening words of Luther's Ten Commandments, while the feet of both figures are firmly planted on a Cosmati mosaic pavement, which all contemporaries would have recognized as that of the sanctuary of Westminster Abbey. It cannot be established how the geometrical instruments above (some of them also occur in Holbein's earlier portrait of the astronomer Kratzer), the copy of Apian's *Newe und Wolhge-gründete Unterweisung alle Kauffmanns Rechnung* or the anamorphic skull[53] in the center are related to this scheme, but the fact that the curtain is drawn back on the left to reveal a crucifix leaves the religious connotation of the painting in no doubt. It could well be regarded as a solemn manifesto of compromise. A program on these lines would have been no less congenial to Holbein than to the men whom he portrayed, for in 1530, three years before the *Ambassadors* was painted, the reform movement reached Basel, and guild members, Holbein among them, were pressed to subscribe to the new faith. Sympathetic as he was toward reform, and hostile to the Papacy as we know him to have been, Holbein refused to communicate by the new rite until a satisfactory explanation of its nature was supplied.

When Dinteville returned to France, his personal position and that of his family appeared secure. But within four years they were menaced by the jealousy of the Duchesse d'Étampes, and in 1539 three of the four brothers, excluding Jean de Dinteville but including the seemingly impregnable Bishop of Auxerre, were forced to flee from France. By 1537 the cloud on the horizon was already visible, and in that year there was commissioned a companion piece to the *Ambassadors* [275]. The artist is unidentified—he was probably a Fleming; the attribution to Félix Chrétien is conjectural—but the subject is reasonably plain. It shows Jean de Dinteville in the center, as Moses, pointing to his brother the Bishop of Auxerre, as Aaron, before the seated figure of Pharaoh, whose features have more than a chance resemblance to those of Francis I. At the back, identified by inscriptions, are two younger brothers, Guillaume

276. PRIMATICCIO: *Jean de Dinteville as St. George* (Private collection)

and Gaucher de Dinteville.[54] The story of Aaron, the just priest, is presented as a parable of the career of François de Dinteville, who was threatened with expulsion from his diocese. Two inscriptions reinforce this point. One is from Genesis, "And Abraham believed in the Lord and he counted it to him for righteousness," while the other is the motto of the Dinteville family, "Fortune the companion of merit." The painting is by no means a great work of art, but its space structure depends from the *Ambassadors,* and its politico-religious symbolism offers an indication of the lines on which the *Ambassadors* should be interpreted.

As it happened, Jean de Dinteville's confidence in divine justice was warranted.

277. UNIDENTIFIED ARTIST: *Queen Elizabeth I* (Siena)

In 1542 François de Dinteville, who, like his brothers, enjoyed the support of the Dauphin and Diane de Poitiers, returned to France, and the family regained its ascendancy. And this climactic point was again depicted in a picture, painted this time by Primaticcio, probably in 1544, when he was working at Polisy [276].[55] It shows Jean de Dinteville alone, in the character of St. George, dressed in classical armor; his helmet is beside him and the head of the vanquished dragon is at his feet. The last glimpse we have of him is in 1552, three years before his death, when he was paralyzed and living in retirement at Polisy, where there were assembled these painted allegories of the three great crises of his career.

278. UNIDENTIFIED ARTIST: *Queen Elizabeth I* (Hatfield House)

Much the most consistent of these allegorist sitters was Queen Elizabeth, the imagery of whose portraits revolves, for almost half a century, round certain reiterated concepts, the most important of them virginity. The simplest personification of virginity is Diana the chaste huntress, and in 1558 we hear of Elizabeth before her accession to the throne assuming the part of Diana in a hunting contest on the edge of Hatfield Forest and receiving a silver-headed arrow made of peacocks' feathers. In France Diane de Poitiers was painted as Diana accompanied by a hound, and in England only seven years after the death of Queen Elizabeth a painting of Diana by a Dutch artist, Hendrik Vroom, could be mistakenly regarded as a portrait of the

279. NICHOLAS HILLIARD: *Portrait
of a Youth* (London)

Queen.[56] More to the Queen's taste than Diana was the vestal virgin, Tuccia, who established her virginity by carrying water in a sieve. According to Camden the sieve was the Queen's favorite device. In a portrait of about 1580 at Siena [277] she holds a sieve in her left hand.[57] Behind her is a pillar with scenes from the story of Dido and Aeneas, and beneath is an inscription from Petrarch's *Triumph of Love*: "Stanco riposo e riposato affano." The sieve also carried a political significance; it was used for sowing, and on the edge is an inscription reminding us that the sieve retains the chaff while the good seed falls through it to the ground. One of the ideas most deeply ingrained in the Elizabethan consciousness was that of empire, and an explicit reference is made to this in the same portrait by an imperial crown above the Queen's right arm. On the right, in a globe with the inscription, "I see everything and much is missing," the theme of territorial expansion implicit in this image is asserted once again.

In the two oil paintings of the Queen which are now commonly given to Nicholas Hilliard, the tide of realism ebbs. In one[58] she wears a jewel with a pelican piercing its breast to feed its young, and in the other [278][59] her sleeve is decorated with an ermine with a collar in the form of a crown, the same symbol which precedes the chariot of Laura in Petrarch's *Triumph of Chastity*, and she holds a sprig of foliage which has been identified as olive. In both paintings a schematic portrait head is super-imposed on an elaborate patterned dress covered with flowers and emblems. The

·280. NICHOLAS HILLIARD: *Portrait of a Youth* (London)

depth of the visible area is not defined, and the portrait is reduced to a flat pattern on the picture plane. It is as though in a long contest between the perceived image and the concept, the concept had at last gained the upper hand.

In the sixteenth century almost the whole of Europe suffered from an attack of what is known, in every language except English, as Petrarchism. In Italy it was led by Bembo and Serafino dell'Aquila in France, by the Pléiade, and in England by Wyatt. For the readers of Tottel's Miscellany in 1557 Petrarch was "the head and prince of poets all"; in 1569 the *Theatre for Worldlings* included adaptations of Petrarchan love poems; and Petrarch's example was fundamental for *Astrophel and Stella* and for *Amoretti and Epithalamion.* So it is not surprising that Petrarchan images should intrude repeatedly into the portraiture of Queen Elizabeth. What is more curious is that in England, two centuries after Petrarch's death, the Petrarchan love sonnet for the first and only time found a visual equivalent. Like the sonnet, the portrait miniature was a minuscule art form; like the sonnet, it was subordinated to a metrical scheme; and like the sonnet, it could become the incandescent record of an emotional relationship. Sometimes the exact context eludes us. It does so, for example, with that beautiful miniature [279] of a lover clasping a woman's hand emerging from a cloud, with the puzzling inscription "Attici amoris ergo."[60] But in other cases the symbolism is as universal and as comprehensible as the metaphors in Shakespeare's sonnets. This is so in the splendid miniature of an unknown man against a background with the flames

of passion, where the tongues of fire form a curtain behind the figure, and the youth looks languishingly at us as he displays a locket worn over the heart [280].[61] It is so also in Hilliard's greatest miniature, the *Youth leaning against a Tree* in the Victoria and Albert Museum [281], which carries across the top an inscription from Lucan's *De Bello Civili*: "Dat poenas laudata fides."[62] These words occur in a passage in which the eunuch Pothinus counsels the death of Pompey, and are rendered by Fletcher in the form: ·

> *And faith, though prais'd, is punish'd, that supports*
> *Such as good fate forsakes.*[63]

The roses in the foreground must consequently be interpreted as symbols of the joys and pains of friendship, and not as an allegory of love. But the magic does not reside in the idea alone; it springs also from the treatment of the pensive head, and from the sense, communicated by the foliage, of that joy in the embroidered surface of the natural world, to which the appeal of the Elizabethan lyric is in large part due.

281. NICHOLAS HILLIARD: *Portrait of a Youth leaning against a Tree* (London)

VI

Donor and Participant

In earlier chapters we have watched the independent portrait emerge from the collective portrait; have followed some of the stages by which the notion of the portrait as a record gave way to the modern concept of portraiture as an art form; have observed the early humanists scanning Roman coins and busts with the same intelligence and pertinacity that was brought to Latin texts; and have seen the stream of portraiture diverted by Leonardo, canalized by Raphael, broadened out by Titian. We have traced the influence of the will to rule upon the will to form, and have examined progressive experiments in psychological differentiation and attempts to bring the rendering of emotion into sharper focus by literary means. The donor portrait involves the whole of the period and many of the artists that have been discussed, but it presents a different imaginative problem from other types of portraiture: the depiction of the individual in the context of belief.

In the thirteenth century the donor portrait intrudes timidly into Italian painting, in the form of tiny figures at the bottom of painted crucifixes. Strictly speaking, the motive for their presence was not portraiture, but the wish to associate the gift with the individual who had donated it. Only in Giotto's generation do donor images acquire some of the character of portraits. Very occasionally, for some special reason, the portrait is enlarged; the most striking instance occurs in Simone Martini's St. Martin Chapel at Assisi, where the figures of the donor, Cardinal Gentile da Montefiore, and of St. Martin, the patron of the chapel, are depicted on one and the same scale. But it remained the normal practice to use the element of size to differentiate the donor from other figures. It would have been unsuitable had the donor impinged upon the action of the altarpiece, and the disparity in scale between the sacred figures and the figures of the men who had called them into being reflects the spiritual values by which they were inspired.

In 1425 this tradition came to a sudden close, and the relation of the donor portrait to the sacred scene was revolutionized. The painting in which this occurred, Masaccio's

fresco of the *Trinity* [282], is one of a group of works in which religious iconography was reinterpreted in realistic terms. The group includes Donatello's relief of the *Assumption*, where the Virgin is represented as an aged figure carried to heaven by athletic angels on a small wooden seat, and Donatello's relief of the *Ascension*, where the imagery is again thought out afresh. Masaccio's *Trinity* is that rare thing, a completely novel painting. It is novel in its perspective structure—the delineation of the space and its projection on the wall seem to have been planned by Brunelleschi; it is novel in its iconography, which represents a Golgotha Chapel or the tomb of Christ; and it is novel lastly in its employment of the donor portrait,[1] for not only are the portraits of Lorenzo Lenzi and his wife on the same scale as the figures of God the Father, the crucified Christ, the Virgin and St. John inside the chapel, but they are accorded greater prominence than the religious figures. Set in the real world of the church, they serve to make the insecurely rendered scene in the interior of the chapel more credible.

What exactly were the forces which impelled the experiments in iconography made by Donatello and Masaccio during the fourteen twenties we do not know. All that is certain is that they were short-lived. By 1435 the movement was already spent, and thereafter through the middle of the century the regression from a realistic style is reflected in a change in the status of the donor portrait. There are donor portraits by Fra Filippo Lippi, of course; in the portrait of Francesco Maringhi in the *Coronation of the Virgin* [53] some lingering memory of the realistic aspiration of the first generation of Florentine Renaissance artists can still be felt. But the later portrait head of Gemini-ano Inghirami in Lippi's *Death of St. Jerome* at Prato [283] is less aspiring and less well observed, and the figure is once more less realistic than the imaginary figures round the bier. With this return to medieval practice, the scale of donor portraits is reduced. In Lippi's Alessandri triptych in the Metropolitan Museum the figures shrink to Lilliputian size, and in the *Annunciation* in the Galleria Nazionale in Rome [284], they are segregated in a little box, as though their right to be included in the painting was once more in doubt. In the whole work of Fra Angelico the only certain donor portrait is the conventionalized figure of the Dominican Cardinal Torrecremata in the *Crucifixion* in the Fogg Museum, and there are no donor portraits at all in the surviving altarpieces of Castagno, or Domenico Veneziano, or Baldovinetti. Even Piero della Francesca, who is revealed in the Arezzo frescoes as a portrait painter of great power, depicts the votive figures beneath the cloak of the Madonna of Mercy at Borgo San Sepolcro as mannikins with particularized heads.

Perhaps the portraits in the *Trinity* reflect some knowledge, on the part of Lenzi or the painter, of Flemish portraiture. At all events, within a decade the course of the donor portrait in the Netherlands was set by Jan van Eyck on somewhat the same lines in an altarpiece commissioned about 1435 for Notre Dame at Autun, depicting

282. MASACCIO: *The Trinity* (Florence)

283. FRA FILIPPO LIPPI: *The Death of St. Jerome* (Prato)

284. FRA FILIPPO LIPPI: *The Annunciation* (Rome)

285. JAN VAN EYCK: *The Chancellor Rolin before the Virgin and Child* (Paris)

the Chancellor Rolin kneeling before the Virgin and Child [285]. As in the *Trinity*, the donor portrait is the more emphatic and more credible component of the group. When Jean Jouvenel des Ursins was painted by Fouquet, in the left wing of a diptych of which the right side contained a Virgin and Child, the same ratio between the real and the unreal figures was preserved.[2] It was maintained also by Rogier van der Weyden, in a succession of diptychs in which a donor and a Virgin and Child are represented in separate panels in half length, and was continued by Memling, who some-

286. HUGO VAN DER GOES: *The Portinari Altarpiece* (Florence)

times sets the figures in a unitary setting and sometimes shows them on a neutral ground.

Florentine frescoes cycles commonly included portraits, but the Flemish practice of donor portraiture was distinct from the commemoration of the family in frescoes; it provided an occasion for personal commemoration which paid tribute to the devotion of the individual, ministered to his self-importance, and supplied a record of his physique. For Tuscan merchants in the Netherlands these paintings exercised an irresistible appeal. In Florence the vogue for donor portraiture acquired momentum after 1476, when an altarpiece by Hugo van der Goes with portraits of the donor and his wife and children on the insides of the wings was commissioned by Tommaso Portinari for Santa Maria Nuova [286]. The first local response to the new fashion occurs in 1488 in an altarpiece painted for Santo Spirito by Filippino Lippi, where portraits of the donors, Tanai de' Nerli and Nanna Dina de' Capponi, are included at

287. FILIPPINO LIPPI: *The Virgin and Child with the Young St. John and Two Saints* (Florence)

the sides [287].[3] In the form in which it us used here the motif of the saint presenting the donor to the central group derives from Van der Goes' Portinari altarpiece, but the portraits of Tanai de' Nerli and his wife also seem to imply some knowledge of the work of Memling, and bear a remarkable resemblance to the portraits of Angelo Tani and his wife on the exterior of the Danzig altarpiece. The head of Nerli is notably

288. FILIPPINO LIPPI: Pier Francesco de' Medici, detail from the *Adoration of the Magi* (Florence)

289. FILIPPINO LIPPI: Cardinal Caraffa, detail from the *Annunciation* (Rome)

more solid than the linear portraits that Filippino Lippi painted not long before in the Brancacci Chapel.

Once it was readmitted, the donor portrait tended to monopolize the scene. Both Gozzoli and Botticelli testify to the Florentine tradition whereby portraits were included in paintings of the Adoration of the Kings. This practice was continued by Filippino Lippi, but with the difference that in the altarpiece of the *Adoration of the Magi* of 1496 one of the spectator portraits [288] takes on a prominence which might suggest the scene is re-created in his imagination or re-enacted for his benefit. The heavy-jowled, self-indulgent head of Pier Francesco de' Medici reads like a Netherlandish portrait,[4] and its function in the painting is exactly that of the Chancellor Rolin in Van Eyck's altarpiece of sixty years before. In Filippino Lippi's *Annunciation* in the Caraffa Chapel in Santa Maria sopra Minerva in Rome the kneeling figure of Cardinal Caraffa at one side operates in rather the same way [289].[5]

Filippino Lippi is a progressive artist whose work often foreshadows High

290. RAPHAEL: Sigismondo de' Conti, detail from the *Madonna di Foligno* (Vatican)

Renaissance style, and it does so in this donor portrait, which must have been familiar to Raphael when he produced the donor portrait of Sigismondo de' Conti in the *Madonna di Foligno* [290].[6] The *Madonna di Foligno* is a votive painting; it was designed about 1511 for the Aracoeli, the church chosen by Conti as his place of burial, and commemorates his miraculous escape when a meteor fell on his house. The relationship between the figures is not, therefore, the impassive relationship between Caraffa and the Virgin Annunciate, but an animate relationship, in which Conti, supported by his patron saints, implores the protection of the Virgin and Child. The placid domestic character of Filippino's iconography is transformed by the heroic elevation of the central group, and the head has a coherence and an intellectual absorption which make it the finest donor portrait painted in Italy in the ninety years that had elapsed since the figure of Lorenzo Lenzi in Masaccio's *Trinity*.

Only a figure of some eminence could claim the public affirmation of a votive portrait. Federigo da Montefeltro did so in the altarpiece by Piero della Francesca which is now in the Brera Gallery at Milan [291], and so did Gian Francesco Gonzaga in the *Madonna of Victories* by Mantegna in the Louvre [294]. Despite the rich documentation of the Urbino court we do not know exactly why Piero's altarpiece was painted. An old tradition connects it with the birth of the Duke's son Guidobaldo in

291. PIERO DELLA FRANCESCA: Federigo da Montefeltro, Duke of Urbino, detail from the *Virgin and Child with Saints* (Milan)

292. PIERO DELLA FRANCESCA: Fra Luca Pacioli as St. Peter Martyr, detail from the *Virgin and Child with Saints* (Milan)

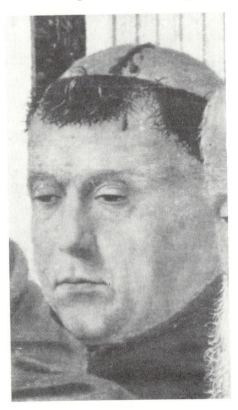

293. UNIDENTIFIED ARTIST: *Fra Luca Pacioli* (Naples)

1472, but nothing in the iconography save the appearance of an ostrich egg above the Virgin's throne lends color to that view.[7] In a prominent position before the throne are the Duke's helmet, gauntlets, and baton, which might suggest that the painting was commissioned after his appointment as Gonfaloniere of the Church in 1474, though he is shown without the Order of the Garter, to which he was appointed in that year. It was destined for the Montefeltro church of San Donato, and only after Federigo's death was it set up in the newly founded San Bernardino, where its rich architecture was in striking contrast to Francesco di Giorgio's comparatively modest scheme. Some change of intention may be inferred from the fact that the figures of San Bernardino and of St. Peter Martyr opposite are afterthoughts interpolated by the artist. The portrait of the Duke in the foreground of this painting has been criticized because it is less abstract than the head in the Urbino diptych of about ten years before.

The reason for the change is that in the interval Piero's sympathy for Flemish painting had increased. The Duke is represented in the earlier painting as ruler, and in the later as a suppliant in the divine presence, and it could well be argued that the later portrait, though more descriptive, is the more profound and more expressive of the two.

It is symptomatic of the realistic trend of Piero's later work that the Brera altarpiece should also include a second portrait in the interpolated head of St. Peter Martyr [292], which represents the mathematician Fra Luca Pacioli.[8] In another painting of Pacioli [293], made by an unknown artist at Urbino, he is depicted expounding Euclid.[9] To the left is a slate, on his desk are a pair of dividers and a set square, and on the extreme right is a copy of his book the *Summa Arithmetica*, which was completed in 1495 and was dedicated to Guidobaldo, Duke of Urbino. The picture is full of fascinating fragmentary detail—a window is, for example, reflected in the polyhedron suspended at the side—but the treatment of Pacioli's head is immobile. To turn from this face, with its schematic forehead and arcs of eyelid above the eyes, to the face of Pacioli in the altarpiece is to appreciate how subtle a portrait painter Piero became in these last works. The unerring grasp of the structure of the face, the delicate shading of the corners of the mouth, the sense of intellectual eminence which colors the whole image makes this one of the peaks of quattrocento portraiture.

On Mantegna's *Madonna of Victories* we are better informed.[10] It was planned in expiation for the unauthorized removal of an earlier religious painting, and originally it was to show the Madonna of Mercy with figures of the Marquess of Mantua, Gian Francesco Gonzaga, his brothers, and his wife, Isabella d'Este, seeking protection beneath her cloak. In July 1495, however, there occurred the Battle of Fornovo, in which Gian Francesco Gonzaga, at the head of the papal, imperial, and Venetian troops, defeated the forces of Charles VIII of France; the Madonna of Mercy protecting the whole Gonzaga family therefore became a votive painting, in which the only portrait was that of the Marquess [294]. The Virgin was now accompanied by two military saints, St. Michael and St. George, Longinus (whose spear had been presented to Pope Innocent VIII three years earlier in 1492), St. Andrew, and the patron saint of Isabella d'Este, St. Elizabeth. The altarpiece is not, however, an orthodox Madonna with a subsidiary donor portrait: it is the kneeling figure of the Marquess that is the focus of the scene. To the Marquess the Virgin accords protection with her outstretched right hand, to the Marquess the Child's gesture of benediction is addressed, and on the Marquess the gaze of the two military saints is turned. All that is preserved of the original conception is the extended cloak, against which the figure of the donor is shown foreshortened and in silhouette. We know from sculptured portraits that Gian Francesco Gonzaga's features were strongly marked,[11] with big protuberant eyes and sensual lips, and in Mantegna's painting their coarseness is not concealed.

294. ANDREA MANTEGNA: Gian Francesco Gonzaga, Marquess of Mantua, detail
from the *Madonna of Victories* (Paris)

295. HANS HOLBEIN THE YOUNGER: *Jakob Meyer* (Basel)

But they are sublimated in the rapture with which the figure greets the vision of the Virgin and the Child. In the *Cortegiano* Castiglione ranks Mantegna beside Leonardo, Raphael, Giorgione, and Michelangelo, as one of the contemporary artists whose styles were dissimilar but who were each most perfect of their kind. Before many of Mantegna's paintings that view would be difficult to justify, but this work establishes his claim to be looked on as a pioneer of High Renaissance portrait painting.

It has been claimed that when Mantegna designed the *Madonna of Victories*, he adapted motifs from Leonardo's *Madonna of the Rocks*, and it has been claimed that in 1528, when Holbein designed the Madonna of Mercy known as the *Meyer Madonna*,[12] he adapted motifs from Leonardo, too. Holbein may, however, have been familiar at first or second hand with Mantegna's altarpiece. He had painted Jakob Meyer at the height of his civic authority in Basel in 1516, in a prosaic, worldly paint-

296. HANS HOLBEIN THE YOUNGER: *The Meyer Madonna*
(Darmstadt)

ing [295] conceived in the idiom in which he had been trained. But by 1528 the enrich-
ing experience of the Erasmus portraits and of the *More Family* lay behind him, while
in the painting of his wife and children he had made new strides in the integration of
psychology and form. The right side of the *Meyer Madonna* [296], with the portraits
of Meyer's first and second wives and of his daughter Anna, is conventional, but the
left side, like the portrait of the artist's wife and children, is a closely compressed
pyramid. Meyer's religious outlook was orthodox—that is to say, he was opposed to
the reforming movement—and the picture (which was probably painted for the chapel
of the Weiherhaus Gross-Gundeldingen outside Basel) must have been intended as
an affirmation of his beliefs. It would be dangerous to infer that the difference between
the secular head of Meyer of 1516 and the more spiritual head of 1528 reflects a change
wrought by vicissitude, but it offers indisputable proof of the ripening of Holbein's

297. LUCAS CRANACH THE ELDER: *Cardinal Albrecht of Brandenburg
kneeling before the Crucified Christ* (Munich)

perceptions as a portraitist. It is interesting to compare this painting with the altar-
piece of *Cardinal Albrecht of Brandenburg before the Crucified Christ*, which was painted
by Cranach in the mid-fifteen twenties for Aschaffenburg [297],[13] where the scheme
depends from the conventional type of St. Jerome before the Crucifix. The features
of the Cardinal are not studied from the life but are imitated from a Dürer print of 1519,
and while the head of Christ is turned compassionately downward to the Cardinal,
there is no reciprocal relationship between the Cardinal and Christ.

In Venice there was a local iconographical tradition whereby the Doge was shown
kneeling before the Virgin and Child. It went back at least to the fourteenth century,
and it was carried on in the fifteenth by Giovanni Bellini, in a great painting at Murano,

298. GIOVANNI BELLINI: Doge Agostino Barbarigo, detail from the *Virgin and Child with Saints* (Murano)

where the Doge Agostino Barbarigo is presented by the patron saint of Venice and his titular saint, Augustine, to the Virgin and Child [298].[14] Barbarigo was elected Doge in 1486, two years before the altarpiece was painted, and the portrait Bellini made of him is remarkable for its nobility. Exalted by his office, he begs for the gifts of divine grace and wise judgment indispensable for the well-being of the state he is called upon to rule. This iconographical tradition must have been present in the minds of the German community in Venice when they commissioned their altarpiece of the *Feast of the Rose Garlands* in San Bartolomeo in Rialto from Albrecht Dürer. In Dürer's painting, now in Prague, the format is once more oblong and the Virgin and Child are once more set beneath a vertical canopy. The theme none the less differs from Bellini's. It comes instead from a woodcut in the *Büchlein der Rosenkranzbruder-schaft*, which was printed at Cologne in 1476.[15] In the presence of spectators the Virgin and Child are shown conferring rose garlands on the kneeling figures. This entailed a change in the nature of the portraits, for where Bellini's Agostino Barbarigo is staid and immobile, Dürer's figures (and especially the ancillary figures at the sides) are more emotional and more involved [299, 300]. The only contemporary reaction to the painting of which we have a record—it occurs in a letter from the artist—relates to its color, but still more striking must have been the sense of personal commitment that Dürer imposed on the participants. Owing to its sadly deteriorated

299. ALBRECHT DÜRER: *The Feast of the Rose Garlands,* detail of left side (Prague)

300. ALBRECHT DÜRER: Male portrait, detail from the *Feast of the Rose Garlands* (Prague)

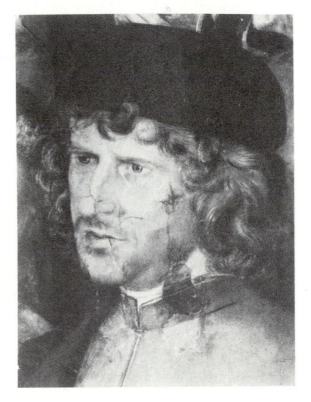

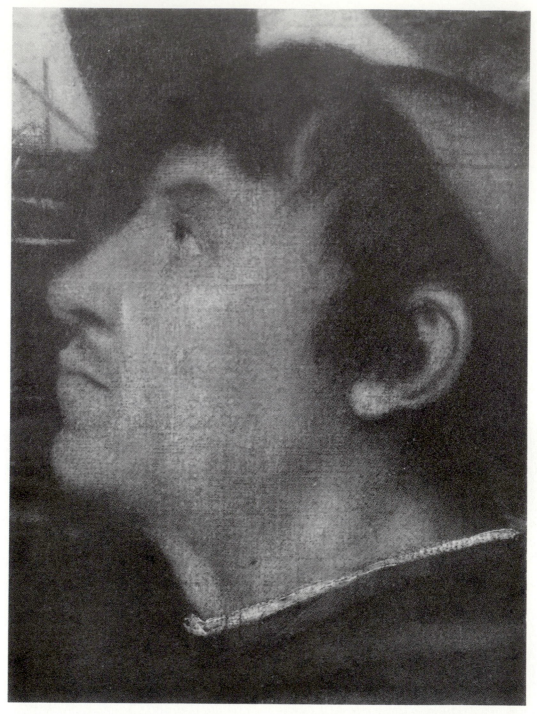

301. TITIAN: Jacopo Pesaro, Bishop of Paphos, detail from *Jacopo Pesaro before St. Peter* (Antwerp)

state, it is hard nowadays to recapture this aspect of the altarpiece, but if the requisite allowance is made for areas of damage and repainting, we can still gain some impression of the spiritual urgency of the portrait heads. In the staid world of Bellini's altarpieces this factor was of startling novelty, and it has some relevance to the style of Titian in the Pesaro altarpiece and in the *Vendramin Family*.

When Titian was commissioned to produce a record of the part played by Jacopo Pesaro, Bishop of Paphos, in the naval victory of Santa Maura in 1502, the convention to which he had recourse was that of Bellini's Murano altarpiece.[16] Pesaro, who had commanded the papal galleys, kneels before St. Peter, holding in his hand the standard entrusted to him by the Pope, Alexander VI. His eyes are turned up to the saint, and his face [301] is tense and grave. The sense of drama is limited to this single head— the Pope's countenance is inexpressive and the saint's is still conceived in the generalized, luministic idiom of Bellini—and this is one reason for supposing that the donor portrait does not date from the time of the commissioning of the altarpiece, but was repainted some ten years later, about 1515.[17] In the interval the *Feast of the Rose Garlands* was finished, and Titian himself, in a whole series of independent portraits, had refined his portrait style. In the head of Pesaro these changes for the first time affect the Venetian votive portrait.

Presumably the repainting of the head was undertaken at the instance of Pesaro

302. TITIAN: Jacopo Pesaro, Bishop of Paphos, detail from the *Pesaro Altarpiece* (Venice)

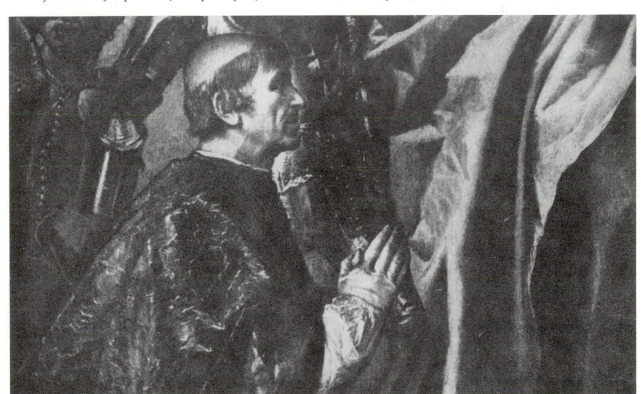

himself, and it is Pesaro again who is the central figure in the painting that marks the second phase of Titian's contribution to the donor portrait. The altarpiece resulted from specially close thought—it occupied the painter for almost seven years[18]—and Pesaro [302] is segregated on the left as the protagonist, presenting to the Virgin and Child the same standard as in the earlier picture. The head is realized with extraordinary intensity and the light on the corselet of the armed man at the back gives it the same prominence that a halo accords to the figure of a saint.

Five further portraits on the right [303] are incidental to the scene. They include three senators of the Pesaro family, one of whom, Benedetto Pesaro, had died in 1503, and two more heads which are also likely to be posthumous and may well be based on earlier heads by Gentile Bellini. These spectator portraits undeniably detract from the movement and drama of the painting. Yet not for twenty years did Titian apply himself to the planning of a group in which all the actors are participants in the full sense. The work in which he does so is the *Vendramin Family* in London [304].[19] In

303. TITIAN: Members of the Pesaro family, detail from the *Pesaro Altarpiece* (Venice)

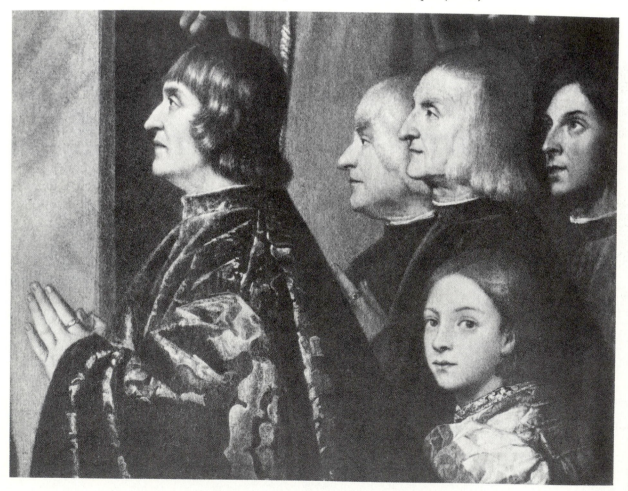

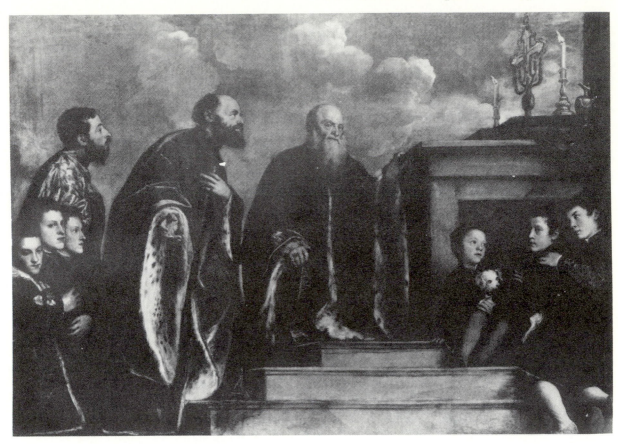

304. TITIAN: *The Vendramin Family* (London)

the mid-fourteenth century their ancestor, Andrea Vendramin, had presented a reliquary of the True Cross to the School of St. John the Evangelist in Venice, and had become involved in at least two miraculous occurrences arising from it, which are recorded in paintings executed for the School. Titian's subjects are Andrea's sixteenth-century successors, the merchant Gabriele Vendramin in the center; his younger brother Andrea beside him, and his nephew, Leonardo, in profile at the left. With the younger members of the family, sons of Andrea, they kneel before the relic, which is exposed on an altar on the right. One of the three bearded figures, Gabriele Vendramin, gazes out at the spectator, while the heads of Andrea and his son are absorbed in an act of invocation more powerful in its effect for the contrast with the three playing children at the side.

Titian was the first great child portraitist. He becomes so in the fifteen forties in

the sensitive painting of the boy Ranuccio Farnese in Washington [305][20] and in the enchanting portrait of Clarice Strozzi in Berlin,[21] where the sedate figure of the little girl is juxtaposed with a classical relief of playing putti. His special responsiveness is revealed once more in the *Vendramin Family* in the third boy from the right, the only one of the three figures of children in the painting whose head is well preserved. Titian's view of the child as an aspirant adult, and of the family portrait as a meeting point of generations, eluded Tintoretto—there was, it seems, no room for the child portrait in Tintoretto's austere emotional world—but was handed on to Veronese, who developed it about 1555 into the beautiful portrait of Giuseppe da Porto with his son Adriano standing shyly at his feet [306].[22]

The *Feast of the Rose Garlands* was not the only statement made by Dürer on the participant portrait, for five years after it was finished, he started work on the *Adoration of the Trinity* for the Chapel of the Zwölfbrüderhaus at Nuremberg.[23] It contains a series of incomparable portraits, notably one of the donor, Matthias Landauer, on the extreme left [307]. It is perhaps the preliminary drawing [308] that speaks more clearly than the painting, and that reveals the imaginative act through which the portrait image and the religious content of the scene were reconciled.

One of the minds on which this painting made an indelible impression was that of Charles V. When Titian was at the imperial court in 1551, he had "constant access to His Majesty," and from these conversations there sprang up in the Emperor's

305. TITIAN: *Ranuccio Farnese* (Washington)

306. PAOLO VERONESE: Adriano, son of Giuseppe da Porto, detail from double portrait (Florence)

307. ALBRECHT DÜRER: Matthias Landauer, detail from the *Adoration of the Trinity* (Vienna)

308. ALBRECHT DÜRER: Study for the head of Matthias Landauer in the *Adoration of the Trinity* (Frankfort on the Main)

mind the vision of an Adoration of the Trinity painted by Titian. Vasari's account leaves little doubt that the initiative lay with the Emperor, not the artist. This is what Vasari says: "At Venice he did for Charles V a large altarpiece of the Trinity with the Virgin and Child, the dove above and a background of fire representing Love, the Father surrounded by burning cherubim, with the emperor on one side and the empress on the other wrapped in shrouds, praying with clasped hands, as the emperor directed. Charles was then at the height of his prosperity, and had begun to betray his intention of withdrawing from the world, as he subsequently did. He told Titian that he wanted this picture for the monastery where he afterwards ended his days."[24] In this way there came into being the great painting known as the *Gloria*. Unlike Dürer's *Adoration of the Trinity*, it was planned on a public plane, and whereas with Dürer the upper figures round the Trinity are prophets and the portraits are confined to the

larger figures in the lower register, with Titian the social hierarchy is reversed, and the ecstatic imperial portraits—of the Emperor Charles V, the Empress Isabella, Philip II, and Mary of Hungary—are shown above on a small scale, as though after death, in direct communion with the Trinity. From the standpoint of the portrait the *Gloria* is no more than an interesting document, and the same is true of the portrait sculptures of the families of Charles V and Philip II which Pompeo Leoni executed later in the century for the Escorial,[25] where the figures are shown, not after death in mystical adoration of the Trinity, but before death, physically present at the Mass.

The limitations of Titian's *Gloria* as portraiture are common also to the altarpiece in the Escorial which was known in 1657 as the *Gloria* of El Greco.[26] In this painting, an allegory of the Holy League in which its leaders, Philip II of Spain, the Doge of Venice, Alvise Mocenigo, and Pope Pius V, are shown with three of its military commanders adoring the Name of Jesus, the figures are sufficiently particularized to establish the meaning of the painting but are not conceived as portraits in the full sense. None the less it was El Greco in a later painting, the *Burial of the Conde de Orgaz* of 1586,[27] who contrived, more successfully than any painter save Dürer, to incorporate a whole series of fully studied portraits into a religious scene [309]. The portraits are intrusive in so far as they are supernumerary to the essential action of the painting.

309. EL GRECO: Antonio de Covarrubias and two companions, detail from the *Burial of the Conde de Orgaz* (Toledo)

310. ANTONIO LOMBARDO: *Miracle of St. Anthony of Padua* (Padua)

Yet it is through the absorbed minds of these spectators that we view the mysterious event. One of the few who can be identified with confidence is Antonio de Covarrubias, an elderly figure on the right, of whom Greco, twelve years or so later, painted an independent portrait.

With the *Burial of the Conde de Orgaz* the donor portrait merges into the rather different category of intrusive portraiture. Some of the most remarkable Venetian portraits in this class occur quite early in the century in the Scuola del Santo at Padua. Considering their pivotal place in the history of Italian painting, we know extremely little about the Padua frescoes. So far as can be judged, they were reactive. At the very beginning of the sixteenth century, in 1501, a cycle of large marble reliefs of scenes from the life of St. Anthony was commissioned for the newly built chapel of the saint in the church of Sant'Antonio [310]. They were antiquarian in intention, and it was prescribed that all the artists who worked on them should follow a rigidly classicizing style. To the uninitiated they would suggest that St. Anthony lived and performed his miracles in the second century A.D. When work started in 1509 on a series of frescoes of scenes from the life of St. Anthony in the upper hall of the Scuola, near the church, a contrary policy was followed; the figures were clothed in contemporary dress. St. Anthony, it seems from these scenes, lived in the early sixteenth century. All the frescoes are filled with portraits, even where they are the work of

311. TITIAN: *Miracle of the New-Born Child* (Padua)

artists devoid of any natural gift for portraiture. This decision preceded Titian's inter-
vention in the frescoes. But in the three frescoes he painted for the school in 1510 and
1511[28] we are immediately aware that the portraits are designed to lend the scenes an
added authenticity. The names of the donors of the frescoes are not recorded in the
payments of the School, but the lady who is depicted as the mother in the *Miracle of
the New-Born Child* [311] may well be the same whom Titian painted about 1510 in the
famous portrait in the National Gallery in London [148].

The task of animating portraits presupposes on the artist's side a relentless grasp

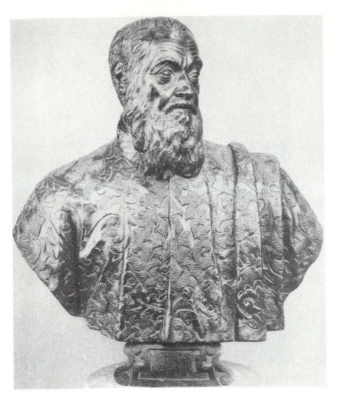

312. ALESSANDRO VITTORIA: *Tommaso Rangone* (Venice)

313. JACOPO TINTORETTO: Tommaso Contarini supporting St. Agnes, detail from the *Martyrdom of St. Agnes* (Venice)

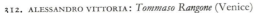

of the sitter's visual identity. That was denied to Tintoretto. There are some fine active portraits in Tintoretto's paintings—one of the best is the figure of Tommaso Contarini supporting the saint in the *Martyrdom of St. Agnes* in the Madonna dell'Orto [313][29]— but nowhere is the focus as sharp as Titian's. With Titian they are the means by which the entire scene is given a contemporary relevance, whereas with Tintoretto they intrude into a timeless narrative. A type case is that of the portraits of the doctor Tommaso Rangone. Rangone's appearance is familiar from two portrait sculptures, a full-length figure by Sansovino which was installed on Rangone's tomb over the entrance to San Giuliano in 1557,[30] and a bronze bust made by Vittoria for the interior of San Geminiano, for whose restoration Rangone was also responsible [312].[31] The two sculptures are some of the most penetrating portraits of their time, and we cannot but ask ourselves what Titian might not have achieved had he recorded this noble, strongly characterized face. Instead, Rangone's choice fell upon Tintoretto. Tintoretto's early reputation rested on a canvas with a Miracle of St. Mark which he had

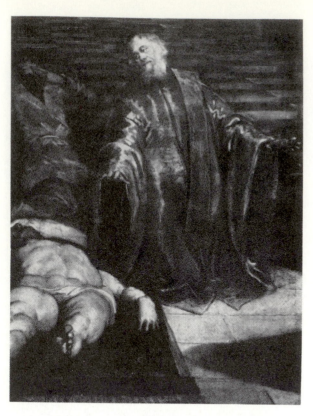

314. JACOPO TINTORETTO: Tommaso Rangone, detail from the *Finding of the Body of St. Mark* (Milan)

315. JACOPO TINTORETTO: Tommaso Rangone, detail from the *Removal of the Body of St. Mark* (Venice)

316. PAOLO VERONESE: *Portrait of Daniele Barbaro* (Florence)

317. PAOLO VERONESE: Marcantonio Cogoli, detail from the *Adoration of the Magi* (Vicenza)

painted for the Scuola Grande di San Marco in 1548. Fourteen years later Rangone volunteered to underwrite three further canvases by Tintoretto for the School.[32] He was actively engaged in impressing his own image on the Venice of his time, indirectly through his commissions and directly through his own likenesses, and he made one condition, that his portrait should appear in all of them. And so it does. In the *Finding of the Body of St. Mark*, Rangone, in the center, expresses pious wonder at the miracle [314]; in the *Removal of the Body of St. Mark* he is seen supporting the shoulders of the corpse [315]; and in *St. Mark rescuing a Saracen* with one arm in the water he assists a shipwrecked mariner. So far from investing the three paintings with heightened actuality, the portraits introduce an element that is only a hair's breadth removed from the absurd.

Veronese performed the same task with greater competence. He was not a face-painter like Tintoretto, and his independent portraits [316] are more decorative and more opulent. But more often than not, once the head is excised from its setting, it looks nerveless and a little dull. Analysis was alien to the cast of Veronese's mind. Yet when his heads are animated, they shed much of their flaccidity and take on a new liveliness. Some of them, like the fine portrait of Marcantonio Cogoli as one of the Three Kings in the *Adoration of the Magi* at Vicenza [317],[33] have the spontaneity of action photographs. Moreover, Veronese, unlike Tintoretto, had a masterly control of the inflections of the countenance, so that the portrait head in some cases takes the full weight of meaning in the scene. One subject in which it does so is that of the centurion welcoming Christ with the words of the Communion: "Lord, I am not worthy that thou shouldest enter under my roof." Like the *Gathering of the Manna* and the *Last Supper*, it had a Eucharistic relevance, and the head of the centurion,

318. PAOLO VERONESE: *Christ and the Centurion* (Madrid)

319. PAOLO VERONESE: Bartolomeo Borghi, detail from a *Miracle of San Pantaleon* (Venice)

invariably a portrait, was in effect the head of a communicant. Through the sharply realized features of the Contarini donor in the magnificent version of this subject in Madrid [318][34] the Gospel narrative is transformed into a personal experience. One of Veronese's most moving portraits occurs in a later, less public painting. The subject is Bartolomeo Borghi, the rector of the Venetian church of San Pantaleon, and he is shown bending tenderly over a dead boy whom San Pantaleon restores to life [319].[35] There is nothing ostentatious or rhetorical about this image; it shows the priest in the role he played in life, his features stamped with pastoral solicitude.

The subject of Christ and the Centurion is one aspect of a great continuing theme of the participant portrait, the individual in physical contact with the body of Christ. It originated in the north, though the first significant occasion on which it occurs is in a picture painted in Italy. Visiting Florence in 1449 or 1450, Rogier van der Weyden saw there, in the predella of the high altar of San Marco, a panel by Fra Angelico showing the body of Christ exposed before the tomb [320].[36] The body is supported by Joseph of Arimathea, and the two arms are extended, in a pose that evokes the Crucifixion, by the mourning Virgin and St. John. This panel inspired Rogier to produce the *Entombment* in the Uffizi, where two additional figures are shown [321].[37] One of them, standing behind Christ and sharing the burden of Joseph of Arimathea, is Nicodemus. From this we can infer that Angelico followed the three synoptic Gospels, which give Joseph of Arimathea sole responsibility for preparing the body for burial, while Rogier followed the Gospel of St. John, which mentions Nicodemus as present at the tomb. Of the two figures, Joseph of Arimathea is generalized, whereas the other, Nicodemus, is a portrait. Possibly he is Cosimo de' Medici; at all events the picture was in Medici possession from the start, and from the portraits of him that survive we have no way of guessing how Cosimo's features would have appeared when they were painted by a Fleming in full face.

At just about this time the figure of Nicodemus is used in precisely the same fashion by Dirk Bouts. In Bouts's Depositions at Valencia and Granada the body of Christ is let down from the Cross by Joseph of Arimathea and is received by Nicodemus, and in both cases the Nicodemus is a portrait.[38] In the *Entombment* by Bouts in the National Gallery in London [322],[39] Joseph of Arimathea appears at the shoulders and Nicodemus at the feet, and the same contrast obtains. In miracle plays in northern Europe the standing of the two participants is differentiated. "Do thou take the head," says Nicodemus to Joseph of Arimathea, "for I am worthy only to take the feet." So if a portrait were to be introduced, it was naturally committed not to Joseph but to the humble Nicodemus. But the portrait involved contemporary dress, so that in Rogier's *Entombment* the humbler figure, Nicodemus, is paradoxically the more richly arrayed.

320. FRA ANGELICO: *The Entombment* (Munich)

In the fifteenth century in Italy these Nicodemus portraits occur very seldom, and when they do, it is almost always in centers which lay open to Flemish influence. But in the sixteenth century, as the Counter Reformation gained momentum and the idea of personal atonement became prevalent, they appear more frequently. In this way not only the donor but the artist could identify himself with the sufferings of Christ, and there is a special fascination in those pictures where the painter stamps mimetically on his own features the overwrought emotions that were proper to this theme. This course was followed both by Titian and by Tintoretto.

Titian had a rather special interest in self-commemoration.[40] About 1545 he prepared a self-portrait in order, Vasari tells us, "to preserve the memory of himself for

321. ROGIER VAN DER WEYDEN: *The Entombment* (Florence)

322. DIRK BOUTS: *The Entombment* (London)

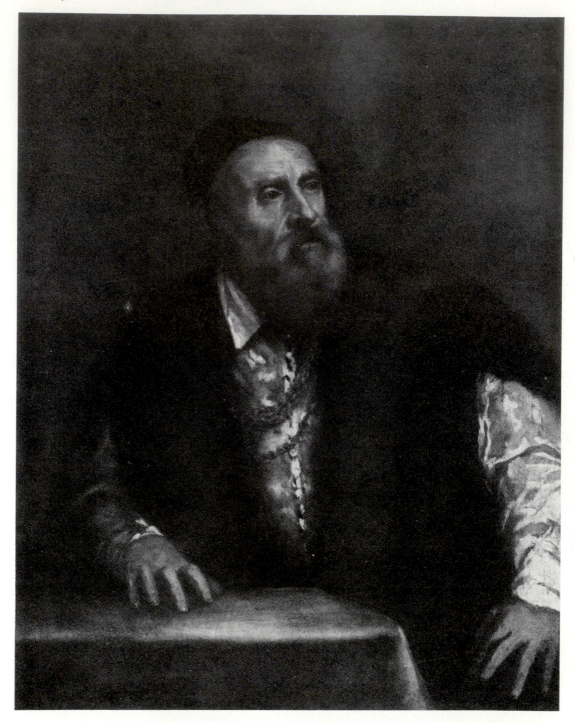

323. TITIAN: *Self-Portrait* (West Berlin)

his sons,"[41] and he also painted a portrait of himself with Francesco Zuccato the mosaicist. At Augsburg he made a frieze of illustrious figures at the Hapsburg court, and at the Emperor's personal request included his own portrait. He inserted his own portrait in the *Gloria*, he painted himself contemplating a portrait of Philip II of Spain, and Vasari, when visiting his studio in 1566, ten years before his death, saw still another self-portrait of four years earlier, "very beautiful and natural."[42] These portraits are not self-analytical; they show the artist as he wished to appear before posterity. In 1620 the poet Marino published a verse on the self-portrait with Zuccato, which reads: "I am Titian. Nature slew me for fear she might be vanquished by my art. But with my own hand I made myself immortal before I died, avenging the wrong that has been done me. Here I stand alive, and I shall once more paint as I was wont to do, but in eternity."[43] The double portrait is recorded in an engraving, and the figure of the painter was developed in a rather later independent portrait in Berlin [323], in which Titian represents himself with eyes gazing into space.[44] Titian the creator is again the subject of a later self-portrait in Madrid,[45] where the high intellectual forehead is illuminated, as in the later portrait of Aretino, by light falling from the left. In his letters and in contemporary accounts Titian presents himself in a predominantly worldly guise, modest, affable, articulate, and remorselessly acquisitive. Yet the testimony of his paintings is that on a deeper level he lived a serious spiritual life, and proof of that, if proof be needed, occurs in 1559, in the great *Entombment*

324. TITIAN: *The Entombment,* detail (Madrid)

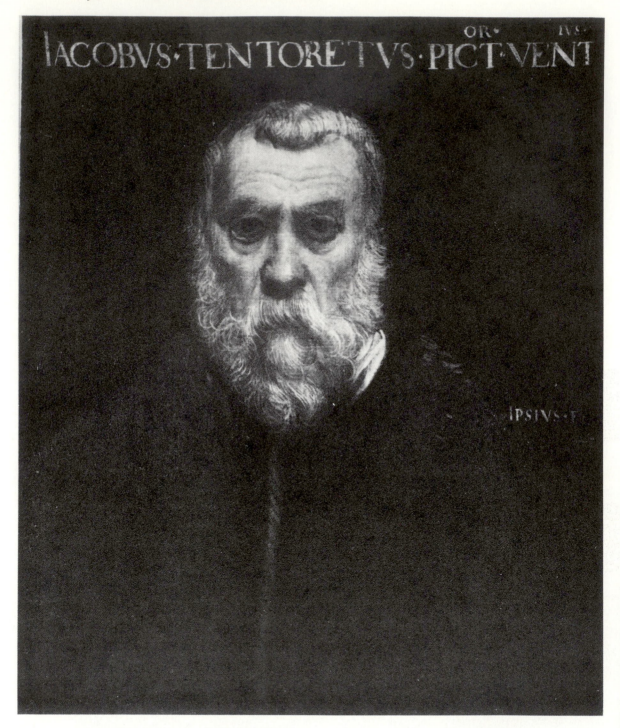

325. JACOPO TINTORETTO: *Self-Portrait* (Paris)

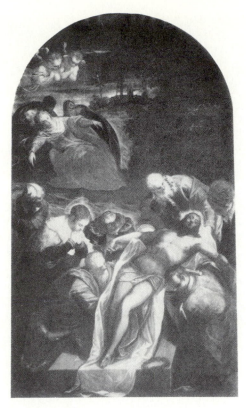

326. JACOPO TINTORETTO: *The Entombment*
(Venice)

painted for Philip II of Spain, in which he depicts himself, with ravaged features, as a participant in the burial of Christ [324].[46]

The personality of Tintoretto was less urbane. He had no pretensions to Titian's international prestige, and in his later works was more exclusively a religious imagist. The self-portraits of Tintoretto that we know are for that reason more revealing than the self-portraits of Titian. The first of them, in the Victoria and Albert Museum, shows the young Tintoretto, the *enfant terrible* whose *Miracle of the Slave* in 1548 so rudely disturbed the placid aesthetic of its time.[47] A second self-portrait [325] dates from about 1588,[48] when the *Paradise* and the last San Rocco canvases were complete, and to it Tintoretto brought the same intensity that was instilled into those paintings. Where Titian's religious experience lies hidden, Tintoretto's is exposed. Contemporary sources tell us of the hours of meditation in the church of the Madonna dell'Orto which provided a background to his professional activity. In one of his last works, painted for the Cappella dei Morti of San Giorgio Maggiore in 1594, he followed the

327. GIROLAMO SAVOLDO: *The Dead Christ with Nicodemus,* detail (Cleveland)

example Titian set, and coupled his own portrait with the scene of the Entombment [326].[49]

In these paintings the portrait image partakes of a corporate experience. But it was also possible, by eliminating narrative, to reduce it to terms that were more meaningful. The first occasion on which that is done in Italy is about 1525, in an altarpiece by the Brescian painter Savoldo, of which the upper part alone survives.[50] The appearance of the Entombment or the Pietà in the upper register of altarpieces was traditional in Venice. But Savoldo's training was not exclusively Venetian—he matriculated in Florence in 1508 and also had contacts with northern painting; in the

328. BACCIO BANDINELLI: *The Dead Christ supported by Nicodemus* (Florence)

upper section of his altarpiece the surrounding figures are for the first time omitted, and a single portrait figure is introduced [327]. The composition is indeed conceived in terms of an antithesis between the intensely realized living portrait and the head of the dead Christ.

In Florence this theme was translated into sculpture in a group which was carved by Bandinelli for his memorial chapel in the Annunziata [328].[51] In it the dead Christ is supported, as in Savoldo's painting, by a kneeling man, whom Vasari identifies as Nicodemus. From the self-portrait reliefs of Bandinelli—one of them is on the back of the altar on which the group is set—we can tell that the head of Nicodemus is an

329. MICHELANGELO: *Pietà* (Florence)

idealized self-portrait. A mannered, rather unyielding sculptor Bandinelli may have been, but there can be no questioning the reality of the emotions which are compressed into this group.

The notion of carving a self-portrait as Nicodemus was not original to Bandinelli. In all probability, indeed, Bandinelli would not have carved his group had not news come from Rome that his rival Michelangelo was carving a group of the same kind for his own tomb. This is the *Pietà* which is now in the Cathedral in Florence [329].[52] It contains four figures, the dead Christ, the Virgin, one of the holy women, and towering above them a bearded figure, which was accepted as early as 1564 as a self-portrait of Michelangelo [330]. That is confirmed by Vasari, who tried to lay hands on the group for the tomb he designed for Michelangelo in Santa Croce in Florence, and gave among his reasons for doing so: "There is an old man in it which is a self-portrait."

Brought up in the Neoplatonic climate of the Palazzo Medici, and biased toward

330. MICHELANGELO: Self-portrait as Nicodemus, detail of *Pietà* (Florence)

ideality, Michelangelo was deeply uninterested in the imitative processes of portraiture. The statues of Giuliano and Lorenzo de' Medici in the Medici Chapel are so loosely connected with authenticated portraits that their status as portraits has repeatedly been questioned, and Michelangelo himself declared that in a thousand years no one would know that they did not look quite as he had presented them. Had he not been thoroughly familiar with the physical appearance of both men, we might suppose that the statues on the tombs resulted from the same creative procedure as the Brutus bust, that they were an imaginary reconstruction of the features inspired by knowledge of the personality.

To no artist was the concept of atonement more actual than to Michelangelo. In a conversation recorded by Francisco Hollanda he protests that "in order to imitate to some extent the venerable image of Our Lord, it is not sufficient merely to be a great master in painting and very wise, but I think it is necessary for the painter to be very good in his mode of life, or even, if such were possible, a Saint, so that the Holy Spirit may inspire his intellect." "O flesh, O blood, O wood, O extreme suffering," he exclaims in one of his later poems, "through you may my sin be atoned." In an extraordinary and moving poem, also dating from the middle fifteen fifties, Michelangelo protests at the veil of ice between divine love and his innermost being, and begs Christ to break down the hard wall that prevents the light of grace from entering his heart. The Nicodemus in the *Pietà* springs from these thoughts; it is a self-portrait of the artist in his spiritual character.

The story that has been outlined in this book is in large part that of an emerging view of man as it was expressed in the interpretation of data gleaned from the study of physical appearances. But nowadays, conscious as we are of the dichotomy between the visible and hidden aspects of the personality, between what can be perceived and what lies concealed within, we may well question the assumption on which these portraits rest, that external fidelity is the prime criterion of portraiture. If we do so, Michelangelo's self-portrait, in which reality is willfully distorted to reveal the inner man, will seem the most profound, most forward-looking Renaissance portrait.

Notes

Notes

Titles Abbreviated in the Notes

BERENSON, B. *Italian Pictures of the Renaissance*. London, 1932.
———. *Italian Pictures of the Renaissance: Florentine School*. London, 1963. 2 vols.
———. *Italian Pictures of the Renaissance: Venetian School*. London, 1957. 2 vols.
———. *Lorenzo Lotto. An Essay in Constructive Art Criticism*. London, 1895; rev. edn., 1956.
DAVIES, M. *National Gallery Catalogues: The Earlier Italian Schools*. London, 1961.
GOULD, C. H. M. *National Gallery Catalogues: The Sixteenth Century Venetian School*. London, 1959.
HILL, C. F. *A Corpus of Italian Medals of the Renaissance before Cellini*. London, 1930. 2 vols.
LEVEY, M. *National Gallery Catalogues: The German School*. London, 1959.
LIPMAN, J. H. "The Florentine Profile Portrait in the Quattrocento," in *Art Bulletin*, XVIII, 1936.
PANOFSKY, E. *Albrecht Dürer*. 2d edn., Princeton, 1945. 2 vols.
VASARI, G. *Le Vite d' più eccellenti pittori, scultori ed architettori*. Ed. G. Milanesi. Florence, 1896. 9 vols. This edition is referred to as "Vasari" throughout; "Vasari (Ricci)" refers to: *Le Vite del Vasari*. Ed. Corrado Ricci. Milan and Rome, 1927. 4 vols. Translations of Vasari are reprinted or adapted from: *Lives of The Most Eminent Painters, Sculptors and Architects*. Tr. Gaston Du C. De Vere. London, The Medici Society, 1912–1915. 10 vols.

I: The Cult of Personality

1. Vasari, I, p. 372: "Il quale, fra gli altri, ritrasse, come ancor oggi si vede, nella cappella del palagio del Podestà di Firenze, Dante Alighieri, coetaneo ed amico suo grandissimo. . . . Nella medesima cappella è il ritratto, similmente di mano del medesimo, di ser Brunetto Latini maestro di Dante, e di messer Corso Donati gran cittadino di que'tempi" (. . . whom [Giotto] portrayed among others, as is still seen today in the chapel of the Palace of the Podestà at Florence, Dante Alighieri, a contemporary and his very great friend. . . . In the same chapel are portraits, likewise by Giotto's hand, of Ser Brunetto Latini, the master of Dante, and of Messer Corso Donati, a great citizen of those times [Medici 1:72]).

2. G. Rowley, *Ambrogio Lorenzetti*, I, Princeton, 1958, p. 107.

3. E. Garin, "I cancellieri umanisti della Repubblica Fiorentina da Coluccio Salutati a Bartolomeo Scala," in *Rivista storica italiana*, LXXXI, 1959, pp. 185–208.

4. Vasari, II, pp. 295–6: "Accadde, mentre che e'lavorava in quest'opera, che e'fu consagrata la detta chiesa del Carmine; e Masaccio, in memoria di ciò, di verde terra dipinse di chiaro e scuro, sopra la porta che va in convento dentro nel chiostro, tutta la sagra come ella fu: e vi ritrasse infinito numero di cittadini in mantello ed in cappuccio, che vanno dietro alla processione: fra i quali fece Filippo di ser Brunellesco in zoccoli, Donatello, Masolino da Panicale stato suo maestro, Antonio Brancacci che gli fece far la cappella, Niccolò da Uzzano, Giovanni di Bicci de'Medici. Bartolommeo Valori, i quali sono anco di mano del medesimo in casa di Simon Corsi gentiluomo fiorentino. Ritrassevi similmente Lorenzo Ridolfi, che in que'tempi era ambasciadore per la repubblica fiorentina a Venezia . . ." (It came to pass, while he was engaged upon this work, that the said church of the Carmine was consecrated; and Masaccio, in memory of this, painted the consecration just as it took place, in chiaroscuro with

terra-verde, over the door in the cloister that leads into the convent. And he portrayed therein an infinite number of citizens in mantles and hoods, who are following the procession; among them he painted Filippo di Ser Brunellesco in wooden shoes, Donatello, Masolino da Panicale, who had been his master, Antonio Brancacci, who caused him to paint the chapel, Niccolò da Uzzano, Giovanni di Bicci de' Medici, and Bartolomeo Valori, who are all also portrayed by the hand of the same master in the house of Simone Corsi, a gentleman of Florence. He also painted there Lorenzo Ridolfi, who was at that time the ambassador of the Florentine Republic in Venice . . . [Medici II:188]).

5. Vienna, Albertina, Sc. R. 150.

6. The task of distinguishing the portraits in the Brancacci Chapel has been undertaken by P. Meller in two original and in part convincing articles ("La Cappella Brancacci," in *Acropoli*, 1960–61, pp. 186–227, 273–312).

7. The basis of this identification is a miniature of Salutati in Cod. Laur. Plut. 53, f. 18, for which see Meller, "La Cappella Brancacci," fig. 42.

8. L. C. Salutati, *Epistolario*, IV, Rome, 1911, p. 474 (doc. XVI). A posthumous portrait of Salutati was also painted for the Arte del Proconsolo (for this, see G. Poggi, "Della data di nascità di Andrea del Castagno," in *Rivista d'arte*, XI, 1929, pp. 56–7).

9. Vasari, II, p. 384, states that Buggiano "fece di marmo la testa del suo maestro ritratta di naturale" ([Buggiano] made a head of his master in marble, taken from the life, which was placed after the death of Filippo in S. Maria del Fiore, beside the door on the right hand as one enters the church . . . [Medici II:235]), and it is inferred from this by J. Pohl (*Die Verwendung des Naturabgusses in der italienischen Porträtplastik der Renaissance*, Würzburg, 1938, pp. 31–2) that the bust was carved from life. Vasari's use of the term *di naturale* is too loose to admit of such an inference.

10. Vasari, II, p. 50: ". . . Giovanni di Bicci de'Medici, veduta la buona maniera sua, gli fece dipigner nella sala della casa vecchia de'Medici . . . tutti quegli uomini famosi che ancor oggi assai ben conservati vi si veggiono" (. . . Giovanni di Bicci de' Medici, seeing his good manner, caused him to paint in the hall of the old house of the Medici . . . all those famous men that are seen there still very well preserved today [Medici II:67]).

11. Vasari, II, p. 54. See also W. and E. Paatz, *Die Kirchen von Florenz*, Frankfort on the Main, 1955, II, pp. 612, 618.

12. *Vita di Bartolommeo Valori*, P. Bigazzi, ed., in *Archivio storico italiano*, 1st ser., IV, 1843, p. 281, quoted by J. Burckhardt, "Das Porträt in der italienischen Malerei," in *Beiträge zur Kunstgeschichte von Italien*, Basel, 1898, p. 169: "Ejus imago a multis expressa miro fuit artificio, cuius gravitatem atque severitatem intuens, virum ab omni parte laudabilem judicabis" (His portrait has been painted by many artists, with great skill. From its gravity and seriousness, you will judge him to be a man praiseworthy from every point of view). R. Borghini, *Il Riposo*, Florence, 1584, p. 316, describes a portrait of Bartolomeo Valori in the house of his sixteenth-century descendant Baccio Valori which was traditionally ascribed to Masaccio.

13. Vasari, II, p. 294: "Considerando quest'opera, un giorno, Michelagnolo ed io, egli la lodò molto, e poi soggiunse, coloro essere stati vivi ne' tempi di Masaccio" (Michelagnolo and I were one day examining this work, when he praised it much, and then added that these men were alive in Masaccio's time [Medici II:187]).

14. Vasari, II, p. 517: "e fattovi molti ritratti di naturale di persone segnalate di que'tempi; i quali per avventura sarebbono oggi perduti, se il Giovio non avesse fattovi ricavar questi per il suo museo . . ." (. . . and in them he introduced many portraits from life of distinguished persons of those times, which would probably now be lost if Giovio had not caused some of them to be preserved for his museum . . . [Medici III:32]).

15. An unsystematic account of the portraits is given by M. Lagaisse, *Benozzo Gozzoli*, Paris, 1934, pp. 88–94.

16. Vasari, III, p. 49: "Sono in tutta quest'opera sparsi infiniti ritratti di naturale: ma perchè di tutti non si ha cognizione, dirò quelli solamente che io vi ho conosciuti d'importanza, e quelli di che ho per qualche ricordo cognizione" (Throughout this whole work there are scattered innumerable portraits from the life; but since we do not know who they all are, I will mention only those that I have recognized as important, and those that I know by means of some record [Medici III:123]). In the *Meeting of Solomon and the Queen of Sheba* Vasari identifies the portraits of Marsilio Ficino, Argyropoulos, and Platina, and a self-portrait of the artist.

17. The principal portrait is identified by Vasari, II, p. 624, as that of Carlo de'Medici, natural son of Cosimo il Vecchio, who was at the time *proposto* of the church.

18. Vasari, II, p. 677: "Di sotto fece lo Sposalizio d'essa Vergine, con buon numero di ritratti di naturale: fra i quali è messer Bernardetto de'Medici, conestabile de'Fiorentini, con un berrettone rosso; Bernardo Guadagni, che era gonfaloniere: Folco Portinari, ed altri di quella famiglia" (Beneath this he painted the Marriage of the Virgin, with a good number of portraits from the life, among which are those of Messer Bernardetto de' Medici, Constable of the Florentines, wearing a

large red *berrettone*; Bernardo Guadagni, who was Gonfalonier; Folco Portinari, and others of that family [Medici iii:102–3]).

19. Vasari, ii, pp. 593–4. The basis of identification of the portrait of Diotisalvi Neroni is likely to have been the inscribed bust by Mino da Fiesole, now in the Louvre. For a further account of the frescoes, see G. Poggi, *I ricordi di Alesso Baldovinetti*, Florence, 1909, pp. 48–9.

20. R. W. Kennedy, *Alesso Baldovinetti*, New Haven, 1938, pp. 179–81, 230.

21. J. Burckhardt, "Das Porträt," p. 179, and E. Schaeffer, "Ueber Andrea del Castagno's 'uomini famosi,'" in *Repertorium für Kunstwissenschaft*, xxv, 1902, pp. 170–7.

22. Vasari, ii, p. 497: "Onde meritò per quest'opera da Luigi Bacci (il quale, insieme con Carlo, ed altri suoi fratelli, e molti Aretini che fiorivano allora nelle lettere, quivi intorno alla decollazione d'un re ritrasse) essere largamente premiato . . ." (For this work, therefore, he well deserved to be richly rewarded by Luigi Bacci, whom he portrayed there round the scene of the beheading of a King, together with Carlo and others of his brothers and many Aretines who were then distinguished in letters . . . [Medici iii:21]).

23. Vasari, iii, p. 255.

24. The frescoes on the right wall of the chapel include portraits of Botticelli and Antonio del Pollaiuolo and a self-portrait of the artist. Among those introduced into Masaccio's fresco of the *Raising of the Son of Theophilus* on the left wall are portraits of Tommaso Soderini, Piero Guicciardini, and Piero del Pugliese, in at least one case from a death mask (for this, see Meller, "La Cappella Brancacci," *passim*). The relation of the heads in the frescoes to Filippino Lippi's independent portraits is discussed by A. Scharf, *Filippino Lippi*, Vienna, 1935, pp. 37–8.

25. The fresco, now in the Pinacoteca Vaticana, is dated 1477. See B. Biagetti, "L'affresco di Sisto IV e il Platina," in *Melozzo da Forlì*, 1938, pp. 227–9, and J. W. Clark, "On the Vatican Library of Sixtus IV," in *Proceedings of the Cambridge Antiquarian Society*, x, 1899. It is demonstrated by A. Schiavo ("Profilo e testamento di Raffaelle Riario," in *Studi romani*, viii, 1960, pp. 414–29) that the figure behind the Pope is the protonotary apostolic Raffaelle Riario, not Cardinal Pietro Riario.

26. For the documentation and iconography of the frescoes, see E. Steinmann, *Die Sixtinische Kapelle*, i, Munich, 1901, pp. 231–544, and L. Ettlinger, *The Sistine Chapel before Michelangelo*, Oxford, 1965. The contemporary significance of the frescoes is overstressed in the earlier and understressed in the later of these books.

27. A. Warburg, *Gesammelte Schriften*, i, Berlin, 1932,

pp. 101–8, gives an exemplary account of the portraits in this fresco.

28. Milanesi, in Vasari, iii, p. 266.

29. Vasari, iii, p. 496: ". . . la quale opera è tutta piena di ritratti di naturale, che di tutti sarebbe lunga storia i nomi raccontare . . ." (the whole of this work is full of portraits from the life, so numerous that it would be a long story to recount their names . . . [Medici iv:15]). Vasari also supplies a list of the portraits painted by Pinturicchio in the Castel Sant'Angelo.

30. Vasari, iv, p. 337: "Dall'altra parte fece il papa che dà le decretali canoniche: ed in detto papa ritrasse papa Giulio di naturale; Giovanni cardinale de'Medici assistente, che fu papa Leone, Antonio cardinale di Monte, e Alessandro Farnese cardinale, che fu poi papa Paolo III, con altri ritratti" (On the other side he painted the Pope presenting the Canonical Decretals. In the Pope he portrayed Pope Julius from the life assisted by Cardinal Giovanni de' Medici, who became Pope Leo X, Cardinal Antonio del Monte, and Cardinal Alessandro Farnese, who afterwards became Pope Paul III, with other portraits [Medici iv:221–2]).

31. C. Ridolfi, *Le Maraviglie dell'arte*, D. von Hadeln, ed., i, Berlin, 1914, p. 59: "E in altra il Papa accompagnava il Doge con la benedittione dell'armata, e vi apparivano le pope di molte galee ornate di fanali e di bandiere con numero de soldati. Era il Doge seguito da molti Senatori ritratti dal vivo, trà quali erano Gio: Barbarigo Cavaliere e Procuratore di San Marco, Tadeo Giustiniano e Giovanni Emo Cavalieri, Vettor Pisano, Carlo Zeno, Fantino Michele Cavaliere e Procuratore, Niccolò e Francesco Contarini Dottori con vesti di brocato e manti di porpora fodrati di armelini; Marino Caravello, Antonio Contarino, Luigi Storlato, Federico Contarino, e Federico Cornaro parimente Procuratori di San Marco; Orsato Giustiniano chiarissimo per le molte legationi, Antonio Loredano creato Cavaliere dal Senato per la difesa di Scutari, e Francesco Barbaro difensore di Brescia, con altri Signori" (In another the Pope accompanied the Doge at the benediction of the fleet. In it appeared the poops of many galleys adorned with lanterns and banners and crowded with a great number of soldiers. The Doge was followed by many Senators portrayed from life, and among them were Giovanni Barbarigo, Knight and Procurator of St. Mark, Taddeo Giustiniani and Giovanni Emo, Knights, Vettor Pisano, Carlo Zen, Michele Fantin, Knight and Procurator, Niccolò and Francesco Contarini, both Doctors, wearing robes of brocade and purple mantles trimmed with ermine; Marino Caravello, Antonio Contarini, Luigi Storlato, Federico Contarini and Federico Cornaro, like-

wise Procurators of St. Mark; Orsato Giustiniani, distinguished for his many embassies, Antonio Loredano, who was knighted by the Senate for his defense of Scutari, and Francesco Barbaro, defender of Brescia, together with other gentlemen).

32. For Giovio's collection of portraits, see E. Müntz, *Le Musée de portraits de Paul Jove*, Paris, 1900, and L. Rovelli, *L'opera storica ed artistica di Paolo Giovio: il Museo dei ritratti*, Como, 1928.

33. The frescoes were painted by Piero della Francesca and Bramantino. Vasari's account of the incident (II, p. 492) reads: "Delle quali teste ne sono assai venute in luce, perchè Raffaello da Urbino le fece ritrarre, per avere l'effigie di coloro che tutti furono gran personaggi: perchè fra essi era Niccolò Fortebraccio, Carlo VII re di Francia, Antonio Colonna principe di Salerno, Francesco Carmignuola, Giovanni Vitellesco, Bessarione cardinale, Francesco Spinola, Battista da Canneto; i quali tutti ritratti furono dati al Giovio da Giulio Romano, discepolo ed erede di Raffaello da Urbino, e dal Giovio posti nel suo Museo a Como" (Of these heads not a few have come to light, because Raphael of Urbino had them copied in order to preserve the likenesses of men who were all people of importance; for among them were Niccolò Fortebraccio, Charles VII, King of France, Antonio Colonna, Prince of Salerno, Francesco Carmignuola, Giovanni Vitellesco, Cardinal Bessarion, Francesco Spinola, and Battista da Canneto. All these portraits were given to Giovio by Giulio Romano, disciple and heir of Raphael of Urbino, and were placed by Giovio in his museum at Como [Medici III:19]).

34. Vasari (VII, p. 699) stresses the "infiniti ritratti di naturale" included in the frescoes. The sources of certain portraits are identified by Meller, "La Cappella Brancacci," in the Brancacci Chapel.

35. For the Farnese fresco cycles see particularly E. Steinmann, "Freskenzyklen der Spätrenaissance in Rom," in *Monatshefte für Kunstwissenschaft*, III, 1910, pp. 45–58, and L. Collobi, "Taddeo e Federico Zuccari nel Palazzo Farnese a Caprarola," in *Critica d'arte*, III, 1938, pp. 70–4.

36. See note 4 above.

37. Initially attributed by Vasari (1550) to Masaccio (Vasari, ed. Ricci, I, pp. 290–1), it was later (1568) given by him to Uccello (Vasari, ed. Milanesi, II, pp. 213–4). The case for supposing that the heads originate from Masaccio's *Consecration of the Carmine* is argued with much force by J. Lányi ("The Louvre Portrait of Five Florentines," in *Burlington Magazine*, LXXXIV, 1944, pp. 87–93). If, however, the heads were copied from this fresco, it is strange that the fact should have escaped the attention of Vasari, who was familiar with the fresco in the original. For later derivatives from the Louvre panel or from a common original, see

Pope-Hennessy, *Paolo Uccello*, London, 1950, pp. 54–6.

38. The two portraits are variously explained by Berenson as copies from Masaccio, by M. Salmi as derivatives from Uccello, and by G. Pudelko as works from the circle of Castagno. R. Longhi ("Fatti di Masolino e di Masaccio," in *Critica d'arte*, V, 1940, p. 181) regards them as copies after Petrus Christus. This is an unconvincing hypothesis. The back of one of the two panels is reproduced by Pudelko ("Two Portraits ascribed to Andrea del Castagno," in *Burlington Magazine*, LXVIII, 1936, pp. 235–40). The paintings perhaps represent Piero (1416–69) and Giovanni (1421–63) de' Medici.

39. Attributed to Zanobi Strozzi, the painting is described by Vasari, II, p. 521: "... e in guardaroba del duca è il ritratto di Giovanni di Bicci de'Medici, e quello di Bartolommeo Valori, in uno stesso quadro, di mano del medesimo" (... and in the guardaroba of the Duke there is the portrait of Giovanni di Bicci de' Medici, with that of Bartolomeo Valori, in one and the same picture by the hand of the same artist [Medici III:35]).

40. The frescoes in the choir of Santa Maria Novella were commissioned by Giovanni Tornabuoni on September 1, 1485. Work was scheduled to begin in May 1486, and they were due to be completed in May 1490. The choir was dedicated on December 22, 1490. It is presumed by J. Lauts (*Domenico Ghirlandaio*, Vienna, 1943, p. 53) that the panel painting of Giovanna degli Albizzi precedes the fresco.

41. Though it was for long attributed by Berenson to Pollaiuolo, the Washington portrait (which has a Torrigiani provenance and has sometimes been thought to represent a member of the Torrigiani family) is now generally accepted as Castagno's. It is dated by M. Salmi (*Andrea del Castagno*, Novara, 1961, p. 19) between 1445 and 1450, that is, in the period of the Sant'Apollonia *Last Supper*; by G. M. Richter (*Andrea dal Castagno*, Chicago, 1943, p. 20) and G. Pudelko ("Florentiner Porträts der Frührenaissance," in *Pantheon*, XV, 1935, p. 92) in the early 1450's; and by W. R. Deusch (*Andrea del Castagno*, Inaug. Diss., Königsberg, 1928, pp. 40–2) ca. 1455.

42. R. Offner, "The Unique Portrait by Andrea del Castagno," in *Art in America*, VII, 1919, pp. 227–34.

43. H. P. Horne (*Alessandro Filipepi, commonly called Sandro Botticelli*, London, 1908, pp. 27–9) dates the painting soon after 1470 and identifies it tentatively as a portrait of Giovanni de' Medici. For the alternative interpretation as a medallist, see J. de Foville, "Portrait d'un médailleur du XV^e siècle," in *Revue numismatique*, 4th ser., XVI, 1912, p. 103.

44. These classifications go back to Dolci, who distinguishes between the *volto in maestà* (full face), the *volto in profilo* (profile), and the *occhio e mezzo* (three-quarter face). For this painting and the portraits contained in it, see H. P. Horne, *Botticelli*, pp. 38–44, and T. Trapesnikoff, *Die Porträtdarstellungen der Mediceer des fünfzehnten Jahrhunderts*, Strassburg, 1909.

45. It is established by M. Davies (*Earlier Italian Schools*, p. 98) that the London portrait is not cut at the top and is probably also untrimmed elsewhere.

46. For the Berlin portrait, see H. Mackowsky, "Ein männliches Bildnis des Luca Signorelli in der Berliner Galerie," in *Zeitschrift für bildende Kunst*, n. s., XI, 1900, pp. 117–20, who proposes a somewhat later dating.

47. The name of the sitter is recorded on the back of the panel in the form: "1494 di Luglio/Pietro Perugino pinse franc° de Lopre Peynago." The sitter has been identified as the brother of the gem-engraver Giovanni delle Corniole. Born in 1451, he died in Venice in 1496.

48. The architect Giuliano da Sangallo (d. 1516) was in Rome from 1504 until November 1507, and the date c. 1505 proposed for the panel by F. Knapp (*Piero di Cosimo*, Halle, 1899, p. 70) is thus improbable. B. Degenhart ("Piero di Cosimo," in Thieme-Becker, *Künstlerlexikon*, XXVII, 1933, p. 16) relates the style to that of the Berlin *Adoration of the Shepherds*, and assigns the portrait to the first decade of the sixteenth century. A late dating is also advanced by G. I. Hoogewerff ("De Kunst van een Zonderling," in *Elziviers Geïllustreerd Maandschrift*, LIX, 1920, pp. 370–1). A good analysis of this and its companion portrait is given by H. Haberfeld (*Piero di Cosimo*, Inaug. Diss., Breslau, 1900, pp. 101–5).

49. The best account of the Florentine profile portrait is that of J. H. Lipman, "Profile Portrait," pp. 54–102.

50. The identification of the donor as Lorenzo Lenzi, proposed by Procacci and followed by E. Borsook (*The Mural Painters of Tuscany*, London, 1960, pp. 143–4), is confirmed by the presence of a Lenzi tomb-chamber with the date 1426 in the vicinity of the fresco, and by the dress worn by the donor, which is that of Gonfaloniere di Giustizia. Lenzi's appointment in 1425 as Gonfaloniere di Giustizia is noted by Scipione Ammirato (*Istorie fiorentine di Scipione Ammirato*, Florence, 1848, Pt. I, IV, p. 335).

51. Florence, Gabinetto dei Disegni, No. 28 E. The ascription to Uccello is accepted by B. Berenson (*The Drawings of the Florentine Painters*, Chicago, 1938, No. 2766, I, p. 15), M. Salmi (*Paolo Uccello, Andrea del Castagno, Domenico Veneziano*, Rome, 1936, pp. 152–4), W. Boeck (*Paolo Uccello*, Berlin,

1939, p. 127), and Pope-Hennessy (*Paolo Uccello*, London, 1950, p. 150). It is wrongly ascribed by H. Beenken ("Zum Werke des Masaccio," in *Zeitschrift für bildende Kunst*, LXIII, 1929, p. 119) to Masaccio, and by F. Hartt ("New Attribution for a Famous Drawing," in *Art Quarterly*, XIX, 1956, pp. 162–73) to Castagno.

52. The attribution to Uccello is due to R. Longhi ("Saggi in Francia: I. Chambéry. Un ritratto di Paolo Uccello," in *Vita artistica*, II, 1927, p. 45), and is accepted by G. Pudelko ("Early Works of Paolo Uccello," in *Art Bulletin*, XVI, 1934, p. 249n., and "Florentiner Porträts," pp. 94–5), M. Salmi (*Uccello, Castagno, Veneziano*, p. 144, as ? Uccello), L. Venturi ("Paolo Uccello," in *L'Arte*, XXXIII, 1930, p. 63), and others. Berenson (*Italian Pictures of the Renaissance* [1932], p. 335) ascribes the portrait tentatively to Masaccio, and J. H. Lipman ("Profile Portrait," p. 101) gives it to a follower of Masaccio. The attribution to Uccello is also rejected by M. Meiss, "Primitifs italiens à l'Orangerie," in *Revue des arts*, VI, 1956, p. 141. A dating ca. 1430–35 proposed by Lipman is likely to be correct. For alternative interpretations of the inscription, see an inconclusive analysis by R. Hadfield, "Five Early Renaissance Portraits," in *Art Bulletin*, XLVII, 1965, pp. 324–5.

53. The attribution to Masaccio is due to Berenson, and is accepted by M. Salmi (*Masaccio*, Milan, 1947, pp. 176–7) with a dating ca. 1425, L. Venturi, and other students. For a contrary view, see J. Mesnil, *Masaccio et les débuts de la Renaissance*, The Hague, 1927, p. 70. Salmi suggests, without good grounds, that the panel may have been one of the portraits by Masaccio seen by Vasari in the house of Simone Corsi. J. H. Lipman ("Profile Portrait," p. 101) ascribes it to a follower of Masaccio and dates it in the second quarter of the fifteenth century. An incorrect attribution to Piero della Francesca is advanced by C. L. Ragghianti, in *Sele arti*, 1–2, 1952, p. 65, and R. Hadfield, "Five Early Renaissance Portraits," p. 331.

54. The panel appears under Masaccio's name in the catalogue of the Artaud de Montor collection, and was subsequently given to Masaccio by Berenson, followed by Salmi (*Masaccio*, pp. 174–5), who regards it as "presumibilmente la prima prova di Masaccio ritrattista giunta sino a noi" (presumably the earliest attempt by Masaccio at portraiture that has come down to us). Lipman ("Profile Portrait," p. 101) regards the panel as the work of a follower of Uccello, and dates it in the second quarter of the fifteenth century. There is no substance in an attribution of R. Hadfield, "Five Early Renaissance Portraits," p. 330, to Domenico di Bartolo.

55. The two Olivieri portraits are given to Uccello by

L. Venturi ("Paolo Uccello," pp. 63–4), Pudelko ("Early Works of Paolo Uccello," pp. 249–50) and R. W. Kennedy (*Alesso Baldovinetti*, p. 132), and to Domenico Veneziano by Berenson (*Italian Pictures* [1932], p. 172) and Salmi (*Uccello, Castagno, Veneziano*, 2d edn., Milan, 1938, p. 173). The attribution to Domenico Veneziano, while not conclusive, is extremely plausible. The two panels date from ca. 1440. Photographs of the backs of the paintings before their transfer from panel to canvas show heraldic devices and fragmentary inscriptions. It is established by R. Hadfield ("Five Early Renaissance Portraits," pp. 325–6) that the paintings represent Matteo, son of Giovanni Olivieri, and Michele, the youngest son of Matteo. Matteo di Giovanni Olivieri is known through a testament of 1365, and Michele di Matteo Olivieri is stated in a *catasto* return to have been aged fifty-nine in 1433. As noted in this article, it is possible that the inscriptions on the portraits date from the late fifteenth century.

56. An exception is the Chambéry portrait, where the inscription is incised on a fictive parapet, which is mistakenly looked upon by Lipman ("Profile Portrait," p. 101) as a later accretion to the painting. The inscribed parapet recurs in the *Leal Souvenir* portrait of Jan van Eyck in the National Gallery in London (1432), but there is no way of determining whether it derives from a Flemish model or whether, as suggested by Pudelko ("Early Works of Paolo Uccello," p. 249), it was arrived at independently.

57. The Lehman portrait, which is much damaged, was ascribed in the Aynard collection to Piero della Francesca. It has subsequently been attributed by Salmi (*Uccello, Castagno, Veneziano* [1938], p. 130) to Domenico Veneziano, by L. Venturi ("Paolo Uccello," p. 64) to Uccello, and by R. Offner ("Mostra del tesoro di Firenze sacra," in *Burlington Magazine*, LXIII, 1933, p. 178), followed by J. H. Lipman ("Three Profile Portraits by the Master of the Castello Nativity, in the Lehman and Bache Collections and the Gardner Museum," in *Art in America*, XXIV, 1936, pp. 11–24) and Berenson (*Florentine School* [1963], I, p. 142), to the Master of the Castello Nativity.

58. E. Müntz, *Les Collections des Médicis au XVᵉ, siècle*, Paris, 1888, p. 85: "uno colmetto con dua sportelli dipintovi dentro una testa di una dama, di mano di maestro Domenico da Vinegia" (A tabernacle with two wings in which is painted the head of a lady by the hand of Domenico of Venice).

59. G. Frizzoni, *Notizia d'opera di disegno pubblicata ed illustrata da D. Jacopo Morelli*, Bologna, 1884, pp. 147–8: "Ambedoi questi ritratti hanno li campi neri, e sono in profilo, e si giudicano padre e figlio, e si guardano l'un contra l'altro; ma in due però tavole" (Both these portraits have black

backgrounds and are in profile. They are thought to be father and son, and face toward each other, but are painted on two separate panels).

60. The double portrait is described by Vasari, IV, p. 144: "il qual Francesco (da Sangallo) ancora ha di mano di Piero (che non la debbo passare) ... dua ritratti, l'uno di Giuliano suo padre, l'altro di Francesco Giamberti suo avolo, che paion vivi" (... Francesco [da Sangallo] still has a work by the hand of Piero [di Cosimo] that I must not pass by ... two portraits, one of his father Giuliano, and the other of his grandfather Francesco Giamberti, which seem to be alive [Medici IV:134]). The identification of the two portraits with the paintings then in The Hague is due to G. Frizzoni ("L'Arte italiana nella Galleria Nazionale di Londra," in *Archivio storico italiano*, 4th series, IV, 1879, pp. 257–8). In view of the fact that Vasari's information was derived from Francesco da Sangallo, the status of the paintings as portraits of Giuliano da Sangallo and of his father, Francesco di Bartolo Giamberti, is not open to dispute. The musical attributes in the second portrait are unexplained. Giuliano da Sangallo died in October 1516. On stylistic grounds the panels are likely to date in the last decade of the fifteenth century rather than in the first decade of the sixteenth. For alternative datings, see note 48 above.

61. The Palazzo Vitelli at Città di Castello was built by Paolo di Niccolò Vitelli, to whom the comission for the portraits may be due. The portrait of Camillo Vitelli is dated by Van Marle ca. 1495 (that is, before the sitter's death at the siege of Circello in Capitanata, 1496). This dating is accepted by M. Salmi (*Luca Signorelli*, Novara, 1953, pp. 52–3), who suggests that the portrait formed a diptych with that of Vitellozzo. In view of the existence of the companion portrait of Niccolò Vitelli, also assigned by Salmi to the last decade of the fifteenth century, this is improbable. A copy of the portrait of Camillo Vitelli is in the Pinacoteca Communale at Città di Castello. The panels are plausibly dated by L. Dussler (*Signorelli*, Berlin, 1927, pp. 122–3) ca. 1504–05.

62. The principal examples of these profile portraits are in the Gardner Museum, Boston, the Metropolitan Museum, New York (Bache Collection), and the Philadelphia Museum of Art (Johnson Collection). The attributions of all three paintings have been extensively discussed. The Johnson portrait is given by F. M. Perkins ("Pitture italiane nella raccolta Johnson a Filadelfia," in *Rassegna d'arte*, V, 1905, p. 115) to Uccello, by Berenson (*Florentine School* [1963], p. 219) to a follower of Domenico Veneziano, and by R. W. Kennedy (*Baldovinetti*, p. 131) to Neri di Bicci. This last attribution is likely to be correct. The

Bache portrait is ascribed by L. Venturi and M. Salmi to Uccello, by G. Pudelko ("Florentiner Porträts," p. 95) to a follower of Uccello known as the Karlsruhe Master, by Berenson (*Florentine School* [1963], p. 62) to Domenico Veneziano, and by R. Offner (in "Mostra del tesoro," p. 178) and J. H. Lipman ("Three Profile Portraits," pp. 11–24) to the Master of the Castello Nativity. The Gardner portrait is attributed by L. Venturi ("Paolo Uccello," p. 64) to Uccello, by Pudelko ("Florentiner Porträts," p. 95) to the Karlsruhe Master, by Berenson (*Florentine School* [1963], p. 62) and Salmi to Domenico Veneziano, and by Offner ("Mostra del tesoro," p. 178) and Lipman ("Three Profile Portraits," pp. 11–24) to the Master of the Castello Nativity. The two portraits date from the third quarter of the fifteenth century and are by a single hand, which is distinct from that responsible for the Lehman portrait. The attributions to Uccello and Domenico Veneziano rest on a misestimate of the quality of the two panels.

63. J. Breck ("A Double Portrait by Fra Filippo Lippi," in *Art in America*, II, 1914, pp. 44–55) dates the New York panel ca. 1440, and on the strength of the coat of arms (or, three bends sable), tentatively identifies the male figure as Lorenzo di Ranieri Scolari (1407–1478). R. Oertel (*Fra Filippo Lippi*, Vienna, 1942, p. 48) and R. Longhi ("Quadri italiani di Berlino a Sciaffusa," in *Paragone*, XXXIII, 1952, pp. 42–5) concur in this dating. The landscape seen through the window is regarded by Longhi as "un tentativo quasi 'alla fiamminga,' 'alla Petrus Christus' " (an essay almost in the Flemish manner, in the style of Petrus Christus).

64. The Berlin portrait is dated by W. Bode (in *Jahrbuch der Preussischen Kunstsammlungen*, XXXIV, 1913, pp. 97–8) ca. 1440; by M. Pittaluga (*Filippo Lippi*, Florence, 1949, p. 199) and Longhi ("Quadri italiani a Sciaffusa,") ca. 1450; and by Oertel (*Fra Filippo Lippi*, p. 49) ca. 1465. A dating ca. 1450 is very probable.

65. The panel, for which see Milanesi (in Vasari, II, p. 622) and Oertel (*Fra Filippo Lippi*, p. 76), was commissioned by the Proposto of the Duomo at Prato, Geminiano Inghirami, for an oratory dedicated to St. Jerome. According to C. Guasti ("Ricordanze di messer Gimignano Inghirami concernanti la storia ecclesiastica e civile dal 1378 al 1452," in *Archivio storico italiano*, 5th ser., I, 1888, p. 20), the oratory was founded shortly before Inghirami's death in 1460.

66. Variously ascribed to Domenico Veneziano (Salmi), Pollaiuolo (Venturi), and Uccello (Boeck, Longhi), the picture was first given to Baldovinetti by R. Fry ("On a Profile Portrait by Baldovinetti," in *Burlington Magazine*, XVIII, 1911,

pp. 311–2). Fry's attribution is accepted by Berenson (*Florentine School* [1963], I, p. 22 and earlier editions) and R. W. Kennedy (*Baldovinetti*, pp. 131–2), who proposes a dating ca. 1465.

67. Bode ("Domenico Veneziano's Bildnis eines jungen Thäddeus in der Berliner Galerie," in *Jahrbuch der Preussischen Kunstsammlungen*, XVIII, 1897, pp. 187–93) gives a good account of the technique of the painting, which was then ascribed to Domenico Veneziano. An illuminating technical comparison of the Berlin and Poldi-Pezzoli portraits is supplied by R. Fry ("Notes on the Italian Exhibition at Burlington House," in *Burlington Magazine*, LVI, 1930, pp. 130–6). The attribution to Antonio Pollaiuolo is due to A. Venturi (*Storia dell'arte italiana: La Pittura del Quattrocento*, VII–I, Milan, 1911, p. 574), and is generally accepted save by Fry and Berenson, who regard both this portrait and that in Milan as works of Piero Pollaiuolo. The arguments against an ascription to Piero Pollaiuolo are stated by S. Ortolani (*Il Pollaiuolo*, Milan, 1948, picture p. 191). The picture is dated by A. Sabatini (*Antonio e Piero del Pollajuolo*, Florence, 1944, p. 77) ca. 1460, and by Ortolani (*Il Pollajuolo*) ca. 1465. A dating in the vicinity of the San Miniato altarpiece is presumed by J. Lopez-Rey (*Antonio del Pollajuolo y el fin del "Quattrocento,"* Madrid, 1935, p. 28).

68. On the back of the panel was a later inscription (since removed) UXOR JOHANNES DE BARDI. There is no way of ascertaining whether or not this identification is correct. The attributional vicissitudes of the panel follow those of the painting in Berlin. The Milan portrait is generally regarded as the later of the two, and is plausibly dated by Ortolani (*Il Pollajuolo*, p. 200) ca. 1470.

69. The traditional ascription of the portrait to Botticelli was contested by Milanesi, Morelli, and Berenson, who ascribed it initially to the Amico di Sandro and subsequently to Domenico Ghirlandaio. The attribution to Botticelli is accepted by Horne (with a dating ca. 1478), Van Marle, Gamba, and Mesnil. It is reinstated as a work of Botticelli in the 1936 and 1963 lists of Berenson.

70. Davies, *Earlier Italian Schools*, pp. 51–2.

71. Inscribed in the upper left corner:

> CORNELIVS.GENVS.NOMEN. FERO.
> VIRGINIS.QVAM.SVA.SEPELIT.
> VENETVS.FILIAM.ME.VOCAT.SE-
> NATVS.CYPRVSO.SERVIT.NOVEM
> REGNOR.SEDES.QVANTA.SIM.
> VIDES.SED.BELLINI.MANVS.
> GENTILIS.MAIOR.QVAE.ME.TAM.
> BREVI.EXPRESSIT.TABELLA.

(I am of the race of the Cornelii and I bear the name of the Virgin. The Venetian Senate calls me daughter and I have been the servant of the

thrones of the nine kingdoms of Cyprus. What I am, you may see. But the hand of Gentile Bellini the elder portrayed me on this small panel.)

72. E. Arslan, "Studi Belliniani," in *Bollettino d'arte*, XLVII, 1962, pp. 40–58.

73. On Giovanni Bellini's portraits, see particularly G. Gronau, "Ueber Bildnisse von Giovanni Bellini," in *Jahrbuch der Preussischen Kunstsammlungen*, XLIII, 1922, pp. 97–105.

74. Leonardo Loredano (b. 1436) became Doge in 1501 and died in 1521. His features were reproduced with great frequency both in painting and relief. A group portrait of the Doge with members of his family, described by Ridolfi in the Palazzo Loredan a Santo Stefano and dated 1507, is published by E. Tietze-Conrat ("Giovanni Bellinis Gruppenbild von 1507," in *Belvedere*, VIII, 1929, pp. 106–8) and a painting of him by Giorgione "da me visto in mostra per un'Assensa, che mi parve veder vivo quel Serenissimo principe" (which I saw displayed in his absence, and which made me think I was seeing the Most Serene Prince in person), is described by Vasari (IV, p. 95). Sanudo in 1505 records a portrait of the Doge beneath which was the irreverent inscription: "Io non mi ne curo, perche io ingrassi et mio fiol Lorenzo" (I do not mind about it because I am growing fat, and so is my son Lorenzo), and "Si ti sara tajato la testa come a Marin Falier, olim principe veneto pro criminibus decapitato" (Your head will be cut off like that of Marino Faliero, the one time Doge of Venice, who was beheaded for his crimes). All reproductions of the London portrait prior to 1964 show it before cleaning.

75. Albergati was born in 1375, was appointed Cardinal by Pope Martin V in 1426, and headed a legation to the rulers of England, France, and Burgundy in 1431. See W. H. J. Weale, "Portraits by John van Eyck in the Vienna Gallery," in *Burlington Magazine*, V, 1904, pp. 190–8.

76. The altarpiece (for which see W. and E. Paatz, *Die Kirchen von Florenz*, IV, p. 24, and M. Salmi, "Ugo van der Goes nel trittico della Cappella Portinari," in *L'Italia e l'arte straniera: Atti del X Congresso internazionale di storia dell'arte*, Rome, 1922, pp. 223–7) seems to have been commissioned in Bruges in 1473–75, and was installed in Florence ca. 1480–82.

77. Light is thrown on the origins of this picture by a passage in Fra Giuliano Ughi's chronicle of San Francesco in Mugello transcribed by C. von Fabriczy in an article on Michelozzo (in *Jahrbuch der Königlich Preussischen Kunstsammlungen*, XXV, 1904, Beiheft, p. 71): "quella di Lazzero, la quale fu presentata a detto Cosimo da un Legato del Papa, che venne di Fiandra, e Cosimo la donò al luogo del Bosco" (the one of Lazarus, which was

presented to the aforesaid Cosimo by a papal legate who came from Flanders, and Cosimo gave it to the friary of Bosco).

78. The altarpiece (for which see M. J. Friedlaender, *Die Altniederländische Malerei*, VI, Berlin, 1928, pp. 21–2) appears to have been commissioned in 1471/2 and was removed to Danzig in 1473.

79. E. Müntz, *Les Collections des Médicis au XV^e siècle*, Paris, 1888, p. 79: "Una tavoletta dipintovi di una testa di dama franzese cholorito a olio, opera di Pietro Cresti da Bruggia" (A panel painted with the head of a French lady colored in oil, the work of Petrus Christus from Bruges).

80. G. Frizzoni, *Notizia d'opere di disegno pubblicata ed illustrata da D. Jacopo Morelli*, p. 206: "El retratto de Rugerio de Burselles pittore antico celebre in un quadretto de tavola a oglio, fin al petto, fu de mano de l'istesso Rugerio fatto al specchio nel 1462" (The head and shoulders portrait of that celebrated old painter Rogier of Brussels, painted in oil on a small wooden panel, was done by Rogier himself with the aid of a mirror in 1462).

81. The principal source for this painting is Filarete's *Trattato dell'architettura*, in which it is described as follows: "Il quale (Fouquet) fe a Roma papa Eugenio du' altri de' suoi appressi di lui; che veramente parevano vivi propri. I quali dipinse in su una panno collocato nella sacristia della Minerva" (In Rome he [Fouquet] painted Pope Eugenius and two of the members of his court, so that they really looked alive. These he painted on a canvas which was placed in the sacristy of the church of the Minerva).

82. To the left of the figure of Maringhi is a cartellino with the words "Is perfecit opus" (he completed the work), and the portrait was for this reason long accepted as a self-portrait of the painter. As pointed out by M. Carmichael ("Fra Lippo Lippi's Portrait," in *Burlington Magazine*, XXI, 1912, p. 194) and R. Oertel (*Fra Filippo Lippi*, p. 65), the age of the subject corresponds with that of Maringhi, who died at the age of seventy in 1441.

83. For the inscriptions on the drawing, see L. von Baldass, *Jan van Eyck*, London, 1952, p. 270.

84. For the relationship between drawing and painting, see the beautiful appreciation of Berenson ("Nova Ghirlandajana," in *L'Arte*, XXXVI, 1933, pp. 165–84).

85. E. Panofsky (*Early Netherlandish Painting*, Cambridge, Mass., 1954, I, p. 349) gives a brilliant analysis of Italian influences in the portraits of Memling. These are manifest in the *Portrait of a Man Holding a Coin of Nero* in Antwerp (which is dated by Friedlaender ca. 1478) as well as in the later portraits at Frankfort and in the Lehman collection. There are also strong grounds for presuming a reciprocal influence of Memling in Italy, especially on the portraits of Perugino. If

the painting of the Passion described by Vasari as formerly in Santa Maria Nuova is identical with a panel at Turin, the work of Memling could have been known in Italy from about 1470. The two Portinari portraits in the Metropolitan Museum of Art, New York, appear to date from 1472. The popularity of Memling's work in Italy is confirmed by the number of his works listed by Michiel, among which are three portraits.

86. The development of this device in the Netherlands is discussed by Panofsky, *Early Netherlandish Painting*, pp. 316–7.

87. The painting was long regarded as a portrait of Verrocchio. The correct identification of the sitter is due to R. Offner ("A Portrait of Perugino by Raphael," in *Burlington Magazine*, LXV, 1934, pp. 245–57). First attributed by Venturi, Gnoli, and Canuti to Perugino, the painting was later ascribed to Lorenzo di Credi (Berenson, Degenhart), and was subsequently republished by Offner as a work of Raphael. If the portrait, as is likely on iconographical grounds, was painted soon after 1500, there is no impediment to regarding it as a late work by the author of the portrait of Francesco delle Opere of 1494.

88. *Les Primitifs flamands*, Vol. I: *Corpus de la peinture des anciens pays-bas meridionaux au quinzième siècle*, M. Davies, *The National Gallery, London*, II, Antwerp, 1954, pl. CCLXXXII, CCXCVIII.

89. X-ray photographs of the panel are published by F. I. G. Rawlins, *From the National Gallery Laboratory*, London, 1940, pl. 9. The panel has been cut below (see Davies, *Earlier Italian Schools*, p. 39), and the inscription on the missing part beneath formed the basis of the long held belief that it was a self-portrait.

90. G. Frizzoni, *Notizia*, pp. 188–9: "Alcuni credono che el sii stato di mano de Antonello da Messina, ma li più, e più verisimilmente, l'attribuiscono a Gianes, ovvero al Memelin" [Memling] (Some believe it was done by Antonello da Messina, but most people ascribe it to Jan van Eyck or Memling).

91. The Cefalù portrait is variously dated ca. 1470 (Venturi) and, more plausibly, in the late fourteen sixties (Bottari). The poles of Antonello's development as a portraitist are established by this painting and by the great male portrait of 1476 in Turin. R. Longhi ("Quadri italiani a Sciaffusa," pp. 42–5) plausibly suggests that the sky and landscape in the still later portrait of 1478 in Berlin are accretions to Antonello's scheme.

92. G. Frizzoni, *Notizia*, p. 150: "e hanno gran forza e vivacità, e maxime in li occhi."

93. Pomponius Gauricus, *De Sculptura*, ed. H. Brockhaus, Leipzig, 1886, pp. 160–1: "Oculi hos natura tanquam conspecillares animorum nostrorum esse voluit."

94. The painting, which is in the Contini-Bonacossi collection, Florence, is inscribed on the back with the name of the sitter and the date "adi xx di zugno MCCCCLXXIIII."

95. Compare, for example, the male portrait in the Uffizi, Florence, which seems to date (Gronau) from the 1490's.

II: Humanism and the Portrait

1. Battista Guarino, *De ordine docendi et studiendi*, tr. W. H. Woodward, in *Vittorino da Feltre and Other Humanist Educators*, Cambridge, 1897, pp. 174–5.

2. The medal shows the head of Francesco I Carrara, lord of Padua from 1355 till 1388, when he was expelled from the city by Gian Galeazzo Visconti, as whose prisoner he died in 1393. The city of Padua was recovered by his son, Francesco II Carrara. The fullest discussion of the Carrara medals is that of J. von Schlosser, "Die ältesten Medaillen und die Antike," in *Jahrbuch der Kunsthistorischen Sammlungen des Allerhöchsten Kaiserhauses*, XVIII, 1897, pp. 64–108. See also G. F. Hill, *Corpus*, I, p. 3, No. 2.

3. Ibid., pp. 8–9, No. 20, follows J. de Foville ("A quelle date Pisanello a-t-il exécuté la médaille de Jean-François I^er de Gonzague?" in *Revue numismatique*, 4th ser., XIII, 1909, p. 409) in dating the medal between 1439 and 1444. A medal was, however, struck to commemorate the investiture of Gian Francesco Gonzaga as Marquess in 1433 (see Magnaguti, *Le Medaglie mantovane*, Mantua, 1921, p. 79, n. 6).

4. Vasari, II, p. 547.

5. C. Grayson, "A Portrait of Leon Battista Alberti," in *Burlington Magazine*, XCVI, 1954, pp. 177–8.

6. On the Alberti self-portraits, see particularly K. Badt, "Drei plastische Arbeiten von Leone Battista Alberti," in *Mitteilungen des Kunsthistorischen Institutes in Florenz*, VIII, 1957–58, pp. 78–87.

7. Badt, ibid., regards the Louvre relief as "eine Selbstkritik der ersten Fassung" (a self-criticism of the first version). The opposite relationship is presumed by Fabriczy.

8. For the medals of Leonello d'Este, see Hill, *Corpus*, I, pp. 8–10, Nos. 24–32.

9. The medal is dated by Hill, ibid., p. 38, No. 158, shortly before 1446. A somewhat earlier dating, ca. 1440–44, is presumed by A. Calabi and G. Cornaggia, *Matteo dei Pasti*, Milan, 1927, pp. 22–3. For Guarino, see G. Bertini, *Guarino da Verona fra letterati e cortigiani a Ferrara*, Geneva, 1921. It is suggested by R. Sabbadini, *Epistolario di Guarino Veronese*, Venice, 1919, III, p. 472, that a reference in a letter of Guarino of 1452 "de servando ad posteritatem nomine meo" (about preserving my name for posterity) is to this medal.

10. Hill, *Corpus*, I, p. 11, No. 38, presumes that

Pisanello's medal was made shortly before or after the death of Vittorino da Feltre on February 2, 1446. For the medal and other likenesses of Vittorino by Pisanello, see Hill, *Pisanello*, London, 1905, pp. 189–90, and for the facts of Vittorino's career, W. H. Woodward, *Vittorino da Feltre and Other Humanist Educators.*

11. Pliny, *Natural History* 35.2.

12. The Della Torre monument is discussed by L. Planiscig, *Andrea Riccio*, Vienna, 1927, pp. 371–403. For its program, see F. Saxl, "Pagan Sacrifice in the Italian Renaissance," in *Journal of the Warburg Institute*, II, 1938–39, pp. 346–67.

13. The best account of the self-portraits is that of J. von Schlosser, *Leben und Meinungen des florentinischen Bildners Lorenzo Ghiberti*, Basel, 1941, pp. 102–3. A brief discussion of them is included in R. and T. H. Krautheimer, *Lorenzo Ghiberti*, Princeton, 1956, pp. 9–10.

14. The available information is summarized in Pomponius Gauricus, *De Sculptura*, ed. H. Brockhaus, Leipzig, 1886, pp. 30–2. The treatises ascribed to Aristotle, with that by Adamantius and a treatise by Polemon which was unknown in the fifteenth century, are printed in *Scriptores physiognomiae veteres*, Altenburg, 1780. The section "De Physiognomica" in Gauricus' *De Sculptura* (pp. 152–60) includes a defense of the usefulness of the study of physiognomy ("... vix jam certe verbis explicari posset, quantum Statuario usum praestet Physiognomonia, nec Statuariis modo sed et omni generi humano" [It is hardly possible to explain in words how important physiognomy is to the sculptor, and not to sculptors alone but to the whole of mankind], p. 154) and advocates physiognomical analysis of the features on the lines later followed by Lavater ("Facies quibus est, Aristoteles inquit, magna, rudiores, quibus parva immoti, quibus larga stupidi, quibus circumlata animosi, Carnosa inquit Adamantius Facies, deliciosi est hominis, lauti ac pubescentis, Macra studiosi, deamatoris, insidiatoris, Parva facies, parvos quoque redarguit mores, Permagna vero stolidiores" [Aristotle says that a large face indicates a meaner person while a small one, a steadfast man; a broad face betrays a stupid man and a roundish visage a courageous person. As Adamantius tells us, a fleshy face is a sign of an effeminate, elegant, and soft person while the countenance of the student, the lover, and the intriguer will be thin. In general, a small face argues a weaker character and a very large one a rather dull person], p. 180).

15. *Leon Battista Albertis Kleinere kunsttheoretische Schriften*, ed. H. Janitschek, Vienna, 1877, pp. 173–5: "Possem hic de similitudinum ratione disquirere; quid ita sit, quod ex natura videmus, eam quidem in quovis animante perpetuo solitma

observare, ut eorum quodque sui generis quibusque persimillimum sit. Alia ex parte, uti ajunt vox voci, nasus naso, et ejusmodi in toto civium numero similis reliquorum nullus invenietur."

16. For the Medici busts of Mino da Fiesole, see W. R. Valentiner, "Mino as a Portrait Sculptor," in *Studies of Italian Renaissance Sculpture*, London, 1950, pp. 70–9. An inscription on the bust of Piero de' Medici (b. 1416) states that it was executed when he was thirty-seven. The bust of Giovanni de' Medici (b. 1424) is undated.

17. Kaiser Friedrich Museum, Berlin. The bust is inscribed with the names of the artist and sitter and with the date 1454.

18. National Gallery of Art, Washington.

19. J. Pope-Hennessy and R. Lightbown, *Catalogue of Italian Sculpture in the Victoria and Albert Museum*, London, 1964, I, pp. 124–6. The bust is inscribed with the names of the artist and sitter and with the date 1456.

20. W. and E. Paatz, *Die Kirchen von Florenz*, Frankfort on the Main, 1953, v, p. 142, as ca. 1457. The relief is ascribed by M. Weinberger and U. Middeldorf ("Unbeachtete Werke der Brüder Rossellino," in *Münchner Jahrbuch der Bildende Kunst*, n.s., V, 1928, p. 93) to Bernardo Rossellino, and by L. Planiscig (*Bernardo und Antonio Rossellino*, Vienna, 1942, p. 53) to Antonio Rossellino.

21. For the bust, which is signed and dated 1468, see ibid., p. 56. Until 1832 the bust stood over the entrance to Palmieri's house. For the career of Palmieri (1406–75), see A. Messeri, in "Matteo Palmieri cittadino di Firenze del secolo XV," in *Archivio storico italiano*, 5th ser., XIII, 1894, pp. 257–340.

22. R. Lightbown, "Giovanni Chellini, Donatello and Antonio Rossellino," in *Burlington Magazine*, CIV, 1962, pp. 102–4, and "Il busto di Giovanni Chellini al Museo Victoria & Albert di Londra," in *Bollettino della Accademia degli Euteleti*, no. 35, 1963, pp. 15–24.

23. *Della Vita Civile di Matteo Palmieri*, ed. F. Battaglia, Bologna, 1944, pp. 36–8.

24. Ibid., p. 167.

25. A summary of the information available on the practice of life casting is given by J. Pohl, *Die Verwendung des Naturabgusses in der italienischen Porträtplastik der Renaissance*, Würzburg, 1938.

26. Though dated by Paatz (*Die Kirchen von Florenz*, I, p. 284) ca. 1466, the monument seems to have been begun in Giugni's lifetime, and the portrait relief was made from it. For this, see Pope-Hennessy and Lightbown, *Catalogue of Italian Sculpture*, I, pp. 146–8.

27. The ascription of the bust to Pollaiuolo was proposed by L. Dami, "Il cosidetto Machiavelli del Museo del Bargello," in *Dedalo*, VI, 1925–26, pp. 559–69, and is accepted by S. Ortolani, *Il Polla-*

juolo, Milan, 1948, pp. 224–5. A. Sabatini (*Antonio e Piero Pollajuolo*, Florence, 1944, p. 99) denies all connection between the bust and the Pollaiuolo studio. There is no independent evidence that Pollaiuolo was active as a marble sculptor.

28. The bust is inscribed and dated 1474. See Pope-Hennessy, *Italian Renaissance Sculpture*, London, 1958, p. 308.

29. Hill, *Corpus*, I, pp. 266–7, No. 1018, who questions the traditional attribution of the medal to Niccolò Spinelli (Niccolò Fiorentino), suggests that it was cast to commemorate the laying of the foundation stone of the Palazzo Strozzi on August 6, 1489.

30. Louvre, Paris. The bust is inscribed with the name of Filippo Strozzi but is not dated. It was perhaps made shortly before Filippo Strozzi's death on May 15, 1491. A terra-cotta sketch-model for the bust is in Berlin.

31. M. Davies, *Earlier Italian Schools*, pp. 94–6. The altarpiece was commissioned for San Piero Maggiore, Florence, probably after 1471.

32. The most important surviving female portrait busts are six sculptures, all of which have at one time or another been ascribed to Desiderio da Settignano. For these, see Pope-Hennessy, *Italian Renaissance Sculpture*, p. 304.

33. Ibid., p. 312, with a tentative dating ca. 1470. The bust is omitted from the Verrocchio monograph of Planiscig.

34. The Bargello bust originates from the Medici collection and was at one time thought to represent Lucrezia Donati. This identification rests on the misreading of a Medici inventory. The bust, for which see L. Planiscig, *Andrea del Verrocchio*, Vienna, 1941, pp. 35–6, 52, and Pope-Hennessy, *Italian Renaissance Sculpture*, p. 312, is generally assumed to date from 1475–80.

35. The only portrait sculpture with a traditional attribution to Donatello is a pigmented terra-cotta bust in the Museo Nazionale, Florence. The identification of this bust as a portrait of Niccolò da Uzzano (d. 1432) and its attribution to Donatello were already current in 1745. A cogent statement of the reasons for rejecting the tradition is supplied by H. W. Janson, *The Sculpture of Donatello*, Princeton, 1957, II, pp. 237–40. A brilliant analysis of the stylistic discrepancies between this bust and the reliquary bust of San Rossore is given by J. Lányi, "Problemi della critica donatelliana," in *Critica d'arte*, IV–V, 1939, pp. 9–23.

36. H. W. Janson, *Sculpture of Donatello*, II, p. 161.

37. Lodovico Scarampi, Cardinal Mezzarota, born in 1402, was appointed Cardinal in 1440. He defeated the troops of Francesco Sforza under Piccinino, and in 1457 won a notable victory on behalf of the papacy against the Turks. He died in 1465. It cannot be established whether the portrait was painted at Padua or Mantua, where Mezzarota attended the Council convened by Pope Pius II between May 27, 1459, and February 8, 1460. A tentative dating in 1459 is advanced by G. Paccagnini, *Mostra di Andrea Mantegna*, Venice, 1961, p. 22, and a dating in 1460 by E. Tietze-Conrat, *Mantegna: Paintings, Drawings, Engravings*, London, 1955, p. 196. P. Kristeller, *Andrea Mantegna*, London, 1901, pp. 170–3, in the best detailed account of the portrait, notes that: "Even though the painting must be ranked, because of its almost frozen immobility and the somewhat finicking, colourless treatment, below many other portraits, yet for profound and delicate characterisation and for distinction of bearing it takes its place among the most striking masterpieces of portraiture."

38. It is reasonably certain that the frescoes in the Camera degli Sposi were completed in 1474, and they are generally assigned to this and to the preceding year. A terminal date as late as 1484 has, however, also been postulated, and it has been claimed, on the basis of a date scratched in the plaster, that work was started as early as 1465. L. Coletti (*La Camera degli Sposi del Mantegna a Mantova*, Milan, 1959, p. 69) conjecturally assigns the ceiling and vaults to the spring of 1473, the fresco on the entrance wall to the summer and autumn of this year, and the fresco above the chimney piece to the winter of 1473–74. It is doubtful if so complex a scheme could have been devised and executed in this brief period of time.

39. There is some disagreement as to the exact subjects of the two narrative frescoes in the room. P. Kristeller, *Andrea Mantegna*, p. 245, explains the fresco on the entrance wall as representing the return of Cardinal Francesco Gonzaga to Mantua to take possession of the church of Sant'Andrea on August 24, 1472. It has been referred alternatively to the Cardinal's return to Mantua in 1471, and has also been explained (Coletti) as "una sintesi ideale di fatti realmente accaduti in relazione con la carriera ecclesiastica di Francesco Gonzaga" (an ideal synthesis of real events that occurred in connection with Francesco Gonzaga's ecclesiastical career) and as an allegory of the connection between the Roman Curia and the Mantuan court.

40. Camesasca, in L. Coletti, *La Camera degli Sposi*, pp. 67–71.

41. Kristeller, *Andrea Mantegna*, p. 242, opposes the then current view that the fresco depicted "an actual event in the family history of the Gonzaga, namely the return of Federigo, the Marquis's eldest son, from voluntary exile to his father's house," and concludes that "no special event is represented, but a quiet and cheerful family scene, almost patriarchal in character." For other interpretations, see Coletti, *La Camera degli Sposi*,

p. 49. There is evidence that at a rather later date embassies to the Mantuan court were received in the Camera degli Sposi, and it is possible that from the first a parallel was intended between the fresco of the Marquess and his court awaiting an undisclosed visitor and the receptions which took place in the room.

42. For German medallic portraits, see G. Habich, ed., *Die deutschen Schaumünzen des XVI. Jahrhunderts*, Munich, 1929–34, and A. Suhle, *Die deutsche Renaissance-Medaille: ein Kulturbild aus der ersten Hälfte des sechszehnten Jahrhunderts*, Leipzig, 1950.

43. The reverse of the medal is decorated with Erasmus' device, Terminus, and is inscribed with the words *Concede nulli* (yield to no man). According to a letter written by Erasmus to Alfonso Valdes in August 1528, the emblem Terminus was adopted from a jewel or cameo presented to him in 1508 by Alexander Stuart, natural son of James IV of Scotland, whom he served as tutor in Italy.

44. The letter, written to Botteus on March 29, 1528, for which see P. S. and H. M. Allen, eds., *Opus epistolarum Desiderii Erasmi*, Vol. VII: 1527–28, London, 1928, No. 1985, reads: "Unde statuarius iste nactus sit effigiem mei demiror, nisi fortasse habet eam quam Quintinus Antuerpiae fudit aere. Pinxit me Durerius, sed nihil simile" (I am at a loss to imagine whence that sculptor got my likeness unless he has the one Quentin cast in bronze at Antwerp. Dürer painted my portrait but it was nothing like). Erasmus' correspondence refers to copies of the medal dispatched to Nicholas Everard, Pirckheimer, and other friends. The media used in the impressions of the medal seem to have been varied experimentally, and there are allusions to an example in solid silver, to versions in lead, and to a bronze version silvered and gilt. At Pirckheimer's request the matrix of the medal was sent to Nuremberg so that further examples could be struck.

45. For Dürer's charcoal drawing of Erasmus, now in the Louvre, see E. Panofsky, *Dürer* (1945), p. 106. According to a statement of Erasmus, work on the drawing was interrupted before the artist could complete it. It appears to have been executed at Brussels between August 28 and September 2, 1520. Dürer, mentioning the drawing in his *Tagebuch* (F. Leitschuh, ed., Leipzig, 1884, p. 59), refers also to an earlier representation of Erasmus: "Ich hab den Erasmum Roterodam noch einmal conterfet" (I have depicted Erasmus of Rotterdam yet once more). According to an annotated copy of the engraving of Erasmus which Dürer completed in 1526, the sittings took place in the presence of Nicholas Kratzer.

46. The drawings (for which, see E. Major, *Hand-zeichnungen des Erasmus von Rotterdam*, Basel, 1933) occur in a manuscript of 1515 in the Universitätsbibliothek at Basel.

47. The most extensive reference in Erasmus' correspondence to the exchange of portraits occurs in a letter to Pirckheimer of March 14, 1525, for a translation of which see J. Huizinga, *Erasmus of Rotterdam*, tr. by F. Hopman, with a selection from the letters of Erasmus, tr. from the Latin by Barbara Flower, London, 1952, pp. 239–40. The relevant passage reads: "Portraits are less precious than jewels—I have received from you a medallic and a painted portrait—but at least they bring my Willibald more vividly before me. Alexander the Great would only allow himself to be painted by Apelles' hand. You have found your Apelles in Albrecht Dürer, an artist of the first rank and no less to be admired for his remarkable good sense. If only you had likewise found some Lysippus to cast the medal. I have the medal of you on the right-hand wall of my bedroom, the painting on the left; whether writing or walking up and down, I have Willibald before my eyes, so that if I wanted to forget you I could not. . . . You have a medal of me. I should not object to having my portrait painted by Dürer, that great artist; but how this can be done I do not see. Once at Brussels he sketched me, but after a start had been made the work was interrupted by callers from the Court. I have long been a sad model for painters, and am likely to become a sadder one as the days go on." For the original letter, see Allen, *Opus epistolarum Desiderii Erasmi*, v, London, 1926, No. 1558.

48. For the history and documentation of the double portrait, see H. Hymans, in *Bulletin des Commissions Royales d'Art et d'Archéologie*, XVI, 1877, pp. 615–44; A. Gerlo, "Erasmus en Quinten Metsijs," in *Revue belge d'archéologie et d'histoire de l'art*, XIV, 1944, pp. 33–45; and G. Marlier, *Erasme et la peinture flamande de son temps*, Damme, 1954, pp. 71–111. Three other putative portraits of Aegidius are reproduced by W. Müller-Wulckow, *Vier Bildnisse des Petrus Aegidius*, Oldenburg, 1961.

49. The painting, now at Longford Castle, is dated 1523 on the cover of a book on the shelf behind. Along the edge of the same book is the inscription:

[IL]LE EGO IOANNES HOLBEIN NON FACILE [VLL]VS
[TAM]MICHI(MIMVS) ERIT QVAM MICHI[MOMVS] ERAT.

It is inferred by P. Ganz (*The Paintings of Hans Holbein*, London, 1950, p. 229) that this and an inscription on the book in the foreground relating to the Labors of Hercules were composed by

Erasmus. A letter from Erasmus to Pirckheimer of June 3, 1524, refers to two portraits dispatched to England, of which this is generally supposed to have been one.

50. One of the two paintings, in the Oeffentliche Kunstsammlung, Basel, is dated 1523. The second and more impressive painting, in the Louvre, is undated, but is identified by H. A. Schmid, *Hans Holbein der Jüngere*, Basel, 1948, I, p. 182, as the second portrait dispatched by Erasmus to England in 1524, and was already in an English collection in the early seventeenth century. That the Longford and Louvre portraits are closely contemporary is proved by a drawing in the Louvre containing a study for the right hand of the portrait in the Louvre and two studies for the left hand of the painting at Longford.

51. J. Huizinga, *Erasmus of Rotterdam*, pp. 231–9.

52. Holbein's representations of Sir Thomas More comprise (1) a lost painting of the *More Family* (for the history of which see note 53); (2) the preliminary composition drawing for this group in the Oeffentliche Kunstsammlung at Basel; (3) a panel in the Frick Collection, New York, dated 1527; and (4) and (5) two drawings of More's head in the Royal Library at Windsor Castle, of which one is associated by P. Ganz (*Paintings of Hans Holbein*, p. 232) with the preliminary drawings for the *More Family*, and the other, pricked for transfer, closely corresponds with the painting in the Frick Collection. The assumption of K. T. Parker (*The Drawings of Hans Holbein in the Collection of His Majesty the King at Windsor Castle*, London, 1945, p. 36) that (5) was made in connection with the *More Family* is debatable. For Holbein's portraits of Sir Thomas More, see also P. Ganz, "Zwei Werke Hans Holbeins d. J. aus der Frühzeit des ersten englischen Aufenthalts," in *Festschrift zur Eröffnung des Kunstmuseums*, Basel, 1936, p. 158.

53. O. Kurz, "Holbein and Others in a Seventeenth Century Collection," in *Burlington Magazine*, LXXXIII, 1943, pp. 279–82. The portrait, which is described by Van Mander as "a very large canvas in water-colour," passed through the Arundel, Imstenraedt, and Bishop Carl von Liechtenstein collections. The evidence cited by Kurz is ignored by Ganz (*Paintings of Hans Holbein*, pp. 276–80), who assumes that the group portrait "was executed as a wall painting in the same technique as the Basel town hall paintings," and "perished or was destroyed on the spot after More's property had been confiscated by the king."

54. The identification of the handwriting on the drawing is due to O. Paecht ("Holbein and Kratzer as Collaborators," in *Burlington Magazine*, LXXXIV, 1944, pp. 134–9). The gift of the drawing was acknowledged by Erasmus in a letter of September 6, 1529, to More's daughter Margaret Roper, printed by Allen, *Opus epistolarum Desiderii Erasmi*, VIII (1934), p. 274, No. 2212.

55. The only copy of the painting which throws significant light on the lost original is that at Nostell Priory, which is signed by Richard Locky and inscribed with a date which has been wrongly read as 1530. It is suggested by M. W. Brockwell (*Catalogue of the Pictures and Other Works of Art in the Collection of Lord St. Oswald at Nostell Priory*, London, 1915, pp. 79–98) that it was commissioned by More for his daughter Margaret Roper. S. Morison (*The Likeness of Sir Thomas More*, London, 1963, pp. 22–5) advocates a later dating.

56. The principal changes occur in the form of the sideboard in the left background and in the objects set on it, the poses of the two figures on the extreme left, the introduction of an additional figure in the doorway on the right, the form of the window on the extreme right and the objects on the window sill, the pose of Dame Alice More (who is shown kneeling in the drawing and seated in the copy), and the foreground (where the robes of More and of his father are lengthened in the copy, four books and a footstool are omitted, and a lapdog is introduced). The figures in the copy are likely to correspond with the figures in the lost original, but the treatment of the foreground is inconsistent with Holbein's practice in, for example, the *Ambassadors* [272].

III: The Motions of the Mind

1. For the condition of the panel, see K. Kwiatkowski, *"La Dame à l'Hermine" de Leonardo da Vinci: étude technologique*, Warsaw, 1955.

2. For the text, see Leonardo da Vinci, *Treatise on Painting*, A. P. McMahon, ed., Princeton, 1956, I, p. 71.

3. Ibid., pp. 70–1.

4. Ibid., p. 70.

5. Kwiatkowski, *La Dame à l'Hermine*, p. 12. For the condition of the *Belle Ferronière*, see also M. Hours, "Analisi delle pitture di Leonardo da Vinci," in *Leonardo: saggi e ricerche*, Rome, 1952, pp. 22–3.

6. Hours, "Analisi," concludes that "in seguito all'esame di laboratorio, i restauratori sono arrivati alla conclusione che si può dare un certo credito all'opinione che il viso fosse un tempo animato da accenti di colore in particolare sulle labbra, indubbiamente dovuti alla presenza di lacche di carmino" (on the basis of laboratory tests, the restorers have come to the conclusion that some credence should be given to the view that the face was at one time enlivened by accents of color especially on the lips, where they were certainly due to the presence of carmine glazes).

There are more extensive traces of red and yellow ocher in the hands. C. De Tolnay ("Remarques sur la Joconde," in *Revue des arts*, ii, 1952, pp. 18–26) infers that the contrast between the warm flesh tones of the hands and the waxen face and throat was from the first a feature of the painting. For interpretations of the painting see particularly H. Focillon, "La Joconde et ses interprètes," in *Technique et sentiment*, Paris, 1919, pp. 78–93.

7. Dated by I. Fraenckel (*Andrea del Sarto*, Strasbourg, 1935, pp. 156–77) to 1528–30, by F. Knapp (*Andrea del Sarto*, Bielefeld/Leipzig, 1928, p. 114) to 1518–19, and by H. Wagner (*Andrea del Sarto*, Strasbourg, 1951, pp. 32–4) to 1523 on the mistaken assumption that the sitter is the sculptor Jacopo Sansovino, the portrait is associated by S. J. Freedberg (*Andrea del Sarto*, Cambridge, 1963, i, pp. 46–7, and ii, pp. 79–80) with the *Madonna of the Harpies* and tentatively assigned to the year 1517. C. H. M. Gould (*National Gallery Catalogues: The Sixteenth-Century Italian Schools*, London, 1962, p. 169) suggests, on the basis of the preliminary drawings, that the block of masonry should be read as a book. This view was widely entertained in the nineteenth century and is revived by J. Shearman (*Andrea del Sarto*, Oxford, 1965, i, p. 120).

8. Uffizi 661Er.

9. Born in 1492, Francesco dell'Ajolle emigrated to France in 1530. Pontormo's portrait is datable ca. 1518–20.

10. The painting of a halberdier, in the Chauncey D. Stillman collection (on loan to Fogg Art Museum, Cambridge), dates from ca. 1527–28. The preliminary drawing (for which see F. M. Clapp, "A Letter to Pontormo," in *Art Studies*, i, 1923, pp. 65–6, and J. C. Rearick, *The Drawings of Pontormo*, Cambridge, Mass., 1964, i, pp. 269–71) is in the Uffizi (6701 F).

11. J. A. Gere and P. Pouncey, *Italian Drawings in the Department of Prints and Drawings in the British Museum: Raphael and His Circle*, London, 1962, pp. 2–3.

12. The sitter has been inconclusively identified as Cardinals Bibbiena (Passavant), Innocenzo Cybo (Cavalcaselle), Ippolito d'Este (Fischel), and Alidosi (Filippini). The portrait is datable to 1510–11.

13. Castiglione, *Il Cortegiano*: "Così in ultimo grado di perfezione dello intelletto particular la guida allo intelletto universale."

14. Ibid.: "La scrittura non è altro che una forma di parlare che resta ancor poi che l'omo ha parlato."

15. Bembo's letter, for which see V. Golzio, *Raffaello nei documenti*, Vatican City, 1936, pp. 43–4, is dated April 19, 1516, and is of some importance for the criticism of Raphael's portraits. It reads as follows: "Raphaello, i quale riverentemente vi si racomanda, ha ritratto il nostro Thebaldeo tanto naturale, che egli non è tanto simile a sè stesso, quanto gli è quella pittura. Et io per me non vidi mai sembianza veruna più propria. . . . Il ritratto di M. Baldassar Castiglione, o quello della buona e da me sempre honorata memoria del S. Duca nostro, a cui doni Dio beatitudine, parrebbono di mano d'uno de' garzoni di Raphaello, in quanto appartiene al rassomigliarsi a comparazione di questo del Thebaldeo. Io gli ho una grande invidia, che penso di farmi ritrarre ancho io un giorno" (Raphael, who respectfully commends himself to you, has portrayed our Tebaldeo with such naturalness that he is not as like himself as the painting is like him. As for myself I never saw a better likeness. . . . In comparison with Tebaldeo's portrait, the portrait of Messer Baldassare Castiglione or that dedicated to the memory of our excellent and ever honored Duke—may God grant him salvation—look as though they had been done by the hand of one of Raphael's apprentices so far as resemblance is concerned. I am jealous, and am thinking of having my own portrait painted someday).

16. The letter (published by G. Campori, in *Atti e memorie delle R. R. Deputazioni di Storia Patria per le provincie Modenesi e Parmensi*, i, 1863, p. 135) was written from Rome on September 12, 1519, by Alfonso Paolucci, and reads: "Trovata la porta di Raphael d'Urbino aperta, vi entrai tenendo per fermo poter veder quanto desiderava, et facto adimandar M. Raphael mi fece responder non poter venir a basso, et smontato per andar di sopra venne un altro servitore che mi disse era in camera con M. Baldassare de Castione che'l lo rettragieva et che non se li potea parlare" (Finding Raphael of Urbino's door open, I went in certain that I should be able to see what I wished. But after asking for Messer Raphael I was told that he could not come downstairs. When I started to go upstairs, there appeared another servant who told me he was in his room with Messer Baldassare Castiglione whose portrait he was painting, and that he could not be disturbed).

17. The Louvre portrait is generally considered to be that referred to by Bembo in 1516, and must therefore have been in existence at this time. The earliest date assigned to it is 1514. It is argued by Wilde (in A. Seilern, *Flemish Paintings and Drawings at 56 Princes Gate*, London, 1955, pp. 48–9) that the canvas has not been cut, and that the modifications of the scheme shown in a drawing by Rembrandt and a painting by Rubens represent a baroque interpretation of the pose.

18. Datable ca. 1516.

19. The earlier of the Inghirami portraits, that in Boston [125], is variously dated 1512–14. A dating ca. 1511 is also admissible. For an analysis of the

differences between the two versions, see S. J. Freedberg, *Painting of the High Renaissance in Rome and Florence*, Cambridge, 1961, I, pp. 177–8.

20. Writers on Sebastiano del Piombo mistakenly refer to Carondelet as a Cardinal. The third son of Jean Carondelet of Dôle, he was born at Malines in 1473, became Archdeacon of Besançon in 1504, and on May 12, 1510, was appointed imperial ambassador to the Papal Curia, holding this post till 1512. Till 1520 he lived at Viterbo, returning in that year to the Abbey of Mont Benoît in the province of Doubs, which had been granted to him by Julius II on his retirement from his ambassadorial post. He died on June 27, 1528. The document shown in the portrait is an imperial dispatch, inscribed "Honorabili devoto nobis dilecto Ferrico Carodelet Archidiacono Bisentino Consiliario et commissario suo. In Urbi" (To our esteemed and faithful servant Ferry Carondelet, Archdeacon of Besançon, Councilor and Commissary. In Rome), and as noted by E. A. Benkard (in his review of Pietro d'Archiardi, *Sebastiano del Piombo, Repertorium für Kunstwissenschaft*, XXXI, 1908, p. 573), makes a dating between 1510 and 1512 mandatory. A dating ca. 1512–15 proposed by L. Dussler (*Sebastiano del Piombo*, Basel, 1942, p. 135) is untenable. It is suggested by R. Pallucchini (*Sebastiano Viniziano*, Milan, 1944, p. 39) that the portrait was painted ca. 1512 at Viterbo. For a modified copy by Rubens dated 1607 see E. Camesasca, "Sulla scia di Sebastiano del Piombo," in *Il Vasari*, XXI, 1963, pp. 16–22.

21. Vasari, IV, p. 338, describes the portrait as "tanto vivo e verace, che faceva temere il ritratto a vederlo, come se proprio egli fosse il vivo" (so lively and truthful that it inspired fear in him who looked at it, as if it were the living man himself). On the respective merits of the various versions, see O. Fischel, *Raphael*, London, 1948, p. 69. The portrait was painted between June 1511 and March 1512, and according to Sanuto was exhibited in 1513.

22. Dated 1516.

23. Pinacoteca, Parma. Datable ca. 1531–32.

24. E. Panofsky, *Dürer* (1945), I, p. 241, comments on the sculptural character of the head, and compares it with the portraits on Ghiberti's *Gate of Paradise*.

25. Mr. Robert Charleston informs me that glass mirrors are alleged to have been in use in Germany in the twelfth century, when they are referred to in a literary text of 1189–97. Glass mirrors were manufactured in Germany in the fourteenth and fifteenth centuries, and may also have been produced in France. The Nuremberg guild of mirror-makers was established by 1373, and already in 1317 a combine of Venetians had lured a German mirror-maker to Venice to try to obtain his secret, without result. It seems that with the aid of foreign workmen mirrors were being made in Venice before the end of the fifteenth century; the first Venetians mentioned in this trade are the Dal Gallo brothers, who in 1503 petitioned for a privilege to make mirrors "de vero cristallin, cossa preciosa et singular." A late fifteenth-century glass convex mirror exists in the Bayerisches Nationalmuseum, Munich, and corresponds with the type of mirror shown in the Arnolfini portrait by Van Eyck and other northern paintings.

26. Panofsky, *Dürer* (1945), II, p. 14, observes that "the inscribed date is now almost generally accepted, though the present inscriptions are doubtless apocryphal." For the arguments in favor of a dating in 1506, see particularly H. Wölfflin, *Die Kunst Albrecht Dürers*, Munich, 1905, p. 136; and E. Heidrich, "Zur Datierung von Dürers Münchner Selbstporträt," in *Repertorium für Kunstwissenschaft*, XXX, 1907, p. 31. An exhaustive bibliography is given in *Alte Pinakothek, München: Katalog II, Altdeutsche Malerei*, 1963, pp. 68–9.

27. Panofsky, *Dürer* (1945), I, p. 43.

28. For the portrait of Dürer in Campagnola's fresco of the *Sposalizio* in the Scuola del Carmine at Padua, see G. Gronau, "Ein wenig bekanntes Porträt Dürers in Padua," in *Pantheon*, II, 1928, p. 533; and H. L. Kehrer, *Dürers Selbstbildnisse und die Dürer-bildnisse*, Berlin, 1934, pp. 75–6.

29. G. Robertson, *Vincenzo Catena*, Edinburgh, 1954, p. 46.

30. The dates assigned to these paintings by Berenson are less plausible than those proposed by Boschetto, in A. Banti, ed., *Lorenzo Lotto*, Florence, 1953.

31. Panofsky, *Dürer* (1945), I, p. 43.

32. P. Ganz, *The Paintings of Hans Holbein*, London, 1950, p. 234. A generic relationship between the painting and late works of Leonardo which Holbein might hypothetically have seen in 1523–24 in France is admitted by H. A. Schmid, *Hans Holbein der Jüngere*, II, Basel, 1948, pp. 305–6. As noted by A. B. Chamberlain, *Hans Holbein the Younger*, London, 1913, I, p. 344, a version of the painting in the museum at Lille is inscribed with the words:

> Die Liebe zu Gott heist Charitas
> Wer Liebe hatt der tragtt kein Mass.

(Love of God is called Caritas
Whoever has love knows no measure.)

It is possible that the original portrait also stems from the conventional iconography of Caritas.

33. R. N. Wornum, *Some Account of the Life and Works of Hans Holbein*, London, 1867, p. 161.

34. The available information on the portrait in Berlin is assembled by G. M. Richter, *Giorgio da Castelfranco, called Giorgione*, Chicago, 1937, p. 209. The sitter is unidentified, and the letters *V V* on the parapet are unexplained.

35. An apocryphal inscription on the parapet describes the sitter as the poet Antonio Broccardo (d. 1531).

36. The portrait is given by B. Berenson, *Venetian School* (1957), I, p. 107, to Domenico Mancini, and by R. Longhi, *Viatico o per cinque secoli di pittura Veneziana*, Florence, 1952, pp. 22, 63, to Giorgione.

37. Pope-Hennessy, *Italian High Renaissance and Baroque Sculpture*, London, 1963, II, p. 104.

38. Datable ca. 1514.

39. Datable ca. 1525.

40. Datable ca. 1540–45.

41. G. Gaye, *Carteggio inedito d'artisti dei secoli xiv, xv, xvi*, Florence, II, 1840, pp. 331–2.

42. On Titian's portraits of Aretino and the engravings derived from them, see particularly L. Baer, "Zu Datierung von Tizians Aretino-Porträts," in *Frankfurter Bücherfreund*, IV, 1906, Nos. 7–8.

43. G. Gronau ("Tizians Bildnis des Pietro Aretino in London," in *Zeitschrift für bildende Kunst*, n.f. XVI, 1905, pp. 294–6) defines the difference between this and the earlier portrait as "eine Komposition gegenüber einer Improvisation" (a composition as against an improvisation). The later painting seems to date from ca. 1548.

44. J. Boggs, *Portraits by Degas*, Berkeley and Los Angeles, 1962, p. 23.

45. Hadeln, "Zum Datum der Bella Tizians," in *Repertorium für Kunstwissenschaft*, XXXII, 1909, pp. 69–71. The letter, which was written by Francesco Maria della Rovere on May 2, 1536, reads as follows: "Direte al Titiano . . . che quel retratto di quella Donna che ha la veste azura, desideriamo che la finisca bella circa il Tutto et con il Timpano" (You will tell Titian . . . that we want him to finish carefully that portrait of a lady in a blue dress, the whole painting and the cover).

46. For the documentary background of the Strada portrait, see H. Zimmermann, "Zur richtigen Datierung eines Porträts von Tizian in der Wiener Kaiserlichen Gemälde-Galerie," in *Mitteilungen des Instituts für oesterreichische Geschichtsforschung*, VI, 1901, pp. 830–57. The relevant letter from Stoppio to Fugger reads: "Ma ben è da ridere que l'altro giorno, dimandando un gentil huomo molto intrinseco di messer Titiano et mio amicissimo che cosa li pareva del Strada, rispose subito messer Titiano: 'Il Strada è uno delli solenni ignoranti che si possa trovare; lui non sa niente ma bisogna haver ventura et sapersi accomodare alle nature delle persone, come ha fatto il Strada in Allemagna, dove caccia tante carotte a quelli Todeschi quanto si puo imaginare et loro, come reali di natura, non conoscono la dopiezza di questo galanthuomo'" (I laughed mightily the other day when a gentleman very close to Titian and a great friend of my own, asked him what he thought of Strada, and Titian immediately

replied: "Strada is one of the most solemn ignoramuses that can be found; he knows nothing, and it must be that he has luck and knows how to adapt himself to people's characters, as he has done in Germany, where he makes fools of the Germans, who, royal as they are by nature, do not see through the fine gentleman's duplicity").

47. For El Greco in Rome, see particularly E. du Gué Trapier, "El Greco in the Farnese Palace, Rome," in *Gazette des beaux-arts*, 6e. per., LI, 1958, pp. 73–90.

48. For the collection of Fulvio Orsini, see P. de Nolhac, "Les Collections de Fulvio Orsini," in *Gazette des beaux-arts*, 2e. per., XXIX, 1884, pp. 427–36. The Clovio portrait is described in Orsini's inventory as being "di mano d'un Grego scolare di Tiziano."

49. H. L. Kehrer, "Ein Besuch des Giulio Clovio im Atelier Grecos," in *Kunstchronik*, XXXIV, 1922–23, pp. 784–5.

50. H. Wethey, *El Greco and His School*, Princeton, 1962, II, pp. 87–8.

51. D. Angulo Iñiguez, "El Caballero de la Mano al pecho," in *Goya*, XI, 1956, pp. 290–1. The correct explanation of the pose is given by F. Márquez Villanueva, "En Torno al Caballero de la mano al pecho," in *Archivo español de arte*, XXXII, 1959, pp. 193–7.

52. Wethey, *El Greco and His School*, pp. 95–6. See also H. Soehner, "Greco in Spanien," in *Münchner Jahrbuch der Bildenden Künste*, VIII, 1957, p. 190.

IV: The Court Portrait

1. The dependence of the head of Sigismondo Malatesta from the obverse of Matteo de' Pasti's medal is corroborated by the appearance on the right side of the fresco of a view of the castle of Rimini on the reverse of the medal. In the fresco the perspective of the medallic reverse is rationalized.

2. Angelo Decembrio, *De politia literaria*, pars. LXVIII, Cod. Vat. Lat. 1794, f. 162ᵛ (transcribed by M. Baxandall, "A Dialogue on Art from the Court of Leonello d'Este," in *Journal of the Warburg and Courtauld Institutes*, XXVI, 1963, pp. 304–26): "Meministis nuper Pisanum. Venetumque optimos aevi nostri pictores in mei vultus descriptione varie disensisse. cum alter macilentiam candori meo vehementiorem adiecerit. alter pallidiorem tamenlicet non graciliorem vultum effingeret. vixque precibus meis reconciliatos."

3. There are significant technical and stylistic differences between the Bergamo portrait of Leonello d'Este and Pisanello's portrait of Ginevra d'Este in the Louvre. If both paintings are by Pisanello, they must reflect the artist's development in an eight-year period between 1433, the putative date of the Ginevra d'Este portrait, and

1441, the probable date of that of Leonello d'Este.

4. Angelo Decembrio, *De politia literaria*, f. 165ᵛ (in Baxandall, "Dialogue on Art"): "Tum Leonellus interdixit: 'Nempe Caesarum ego vultus non minus singulari quadam admiratione aereis numis inspiciendo delectari soleo. Nam idcirco ex aere frequentiores quam ex auro argentove superfuerunt: quam eorum staturas uti suetonii vel aliorum scriptis contemplari quod intellectu solo percipitur' " (Leonello then interposed: "My admiration for the faces of the Caesars is no whit less when I gaze upon them in bronze [for it is in bronze rather than in gold and silver that most of them have survived], than when I behold them in the writings of Suetonius or of other authors, for then I only perceive them with the mind").

5. The portrait, now in the Kunsthistorisches Museum, Vienna, was first associated by J. Wilde ("Ein zeitgenössisches Bildnis des Kaisers Sigismund," in *Jahrbuch der Kunsthistorischen Sammlungen in Wien,* n.s. IV, 1930, pp. 213–22) with Konrad Laib, and was later reattributed by B. Degenhart ("Un'opera di Pisanello: il ritratto dell'Imperatore Sigismondo a Vienna," in *Arti Figurative,* II, 1945, pp. 166–85) to Pisanello. Conclusive arguments against the ascription to Pisanello are marshaled by N. Rasmo ("Il Pisanello e il ritratto dell'imperatore Sigismondo a Vienna," in *Cultura atesina,* IX, 1955, pp. 11–16), who regards the painting as Bohemian and dates it ca. 1430–40.

6. Louvre, Paris, No. 2339. B. Degenhart, *Antonio Pisanello,* Vienna, 1940, pp. 18, 37.

7. Pier Candido Decembrio, *Vita Philippi Mariae Vicecomitis,* in L. A. Muratori, *Rerum italia carum scriptores,* Milan, 1723–51, XX, p. 1007: "Quamquam a nullo depingi vellet, Pisanus ille insignis artifex miro ingenio spiranti parilem effinxit."

8. It is established by A. Cinquini ("Piero della Francesca ad Urbino e i ritratti degli Uffizi," in *L'Arte,* IX, 1906, p. 56) that the panels were in existence in 1466, when a poem on them was written by the Carmelite Ferabos (Vat. Cod. Urb. Lat. 1193, f. 114). The poem reads:

IMAGO EJUSDEM PRINCIPIS A PIETRO BURGENSI
PICTA ALLOQUITUR IPSUM PRINCIPEM
Me finxit magna solers haud arte timantes
 Qui capit aut falso palmite Zeuxis aves.
Parrhasius tabula, euphranor non marmore sculpsit,
 Pyrghoteles gemma, mentor et in patera,
Nec sum Praxitelis Lysippi vel polycleti
 Caelatusque copae phidiachaque manu.
Ast Petrus nervos mihi dat cum carnibus ossa,
 Das animam, Princeps, tu deitate tua;
Vivo igitur, loquor et scio per me posse moviri;
 Gloria sic Regis praestat et artificis.

(THE LIKENESS OF THE PRINCE PAINTED BY

PIERO DELLA FRANCESCA ADDRESSES THE PRINCE HIMSELF
Clever Timanthes, with his great art, did not portray me here,
 Nor was it Zeuxis who captured birds with his false vine branches.
I am not work of Parrhasius, nor did Euphranor carve me in marble.
 I was not cut into a cameo by Pyrgoteles, nor by Mentor was I embossed on a metal plate.
The great Praxiteles was not my creator, nor did Lysippus nor Polycletus depict me.
 I am not born of the hand of the master, Phidias.
Piero has given me nerves and flesh and bone,
 But thou, Prince, hast supplied me with a soul from thy divinity.
Therefore, I live, and speak and have movement of myself.
 Thus does the glory of a King transcend the glory of the artist.)

An attempt of C. E. Gilbert ("New Evidence for the Date of Piero della Francesca's *Count and Countess of Urbino,*" in *Marsyas,* I, 1941, pp. 41–51) to date the panels after the death of Battista Sforza on July 6, 1472, is unconvincing.

9. The commission for the altarpiece (for which see W. Bombe, "Zur Kommunion der Apostel von Josse van Gent in Urbino," in *Zeitschrift für bildende Kunst,* LXV, 1931, p. 70) was transferred to Justus of Ghent in 1473.

10. On this and the companion paintings in the Studiolo, see *Mostra di Melozzo e del quattrocento romagnolo,* Cesare Gnudi and Luisa Becherucci, eds., Forlì, 1938, pp. 25–35.

11. For the extensive bibliography of this portrait see especially H. Bodmer (*Leonardo,* Stuttgart and Berlin, 1931, pp. 367–8), who follows Morelli in ascribing it to Ambrogio de Predis, K. Clark (*Leonardo da Vinci,* 2d edn., Cambridge, 1952, pp. 50–1), who rejects the possibility that Leonardo could have painted a profile portrait, and W. Suida ("Leonardo's Activity as a Painter," in *Leonardo: saggi e ricerche,* Rome, 1952, p. 322), who regards it as a collaborative work. An unconvincing attribution to Lorenzo Costa is advanced by R. Longhi (*Officina Ferrarese,* Florence, 1956, pp. 142–3).

12. The status of the Louvre drawing as an autograph cartoon is questioned by K. Clark, *Leonardo da Vinci,* p. 103.

13. For the portraits of Isabella d'Este, see A. Luzio, *La Galleria dei Gonzaga venduta all'Inghilterra nel 1627–28,* Milan, 1913, pp. 183–238.

14. For this portrait, see F. Hartt, *Giulio Romano,* New Haven, 1958, I, pp. 82–4.

15. The portrait, now in the Kunsthistorisches Mu-

seum, Vienna, was delivered in 1536, and is based on a portrait by Francia of 1511–12. For the history of the painting see H. Tietze and E. Tietze-Conrat, "Tizian-Studien," in *Jahrbuch der Kunsthistorischen Sammlungen in Wien*, n.s., x, 1936, pp. 139–40. The identification is contested by L. Ozzola, "Isabella d'Este e Tiziano," in *Bollettino d'arte*, ser. II, x, 1931, pp. 491–4.

16. F. Winkler, *Die Zeichnungen Hans Süss von Kulmbachs und Hans Leonhard Schäufeleins*, Berlin, 1942, pp. 66–7.

17. For the iconography of the Emperor Maximilian I, see L. von Baldass, "Die Bildnisse Kaiser Maximilians I," in *Jahrbuch der Kunsthistorischen Sammlungen des Allerhöchsten Kaiserhauses*, XXXI, 1912, pp. 247–334, and G. Otto, *Bernhard Strigel*, Munich, 1964, pp. 101–2.

18. For this, see E. Panofsky, *Dürer* (1945), II, p. 15.

19. A good summary of the information available on Titian's portraits of the Emperor Charles V is supplied by H. von Einem, *Karl V und Tizian*, Cologne, 1960. For other portraits of the Emperor Charles V, see G. Glück, "Bildnisse aus dem Hause Habsburg: III, Kaiser Karl V," in *Jahrbuch der Kunsthistorischen Sammlungen in Wien*, n.s., XI, 1937, pp. 165–78.

20. The earliest Italian full-length portrait is Carpaccio's *Portrait of a Knight* (tentatively identified as Francesco Maria della Rovere) in the Thyssen collection at Lugano. At one time assigned to the 1490's (R. Offner, "Un 'Sant' Eustachio' del Carpaccio," in *Dedalo*, II, 1921–22, pp. 765–9), it has proved on cleaning to be dated 1510 (J. Lauts, *Carpaccio*, London, 1962, p. 39), and was evidently planned under strong German influence. No Italian full-length portrait can be assigned with confidence to the sixteen years which intervene between this painting and the *Portrait of a Man* in full length of 1526 by Moretto da Brescia in the National Gallery in London (for this see G. Gombosi, *Moretto da Brescia*, Basel, 1943, p. 35).

21. Points of comparison are offered by two woodcuts commissioned from Burgkmair by the Emperor Maximilian I in 1508. One of these, inscribed DIVUS GEORGIUS CHRISTIANORUM MILITUM PROPUGNATOR (St. George, the champion of all Christian warriors), represents St. George, and the other contains an equestrian portrait of the Emperor.

22. Pope-Hennessy, *Italian High Renaissance and Baroque Sculpture*, London, 1963, I, p. 97.

23. M. J. Friedlaender and J. Rosenberg, *Die Gemälde von Lucas Cranach*, Berlin, 1932, Nos. 52, 286.

24. According to Vasari, VI, p. 264, the portrait was painted for Goro Gheri, secretary to Lorenzo de' Medici, Duke of Urbino (d. 1518), and was later owned by Alessandro d'Ottaviano de' Medici.

25. Vasari, VII, p. 657: "Feci adunque, in un quadro alto tre braccia, esso Duca Alessandro, armato e ritratto di naturale, con nuova invenzione, ed un sedere fatto di prigioni legati insieme, e con altre fantasie. E mi ricorda che, oltre al ritratto, il quale somigliava, per far il brunito di quell'arme bianco, lucido e proprio, io vi ebbi poco meno che a perdere il cervello: cotanto mi affaticai in ritrarre dal vero ogni minuzia" (Then I painted from the life, in a picture three braccia high, Duke Alessandro in armor, with new invention and a seat formed of captives bound together and with other fantastic things. And I remember that besides the portrait, which was a good likeness, in seeking to make the burnished surface of the armor bright, shining, and natural, I almost went out of my mind, so much trouble did I take to depict every detail from the life [Medici x:176]).

26. Vasari, VII, pp. 597–8: "Il signor duca, veduta in queste ed altre opere l'eccellenza di questo pittore, e particolarmente che era suo proprio ritrarre dal naturale quanto più diligenzia si può imaginar, fece ritrarre sè, che allora era giovane, armato tutto d'arme bianche e con una mano sopra l'elmo."

27. For this see G. F. Young, *The Medici*, London, 1909, II, pp. 288–9. The tomb of Eleanora of Toledo was opened in 1857. An example of the same brocade in the Museo Nazionale, Florence (Carrand Collection), is reproduced by F. Hoeber ("Brokatmuster auf einem Bild Bronzinos," in *Mitteilungen des Kunsthistorischen Instituts in Florenz*, I, 1911, pp. 22–4). There is some doubt as to the date of the painting. If the child is Don Giovanni de' Medici (b. 1543), as supposed by Vasari, it would appear to have been executed about 1546. If, on the other hand, the child is Don Garzia (b. 1547), it must be of later date.

28. The letter, which is dated January 27, 1551, is published by D. Heikamp ("Angelo Bronzinos Kinderbildnisse aus dem Jahre 1551," in *Mitteilungen des Kunsthistorischen Instituts in Florenz*, VII, 1953–56, pp. 133–8). The relevant section reads as follows: "Io son quassù in Pisa, come quella sa, dove continuamente mi sono trovato con questi santissimi signori et mi godo la beata dolcezza di tanto buono et benigno principe, che certo è incomparabile. Et per dirla in una, la sua Ill. ma. et unica consorte e gli suoi angelici et dolcissimi figliuoli son tali quali merita d'havere un tanto signore e egli è tale quale son degni d'havere per degno padre et Marito, tanta Donna piena di bontade et tanti saggi et bellissimi et ben creati figliolini, che certo mi pare, quando io gli veggo, vedere tanti angeli et udendoli sentire tanti Spiriti dal cielo. Trovomi a dipingere dove imparano le lettere latine et le greche et mi piglio grandissimo piacere a vedere che queste tenere piante et così ben nate, siano così bene et purgate

et custodite et così perfettamente corrette et indiritte a ottimo segno, acciò se ne debba corre felicissimo frutto."

29. For Corneille de Lyon, see L. Dimier, *Histoire de la peinture de portrait en France au XVIᵉ siècle*, Paris and Brussels, 1924, I, pp. 32–46.

30. Brantôme, "Sur la reyne, mère de nos roys derniers, Catherine de Médicis," in *Receuil des dames*, vol. VII of his *Œuvres complètes*, L. Lalanne, ed., Paris, 1873, pp. 343–4.

31. A comprehensive survey of the portraits of Francis I is supplied by L. Dimier in "Les Portraits peints de François Iᵉʳ," in *Revue archéologique*, 4th ser., XVI, 1910, pp. 283–303, and *Histoire de la peinture de portrait en France*, I, pp. 3–31.

32. The relevant material is discussed and illustrated by E. Auerbach, *Tudor Artists*, London, 1954.

33. L. Baldass, *Joos van Cleve*, Vienna, 1925, p. 41, No. 82.

34. Sammlung Thyssen-Bornemisza, Lugano, previously Althorp.

35. The fresco was destroyed by fire in 1698. The composition is recorded in a copy made by Leemput in 1667 for King Charles II (Hampton Court). The surviving part of the original cartoon is in the National Portrait Gallery.

36. Galleria Nazionale d'Arte Antica, Palazzo Barberini, Rome. P. Ganz (*The Paintings of Hans Holbein*, London, 1950, p. 251) regards the portrait as a copy from a lost original executed in 1539–40 on the occasion of the marriage of the King to Anne of Cleves. A workshop replica of a portrait in similar pose at Windsor Castle is dated 1537.

37. Quoted by A. B. Chamberlain, *Hans Holbein the Younger*, London, 1913, II, p. 94: "Zo wel getroffen, dat het den beschouwer met verbaastheid aandoet" (so well represented that the viewer stands amazed).

38. The drawing is discussed by K. T. Parker, *The Drawings of Hans Holbein in the Collection of His Majesty the King at Windsor Castle*, London, 1945, p. 47. For the painted portraits, see P. Ganz, *Paintings of Hans Holbein*, p. 249. Holbein's working procedure is discussed by Parker, *Drawings of Hans Holbein*, pp. 29–31.

39. The documentation of this phase of Holbein's activity in A. B. Chamberlain (*Hans Holbein the Younger*, II, pp. 114–37, 170–84), is amplified by E. Auerbach, *Tudor Artists*, pp. 49–50.

40. For the condition and history of the portrait, see M. Levey, *National Gallery Catalogues: The German School*, London, 1959, pp. 54–7. The sitter is shown wearing mourning.

41. The portrait is on parchment mounted on canvas. It is suggested by P. Ganz (*Paintings of Hans Holbein*, p. 251) that this material was chosen to facilitate the transport of the painting from Düren to London.

42. L. Dimier, *Histoire de la peinture de portrait en France*, II, pp. 47–101.

43. Sonnet XVII.

44. E. Auerbach, *Nicholas Hilliard*, London, 1961.

45. J. Pope-Hennessy, "Nicholas Hilliard and Mannerist Art Theory," in *Journal of the Warburg and Courtauld Institutes*, VI, 1943, pp. 89–100. The text of *A Treatise Concerning the Arte of Limning* is printed in *Walpole Society*, I, 1912, pp. 1–54.

V: Image and Emblem

1. The portrait of Giovanni Antonio Pantera is dated by G. Lendorff, *Giovanni Battista Moroni*, Winterthur, 1933, p. 66, ca. 1560.

2. The identification of the sitter as Lucina Brembati is due to C. Caversazzi, in *Bollettino della Biblioteca Civica di Bergamo*, X, 1913, pp. 23–5, and is accepted by B. Berenson, *Lotto* (1956), pp. 57–8.

3. I am indebted for this information to Miss Stella Mary Pearce.

4. G. F. Hill, *Corpus*, I, p. 12, No. 41.

5. M. A. Lazzaroni and A. Muñoz, *Filarete, scultore e architetto del secolo XV*, Rome, 1908, p. 227.

6. G. F. Hill, *Portrait Medals of Italian Artists of the Renaissance*, London, 1912, pp. 62–3. The medal dates from ca. 1564. A sonnet by Lomazzo refers to the imagery of the reverse:

> La Prudenza ch'insieme è la Fortuna
> A cui sto innanzi chin, soprà un roverso
> Por fei d'una medaglia, o con stil terso
> Un mi ritrasse per furor di luna.

7. The medal is referred to in a letter of Leoni to Michelangelo of March 14, 1561 (E. Plon, *Les maîtres italiens au service de la maison d'Autriche; Leone Leoni sculpteur de Charles-Quint et Pompeo Leoni sculpteur de Philippe II*, Paris, 1887, pp. 270–2). For the interpretations of the reverse, see G. Vasari, *La Vita di Michelangelo*, P. Barocchi, ed., Milan and Naples, 1962, IV, pp. 1735–8.

8. The inscriptions are analyzed by C. E. Gilbert, "New Evidence for the Date of Piero della Francesca's *Count and Countess of Urbino*," in *Marsyas*, I, 1941, pp. 41–51.

9. For the transcription of this passage, see Frimmel, in *Beilage der Blätter für Gemäldekunde*, I, 1905–10, pp. 59, 76. The entry reads: "Vi è uno ritratto picolo di M(isser) Alvixe Contarini con M(isser) ... che morse già anni, et nel instesso quadretto v'è al incontro ritratto d'una monacha da San Segondo, e sopra la coperta de detti retratti una carretta in una paese, e nella coperta de cuoio de detto quadretto fogliami de oro maxenato, di mano di Jacometto, opera perfettissima." For the entry in the 1565 inventory of the Camerino delle Antigaglie di Gabriele Vendramin (d. 1552), see

A. Ravá, "Il 'Camerino delle Antigaglie' di Gabriele Vendramin," in *Nuovo archivio veneto*, n.s., XXXIX, 1920, p. 170: "Un quadreto de man de Zuan Belin con una figura de dritto et de roverso una cerva. Un altro quadreto con una munega de man de Zuan Belin" (A little painting by the hand of Giovanni Bellini with a figure on the front and a hind on the back. Another little painting with a nun by the hand of Giovanni Bellini). It must be noted that these descriptions are not fully consistent with one another or with the two paintings from the Liechtenstein collection to which they are generally referred. Further evidence of the vogue of the box portrait in Venice is supplied by the Vendramin inventory (Ravá, "Il 'Camerino delle Antigaglie' " p. 169), which describes "un altro quadreto con il retrato de Zuan Bellini et de Vetor suo dixipulo nel coperchio" (another little painting with the portrait of Giovanni Bellini and that of Vittorio his disciple on the cover).

10. A. Emiliani, *Il Bronzino*, Busto Arsizio, 1960, pl. 8. The portrait and cover date from 1529–30.
11. G. Glück, "Ein neugefundenes Jugendwerk Lorenzo Lottos," in *Kunstgeschichtliches Jahrbuch der K. K. Zentralkommission für Erforschung und Erhaltung der Kunst- und Historischen Denkmäler*, IV, 1910, pp. 212–27, and T. Borenius, "The New Lotto," in *Burlington Magazine*, LXV, 1934, pp. 228–31.
12. The best account of the frescoes is that of H. P. Horne, *Alessandro Filipepi, commonly called Sandro Botticelli*, London, 1908, pp. 142–8, who identifies the female figure as Giovanna degli Albizzi on the strength of "traces of a shield bearing the arms of Albizzi." The case against this identification was first stated by U. Thieme, "Ein Porträt der Giovanna Tornabuoni von Domenico Ghirlandaio," in *Zeitschrift für bildende Kunst*, n.s., IX, 1897–98, pp. 192–200, and is accepted by J. Mesnil, *Botticelli*, Paris, 1938, pp. 100–4. It has also been suggested that the youth in the first fresco is Antonio, the elder brother of Lorenzo Tornabuoni, and that the girl in the second fresco is Ginevra di Bongiani Gianfigliazzi, who became Lorenzo Tornabuoni's second wife in 1494. On stylistic grounds the most plausible dating for the frescoes is before Lorenzo Tornabuoni's first marriage (1486).
13. As noted by G. F. Hill (*Pisanello*, London, 1905, pp. 70–4), the impresa of a shrub in a two-handled crystal vase, which appears on the Louvre portrait, is mentioned in an Este account book of 1441. The identification of the sitter as Ginevra d'Este, daughter of Niccolò III d'Este and wife of Sigismondo Malatesta (b. 1419; m. 1433; d. 1440), is based on the sprig of juniper she wears. A dating in the early 1430's is postulated by Hill and most other students. G. Gruyer, "Vittore Pisano, appelé aussi le Pisanello," in *Gazette des beaux-arts*, 3e. per., X, 1893, p. 366, suggests that the sitter is Margherita Gonzaga, wife of Leonello d'Este, and is followed in this by Degenhart.
14. The identification of the Liechtenstein painting with the portrait of Ginevra de' Benci mentioned by Vasari (IV, p. 39) is proposed by W. Bode (*Studien über Leonardo da Vinci*, Berlin, 1921, pp. 28–31) and is accepted by K. Clark (*Leonardo da Vinci*, 2d edn., Cambridge, 1952, pp. 14–16). It is established by Carnesecchi ("Il ritratto leonardesco di Ginevra Benci," in *Rivista d'arte*, VI, 1909, pp. 281–96) that Ginevra de' Benci married Luigi Niccolini on January 15, 1474, Niccolini's first wife having died in August of the preceding year. A portrait formerly in Casa Pucci, Florence, apparently of the same sitter as Leonardo's painting, is inscribed on the back with the name of Ginevra d'Amerigo Benci.
15. As noted by J. Wilde, "Ueber einige Venezianische Frauenbildnisse der Renaissance," in *Hommage à Alexis Petrovics*, Budapest, 1934, pp. 206–12, an ideal portrait of Laura by Jacopo Bellini is mentioned by Ridolfi. For Giorgione's *Laura*, see Wilde, "Ein unbeachtetes Werk Giorgiones," in *Jahrbuch der Preussischen Kunstsammlungen*, LII, 1931, pp. 91–100, and G. M. Richter, *Giorgio da Castelfranco, called Giorgione*, Chicago, 1937, pp. 251–2.
16. The case for identifying the painting as a portrait of Ariosto is stated by C. H. M. Gould, *Sixteenth Century Venetian School*, pp. 59–60.
17. The identity of the sitter is established by Finzi, "Il ritratto di Gentildonna del Correggio all' Ermitage di Leningrado," in *Nuove lettere emiliane*, I, 1962.
18. S. J. Freedberg, *Parmigianino*, Cambridge, 1950, pp. 202–3. It is suggested by Sanvitali (*Memorie intorno alla rocca di Fontanellato*, Parma, 1857, pp. 44–6) that the object in the sitter's hand is not a coin or medal but a seal with the reversed letters *C.F.* (for Comes Fontanellati). This explanation is rejected by C. Ricci ("Di Alcuni quadri di scuola parmigiana," in *Napoli Nobilissima*, III, 1894, pp. 148–52).
19. D. Cugini, *Moroni, pittore*, Bergamo, 1939, pp. 57–69.
20. H. A. von Kleehoven, "Cranachs Bildnisse des Dr. Cuspinian und seiner Frau," in *Jahrbuch der Preussischen Kunstsammlungen*, XLVIII, 1927, pp. 230–4.
21. G. Swarzenski, "Bartolomeo Veneto und Lucrezia Borgia," in *Staedel Jahrbuch*, II, 1922, pp. 63–72, quoting J. K. Huysmans, *Trois primitifs*, Paris, 1905, p. 70.
22. Berenson's classic monograph on Lotto (*Lotto* [1895]) contains by far the best available account of the artist's temperament and style. Some light

is thrown on Lotto's attitude to imagery by a letter on the covers of the intarsias at Bergamo printed in L. Chiodi, ed., *Lettere inedite di Lorenzo Lotto su le tarsie di S. Maria Maggiore in Bergamo*, Bergamo, 1962, p. 28: "Circha li disegni de li coperti, sapiate che son cose che non essendo scritte, bisogna che la imaginatione le porti a luce" (Concerning the drawings for the covers, you should know that their subjects are not based on written descriptions, and that imagination was required to bring them to light).

23. Berenson, *Lotto* (1956), p. 57, regards the portrait as "the first positively humorous interpretation of characters and of a situation that we have in Italian painting. . . . The characters are presented to us as distinctly as in a modern psychological novel."

24. For the identification as a self-portrait on the basis of a Borghese inventory, see P. Della Pergola, "Il ritratto n. 185 della Galleria Borghese," in *Arte Veneta*, VI, 1952, p. 187. The appearance in the background of St. George and the Dragon seems to refer to a similar feature in Lotto's altarpiece in the Carmine in Venice of 1529.

25. The Vienna portrait is dated by Berenson (*Lotto* [1956], p. 100), ca. 1527.

26. The sitter is identified by A. Boschetto (in A. Banti, ed., *Lorenzo Lotto*, Florence, 1953, p. 79) as the architect Sebastiano Serlio, whose visit Lotto witnessed in Venice in April 1528 (for this see G. Ludwig, "Archivalische Beiträge zur Geschichte der venezianischen Malerei," in *Jahrbuch der Königlich Preussischen Kunstsammlungen*, XXIV, 1903, Beiheft p. 42). A considerably later dating ca. 1535–39 is proposed by Berenson, *Lotto* (1956), p. 107.

27. Variously dated ca. 1524 (Berenson) and after 1528 (Coletti).

28. G. Frizzoni, *Notizia d'opere di disegno pubblicata ed illustrata da D. Jacopo Morelli*, Bologna, 1884, p. 159: "El retratto de esso M. Andrea, a oglio, mezza figura, che contempla li frammenti marmorei antichi fu de man de Lorenzo Lotto" (the half-length portrait in oil of this Messer Andrea, contemplating antique marble fragments, is by the hand of Lorenzo Lotto).

29. J. Burckhardt, "Das Porträt in der italienischen Malerei," in *Beiträge zur Kunstgeschichte von Italien*, Basel, 1898, p. 265.

30. Berenson, *Lotto* (1956), pp. 58–9.

31. Ibid., p. 59.

32. No. 647E.

33. The painting is regarded by H. Wagner (*Andrea del Sarto*, Strasbourg, 1951, pp. 32–4) and S. J. Freedberg (*Andrea del Sarto*, Cambridge, 1963, II, pp. 183–5) as a portrait of the painter's step-daughter Maria del Berrettaio. This identification is rejected by J. Shearman, *Andrea del Sarto*,

Oxford, 1965, II, pp. 270–1.

34. The portrait is assigned by L. Becherucci, *Manieristi toscani*, Bergamo, 1944, pp. 50–1, to the half decade 1555–60, and was perhaps motivated by the publication of Bronzino's and Laura Battiferri's poems in the latter year. The sonnets of Petrarch are XLIX and CLXXXII.

35. A. Emiliani, *Bronzino*, pl. 94. A dating in the decade 1550–60 is proposed for the portrait by A. K. McComb, *Agnolo Bronzino, His Life and Works*, Cambridge, Mass., 1928, p. 64.

36. K. Frey, *Der literarische Nachlass Giorgio Vasaris*, I, Munich, 1923, p. 27.

37. It was inferred by D. von Hadeln ("Zu Gentile Bellini in der National Gallery in London," in *Repertorium für Kunstwissenschaft*, XXX, 1907, pp. 536–7) that the attributes form a later addition to a pre-existing portrait. A decisive statement of the contrary case is presented by M. Davies, *Earlier Italian Schools*, pp. 61–4.

38. C. Ridolfi, *Le Maraviglie dell'arte* (Berlin, 1914–24), cited by F. Valcanover, *Tutta la pittura di Tiziano*, II, Milan, 1960, p. 48. The picture is tentatively identified by Morelli with a portrait in the Borghese Gallery, Rome, which seems to represent St. Vincent Ferrer rather than St. Dominic.

39. O. Fischel, *Raphael*, London, 1948, I, pp. 123–4.

40. The painting, which is in the Capitoline Gallery, Rome, is dated by A. Boschetto, *Giovan Gerolamo Savoldo*, Milan, 1963, pl. 48, ca. 1530.

41. R. Oertel, *Frühe italienische Malerei in Altenburg*, Berlin, 1961, pp. 151–4, dates the painting ca. 1481 and identifies it as a portrait of Caterina Sforza Riario.

42. Vasari, IV, p. 93: "come se ne vede ancora tre bellissime teste a olio di sua mano nello studio del reverendissimo Grimani patriarca d'Aquileia, una fatta per Davit (e, per quel che si dice, è il suo ritratto)" (. . . of which we still have proof in three most beautiful heads in oils by his hand, which are in the study of the Very Reverend Grimani, Patriarch of Aquileia. One represents David—and this, according to what is said, is his own portrait . . . [Medici IV:110]).

43. In addition to G. M. Richter, *Giorgio da Castelfranco*, pp. 209–10, see C. Müller Hofstede, "Das Selbstbildnis von Giorgione in Braunschweig," in *Venezia e l'Europa; Atti del XVIII Congresso internazionale di storia dell'arte, 1955*, Venice, 1956, pp. 252–3.

44. Painted ca. 1520. The picture was engraved by Sandrart.

45. J. Burckhardt, *Kulturgeschichte der Renaissance*[9], II, p. 87, n. 1.

46. A. Luzio, "Isabella d'Este e il Sacco di Roma," in *Archivio storico lombardo*, 4th ser., X, 1908, pp. 5–107, 361–425.

47. J. Crans, "Ein antiker Fries bei Sebastiano del Piombo," in *Mitteilungen des Deutschen Archaeologischen Instituts*, Röm. Abt. LV, 1940, pp. 65–77.

48. Vasari, V, pp. 613–4, describes the subjects as "molti capitani a sedere armati, parte ritratti di naturale, e parte imaginati, fatti per tutti i capitani antichi e moderni di casa Doria" (. . . many seated figures of captains in armour, some drawn from life and some from imagination, and representing all the ancient and modern captains of the house of Doria . . . [Medici VI:210]).

49. The statue was commissioned from Bandinelli by the Republic of Genoa possibly in 1523 and certainly before 1529. It seems not to have been begun before the early 1430's, and was still in course of execution ca. 1536–37.

50. It is established by Craig Smyth (to whom I am indebted for a transcript of the relevant appendix of a dissertation at New York University) that the emblem of the trident was originally an oar, and that the painting is therefore identical with a portrait owned by Paolo Giovio which is reproduced in the Basel edition of Giovio's *Elogia virorum bellica virtute illustrium* (1577). A later copy is in the Palazzo Doria, Rome. Vasari, VII, p. 595, states that the Giovio portrait was painted not long after Bronzino's return from Pesaro to Florence, and a dating ca. 1531–32 is proposed by Craig Smyth. A dating after 1540 advanced by other authorities is inconsistent with Vasari's account.

51. For the medal, see E. Plon, *Leone Leoni*, pp. 256–7, and for the plaquette, E. R. D. Maclagan, *Victoria and Albert Museum: Catalogue of Italian Plaquettes*, London, 1924, p. 71.

52. The essential bibliography of the painting is given by M. Levey, *The German School*, pp. 47–54. The identification of the two figures and of much of the detail is due to M. F. S. Hervey, *Holbein's "Ambassadors," the Picture and the Men*, London, 1900. The predominantly secular lines of this interpretation are followed, for example, by K. G. Heise, *Die Gesandten*, Stuttgart, 1959. A rather different interpretation is adumbrated by Levey, *The German School*, who observes that "the choice of the *Veni Creator Spiritus* certainly seems to indicate an appeal for the Holy Spirit to come, perhaps to heal dissension . . . the sentiment of the original is unchanged and could be subscribed to by Catholic and Protestant alike." The objects on the two shelves in the center are identified by Hervey and all subsequent students as emblems of the Quadrivium.

53. The theory of Hervey (*Holbein's "Ambassadors"*) that the anamorphic skull in the center foreground is "distorted by reflection in a curved mirror" and was intended to be seen from the right-hand side of the painting is contested by E. R. Samuel ("Death in the Glass—A New View of Holbein's Ambassadors," in *Burlington Magazine*, CV, 1963, pp. 436–41), who proves that the skull is designed to be seen frontally through a glass tube. Samuel follows J. Baltrušaitis (*Anamorphoses, ou perspectives curieuses*, Paris, 1955), who connects the imagery with Cornelius Agrippa's *De incertitudine et vanitate scientiarum et artium*, in regarding the painting as a *memento mori* where "the mundane glories of the State and the Church and of secular learning are contrasted with the brevity of life and inevitability of death."

54. Published by M. F. S. Hervey and R. Martin Holland, "A Forgotten French Painter: Félix Chrétien," in *Burlington Magazine*, XIX, 1911, pp. 48–55. The attribution and interpretation proposed in this article are accepted by C. Sterling, *Metropolitan Museum of Art: Catalogue of French Paintings XV–XVIII Centuries*, New York, 1955, pp. 44–7, and A. F. Blunt, *Art and Architecture in France 1500 to 1800*, London, 1953, pp. 69, 83.

55. The attribution to Primaticcio is due to C. Sterling ("École de Fontainebleau," in *Le Triomphe du maniérisme européen*, Amsterdam, 1955, p. 82, No. 101) and is accepted by S. Béguin (*L'École de Fontainebleau*, Paris, 1960, p. 55). For Primaticcio's activity at Polisy see L. Dimier, *Le Primatice*, Paris, 1900, pp. 85, 382–3.

56. The painting is accepted as a portrait of Queen Elizabeth by F. M. O'Donoghue (*A Descriptive and Classified Catalogue of Portraits of Queen Elizabeth*, London, 1894, No. 75) and is rejected by R. C. Strong (*Portraits of Queen Elizabeth I*, Oxford, 1963, p. 48), who identifies it as a version of a Netherlandish allegorical painting variously attributed to Frans Floris and Martin de Vos (for the latter, see M. J. Friedlaender, *Die altniederländische Malerei*, Berlin, 1936, XIII, pl. XXXVI). F. A. Yates (*Allegorical Portraits of Queen Elizabeth I at Hatfield*, London, 1952, p. 2) cites an inventory of 1611 in which the painting is described as "a portrait of her late Majesty." The imagery of Diane de Poitiers is discussed by F. Bardon, *Diane de Poitiers et le mythe de Diane*, Paris, 1963.

57. On the Siena portrait, see Strong, *Portraits of Queen Elizabeth I*, pp. 21–2, 66–8, and on the iconography of Queen Elizabeth, F. A. Yates, "Queen Elizabeth as Astraea," in *Journal of the Warburg and Courtauld Institutes*, X, 1947, pp. 26–82.

58. Collection of Lord Rothschild, Cambridge. A dating ca. 1580 is proposed by E. Auerbach, *Nicholas Hilliard*, London, 1961, p. 319, and Strong, *Portraits of Queen Elizabeth I*, p. 60. An earlier portrait showing the pelican jewel is in the Walker Art Gallery, Liverpool.

59. Marquess of Salisbury, Hatfield House. The portrait is dated 1585. For the attribution to Hilliard, see Auerbach, *Nicholas Hilliard*. An

alternative attribution to William Segar is proposed by Strong, *Portraits of Queen Elizabeth I*, p. 82. On the ermine, see Yates, *Allegorical Portraits of Queen Elizabeth I at Hatfield*, pp. 1–2, and on the sword and sprig of olive, representing *Justitia* and *Pax*, Strong, *Portraits of Queen Elizabeth I*.

60. The miniature exists in two versions in the collection of Lord Wharton and in the Victoria and Albert Museum, London, both dated 1588. See Auerbach, *Nicholas Hilliard*, pp. 100, 299.

61. Victoria and Albert Museum, London, Auerbach. *Nicholas Hilliard*, pp. 137, 308, dates the miniature in the late 1590's.

62. Victoria and Albert Museum, London. For the inscription and its interpretations, see Auerbach, *Nicholas Hilliard*, pp. 103–9, 300.

63. For a discussion of this and other translations of the passage, see L. Hotson, *Mr. W. H.*, London, 1964, pp. 208–20. The miniature is identified by Hotson as a portrait of William Hatcliffe, the presumed Mr. W. H. of the Shakespeare Sonnets. According to this interpretation, the hand on the heart represents friendship and the tree constancy, while the rose thorns symbolize friendship in adversity or trouble.

VI: Donor and Participant

1. For the identification of the donors, see Chapter 1, note 50. C. De Tolnay, "Renaissance d'une fresque," in *L'Œil*, 1958, January, pp. 37–41, regards the skeleton beneath the fresco as that of Adam, and interprets the platform on which God the Father stands as the suspended tomb of Christ. The donor is here wrongly described as Don Lorenzo Cardoni, prior of Santa Maria Novella. U. Schlegel ("Observations on Masaccio's Trinity Fresco in Santa Maria Novella," in *Art Bulletin*, XLV, 1963, pp. 19–33), who describes the scene as a Golgotha Chapel, also presumes an antithesis between the corrupt body, representing Death, and the incorrupt body of Christ.

2. The significance of this portrait is discussed by O. Paecht, "Jean Fouquet: a Study of his Style," in *Journal of the Warburg and Courtauld Institutes*, IV, 1940–41, pp. 85–102.

3. It is known that in 1457 Tanai de' Nerli was thirty-one and his wife twenty-eight. The altarpiece is dated ca. 1487–88 by A. Scharf, *Filippino Lippi*, Vienna, 1935, p. 109, and K. B. Neilson, *Filippino Lippi*, Cambridge, Mass., 1938, pp. 71–3. A later dating, ca. 1493–94, has also been proposed.

4. The portraits are identified by Vasari, III, p. 473: "e vi ritrasse in figura d'un astrologo che ha in mano un quadrante Pier Francesco vecchio de' Medici figliuolo di Lorenzo di Bicci, e similmente Giovanni padre del signor Giovanni de' Medici, e un altro Pier Francesco di esso signor Giovanni fratello ed altri segnalati personaggi" (... wherein he portrayed the elder Pier Francesco de' Medici, son of Lorenzo di Bicci, in the figure of an astrologer who is holding a quadrant in his hand, and likewise Giovanni, father of Signor Giovanni de' Medici, and another Pier Francesco, brother of this same Signor Giovanni, and other people of distinction [Medici IV:8]).

5. The frescoes in the Caraffa Chapel were executed in 1488–93. There is some damage in the portrait head.

6. The altarpiece is generally dated 1512–13, and was moved to Foligno in 1565.

7. M. Meiss, "Ovum Sruthonis," in *Studies in Art and Literature for Belle da Costa Greene*, D. E. Miner, ed., Princeton, 1954, pp. 96–7, 101, states a strong case for supposing that the altarpiece commemorates the birth of Federigo da Montefeltro's son Guidobaldo in January 1472 and the death of his wife, Battista Sforza, in July of the same year. Federigo da Montefeltro is shown without the Order of the Garter, which was awarded to him in 1474. The picture is dated ca. 1472 by R. Longhi (*Piero della Francesca*, Florence, 1963, pp. 68–71), and ca. 1470–75 by K. Clark (*Piero della Francesca*, London, 1951, p. 48). It is shown by P. Rotondi ("Quando fu costruita la chiesa di S. Bernardino in Urbino?" in *Belle Arti*, I, 1946–47, pp. 191–202) that the altarpiece must have been painted not for San Bernardino at Urbino, where it was subsequently installed, but for the adjacent church of San Donato.

8. The identification of the head of St. Peter Martyr as a portrait of Fra Luca Pacioli is advanced, on the basis of resemblances to the Naples portrait (see below), by C. Ricci (*Pier della Francesca*, Rome, 1910, p. 11), and is accepted, among others, by Clark (*Piero della Francesca*, p. 49).

9. O. Benesch, "A New Contribution to the Problem of the *Portrait of Fra Luca Pacioli*," in *Essays in Honor of Hans Tietze, 1880–1950*, Paris, 1958, pp. 407–10, observes that the drawing on the blackboard illustrates the construction of the first regular solid (*De divina proportione*, c. xxvi), that the fifth regular solid, a dodecahedron, appears on the book to the right, and that an iconohexahedron (*De divina proportione*, c. liii) is suspended on the left. The provenance of the painting is established by Gronau, "Per la storia d'un quadro attribuito a Jacopo de' Barbari," in *Rassegna d'arte*, v, 1905, pp. 407–10. A thorough analysis of the problem of its authorship is contained in the catalogue of the *Mostra di Melozzo e del quattrocento romagnolo*, C. Gnudi and L. Becherucci, ed., Forlì, 1938, No. 45, pp. 36–8.

10. The circumstances from which the *Madonna of*

Victories sprang are best described by P. Kristeller, *Andrea Mantegna*, London, 1901, pp. 302–16. For a summary of the available information on the painting, see E. Tietze-Conrat, *Mantegna: Paintings, Drawings, Engravings*, London, 1955, p. 213.

11. The sculptured portraits of Gian Francesco Gonzaga are illustrated and discussed by G. Paccagnini in *Mostra di Andrea Mantegna*, Venice, 1961, pp. 149–50, Nos. 108, 109.

12. P. Ganz, *The Paintings of Hans Holbein*, London, 1950, p. 223. H. A. Schmid (*Hans Holbein der Jüngere*, Basel, 1948, I, pp. 202–3) relates the scheme to paintings by Zenale and Borgognone.

13. The painting is dated by M. J. Friedlaender and J. Rosenberg, *Die Gemälde von Lucas Cranach*, Berlin, 1932, p. 59, No. 155, ca. 1520–25. For the portrait head, see W. A. Luz, "Der Kopf des Kardinals Albrecht von Brandenburg bei Dürer, Cranach, und Grünewald," in *Repertorium für Kunstwissenschaft*, XLV, 1925, pp. 41–77.

14. Dated 1488.

15. H. Wölfflin, *Die Kunst Albrecht Dürers*, 3d edn., Munich, 1919, p. 144.

16. For the circumstances of the commissioning of the altarpiece, see F. Valcanover, *Tutte le opere di Tiziano*, Milan, 1960, I, p. 46, pl. 10.

17. The discrepancy in style between the head and the remainder of the painting was first noted by W. E. Suida, *Tizian*, Zurich and Leipzig, 1933, pp. 23–4.

18. Commissioned for the altar of the Conception in the Frari, on April 24, 1519, the painting was inaugurated on the feast of the Immaculate Conception (December 8) 1526.

19. For the *Vendramin Family*, see C. H. M. Gould, *Sixteenth Century Venetian School*, pp. 117–20. The painting has a structural precedent in the fresco of Andrea Gritti before the Virgin and Child in the Palazzo Ducale, Venice, executed by Titian in 1523 and destroyed in 1797, which is recorded in an engraving (Valcanover, *Tutta la pittura di Tiziano*, II, pl. 190).

20. For Ranuccio Farnese (who became Archbishop of Naples at the age of fourteen, was appointed Cardinal at fifteen, served as Patriarch of Constantinople and Archbishop of Ravenna from 1549–63, and died as Archbishop of Milan in 1565), see G. Gronau, "Zwei Tizianische Bildnisse der Berliner Galerie," in *Jahrbuch der Königlich Preussischen Kunstsammlungen*, XXVII, 1906, pp. 3–12. Ranuccio Farnese visited Venice in 1542.

21. According to Gronau, "Zwei Tizianische Bildnisse," Clarice, daughter of Roberto Strozzi, was painted by Titian in 1542 at the age of two. She married Cristoforo Savelli in 1557, and died in 1581. The date of the painting is confirmed by a letter of Aretino to Titian of July 6, 1542.

22. The portrait, now in the Contini-Bonacossi col-lection, Florence, forms a companion piece to the double portrait of Lucia Thiene, wife of Giuseppe da Porto, with her daughter Porzia, in the Walters Art Gallery, Baltimore. The sitters were married in 1545, and the paintings seem to date from ca. 1555–56 (R. Pallucchini, *Mostra di Paolo Veronese*, Venice, 1939, p. 73, No. 26).

23. For the *Adoration of the Trinity*, which was begun in 1507 and completed in 1511, see E. Panofsky, *Dürer* (1945), I, pp. 125–31.

24. Vasari, VII, p. 451.

25. The two groups were commissioned in or after 1591, and were installed in May 1598.

26. H. E. Wethey, *El Greco and His School*, Princeton, 1962, II, pp. 74–6. The altarpiece, now in the chapter house of the Escorial, was painted ca. 1579, probably in commemoration of Don Juan of Austria, who had died in the preceding year.

27. Wethey, *El Greco*, II, pp. 79–81. The identities of the other portrait figures in the painting are hypothetical.

28. The name of Titian appears in the account books of the Scuola del Santo on December 1, 1510. Work on the frescoes (for which, see A. Morassi, *Tiziano: gli affreschi della Scuola del Santo a Padova*, Milan, 1956) was begun before April 23, 1511, and was completed by December 2 of the same year.

29. The identification of the portrait as that of Tommaso Contarini (1488–1578) is due to H. Thode, "Tintoretto: Kritische Studien über des Meisters Werke," in *Repertorium für Kunstwissenschaft*, XXIV, 1901, p. 435.

30. Pope-Hennessy, *Italian High Renaissance and Baroque Sculpture*, London, 1963, III, pp. 108–9.

31. Ibid., p. 115. The bust was commissioned in or about 1571 for a corridor adjacent to the sacristy of San Geminiano.

32. The proposal of Rangone to commission the paintings was put forward on June 21, 1562, and the canvases were finished by 1566, when they were seen by Vasari, VI, p. 592. See also C. Ridolfi, *Le Maraviglie dell'arte*, D. von Hadeln, ed., II, Berlin, 1921, p. 22. For the portrait of Rangone included in the *Miracle of the Slave* of 1548 see R. Pallucchini, *La Giovinezza del Tintoretto*, Milan, 1950, p. 119.

33. R. Pallucchini, *Mostra di Paolo Veronese*, No. 61, pp. 145–7. The painting dates from 1573.

34. The identification of the Madrid painting with a canvas described by Ridolfi in the Palazzo Contarini is proposed by Hadeln, in Ridolfi, *Maraviglie dell'arte* (1914), I, p. 318.

35. Pallucchini, *Mostra di Paolo Veronese*, No. 89, pp. 207–9. For the date of the painting (1587), see Gallo, "Per la datazione delle opere del Veronese," in *Emporium*, LXXXIX, 1939, p. 146.

36. Pope-Hennessy, *Fra Angelico*, London, 1952, pp

174–5. The predella panel dates from ca. 1438–40.

37. E. Panofsky, *Early Netherlandish Painting*, Cambridge, Mass., 1954, I, pp. 274–5.

38. R. van Schoute, *La Chapelle Royale de Grenade: Les Primitifs flamands*, Brussels, 1963, pp. 36–53.

39. The painting is dated by Friedlaender ca. 1455. See also M. Davies, *National Gallery Catalogues: Early Netherlandish School*, London, 1955, pp. 12–13.

40. On Titian's self-portraits see, in addition to the standard monographs, L. Foscari, *Iconografia di Tiziano*, Venice, 1935.

41. Vasari, VII, p. 446: "Nel medesimo tempo ritrasse Tiziano se stesso per lasciare quella memoria di se ai figliuoli."

42. Vasari, VII, p. 459: "e, come s'è detto, un suo ritratto, che da lui fu finita quattro anni sono, molto bello e naturale."

43. C. Ridolfi, *Maraviglie dell'arte*, I, p. 200.

44. The Berlin portrait is discussed by G. Gronau, "Tizians Selbstbildnis in der Berliner Galerie," in *Jahrbuch der Königlich Preussischen Kunstsammlungen*, XXVIII, 1907, pp. 45–9. Though Foscari (*Iconografia di Tiziano*, p. 16) and H. Tietze (*Titian*, London, 1950, p. 368) accept the Berlin painting as a work of ca. 1550, it appears to show the artist at a more advanced age than an engraved self-portrait which can be assigned to 1550 on the evidence of a letter of Aretino (for this see F. Mauroner, *Le Incisioni di Tiziano*, Venice, 1941, pp. 41–2).

45. Tietze, *Titian*, p. 385, follows Suida in dating the portrait in Madrid ca. 1562.

46. The identification of the head as a self-portrait is due to L. Foscari, *Iconografia di Tiziano*. Another participant self-portrait by Titian is recorded by Vasari, VII, p. 442, at Cadore: "Ha fatto Tiziano in Cador, sua patria, una tavola dentro la quale e una Nostra Donna e San Tiziano vescovo, ed egli stesso ritratto ginocchioni" (In Cadore, his native place, Titian has painted an altarpiece in which are Our Lady, S. Tiziano the Bishop, and a portrait of himself kneeling [Medici IX:168]).

47. Victoria and Albert Museum, London. The portrait is published by D. von Hadeln ("A Self-Portrait by Tintoretto," in *Burlington Magazine* XLIV, 1924, p. 93) as a work of ca. 1548, and is discussed by R. Pallucchini in *La Giovinezza del Tintoretto*, p. 116.

48. Louvre, Paris. The portrait was engraved by Gisbert van Geen in 1588, and is dated by H. Tietze, *Tintoretto*, London, 1948, p. 358, in this year.

49. *Mostra del Tintoretto*, Venice, 1937, No. 74. The head is closely related to the Louvre self-portrait of six years earlier.

50. The terminal dates proposed for the Cleveland *Pietà* are 1521 (Pallucchini) and 1530 (Longhi). C. E. Gilbert ("Milan and Savoldo," in *Art Bulletin*, XXVII, 1945, pp. 124ff.) proposes a dating ca. 1525, and is followed in this by A. Boschetto (*Giovan Gerolamo Savoldo*, Milan, 1963, pl. 20), and H. Francis ("The Liechtenstein Pietà by Savoldo," in *Bulletin of the Cleveland Museum of Art*, XL, 1953, pp. 119–21). Since this lecture was delivered, the subject of artists' and donors' portraits as Nicodemus has been discussed by W. Stechow, "Joseph of Arimathaea or Nicodemus?" in *Studien zur Toskanischen Kunst: Festschrift für Ludwig Heinrich Heydenreich*, W. Lotz and L. L. Möller, ed., Munich, 1964, pp. 289–302.

51. The group is dated 1559. Work on it seems to have begun in 1554. The figure supporting Christ is described by Vasari as Nicodemus. For the literature of the group see Pope-Hennessy, *Italian High Renaissance and Baroque Sculpture*, III, pp. 64–5.

52. The group was begun in or before 1550, when it is mentioned in the first edition of the *Vite* of Vasari, and was abandoned in or before 1555. The designation of the supporting figure as Nicodemus occurs in Condivi's life of Michelangelo (1553). In a letter to Leonardo Buonarroti of March 18, 1564 (K. Frey, *Der Literarische Nachlass Giorgio Vasaris*, Munich, 1923, No. CDXXXVI), Vasari includes the words: "Oltre che ella è disegniata per lui, evvi un vechio che egli ritrasse se."

Index

Index

Names of persons discussed as such are in roman type; of those discussed as subjects of portraits, in *italic*. A page number preceded by an asterisk indicates an illustration.